OUT OF THE BOX THE RISE OF SNEAKER CULTURE

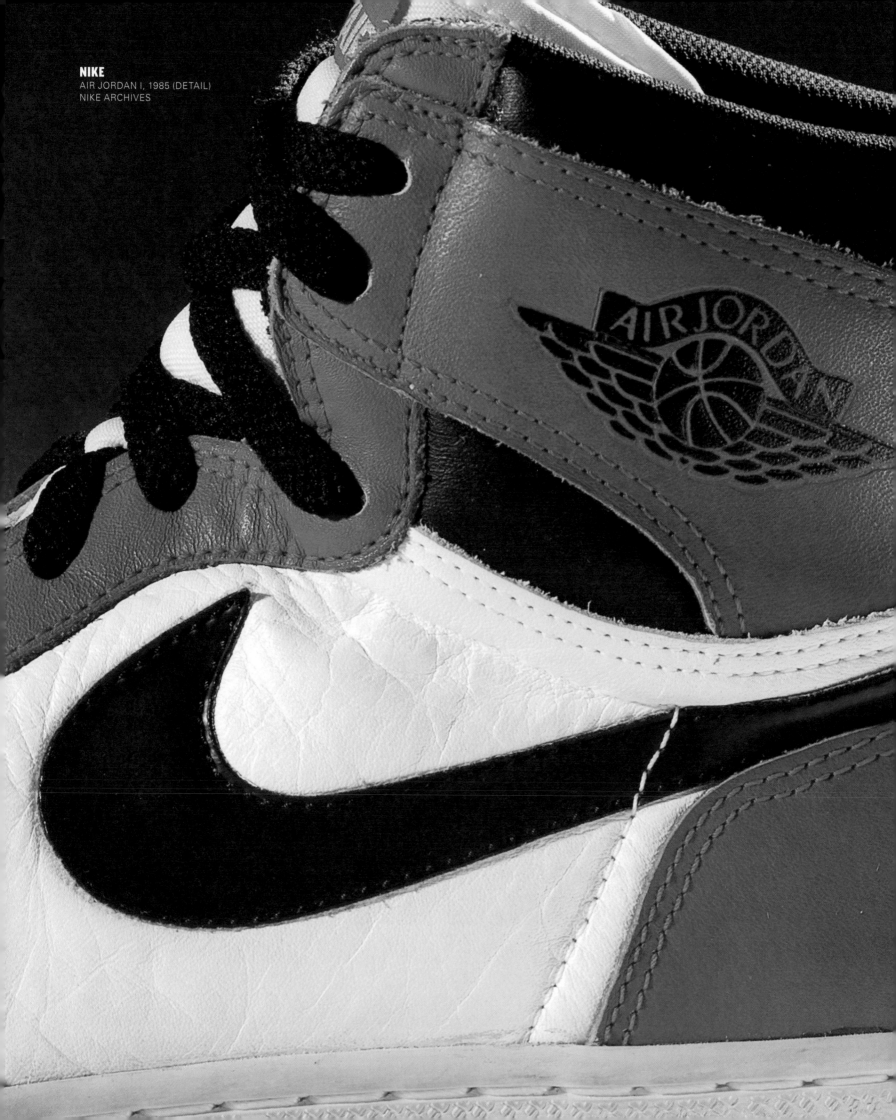

OUT OF THE BOX

THE RISE OF SNEAKER CULTURE

AMERICAN FEDERATION OF ARTS

American Federation of Arts in partnership with the Bata Shoe Museum and Skira Rizzoli

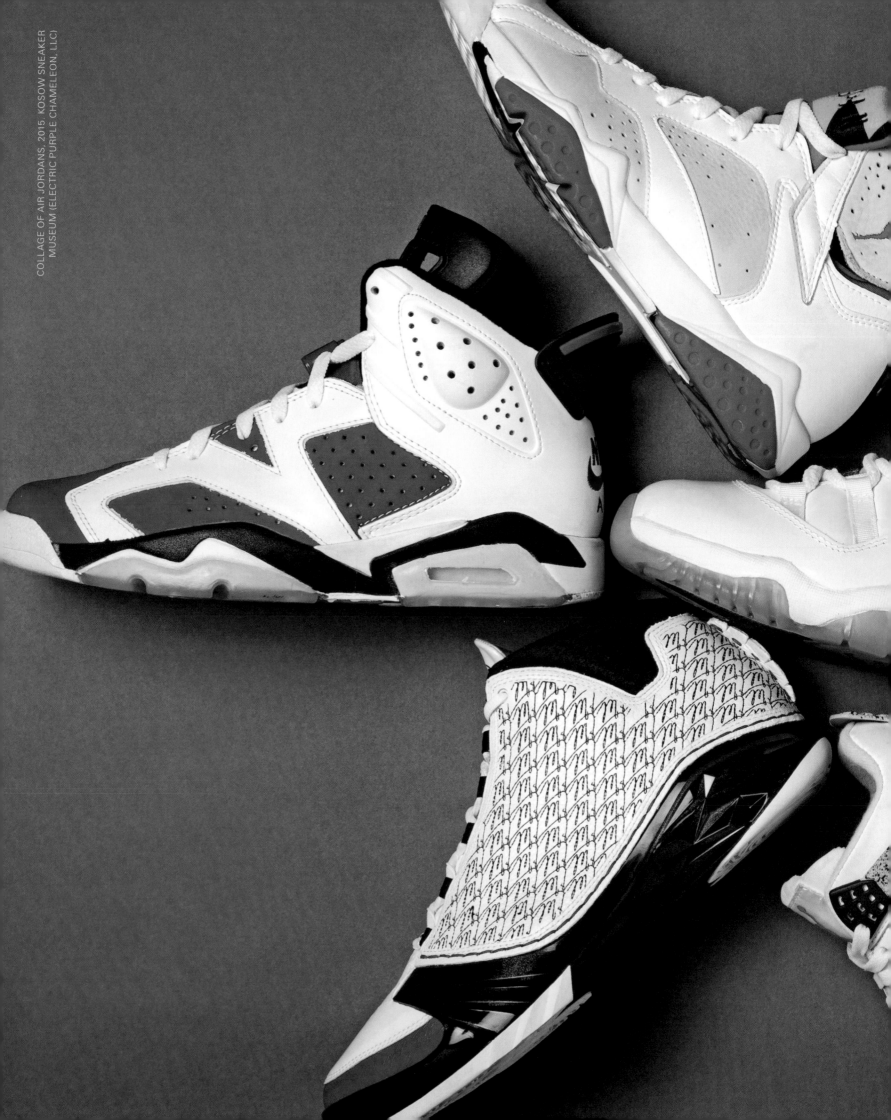

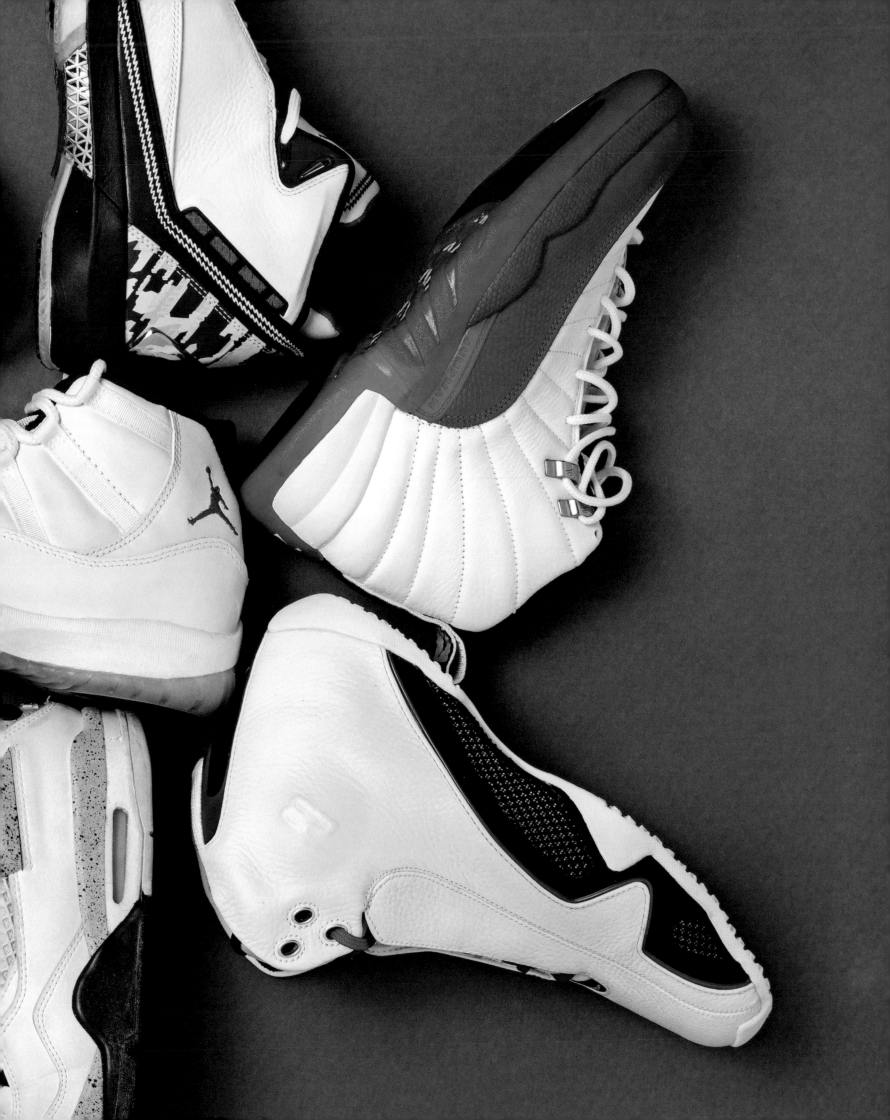

TABLE OF CONTENTS

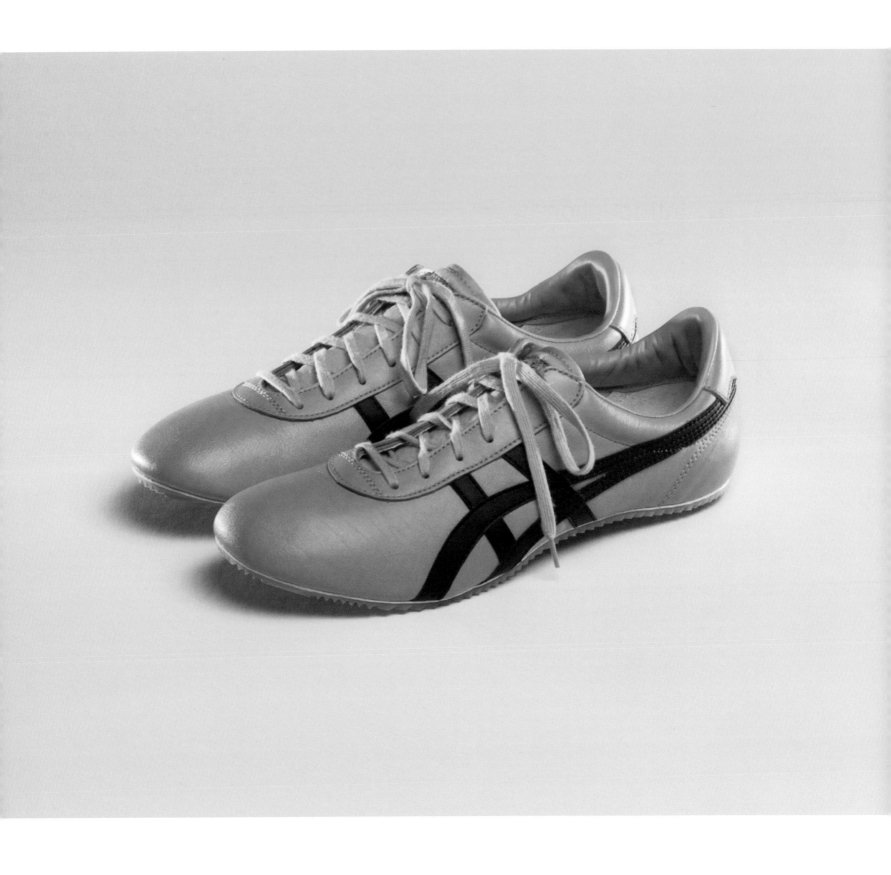

FOREWORDS
EMANUELE LEPRI, DIRECTOR, BATA SHOE MUSEUM

The Bata Shoe Museum holds an impressive collection of footwear, more than 13,000 artifacts and counting, spanning history from Ancient Egypt to today and around the globe from the Arctic to Australia. Our mandate is both highly specialized and encyclopedic at the same: we collect footwear, all types of it. Thus, it is only natural that the Bata Shoe Museum would eventually cross paths with one of the most seemingly democratic, functional, and technologically advanced types of footwear: the sneaker.

Museums are conservative institutions by nature. Their comfort zone is in preserving, documenting, and interpreting the past. The present or even the too-recent past is frequently perceived as foreign territory, risky business to say the least. It takes courage for a museum to venture into the interpretation of a contemporary cultural phenomenon. Especially when the very essence of such a phenomenon speaks of anti-establishment values, rebellion, and challenges to formality and traditional social structures. What makes the project unique is that *Out of the Box* doesn't simply address these aspects of the sneaker but deals with the cultural meanings hidden in those rubber soles, and makes an effort to present, in an engaging and cohesive way, the extraordinary trajectory of the sneaker in its endless transformations since the nineteenth century.

Only rarely do the stars align and make endeavors such as *Out of the Box: The Rise of Sneaker Culture* possible. When our Senior Curator Elizabeth Semmelhack presented her concept for the first time, she was surprised to see the enthusiastic reaction of management, staff, and the museum's Board. We all felt energized by the compelling challenge of working on an exhibition which dealt with something so relevant in our contemporary world, yet so new in terms of academic or curatorial work. The prospect was daring, yet promising, and opened our museum to a new range of opportunities. Indeed, sneakers have not failed us—quite the contrary, as the transformation of *Out of the Box* into a traveling exhibition attests.

It has been a profound pleasure working with the American Federation of Arts on this complex and expanded version of the exhibition and its accompanying book. The exceptional vision, dedication, and hard work of the AFA has been unparalleled and has allowed the mission of the Bata Shoe Museum to reach larger audiences. We are also extremely grateful to the AFA and Skira Rizzoli Publications for their tireless work on this exciting book.

A project this ambitious requires numerous expressions of gratitude. The staff at the AFA, especially Curator of Exhibitions Michelle Hargrave and Manager of Publications and Communications Audrey Walen are heartily thanked, as is the dedicated staff of the Bata Shoe Museum, in particular Senior Curator Elizabeth Semmelhack, Conservator Ada Hopkins, Collections Manager Suzanne Petersen McLean, and Curatorial Assistant Nishi Bassi. In addition, the museum would like to acknowledge the incredible and consistent support from the community of collectors, experts, designers, and makers of sneakers that has allowed *Out of the Box: The Rise of Sneaker Culture* to blossom not only into a successful traveling exhibition and publication but into a groundbreaking project for outreach and community building.

Out of the Box: The Rise of Sneaker Culture is a title that speaks not only of this revolutionary shoe's elevation over the centuries from athletic footgear to style staple and luxury item but of its importance in contemporary cultural life. Whether in the arena of athletics, fashion, or street culture, the wearing of sneakers communicates a central message about the style, status, and even weltanschauung of the wearer. When they are not being worn but rather painstakingly preserved in pristine condition, sneakers convey our dreams and aspirations. By telling the story of sneaker culture in the fine arts museum, we are acknowledging that the far-reaching influence of sneakers on society continues to grow while placing today's developments within a historical frame.

The American Federation of Arts remains steadfastly committed to presenting art and culture in all the forms in which it is created. When Bata's Senior Curator Elizabeth Semmelhack suggested we develop a touring presentation of *Out of the Box*, we knew that this project fit within the AFA's programming objectives. This meticulously researched exhibition and catalogue enable us to share with communities across the country a deeper appreciation of the sneaker's radical cultural significance and profound impact. We are extraordinarily grateful to her.

A project of this complexity involves the efforts of many people. First and foremost, we must recognize Bata's visionary director, Emanuele Lepri, and his wonderful staff, including Suzanne Petersen McLean, Collections Manager, and Ada Hopkins, Conservator. We are fortunate to have a great team here at the AFA, including Michelle Hargrave, our Curator of Exhibitions; Audrey Walen, Manager of Publications and Communications; and Lindsey O'Connor, Curatorial Assistant. Their professionalism, creativity, and dedication to scholarly excellence can be seen in the pages of this volume. We also thank Thierry Daher of CAID Digital Productions for all his efforts on behalf of this project.

This publication would not have been a success without the generosity of the cultural visionaries, writers and thinkers, lenders, photographers, and others who collaborated with us on *Out of the Box*. All are listed at the back of the book; we are honored to have had the opportunity to work with each of them. We also must acknowledge our Trustees, members, and funders, whose ongoing support enables us to create exhibitions such as this and bring them to audiences across the nation and beyond.

I extend enormous gratitude to Charles Miers, Publisher; Margaret Chace, Associate Publisher; and the group at Skira Rizzoli, especially Senior Editor Jessica Fuller, for believing in this book and introducing us to the gifted design team of Stella Giovanni. It has been wonderful to have worked on this book with Stella and Tony.

Finally, we recognize the museums presenting this important exhibition: Brooklyn Museum, Speed Art Museum, and the Toledo Museum of Art. Collaborating with each of these institutions has been a pleasure, and we thank them for being such enthusiastic and innovative partners willing to break this new ground with us.

JEREMY SCOTT

ADIDAS X JEREMY SCOTT, WINGS 1.0 (DETAIL), 2009, ADIDAS AG

The Wings have become quite an emblem of my collection. I wanted to do something that would bring the eye down to the foot, that would change the volume—the appearance—of the shoe, but not impede the actions of the wearer. I was inspired by Greek statues and basketball players flying through the air to make a slam dunk. I feel that the wing is a very uplifting and optimistic icon.

FASHION DESIGNER AND CREATIVE DIRECTOR FOR MOSCHINO JEREMY SCOTT COLLABORATES WITH ADIDAS TO CREATE A HIGHLY SOUGHT-AFTER LINE OF WHIMSICAL SNEAKERS.

INTRODUCTION
BOBBITO GARCIA

November 13, 2014. Last week, I was invited to be a guest of honor at STR.CRD, Africa's first and foremost sneaker event. Today, I'm flying to Amsterdam to do the same at Sneakerness, Europe's premiere traveling celebration of all things cool surrounding footwear. During my visit, Patta—one of the top shoe shops in the world—and I will release a collaborative apparel collection. While looking for inspiration for one of the pieces, I came up with this:

HEAD HEAD
FIEND FIEND
ADDICT ADDICT
COLLECTOR COLLECTOR
CUSTOMIZER CUSTOMIZER
CONNOISSEUR CONNOISSEUR
RESELLER RESELLER
DESIGNER DESIGNER
EXPERT HEAD EXPERT
KING FIEND KING
LEGEND ADDICT LEGEND
COLLECTOR COLLECTOR
CUSTOMIZER CUSTOMIZER
CONNOISSEUR CONNOISSEUR
RESELLER RESELLER
DESIGNER DESIGNER
EXPERT EXPERT
KING KING
LEGEND LEGEND

Not all of these roles describe who I am, was, or ever will be, but they encompass a great majority of people drawn to the pieces of leather, rubber, nylon, synthetics, and other materials wrapped around their feet.

When I was born, in 1966, none of these titles applied to anyone, anywhere. I was blessed to be born in the '60s. As a shorty, I caught the tail end of the civil rights and black power movements. I remember watching the first man walk on the moon. The world was changing in powerful fashion.

In a much smaller step, the early 1970s birthed a new cultural movement in New York that did not even have a name to describe it at first, but eventually became known globally as hip-hop. Footwear had been important on the street for two decades before b-boys did their first top rock, but the range of what the savvy could wear was limited. That changed dramatically by the mid-1970s as new brands popped up, distribution improved, and new materials were introduced. The days of strictly canvas choices between Converse Chuck Taylors or PRO-Keds 69ers were gone. Suede Puma Clydes, nylon Adidas Americanas, leather Pony David Thompsons, nubuck/polyurethane Wilson Batas, and an unknown brand called Nike (pronounced like bike) with these moon boots called Blazers—all were catching *fuego* in my 'hood.

Early DJs, MCs, b-boys, and b-girls took their fashion cues for their footwear directly from one source: the NYC basketball community. Any iconic hip-hop sneaker, from Chucks to Shell Toes to Air Force 1s, was first made cool by ballplayers outdoors, without exception. These models eventually transcended their designed function and sport, and became important items on anyone's feet that wore them. Moreover, they became extensions of that person's identity, and creative expressions of their individuality.

In the 1970s, New Yorkers in the basketball and hip-hop community changed the perception of sneakers from sports equipment to tools for cultural expression.

In 1980, I started painting the stripe or entire upper of my sneakers. Not only was I making a statement that "I am unique!" but also I was creating a social bridge. I'd be asked by many a stranger, "Yo, my man, where'd you get those?" Cats who ironed their shoelaces to make them wider had the same mentality. It wasn't just *what* you wore, but *how* you wore it. We injected a mentality and approach toward footwear that gave it life and importance. We laid the foundation not only for the worldwide cultural movement that is seen today but also the 300% growth in sales the industry saw by the end of the '80s.

What sometimes gets lost in this history is that we, the progenitors of sneaker culture, were predominantly people of color—scratch that, kids of color—who

grew up in a depressed economic era and experienced a lack of resources. That era, as difficult as it was, was beautiful for me and I wouldn't trade it for anything. Pretty amazing, right?! So when I started reading mass media articles in the late 1990s/early 2000s about a "new sneaker phenomenon," I set out to correct the misinformed. I lived through the formative years and was part of it first hand, plus I'm still around to share it.

In 1990, a year-old hip-hop magazine called *The Source* asked me to write an article about sneakers. I titled the piece "Confessions of a Sneaker Addict." It was the very first documentation of the culture in all media. The pages caught the eye of Testify Books publisher Dana Albarella, who approached me about authoring a book on the subject. In 2004, I released the critically acclaimed title *Where'd You Get Those? New York City's Sneaker Culture: 1960–1987*. A year later, ESPN invited me to be the host/creative producer of a series called *It's The Shoes*. The weekly program was the very first in television history to be based on sneaker culture.

With the support of the *It's The Shoes* producers, I used the show as a platform to promote Hoops 4 Hope (hoopsafrica.org). This nonprofit organization, based in South Africa and Zimbabwe, uses sneaker donations from the U.S. as a way to draw youth to their basketball clinics, where they teach life skills and HIV prevention. Hoops 4 Hope is not alone. Soles4Souls (soles4souls.org) and Samaritan's Feet (samaritansfeet.org) are two other nonprofit organizations that collect sneaker donations and deliver them to developing and disaster relief areas of the world where even a worn-out outsole can be helpful.

Sneakers have become agents of social change.

I should add DONOR, AMBASSADOR, and ACTIVIST to the above list of roles for people involved in sneaker culture. I hope you personally consider doing the same when you describe your own activity within the culture.

Sneakers have also become the subject of historical study. In 2009, the first college course in the world based on sneaker culture was offered at Carnegie Mellon University. My book was used as the main text!

In 2013, the Bata Shoe Museum created the *Out of the Box* exhibition and invited me to attend the opening. I thought I knew all there was to know about sneaker history, but I found myself jaw open, learning so much more than I had expected! So I was ecstatic to find out that the show had wheels, and that so many more people would be able to participate in the richness as the exhibition travels to other museums. A lot has changed. Let's continue to figure out new ways to interpret what we wear on our feet, and how it can impact others.

Opposite Page:
Customized Nike Air Force 1 Texas Longhorn, Courtesy Bobbito Garcia Archive

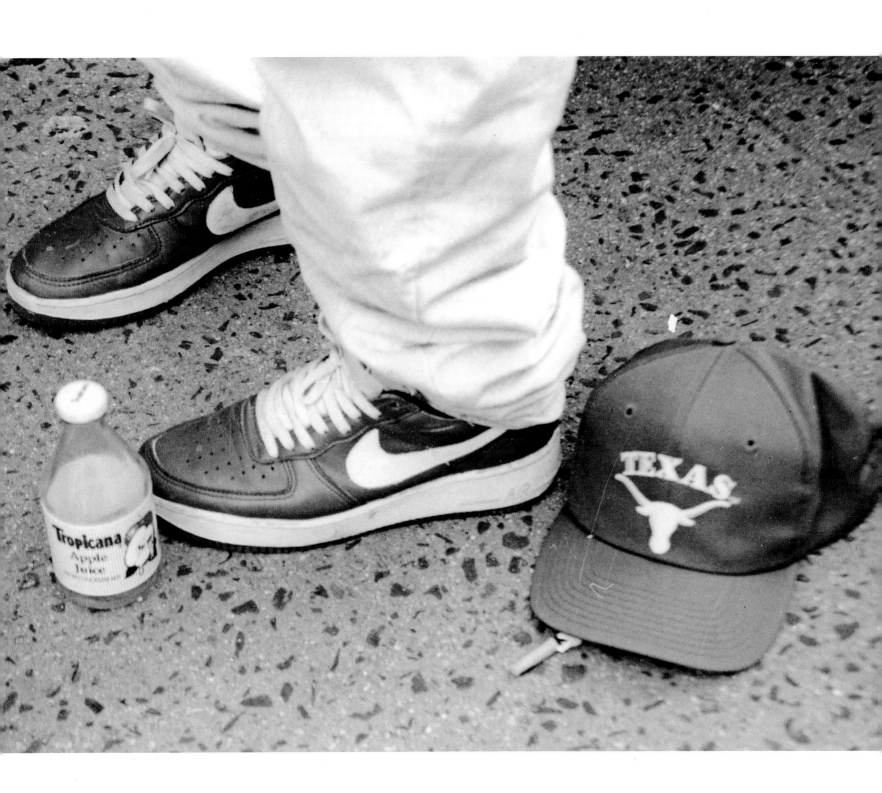

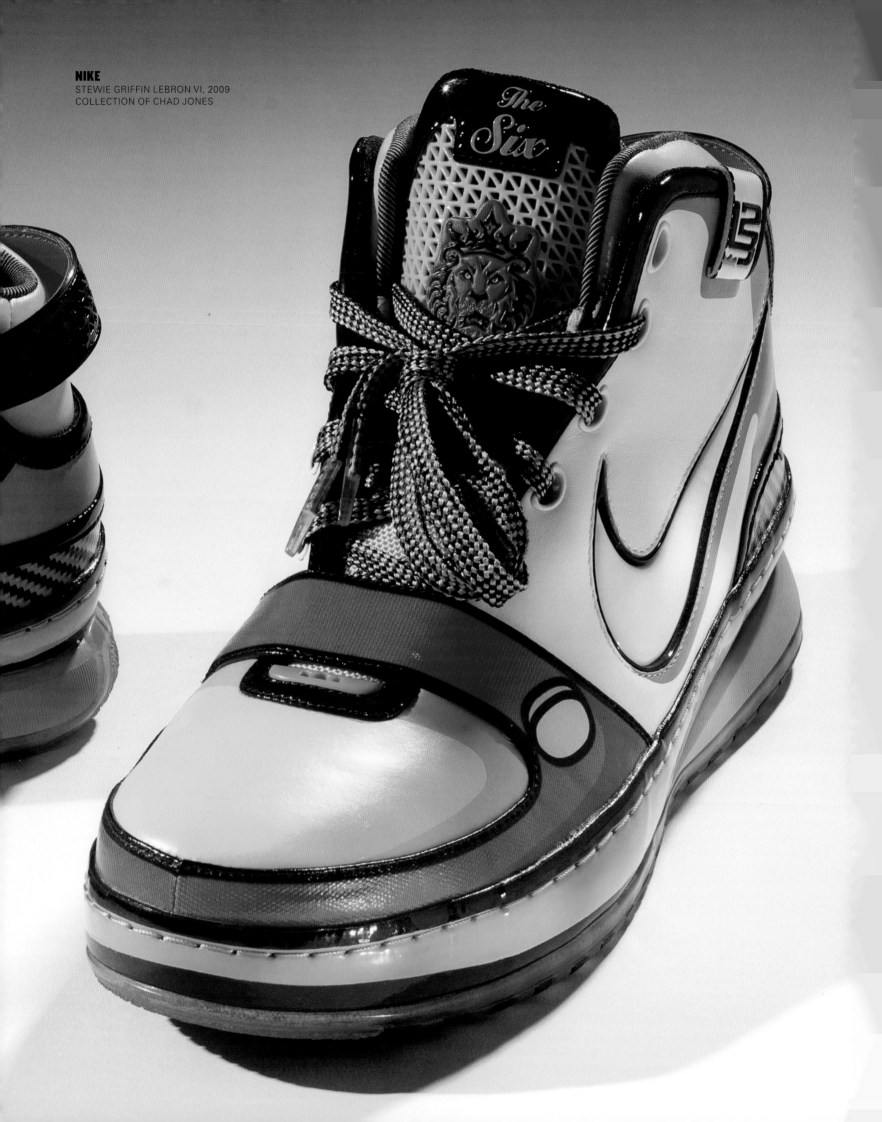

OUT OF THE BOX: THE RISE OF SNEAKER CULTURE
ELIZABETH SEMMELHACK, SENIOR CURATOR, BATA SHOE MUSEUM

Sneakers are worn by millions worldwide and seem to transcend gender, age, and socioeconomic condition. Yet under the broad category of "sneaker" lies a minefield of meaning full of social significance. In other words, although sneakers might appear to be democratic, not all are created equal, as the rise of sneaker culture attests.

How have some sneakers come to be valued more highly than others, with the most prized inspiring private collections numbering thousands of pairs? How did sneakers transform from specialized sports footwear to staples of street fashion and in turn become accessories central to expressions of masculinity? How is it that with a single glance, a pair of sneakers can reveal profoundly nuanced social information? A picture may paint a thousand words, but today, so does a pair of original Air Jordan IIIs. The answers to these questions are embedded in the long history of sneaker culture and are intertwined with compelling stories that reflect fascinating consistencies and profound changes from the relentless pursuit of the new and innovative to the constantly shifting politics of inclusion and exclusion.

The origin of the sneaker dates back to the early nineteenth century, when it was born from a confluence of technological advancements and societal shifts. The wealthy of the Industrial Age sought diversion in physical recreation and eagerly consumed athletic footwear to improve their performance and proclaim their privilege. As the century wore on, however, the perceived relationship between criminality, degeneracy, and the wearing of sneakers also emerged, as connections between morality, physical fitness, and the conditions of the urban poor became a cultural focus. Advances in sneaker production innovated in the 1920s dramatically increased the availability of sneakers, but the sneaker's democratization was driven by the pursuit of bodily perfection in relation to nationalism and, more specifically, the emergence of fascism in the 1930s. The introduction of television into the households of millions in the 1950s marked another step in the increasing cultural importance of the sneaker, as it paved the way for the creation of highly commodifiable superstar athletes whose sneakers would become objects of desire in the following decades. The 1970s saw the emergence of innovative sneakers that promised improved athletic performance, which were eagerly consumed by the Me Generation obsessed with achieving their own personal best, while simultaneously in urban America, basketball sneakers were being transformed into cultural icons. Two of the most pivotal events in sneaker history, Nike's signing of basketball rookie Michael Jordan and Adidas's signing of rap group Run–DMC, popularized status basketball shoes to a wider audience and took urban sneaker fashion global, giving rise in the 1980s to what is now known as sneaker culture.

The entrance of high-end fashion designers into sneaker culture in the 1990s further established the sneaker's essential place in wardrobes of many men.

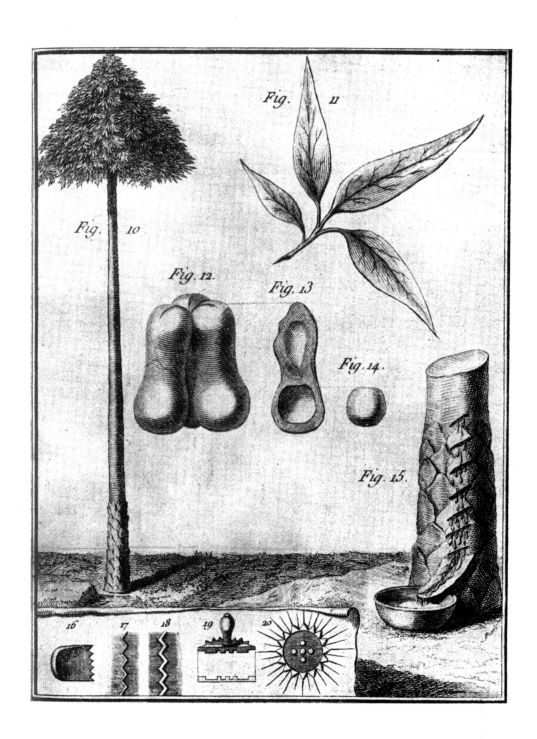

Opposite Page:
This illustration from Charles-Marie de La Condamine's publication on rubber includes a depiction of the pattern left on the tree trunk by the continual scoring of the bark to release the rubber sap. This chevron-like pattern shares a striking similarity to the pattern that the treads of many sneakers would come to feature.
Charles-Marie de La Condamine, *Dissertatio de principio minimae actiones una cum examine obiectionum cl. Prof. Koenigli contra hoc principium factarum* (Berolini: Ex officina Michaelis, 1753)

The more relaxed dress codes of the final decades of the twentieth century fueled interest in sneakers as a means of establishing nuanced individuality, and marked men's larger participation in the fashion system. Through sneaker culture, men have been repositioned as active consumers, using fashion to construct idealized versions of masculinity and masculine success. Limited editions, retro packs, customizations, vintage originals, rare colorways, and designer kicks are all eagerly sought because of the complex meanings they convey. The global explosion of sneaker culture today is rich with social significance because of the long history of the sneaker, which is a history composed of diverse and complex narratives stretching from the Industrial Age to today.

RUBBER REVOLUTION: THE ORIGIN OF THE SNEAKER

The history of the sneaker begins in the forests of South and Central America where the milky sap of indigenous "weeping wood" trees had long been exploited by the region's people to make everything from rubber balls to waterproof clothing.[1] Although Europeans had been aware of this unusual substance since the sixteenth century, it wasn't until the middle of the eighteenth century that this material, called "latex" after the Latin word for liquid, became of interest, after the French mathematician and explorer Charles-Marie de La Condamine sent a report on this curious sap from Brazil to the French Academy of Sciences in 1736.[2] Rubber's remarkable elasticity and waterproof qualities fascinated both scientists and the public alike, but its practical application was frustrated by a number of challenges. Outside of the jungles of Brazil, rubber's lack of resilience in different temperatures was immediately apparent: it melted in hot weather and became brittle in cold. Rubber was also most workable in its natural liquid form, but experimenters in America and Europe were forced to work with coagulated rubber, as latex quickly congealed after tapping, making it impossible to export in a liquid state. In addition, rubber was a labor-intensive, limited commodity; a single tree could be tapped only every other day and yielded little more than a cup of sap at each tapping. One of its first uses in the West, rubbing out pencil marks, gave the material its name—rubber—but also pointed to the rather humble expectations placed on its potential. However, despite the challenges of latex, the Western desire for the new and novel in the early 1800s motivated some to import rubber products from Brazil, such as rubber overshoes, which were eagerly consumed despite costing an estimated five times the amount of a pair of leather shoes and having questionable resilience.[3] This also motivated others to attempt to find solutions to rubber's volatility in the hopes that durable rubber products could eventually be made domestically.

These early experimenters failed to produce stable goods, so the hopes of Western rubber speculators were dashed and the market for Western-made rubber goods collapsed in the 1830s. As W. H. Richardson would later write, "Goods

22

manufactured . . . in April became a sticky mass of useless rubbish in July."[4] Despite the ensuing rubber panic, many in American and Europe continued to strive to make rubber a stable, useful material. Wait Webster was granted a U.S. patent for his process of attaching India rubber soles to shoes in 1832.[5] Three years later, mention is made in the public documents of Massachusetts concerning the adhesion of rubber soles to sports shoes.[6] Although the material used for the uppers is not mentioned, it is of interest that they were specifically designed for sports.

The solution to the instability of rubber arrived in 1838, when Massachusetts based Nathaniel Hayward added sulfur to latex, creating a resilient rubber.[7] Hayward then sold the rights to Charles Goodyear, who, in turn, discovered that by adding heat in addition to sulfur, rubber could be stabilized; he patented this process in 1839. British scientist Thomas Hancock, inspired by Goodyear's experiments, further developed the process in England. It was dubbed vul-canization by a friend of his after the ancient Roman god of fire, Vulcan. The experiments of these three men paved the way for such revolutionary things as tires and sneakers.

Tough, flexible vulcanized rubber became the "muscles and sinew"[8] of the Industrial Age, and as manufacturing increased so did the number of manufac-turers with social aspirations of their own. The flaunting of success through the pursuit of leisure became an important means of conveying one's ascent up the social ladder, and tennis, croquet, and seaside holidays gained in popularity. This, in turn, led to the desire for the equipment and clothing required to pursue these amusements—for reasons of practicality and conspicuous consumption—a desire that the middle class, through innovation and manufacturing, could meet for itself. It was into this milieu that the sneaker was born.

Exactly when the canvas-upper rubber-soled shoe was first created remains to be determined. In the United States, the Candee Rubber Company has been posited as the originator. It certainly made croquet shoes, but it is unclear what exactly a croquet shoe was. Early advice for players of croquet seems to advocate for overshoes. The *Gentleman's Magazine* in 1868 stated "In wet weather, if anxious mammas forbid thin shoes, shoes maybe cast away altogether, and India-rubbers substituted, not over the shoe, but over the sock or stocking."[9] It may be that the croquet shoes, also called croquet sandals and slippers, made by Candee were simply rubber overshoes, not sneakers.

Another theory about the origin of the sneaker suggests that it was initially designed as a beach shoe; certainly its rubber sole would have been perfect for the wet environment, and it has been suggested that the British Liverpool Rubber Company introduced the sandshoe in the 1830s, but evidence of this

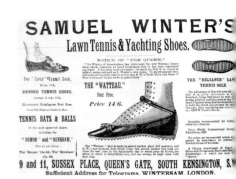

THOMAS DUTTON AND THOROWGOOD

RUNNING SHOE, 1860–65

COLLECTION OF THE NORTHAMPTON MUSEUMS AND ART GALLERY

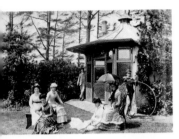

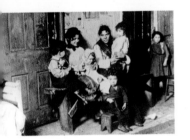

remains to be uncovered. There are discussions in mid-nineteenth-century magazines concerning seaside attire, and sandshoes are often advocated for delicate feet, yet descriptions of these early sandshoes are frustratingly elusive. When the soles of sandshoes are mentioned, they are described as being made of cork, not rubber.

There is no question that rubber-soled footwear with canvas uppers were worn to play tennis. By the mid-nineteenth century, the "sport of kings" was becoming democratized, and manufacturers began to offer specialized tennis shoes with corrugated rubber soles, which provided better traction than leather soles on slippery grass. As with other early rubber footwear, tennis shoes were expensive, suggesting that tennis, like many of the other sports that were becoming popular, was as much an exercise in flaunting status as it was a means of physical exertion.[10]

All of this nineteenth-century play, however, was not simply sybaritic. As industrialization progressed, play began to be seen through an increasingly moralistic lens. Play came to be seen as a means of addressing the perceived physical and moral ills that threatened the middle class due to their newly sedentary lifestyles. There was also growing concern among the privileged classes that the workers they employed were also being corrupted by industrialization. Indeed, physical activity was coming to be seen as an antidote to the "diseases of affluence"[11] and the sneaker as a necessary part of the modern wardrobe.

In 1844, the Young Men's Christian Association (YMCA) was established in London with the aim, in part, of providing businessmen with healthy diversions, including doses of Bible study along with physical education. The belief was that the pursuit of morally edifying physical activity was a means of keeping urban degeneracy and all of its enticements at bay, with a principal goal being to shift the focus of sports away from gambling toward spirituality. The concept of the Muscular Christian emerged at this time and reflected the growing connections between Christian devotion and rugged masculinity that were gaining currency in England and America in the middle of the century. By 1851, the YMCA was established in the U.S., and its ambitions dovetailed with ideals held by many American physical fitness proselytizers.

In the U.S., the creation of large urban parks in the middle of the nineteenth century reflected public interest in getting outdoors. Central Park in New York, the first public park in America, was created for this express purpose. Its wealthy advocates argued that in addition to enhancing the status of New York as a grand city on a par with its European rivals, Frederick Law Olmsted's design, which included bridle paths, tennis courts, and a rowboat lake, would offer the wealthy a place for the pursuit of pleasure and the working classes with a

Top Left:
The stabilization of rubber allowed for not only the sneaker to be invented but also the rubber tire, which ushered in a craze for cycling. This photograph from the nineteenth century depicts a family at leisure and prominently features tennis equipment as well as a velocipede, an early bicycle.

Bottom Left:
While the wealthy enjoyed healthy pursuits, the plight of the urban poor and the unhealthy conditions in which they lived became cultural concerns. Access to exercise and fresh air came to be seen as an antidote to degeneracy and inspired the creation of public parks, such as Central Park in New York City. This photo shows a family in a tenement slum in New York, ca. 1890.

HIROKI NAKAMURA

NAKAMURA

The thing I keep in my mind when I design our shoes is that we focus on having meanings (messages) behind the products.

The meaning can be anything. In my case, it is about comfort. I am trying not to stick with the outside of the thing or the appearance. Once the meaning is decided and it is clear, I believe the appearance will come together spontaneously. When the sample arrives at our studio and I try it, and I can feel the message clearly, I know it is most likely that the style will be well accepted.

HIROKI NAKAMURA IS THE FOUNDER OF VISVIM, A FOOTWEAR, CLOTHING, AND ACCESSORIES BRAND WITH A DESIGN AESTHETIC THAT BLENDS NATIVE AMERICAN FUNCTIONALITY, JAPANESE WABI-SABI, AND VINTAGE AMERICANA.

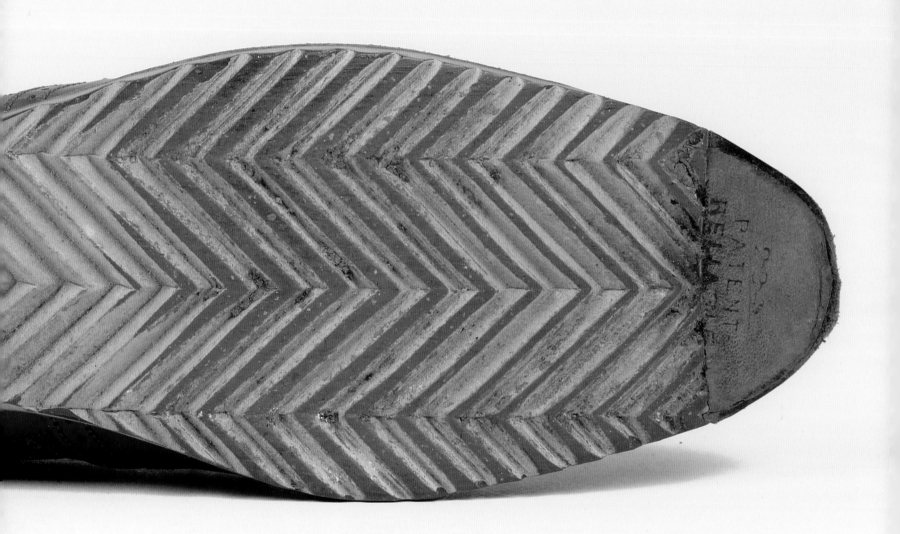

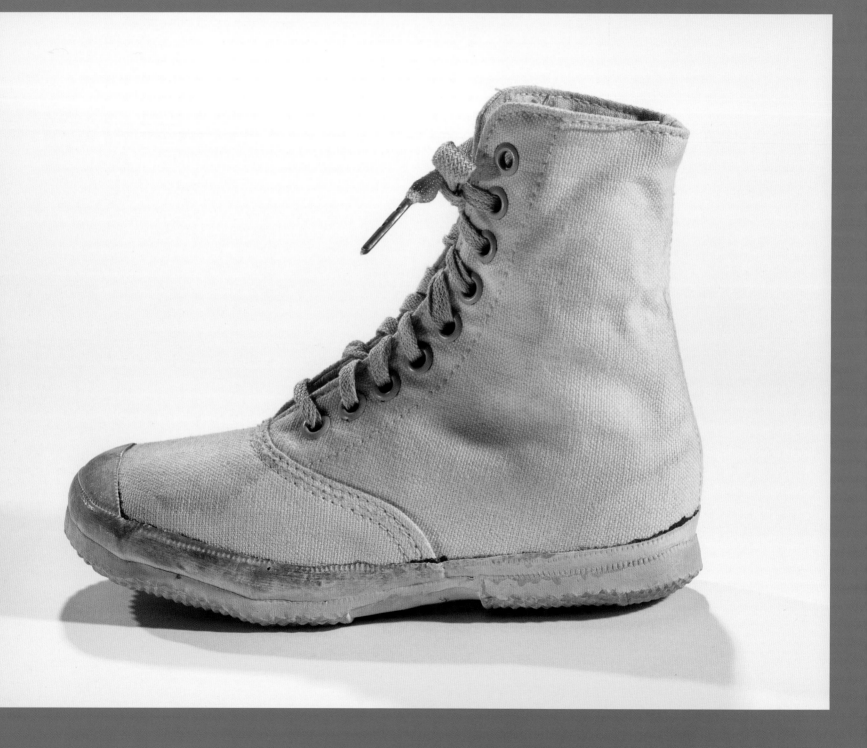

healthy alternative to saloons and other degenerate distractions.[12] Olmsted's 1865 design for Prospect Park in Brooklyn similarly sought to encourage "thousands to enjoy pure air, with healthful exercise, at all seasons of the year."[13] In 1884, the *New York Times* reported on the great demand for access to the public tennis courts in the Brooklyn parks system, stating that the parks commissioners required all players "to wear tennis shoes to avoid injury to the turf,"[14] providing evidence for the widespread embrace of the game and the concomitant use of rubber-soled footwear.

The second half of the nineteenth century saw a wide range of amusements for people to either participate in or watch, and all required specialized forms of footwear—from the spectator shoe to the running spike. Production of sports footwear increased to meet demand, and prices fell to match competition as sneakers began to be worn for more than just exercise. By the early 1870s, rubber-soled sports shoes had been integrated into the wardrobes of thousands and the slang term *sneaker* had become entrenched in American vernacular—contrary to the claim that Keds, a product line developed by the United Rubber Company in 1916, coined the term.

The origin of the word *sneaker* lay in the fact that rubber soles let one pad around noiselessly—a quality enjoyed by pranksters and criminals alike. A newspaper interview with a rather colorful Chicago criminal named Patrick Kent in 1887 included his advice to future "sandbaggers"—criminals who knocked victims senseless with bags full of birdshot and then robbed them. Kent recommended, "If you want to be successful you must wear rubber shoes, then you can sneak up when his back is turned and do him."[15] Guyer's Shoe Store, however, countered these connections to criminality with the advertisement, "A man is not necessarily a sneak because he wears sneakers. That is a name applied to rubber sole tennis shoes,"[16] a statement remarkably similar to the Run–DMC lyric for "My Adidas," "I wore my sneakers but I'm not a sneak," written one hundred years later, illustrating the long history of linking sneakers to delinquency.

The growing popularity and availability of sneakers were part of the ever-increasing appetite for rubber in both daily life and industry. John Boyd Dunlop's reinvention of the pneumatic tire started a bicycle craze, which paved the way for the car, and innovation in industrial production continued to rely heavily on rubber. The insatiable appetite for rubber led to unprecedented abuses in rubber-cultivating regions. Despite the transplanting of rubber-producing trees to many areas of the world, itself an act of subterfuge and greed, the proliferation of trees did not increase the speed with which latex could be collected. The exceedingly labor-intensive form of harvesting, which required trees to be scored by hand and only small containers of sap collected, resulted in the wholesale exploitation and enslavement of entire populations. Conditions in South America rivaled the

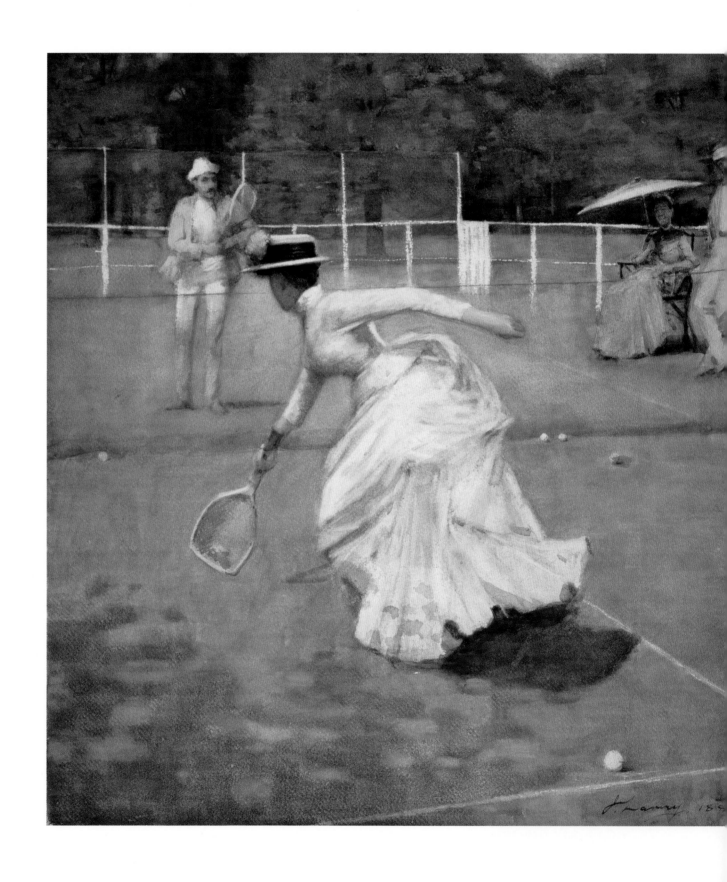

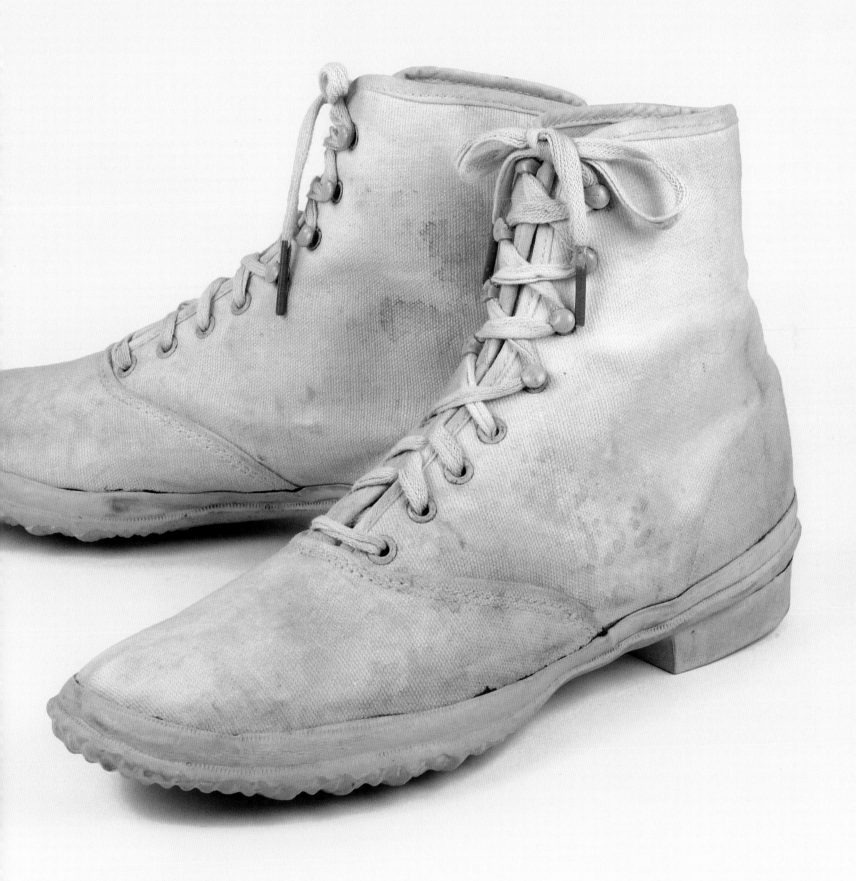

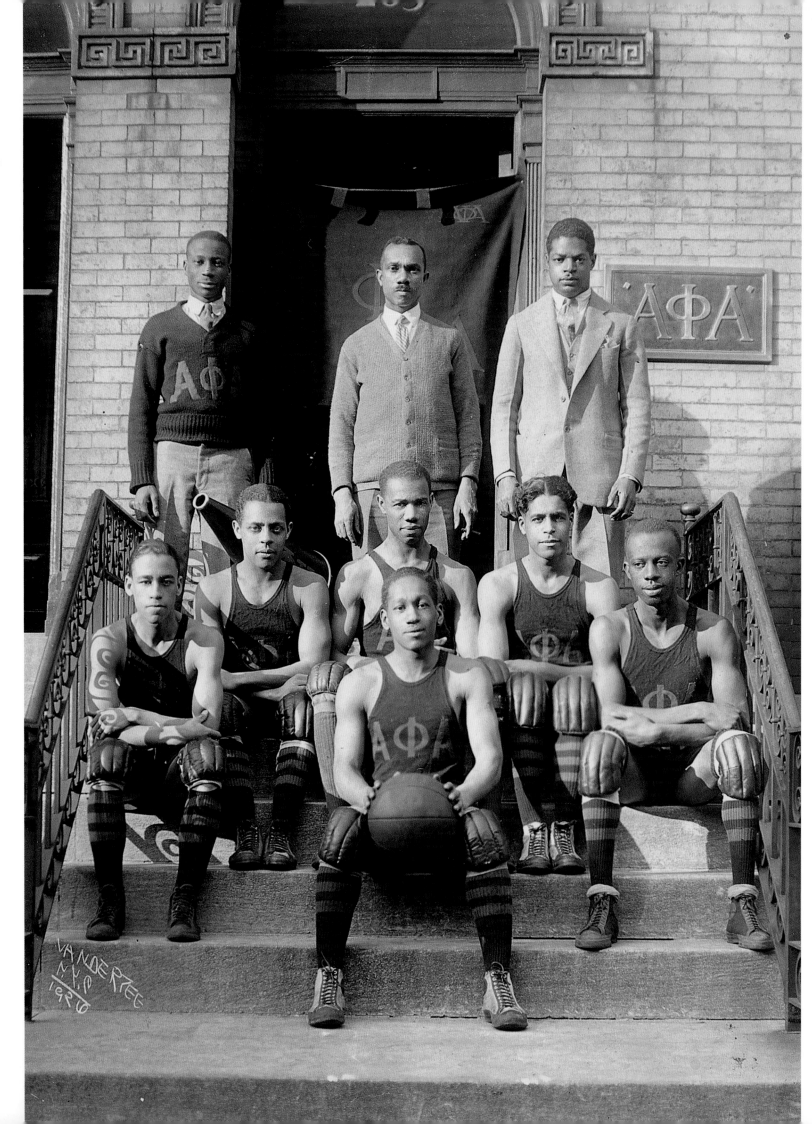

brutality exercised by King Leopold of Belgium in his "colony," the Congo Free State, where the atrocities committed in the name of rubber caused the African American missionary William Henry Sheppard to publicly expose them and inspired the novelist Joseph Conrad, who worked for the Belgian government in the Congo in the 1890s, to write *Heart of Darkness*. Despite growing concerns about the inhumane treatment of rubber tappers, the demand for rubber increased as did its myriad uses.

THE NEED OF A NEW GAME: THE INVENTION OF BASKETBALL

It was near the end of the nineteenth century that basketball, one of the most important sports to the history of sneaker culture, was invented. In 1891, in Springfield, Massachusetts, the same town in which Charles Goodyear had worked on the vulcanization of rubber fifty years earlier, the Canadian-American James Naismith created a brand-new game for the YMCA Training School.[17] Inspired by a game that he had played as a boy in rural Ontario, Naismith designed basketball as a wintertime diversion that encouraged camaraderie and exercise while limiting aggression, in keeping with the Christian ideals of the YMCA. Enthusiasm for the game was almost instantaneous. It could be played in a relatively small space, could be played indoors or out, and didn't require specialized equipment, thus making basketball accessible to a wide range of players. Universities and secondary schools quickly incorporated basketball into their athletic programs, and the game became especially popular in urban centers where real estate dedicated to sports was minimal. Basketball flourished in city neighborhoods and, from the very beginning, was dominated by players of diverse ethnic backgrounds. A *New York Times* article from 1909 concerning the development of new athletic facilities being built to encourage play in the Lower East Side of New York wrote that "the top floor of the building will be the boys' gymnasium where they can work off their animal spirits in basket ball. . . . Basket ball, by the way, is coming to be the favorite game of the rising generation on the east side. Of course the boys prefer to play in a gymnasium or in a park with the regulation ball and baskets, but lack of these does not stop the sport. In many cases a bundle of rags is substituted for the orthodox pigskin, but they play just the same."[18] Because of its expressly nonaggressive game play, basketball was also widely touted as a game that women could play. The *Washington Post* article "Active Woman's Game: Basket-ball the Rage for Society's Buds and Matrons" even went so far as to claim that the game was invented by college girls who wanted a feminine substitute for the game of football, and it went on to say that the game gives "all the exercise of football, but the rough plays and dangers are eliminated."[19]

As with many of the other sports that became popular in the nineteenth century, basketball would also get its own form of specialized footwear. However, it is

DAN ROOKWOOD

Until recently, the idea of mixing the formality of fine tailoring with the informality of a sports shoe would have been considered a sartorial faux pas on the same level as wearing Goodyear-welted dress shoes with track pants. Just: no. They were from opposite ends of the scale. Never the twain should meet.

But lately we have seen a blurring of the dress codes. The rigid formality of tailoring has softened up with the introduction of deconstructed jackets, unlined with little or no padding in the shoulders. And at the same time, sneakers have smartened up their act. High-end designers like Saint Laurent, Balenciaga, and Valentino have made sneakers high fashion. Meanwhile, sneaker culture has gone from niche to mainstream. This has all helped to usher in an important menswear trend—"sports luxe" or "athletic luxury." Tailored sportswear is now the new cool.

For many men the world over, wearing a suit is a corporate uniform. But wearing a suit with sneakers is a clear style choice, a declaration of contemporary cool.

Influential celebrities such as Pharrell Williams, Kanye West, Justin Timberlake, and Mark Ronson have demonstrated how to successfully wear sneakers and suits together, educating the next generation of sartorially savvy consumers via the instant global diffusion of social media.

So where once they were poles apart, sneakers and suits are now meeting in the smart-casual intersection of the formality spectrum. But while the rules may have relaxed, we at MR PORTER have put together some useful guidelines to ensure you don't get it horribly wrong and end up looking like a middle-management commuter walking to the office during a mass transit strike.

1. Nothing high-performance. Technical marathon running shoes are for Barry's Bootcamp and Larry David. (Choose your type of sneakers from the list below.)

2. Dial down the formality. The suit should be matte, deconstructed, and fitted rather than boxy and formally structured with a silky sheen. Avoid "businessy" patterns such as pinstripes or Prince of Wales checks. Do not wear sneakers with a smart dress shirt and silk tie. If you wear a tie at all, it should be knitted or woollen and the shirt should be soft cotton. Better still, try just wearing a crew-neck T-shirt or a fine-gauge round-neck knit.

3. A slim trouser is key. The pants should stop just above the ankle—no loose fabric puddling over the feet. Don't be afraid to show a little sock or skin, weather permitting.

4. Beware bulky high-tops. Either you'll have to tuck your trousers into your shoes, which will look ridiculous, or else you'll have to pull them over the shoe, which will interrupt the silhouette.

5. Read the context. There is a time and a place for sneakers. Never wear them for really formal occasions: funerals, weddings, interviews, court cases. Ditto if you have a formal job—banker, insurance salesman, lawyer. This is strictly an off-duty look for you.

6. Keep 'em clean. A soiled pair of sneakers will bring down the whole tenor of your suited look and make you look scruffy. Spot clean your shoes regularly to keep them looking box-fresh so as to preserve the clean lines of your tailoring. Consider fresh laces, especially if they're white. Speaking of laces, keep the bow neat. A big bulky knot and trailing laces will look messy.

CHOOSE YOUR SHOES

Designer sneakers: Look to high-fashion brands, such as Saint Laurent, Balenciaga, Lanvin, Valentino, and Maison Martin Margiela—and expect to pay designer prices. These sneakers tend to run the gamut from pared back to avant-garde.

Tennis shoes: Consider all-white leather or canvas minimalist low-tops from the likes of Converse Jack Purcell and Converse All Stars to Adidas Stan Smiths and (at the upper end of the price scale) Common Projects. These are very easy to wear, especially in summer.

Sneakerhead shoes: Limited editions, principally from Nike, Jordan, and Adidas, are often bought by collectors in multiples and kept box-fresh for resale online and at conventions. Often bought as high-tops, these can be tricky to wear with tailoring.

Nike Frees and Nike FlyKnits: Perhaps the emblem of athletic luxury, these sneakers crossed over to become a must-have fashion shoe. They are the one style that can be worn both for sport and as part of a smart-casual ensemble. Their slim silhouette makes them easier to wear with tailoring than, say, Nike Air Max.

Retro classics: You'll find various New Balance and Saucony styles along with as some old-school classic styles such as Adidas Sambas and suede Puma Clydes as well as Vans slip-ons.

DAN ROOKWOOD IS THE U.S. EDITOR FOR MR PORTER, A GLOBAL ONLINE LUXURY FASHION RETAILER FEATURING ORIGINAL EXPERT EDITORIAL CONTENT.

difficult to firmly establish the precise date when or even who created the first basketball shoe. High-top sneakers were already being produced prior to the invention of basketball, as seen in the many tennis sneakers that featured ankle-covering uppers. Some have suggested that the first basketball shoe was created by the Colchester Rubber Company in 1893. Certainly the company, like many others, was offering rubber-soled athletic footwear, but there is no evidence of them making shoes expressly for basketball.[20] A 1897 advertisement for A. G. Spalding Brothers promoting a special offer to YMCA members of a "complete" outfit, presumably for gym activities, included tights, a shirt, trunks, a towel, bathing trunks, and one pair of "strong canvas rubber sole shoes." At the bottom of the ad, it notes that basketball and football suits are also available. There is no mention of specialized footwear. Likewise, images of early teams show no evidence of there being any standardization of footwear. Photographs of the Buffalo Germans YMCA basketball team, which won the basketball demonstration tournament at the 1904 Olympics in St. Louis, show all the players in canvas high-tops, but images of university teams from around that same time show a range of footwear types. Naismith, in his book *Basketball: Its Origin and Development*, wrote that the first "suction sole basketball shoes were advertised by the Spalding Company in 1903."[21] This is interesting, as it seems to be implying that other basketball shoes were already on the market, the special feature of the Spalding shoe being its suction sole. An advertisement for Spalding basketball shoes from 1907 shows a simple lace-up high-top. The Beacon Falls Rubber Company offered basketball shoes as early as 1909, but what they looked like is also unclear.

History would be changed, however, when the Converse Rubber Company introduced the Converse All Star in 1917. The company was started by Marquis Mills Converse in 1908 after a stint at the Beacon Falls Rubber Company. Converse at first focused on the production of rubber galoshes, but in 1915, began to make tennis shoes and in 1917 added basketball shoes to the company's offerings. Almost immediately, Converse employed a marketing strategy that used basketball coach endorsements to promote his new basketball shoes. University of Chicago coach Pat Page endorsed the All Star in 1920, saying, "I wish to take this opportunity to thank you personally for the effort you have made to put an ideal basket-ball shoe on the market." The following year, Converse hired basketball player and coach Chuck Taylor.

In the same year that the Converse All Star was launched, the U.S. entered World War I, and national ideas concerning the fitness of the American populace came to the fore. An article titled "A Plea for Sports" discussed the role of sports in preparing men for battle: "There is a saying in the British Isles that 'England's battles were won on the cricket fields.' America's coming victories in the cause of democracy and humanity can be attributed to the baseball diamond, the football

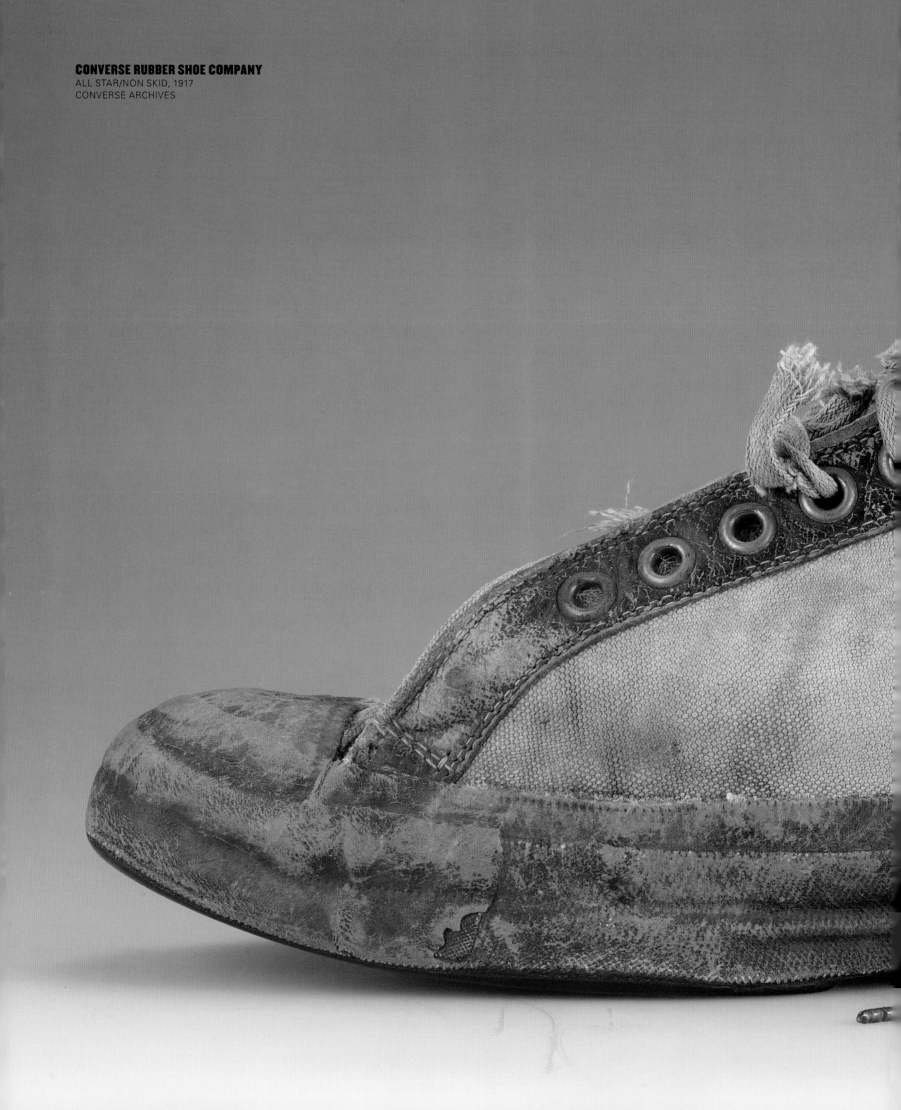

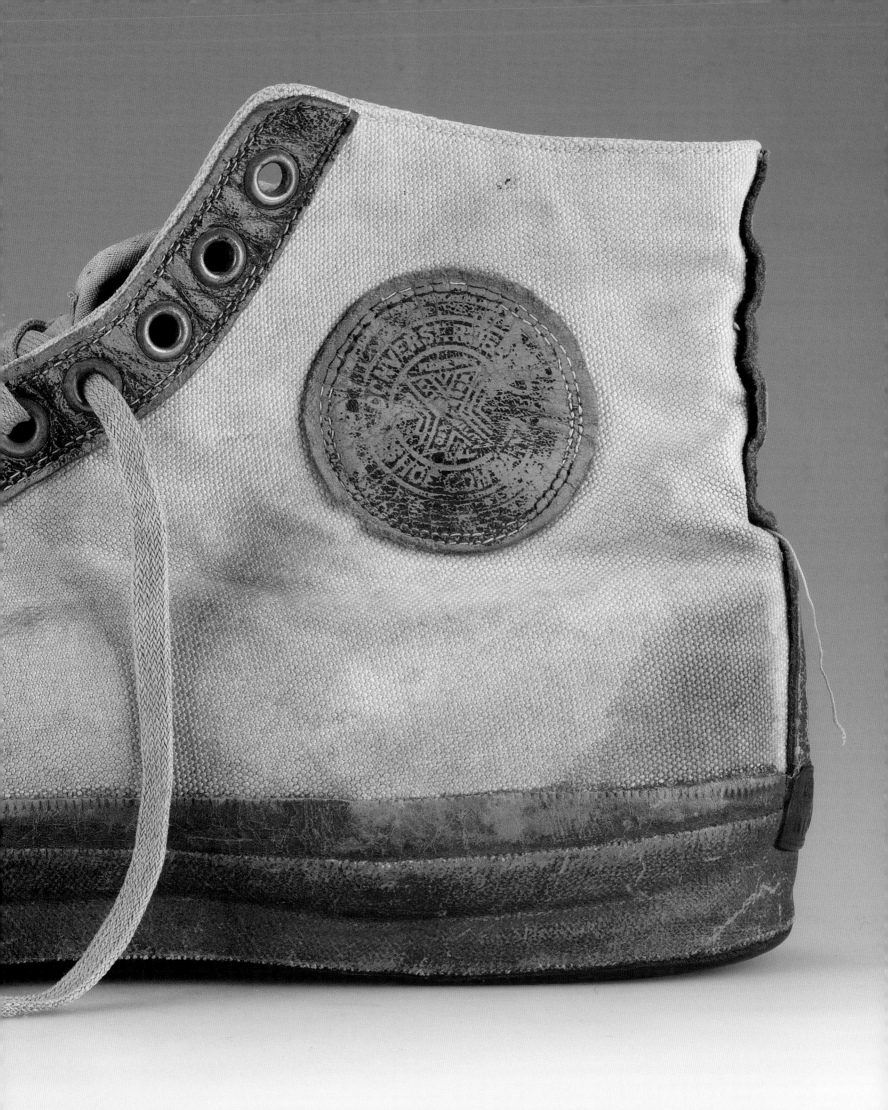

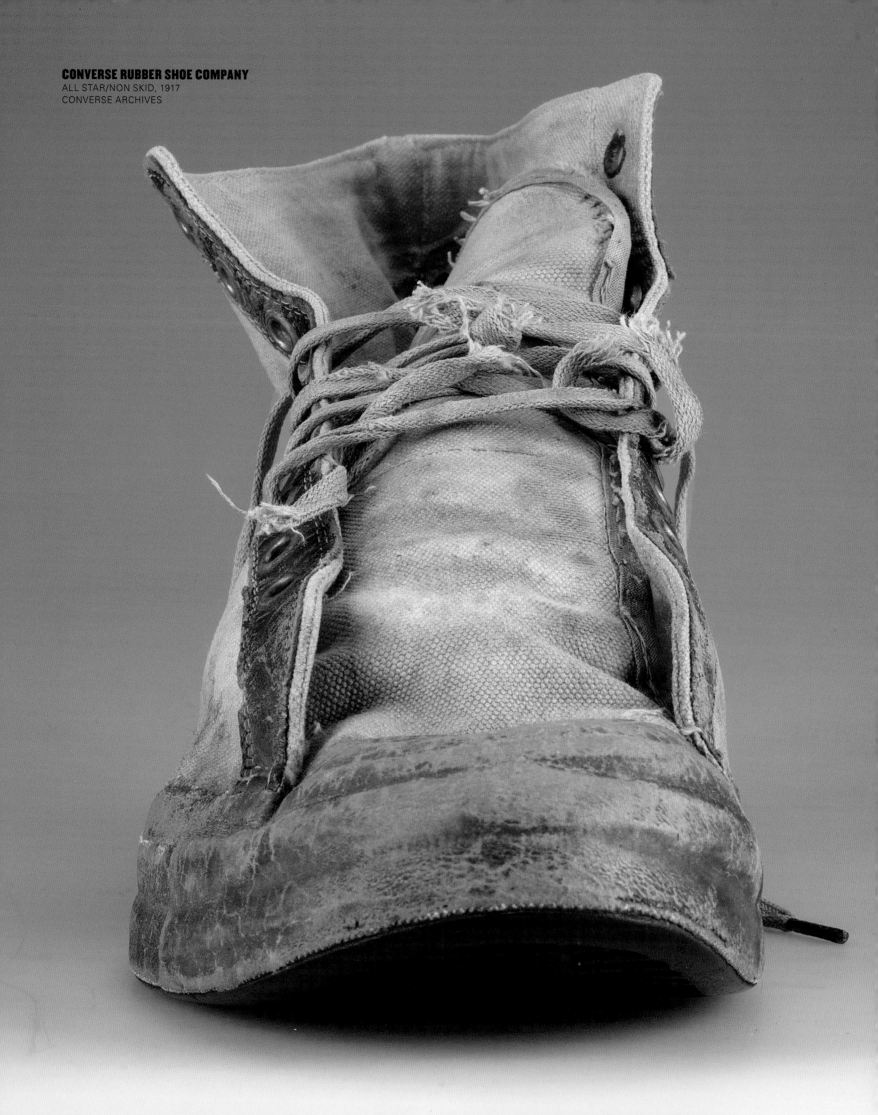

Right:
Basketball coach Chuck Taylor
began working for Converse in
the 1920s, and by 1934 his name
was added to the famous Con-
verse All Star. This photograph
of Taylor dates to the 1920s.
Converse Archives

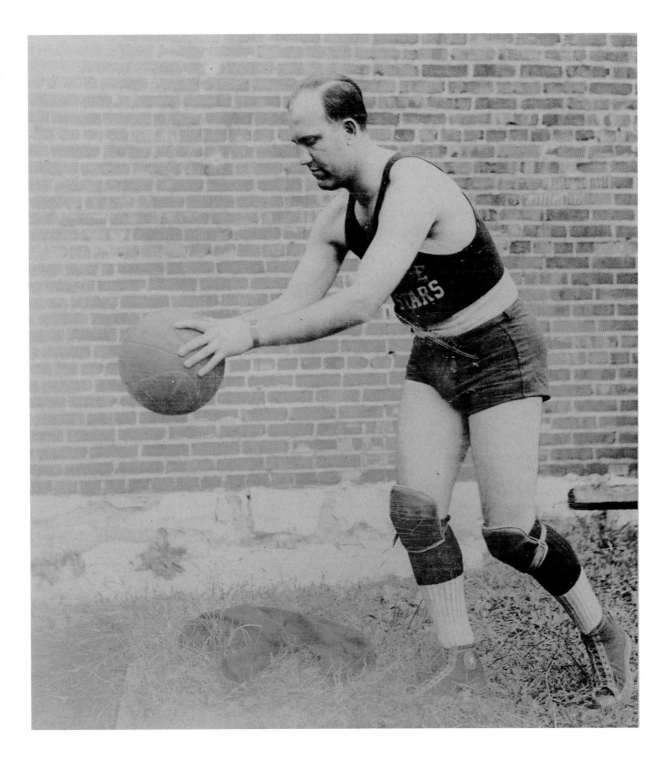

field, the tennis court, track, field and water, for the ten million young men who have answered the registration call of the president have received a preliminary training in the great American army of sport."[22] The article expressed the hope that the strapping athletic youth of the new century would be victorious in battle. However, despite the increased popularity of sports, the number of men fit for battle was shockingly low. *Physical Culture* magazine reported in 1917 that "only two million men out of ten million [are] physically able men for military service."[23] In the same article, Congressman Ray Madden was quoted as "endorsing physical education as a means of preventing our country from being a disgrace among nations in the matter of physical efficiency."[24]

The lack of physical fitness among those called to arms was unsettling, but the realities of the profound devastation wrought on life and limb during the war was shocking. The unprecedented number of deaths from the 1918 Spanish Flu epidemic that followed on the heels of the war further exposed just how vulnerable the modern body could be and heightened concerns for increasing the health of the citizenry.[25]

PHYSICAL ATTRACTION: HOLLYWOOD, HEALTH, AND HARD TIMES

In the interwar period, physical perfection became the outward evidence of social and racial superiority, and physical fitness was pursued less for reasons related to Christianity and the ideals of camaraderie and more as a means of proving racial and national supremacy. The economic boom also saw the flaunting of wealth through the pursuit of leisure activities, and as the 1920s went on, the focus on bodily perfection grew. The physiques of the ancient Greeks were held up as ideals and the Olympics were infused with new energy. Outdoor exercise and suntanning created bronzed "gods" whose glistening bodies somehow seemed impervious to the violence of war.

Movies and the media put a greater emphasis on physical beauty, and fashion introduced clothing that revealed the female body, specifically, in unprecedented ways. Sleeveless shifts with short hemlines exposed arms and legs and required slim boyish silhouettes. Constricting corsets were replaced by exercise and dieting. While women took advantage of new opportunities opening up for them in the realm of sports, femininity remained paramount, a point attested to by a large number of heeled sneakers. For the fashionable man, white tennis shoes conveyed a sense of privileged leisure, and they were worn both on and off the court in casual summertime settings.

The stock market crash in 1929 and the ensuing Great Depression further propelled the ascendency of the sneaker. The new economic conditions of the 1930s allowed the long-standing demands of labor unions for shorter workdays

Left:
Both Hollywood and fashion glamorized physically fit and youthful bodies in the 1920s and 1930s, and exercise became increasingly important as many sought to perfect their forms.

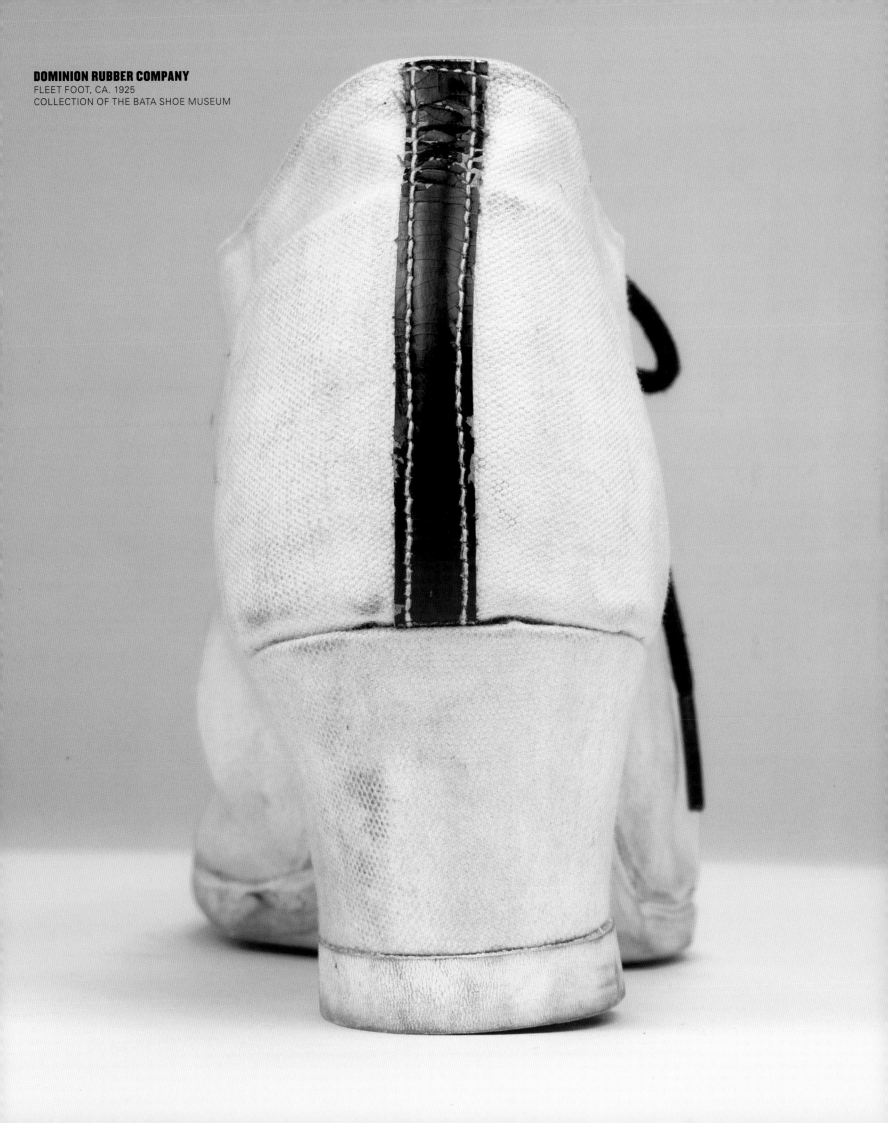

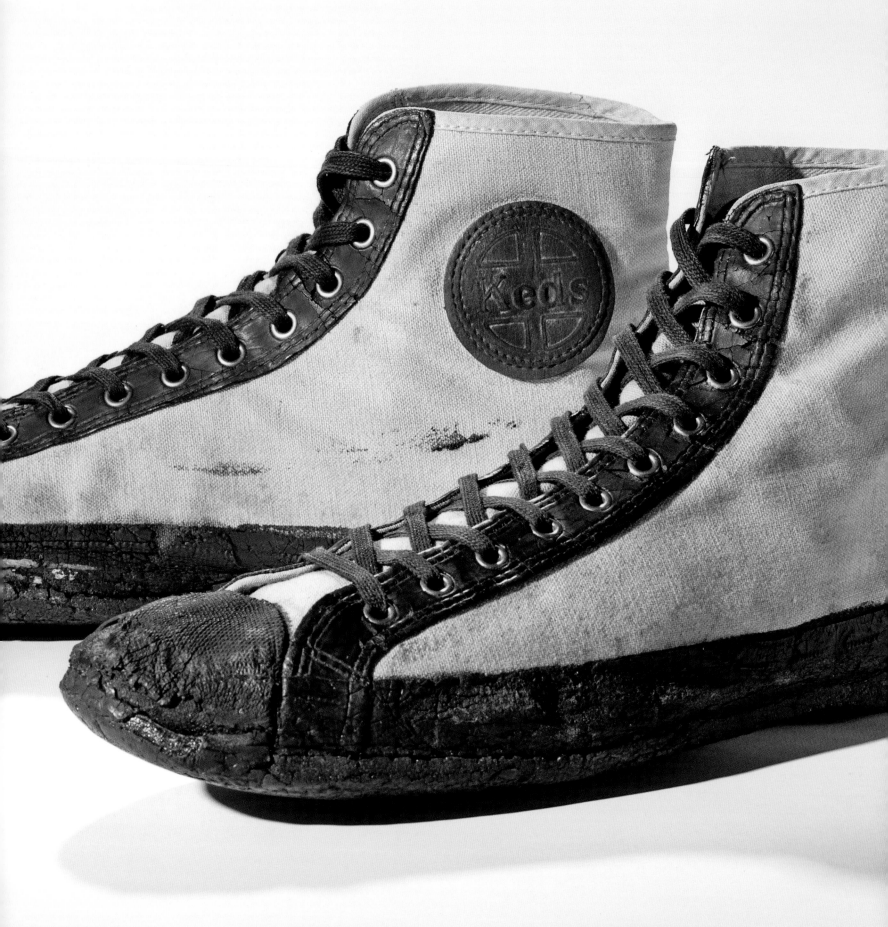

and two days off per week to become a reality, increasing workers' time off. These newfound hours were termed *leisure*, despite the climate of economic hardship. However, this new leisure time was not a means of expressing privilege and status. Instead, it was filled with inexpensive amusements, such as visiting local beaches or going to the movies, and the sneakers worn to enjoy these pursuits were now low cost because of innovations in manufacturing and increased importations from countries such as Japan and Czechoslovakia, where labor costs were minimal.[26] In these trying economic times, fashion became infused with a new level of casualness, and the wearing of sneakers for non-athletic purposes became common.

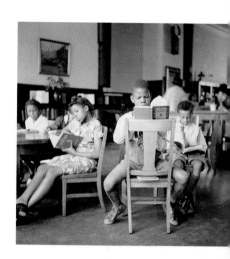

Sneaker manufacturers in the U.S. and Britain developed new lines and marketing strategies to capitalize on this trend and compete with inexpensive foreign imports. An article from 1934 in the *Boot and Shoe Recorder* quoted Matthew Woll, vice president of the American Federation of Labor, as saying "leisure is no longer a privilege but a condition of life." The article added that, "again America takes to the out-of-doors. Everybody—men, women, and children—planning to be out in the open as much as possible, and most of them having more time than ever to loaf or play! It's up to the shoe merchants to emphasize and dramatize SPORTS SHOES!"[27] Sneaker makers were listening, and some turned to celebrity athletes for endorsements to garner attention and establish value and distinction for their brands. Converse had been using endorsements for years, but it was the company's association with the basketball player and coach Chuck Taylor that would create one of the most enduring sneakers of all time. Taylor began working for Converse in 1921 to promote its All Stars, and he made a living traveling to colleges and companies with amateur basketball leagues, conducting basketball clinics and taking orders for the sneakers. In 1934 he became the first person to have his name added to a sneaker; today, Chuck Taylor All Stars are called Chucks. Other companies likewise saw the benefits of aligning themselves with athletes. B. F. Goodrich signed the famed Canadian badminton player Jack Purcell and in 1934 began to sell the Jack Purcell shoe. The sneaker was designed to improve performance on the tennis and badminton court, but it went on to become a style icon.

One of the challenges companies faced in getting endorsements was the fact that the most accomplished athletes were required to maintain amateur status in order to compete. Professional athletes were rare. Jack Purcell had been stripped of his amateur status after he wrote an article for the *Toronto Star* in 1932, thus establishing him as a professional athlete and therefore able to endorse the eponymous shoe. Simple association, however, also had its benefits. The Dunlop Green Flash received a huge boost simply through association while the unstoppable British tennis player Fred Perry wore them when he won three consecutive Wimbledons from 1934 to 1936, despite the fact that his amateur status prevented him from providing an official endorsement. The sprinter Jesse Owens, one of the greatest athletes of his day, found the restrictions placed on amateur athletes onerous, depriving them of opportunity.

JAMES BOND

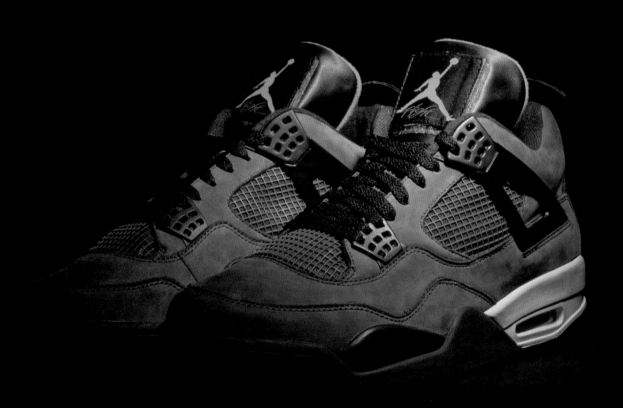

NIKE, AIR JORDAN IV UNDFTD, 2005, COURTESY UNDEFEATED ARCHIVES

Undefeated is a brand that was born out of necessity, because there wasn't a store in Los Angeles that either I or my partner Eddie Cruz felt we could embrace or call our own. Undefeated has allowed us to create product authentic to an athletic lifestyle. Part of building a brand is the story: what does it mean; who or what does it represent. Undefeated is a brand with East Coast owners who have a passion for the West Coast lifestyle. Rooted in sport with the basic philosophy of fashion and function, we pull our inspiration from sports teams, their management styles, and the ideology of military regimen and order.

Sport is War and Play Dirty are Undefeated philosophies we use to express the lengths one should go when participating in daily life, whether one pushes oneself at work or at play. Nike, Adidas, Converse, and Puma, to name a few partners, have chosen Undefeated in the past to help introduce energy to a consumer who normally doesn't respond to conventional sales models to reach their products. These brands have given Undefeated opportunities to work with iconic figures in fashion, sports, and design, and make new friends and fans through hard work and innovative thinking. Having these types of experiences with the people we get to interact with regularly sets us apart. Brands work with us to see how far we can push and inspire the emerging youth-oriented consumer.

Based in Los Angeles, where every location is considered a destination, you have to really set yourself apart. By building a well-curated, inviting atmosphere with knowledgeable staff and limited product, we've created the luxury sneaker experience.

People always ask what the name Undefeated means; I ask, what does Undefeated mean to you? For me, Undefeated is that moment when you realize you're tired of cheating on your future with your past, and find the courage to break the cycle.

JAMES BOND IS THE COFOUNDER OF UNDEFEATED, A HIGH-END SNEAKER BOUTIQUE AND LIFESTYLE BRAND KNOWN FOR ITS COLLABORATIONS WITH INTERNATIONAL BRANDS INCLUDING BATHING APE (BAPE), NIKE, ADIDAS, AND PUMA.

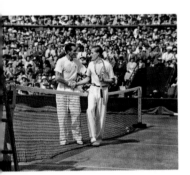

BODY POLITIC: SNEAKERS AND THE STATE

Owens had broken world records in 1935 in sprinting and long jumping, and in 1936, became part of the U.S. Olympic team. The so-called Nazi Olympics in Berlin were overseen by Adolf Hitler, who saw the games, in part, as an opportunity to flaunt his ideas concerning racial superiority. Jesse Owens challenged these concepts. Every event that he entered he won, and by the end of the games, Owens had become the winningest Olympian up to then.

At the Olympics, Owens was offered running spikes by the Bavarian shoemaker Adolf "Adi" Dassler who, along with his brother Rudolf, had established the Gebrüder Dassler Schuhfabrik in 1924. Dassler shoes had been worn by athletes in the 1928 Olympics, and the company was eager to have its shoes on the feet of as many Olympic athletes as possible during the 1936 Olympics. Adi Dassler approached the German track coach Jo Waitzer, with whom he had worked in the development of his running shoes, to see about getting shoes to Owens. Waitzer was hesitant due to the highly charged Nazi climate, but eventually a few pairs found their way to Owens, who wore them for practice.[28] Owens's achievements seemed to fly in the face of Hitler's racist ideology, and the sprinter's fame spread worldwide. He was thronged by fans in Europe, the American Associated Press named him the Athlete of the Year, and enticing offers headed his way. However, his status as an amateur prevented him from accepting any endorsements. Frustrated with this situation, Owens entertained some lucrative offers, leading to his suspension, but any collaboration between him and the Dasslers was soon rendered impossible by the outbreak of war.[29]

Despite Owens's individual Olympic success, the Germans took home the most medals overall, and Nazi dreams of the physical supremacy of the Aryan race remained. In *Mein Kampf*, Hitler declared, "If the German nation were presented with a body of young men who had been perfectly trained in athletic sports, who were imbued with an ardent love for their country and a readiness to take the initiative in a fight, then the national State could make an army out of that body in less than two years . . . They must also develop that athletic agility which can be employed as a defensive weapon in the service of the Movement."[30] To this end, Nazi propaganda promoted images of the perfected German body, and exercise rallies were held throughout the country to encourage participation in physical fitness and as a means of demonstrating widespread allegiance to the regime. The other fascist states, Japan and Italy, also conducted mass sports rallies.

However, it wasn't only the fascists who advocated exercise. As the 1930s wore on, the amateur leagues and sports in American schools were increasingly complemented by U.S. government initiatives encouraging fitness. In the United Kingdom, national fitness campaigns were launched across the

Left:
Tennis player Fred Perry won Wimbledon three consecutive times between 1934 and 1936, purportedly wearing Dunlop Green Flashes. Although his amateur status did not allow him to endorse any products, Dunlop's association with the tennis great served the company well. Here he is seen with Gottfried von Cramm at Wimbledon, July 5, 1935.

Pages 58–59:
Jesse Owens, the first athlete to receive four gold medals in the Olympic Games, is shown winning one of the 200-meter heats at the summer Olympic Games in Berlin, 1936. Owens trained at the Olympics in shoes provided by Adi Dassler.

DUNLOP
GREEN FLASH, CA. 1960
COLLECTION OF THE NORTHAMPTON MUSEUMS AND ART GALLERY

MARC ECKŌ

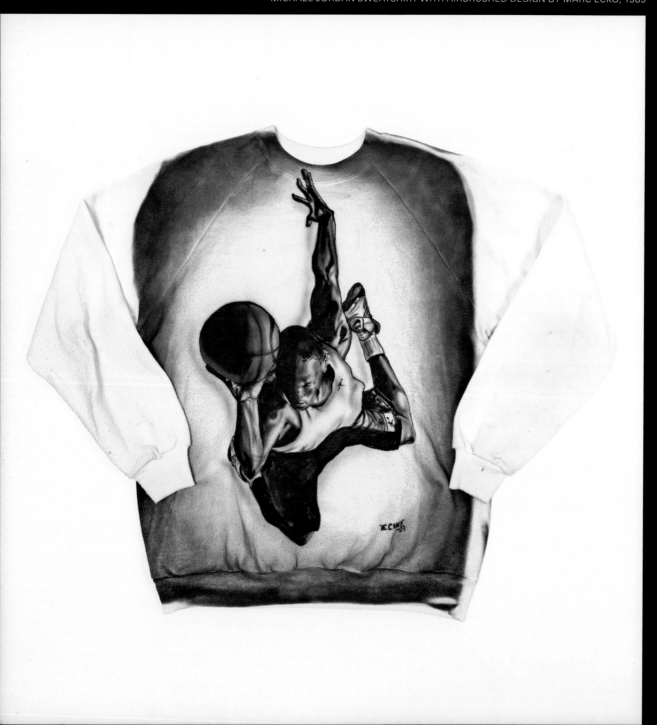

MICHAEL JORDAN SWEATSHIRT WITH AIRBRUSHED DESIGN BY MARC ECKŌ, 1989

Fly into 1984.

I am in 8th grade.

Lakewood, New Jersey—my hometown.

Darren Robinson, my best friend and neighbor, doesn't show up to shoot hoops in my driveway that day after school like he usually does.

I wait for him until dusk.

"Damn. No show."

Then at 8 p.m. the doorbell rings.

Darren is standing there with a wide smile. Eyes bright. I push the rusty screen door out and step onto the stoop.

"I got them, I got them!" he brags, as he proudly holds up a black shoe box with red wings spread across the top. Before I can say a word, there they are in their full glory. With the smell of the barely dried glue that keeps the outsole on the upper. That smooth full-grain leather and WHOA! that red. I rub my palm against the bottom of the outsole, then across those wings and the embossed words—Air Jordan.

I'll never forget that moment. Why? Was it my adoration for Michael Jordan? My crush on all things Nike?

It had to be the shoes, right?

No. For me, it was not.

For me, that was the moment that I discovered I wanted to be a designer. That moment I fell in love with design under the fluttering dim light of a mosquito lamp as we hero-worshipped Jordan 1s.

That moment was about aesthetic. An aesthetic I could relate to and aspire to.

Up until that point, I fancied myself a kid who liked art. I would paint sweatshirts by hand with an airbrush from a setup in my parents' garage. I didn't go to a formal art or design school, but that night school came to me. Eureka didn't happen in the lecture halls or pattern-making rooms of Parsons. Those Jordans were at the center of my first-year curriculum in self-taught design.

Many folks don't understand this about the impact of sneaker culture. It is often stigmatized as a club filled with man-boy nerds who obsess over basketball and collect this "new" class of comic books. Like any "sub" or counter-culture phenomenon, there will always be zealots and those who claim "they were there first" and know best about the history of "when it was good" and why.

I'm not that guy. Some real heads may even call me an interloper.

For me, the most impactful part of sneaker culture that so often gets overlooked is the impact it had and continues to have on a new cohort of creative types as well as on notions of design and fashion. Until that moment—before the sneaker industry started to push the technical boundaries of where design could take sporting goods—sneakers were in the domain of industrial design, not fashion. If and when Tinker Hatfield designs a high-top basketball shoe, fashion gatekeepers deem it the merely work of an industrial designer. But when Louis Vuitton and Marc Jacobs design essentially the same thing (a knock-off even), they call it "fashion?!"

Over my years in the business, the single greatest movement to usher diversity in the fashion industry (not just by demographics but ideas too) has come from the ground up: SNEAKERS.

Thanks to time and the proven cultural impact of sneakers (and hip-hop culture in general) on the masses, the fashion industry now has to contend with kids who, like me, draw influence and inspiration from the most unsuspecting and asymmetric of places. That is what fashion is all about. And there should be no rules.

Sneakers make fashion less fascist. And that is good.

So though it may just be airbrush paint on a pre-made crew-neck sweatshirt, in 1989, when I painted it with my own hands—I made fashion.

MARC ECKŌ, THE FOUNDER AND CHIEF BRAND OFFICER OF COMPLEX MEDIA, IS AN ENTREPRENEUR, ARTIST, AND FASHION AND LIFESTYLE MOGUL.

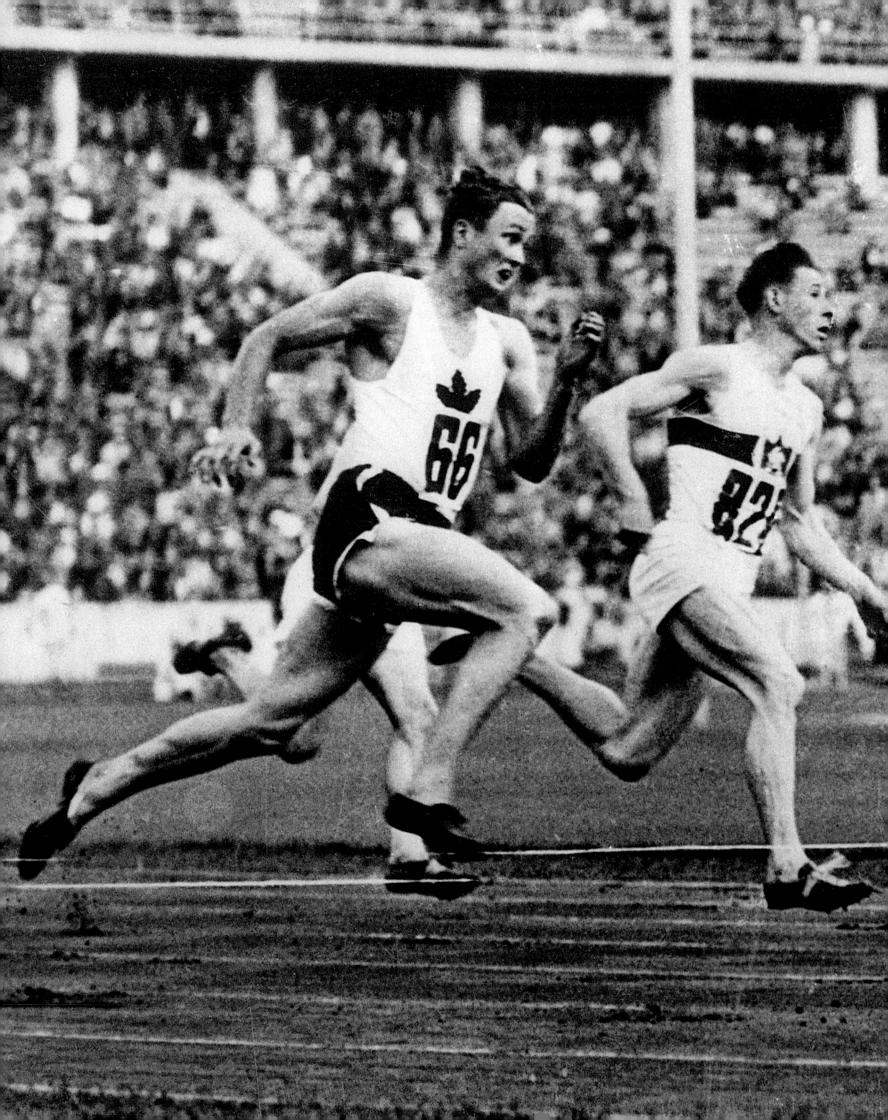

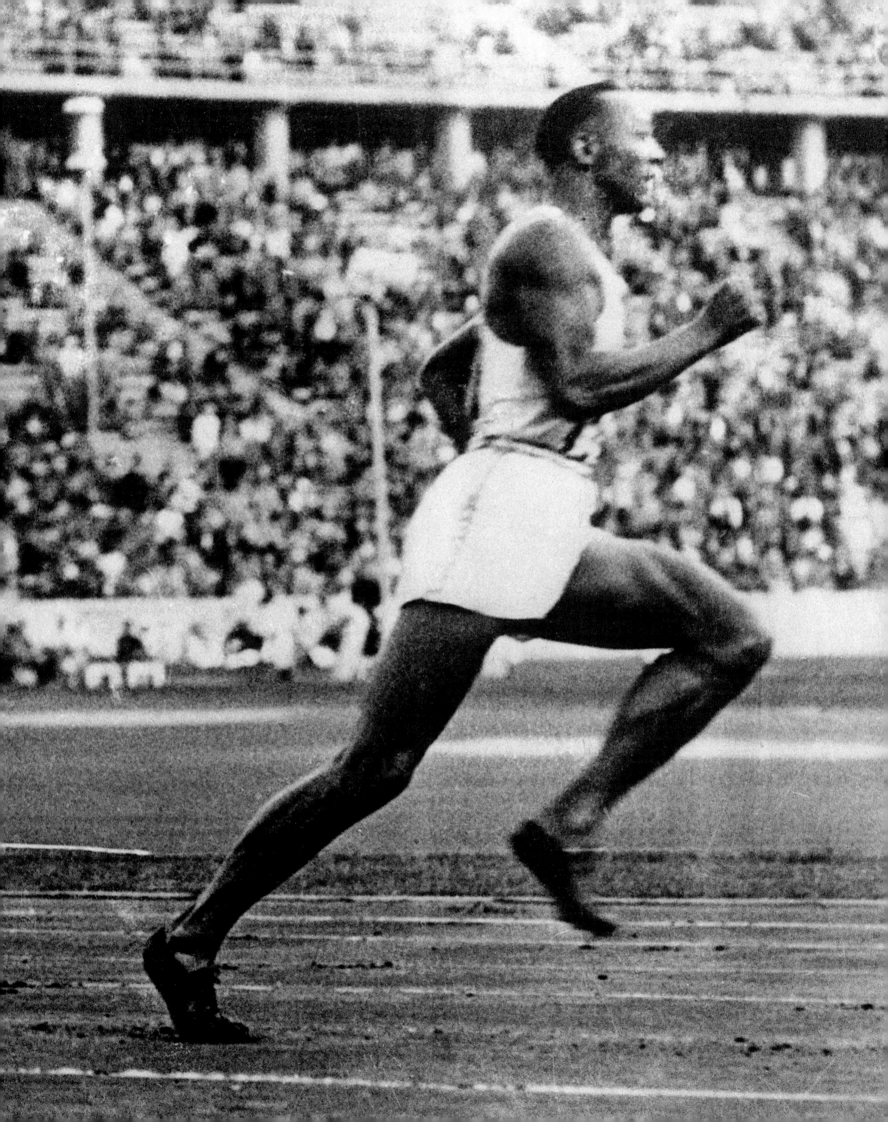

MADE IN BRITISH INDIA

Bata

"white Dominions"[31] urging people to exercise, and in 1939 the BBC broadcast a ten-minute exercise program.[32] In this period of the "politics of perfection," the sneaker emerged as one of the most democratic forms of footwear, and the sneaker industry boomed. The wide availability of sneakers and their ease of manufacture even recommended them for military use. During World War II, the U.S. Army attempted to shoe its infantry soldiers in high-top sneakers, but the quality of the sneakers produced proved to be inadequate for European battle conditions, and they were replaced by newly developed combat boots.

The rubber-soled high-top, however, did provide a useful model for the development of the military jungle boot for use in the Pacific theater. The production of jungle boots in the West was frustrated by the shortage of rubber as a result of military demands coupled with the decreased availability of latex following the Japanese takeover of most of the rubber plantations in Southeast Asia. This control of much of the world's rubber production, however, fed Japan's already robust rubber-footwear industry, and many Japanese soldiers wore sneaker-inspired combat footwear to fight.[33]

This shortage of rubber caused most other nations to ration it. In the U.S., items made of rubber, such as tires, were the first things to be restricted. However, when sneakers, as part of a larger rationing of footwear, were added to the ration list on February 9, 1943, public outcry was loud. Sneakers were so integral to the American wardrobe that their ban was quickly overturned, and for the remainder of the war, sneakers were relatively inexpensive and widely worn.[34]

After the war, sneaker production continued to grow. The baby boom provided a huge youth market for sneakers. Simple canvas high-tops and low-cut skippies were now the footwear of childhood, required in gym classes and preferred on the playground. As the peacetime economy began to flourish, standards of living increased for the majority of Americans. New consumer goods came on the market, and new pastimes were introduced. One of the biggest postwar cultural revolutions to affect sneaker culture was the popularization of television.

In 1946, only six thousand homes in the U.S. had televisions, but by the middle of the 1950s more than half of American households had a black-and-white set.[35] Sneaker manufacturers were early sponsors of television shows. As early as 1948, B. F. Goodrich sponsored the popular comedy program *The Burns and Allen Show*. Keds pitched sneakers through Kedso the clown in spots on Saturday morning cartoons. It was the advent of televised sports, however, that would have the biggest impact on sneakers. Television ushered in the age of professional sports and with it came the accompanying hero worship among millions of new spectators, which would ultimately drive sneaker consumption by fans. The rise of professional sports also pushed the market forward for cutting-edge athletic footwear customized for individual sports. New companies, especially from outside the U.S., stepped in to meet these new needs.

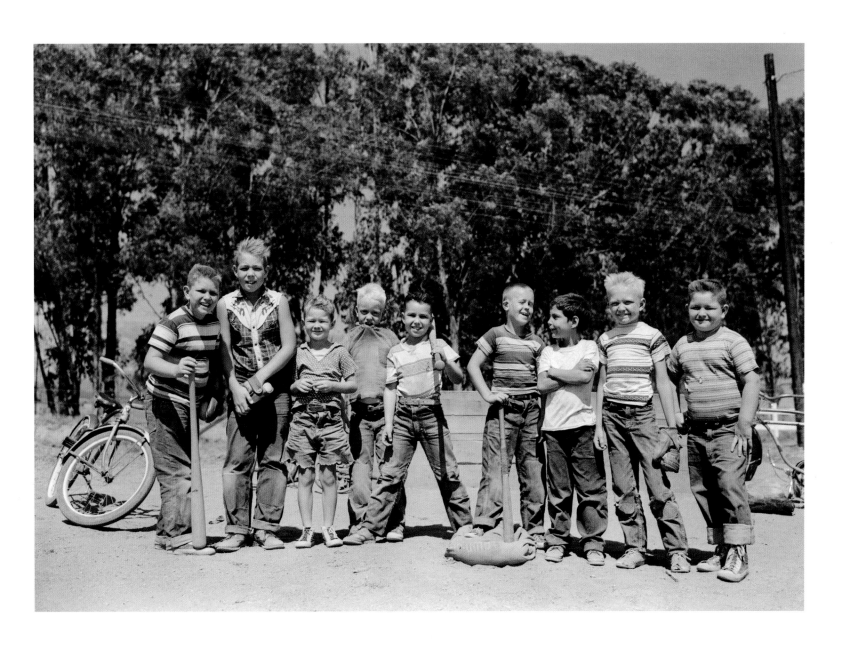

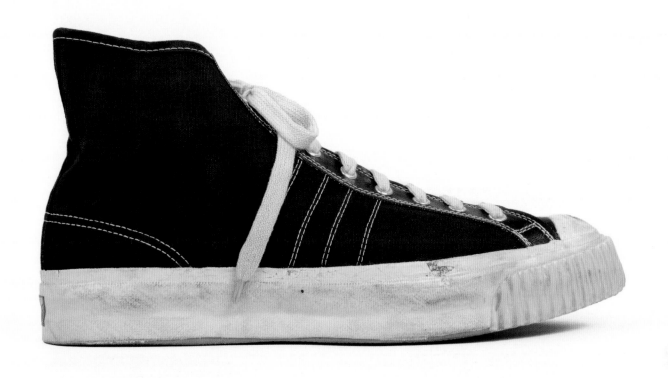

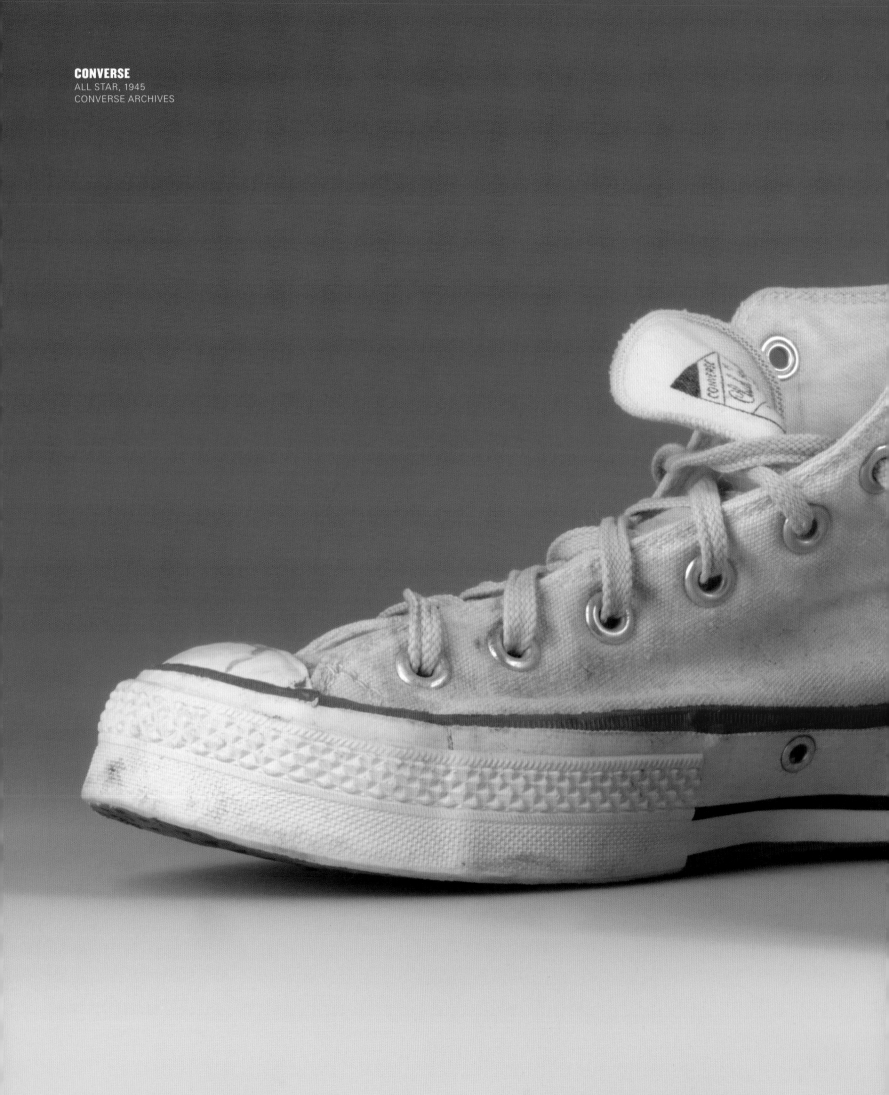

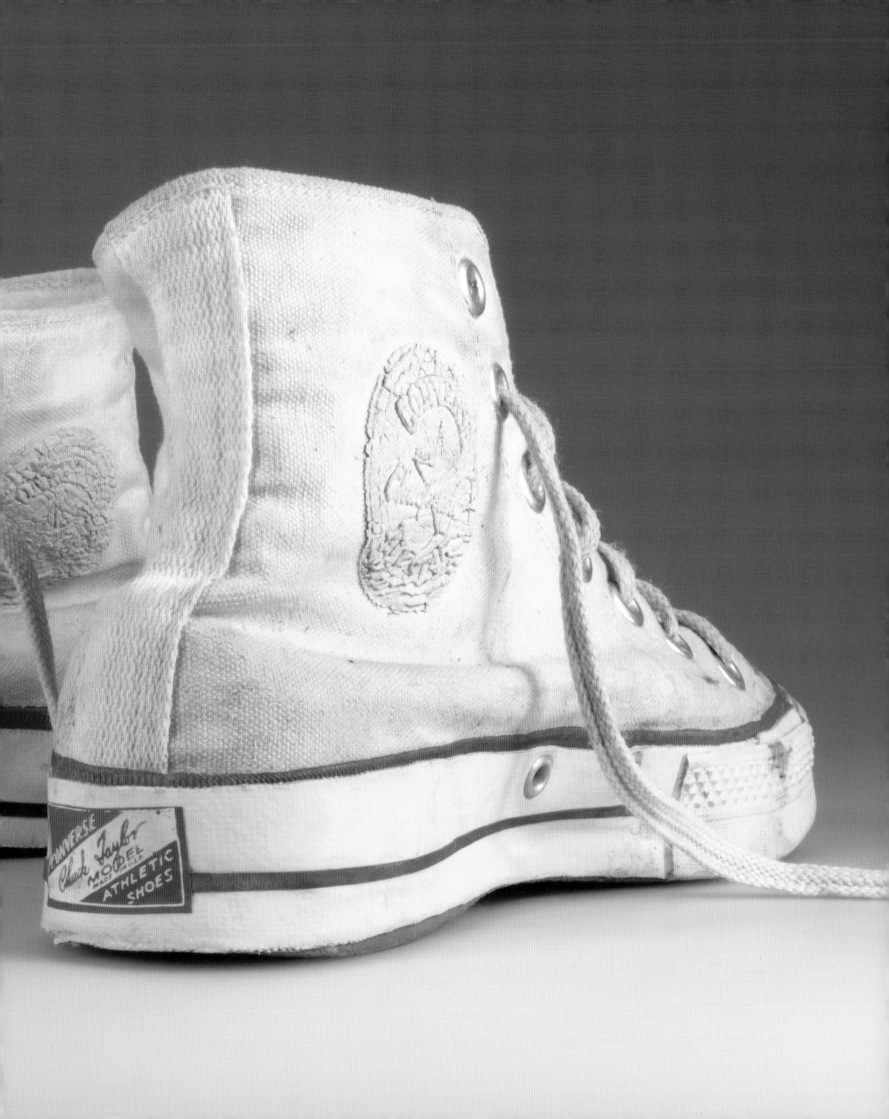

win basketball games

Converse ★ ALL STAR NON-SKID

...AIN *improved!*

...rst to develop new features ...ruction in their products. ...RSE was first to incorporate ... BUTTON in a molded sole ...l shoe. Now CONVERSE ...s the *corrugated* pivot but- ...ive you *additional* traction ...s *additional* wear.

In the improved ALL STAR are these outstanding features that have made this basketball shoe the favor- ite of champions in every classifica- tion:

Peg-top uppers.
Cushion heel and arch—built in.

...YOUR TEAM WITH ...LL S...

Basketball pro? No

Just a guy who likes the feel of the world's greatest basketball shoes

...verse All Stars, both high cuts and oxfords, appear on a lot of famous feet.
..., college, and high school basketball players, for instance. Every Olympic team since
... basketball became an Olympic event). A great many leading club squash, badminton,
...l players, too. In fact, Converse All Stars are specified by more coaches, worn by more
...an any other shoe specifically made for basketball. But . . . there are many other
...ys who won't drive down to the store in anything else but Converse All Stars.
...und-the-yard men who like the feel of the great shoe. And leisure time athletes
...verywhere. So why not get a pair for your closet? Wherever sporting goods are sold.
 For your nearest dealer call anytime free (800) 243-0355. In Conn. call collect
 325-4336. You'll also find world-famous Converse tennis shoes and the new
 NS-1 for yachtsmen. Converse Rubber Co., Malden, Massachusetts 02148.

★ **CONVERSE** When you're out to beat the world

Converse ...k Taylor ...L STAR ...TBALL SHOES

1

2

3

1 BLACK CANVAS "ALL STAR"
 Continues to outsell any basket...
 shoe made.

2 BLACK LEATHER "ALL STAR"
 Entirely new "All Star" of ye...
 back "Kanga" leather with new...
 type outsole construction.

3 LEATHER "COURT STAR"
 Newly styled blue-back ...
 leather basketball shoe with i...
 construction features.

It'...
a 49 year...

CHICAGO: 212 W. Monroe St.

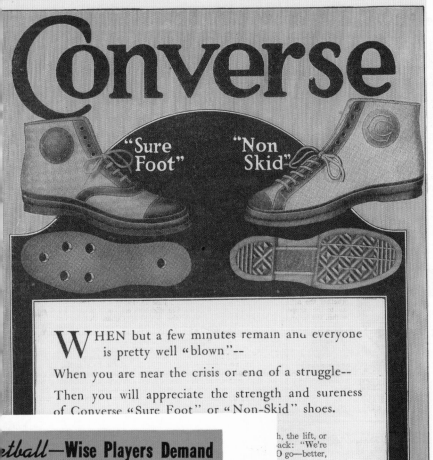

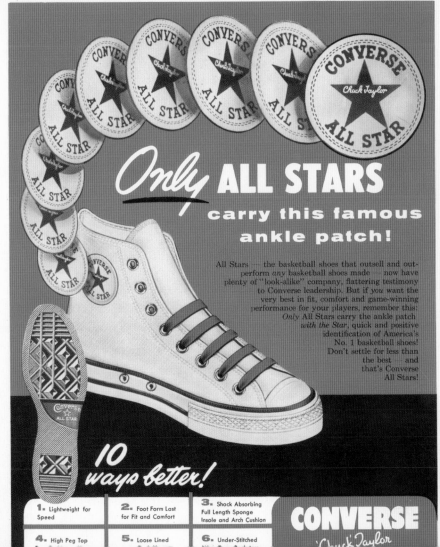
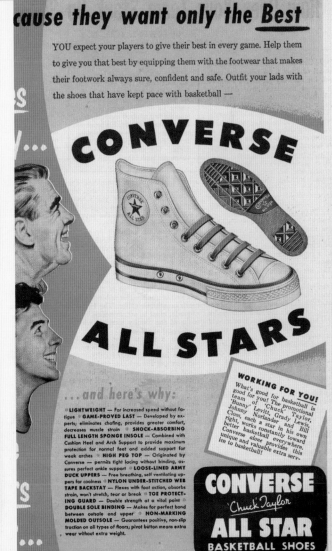

CEY ADAMS

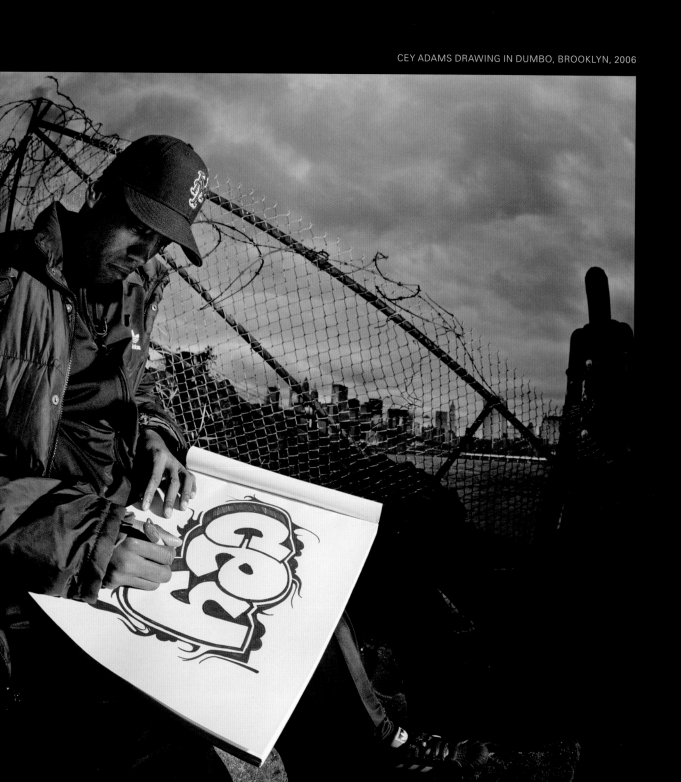

CEY ADAMS DRAWING IN DUMBO, BROOKLYN, 2006

As one of the original pioneers of the culture and as someone who witnessed its birth—first as a graffiti writer, then as a graphic designer in the music industry—it's my responsibility to remind folks that the road they're traveling was paved by creative and passionate young people like themselves. Young people on a mission to make art and be heard by society at large. We were writers, musicians, poets, dancers, fashion designers, and artists—all trying to find our voice. The direction wasn't clear. We made the rules as we went along.

During the early '70s, while I was still in grade school, my fascination with graffiti began. Like most of my friends, I was writing and drawing on everything. My parents were constantly on my case. My clothes were always covered in marker ink and spray paint. Around this time, sneakers also became very important to me. In school everyone judged you by your sneakers. That was my first introduction to the concept of cool. Pro Keds and P. F. Flyers were hot at that time, then later on Pumas and Adidas. Growing up in a large family, we didn't have much money, so name-brand kicks were out of the question. My choices were limited, so I had to make the best of my situation. I recall hand-painting stars and stripes on whatever cheap pair of skips I had. As an artist, I felt I had to do something to add a hint of personal style to my shoes.

Back then, no one was asking us what we liked or didn't like on a shoe. No one was asking about different colorways or how a certain shoe felt or performed. We were just stupid kids; what did we know about marketing and design, performance and target demographics?

After years of painting New York City subway cars, it was time to retire, time to call it quits. It was the beginning of the '80s. My son Eric was born. I had to grow up—fast! In my family that meant getting a real job. A real job for me meant using my artistic talent to convey the message that graffiti is Art with a capital A. After a brief introduction to music man Russell Simmons, I began my career as a graphic designer. I used the same skills I perfected as a graffiti writer to craft logos and posters for his company Rush Artist Management. A short while later, he and Rick Rubin formed Def Jam Recordings. As the label's creative director, I was responsible for producing album cover and merchandising designs for everyone from Run–DMC and the Beastie Boys to LL Cool J, Public Enemy, EPMD, and Jay-Z.

After the huge success of Run–DMC's 1986 hit "My Adidas," the band inked a deal with Adidas to create a line of custom shoes and merchandising apparel. As a way of ensuring their core audience would be satisfied with the look and feel of the collection, the guys convinced the executives at the company to give me a shot as a fashion and shoe designer. This was a big deal for us at the time. We were breaking new ground and making history . . . together.

Fast-forward to the present day—the good folks at Adidas approached me again, but this time I was commissioned to design my own signature collection of shoes and apparel. Unlike back then, I had complete creative control of my designs, clothing, and the shoes . . . yes, the shoes! I was in direct contact with the manufacturing plants overseas, and everything was done to make sure I was completely satisfied. It was the best feeling EVER!

Over the years, I've had many amazing opportunities to create iconic images and branding for leading companies. I consider it an honor and huge responsibility to represent the culture with pride and dignity. Today, everyone wants the input and feedback of younger consumers and creatives. To this I say YES!! FINALLY!!

My friends and I fought a lot of battles (big and small) to make these opportunities possible for us all. It's important for young people to understand how we got here. Heads were checked, fools were schooled, sacrifices were made, all to get our collective voice heard in America and around the world.

We played by our own rules, and we said, FUCK THE SYSTEM!

Respect your craft Respect the culture!

PAINTER AND GRAFFITI ARTIST-CUM-GRAPHIC DESIGN VISIONARY CEY ADAMS WAS THE FOUNDING CREATIVE DIRECTOR AT DEF JAM RECORDINGS, WORKING WITH ARTISTS INCLUDING RUN–DMC, BEASTIE BOYS, PUBLIC ENEMY, AND DE LA SOUL.

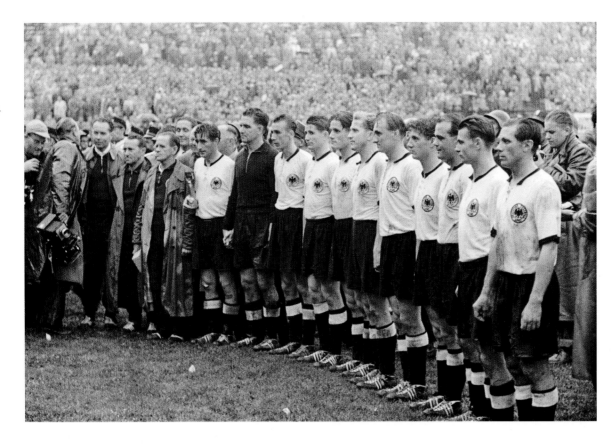

Left:
Adi Dassler posing with the German football team, July 4, 1954. Adidas, the athletic footwear company started by Dassler after World War II, became well known after the German football team won the World Cup in 1954 wearing Adidas footwear.

FASHIONING FITNESS: SPORTS AND STATUS SNEAKERS

Two of the biggest sneaker companies in the world, Adidas and Puma, emerged at this time. The Gebrüder Dassler Schuhfabrik had survived the war, but animosity between the brothers caused the company to be dissolved, despite the fact that it was successfully selling basketball footwear to American GIs stationed in Germany. With their relationship utterly fractured, the brothers went their separate ways—to the opposite sides of the Aurach River, which divided the small town of Herzogenaurach. Rudi Dassler established his company in 1948. He first called it Ruda, which was a conflation of his first and last names, and later changed it to Puma. Adi Dassler also conflated his name and registered Adidas in 1949. Their competition and innovations changed the look of sneakers and transformed both companies into extremely important players in the international sports-shoe market.

Adi Dassler, always an innovator, focused on making footwear for elite athletes. Although Adidas shoes were designed for the serious competitor, many of Adi Dassler's shoes, such as the Samba, an all-around training shoe from 1950, proved to be an instant success with amateur athletes. The use of three stripes helped to establish the brand. When the German soccer team wore his football boots with removable cleats to beat the Hungarians and take the World Cup in 1954, Adidas became a household name in Europe. As Adidas grew, it diversified and offered sneakers for multiple sports. In 1965, Adidas broke into the American basketball market with the introduction of the leather Pro Model. The company also aggressively sought elite athletes, and at the 1968 Mexico City Olympics more than 80 percent of all competitors wore Adidas.[36] The next year, Adidas in-

ADIDAS
GAZELLE, 1971
ADIDAS AG

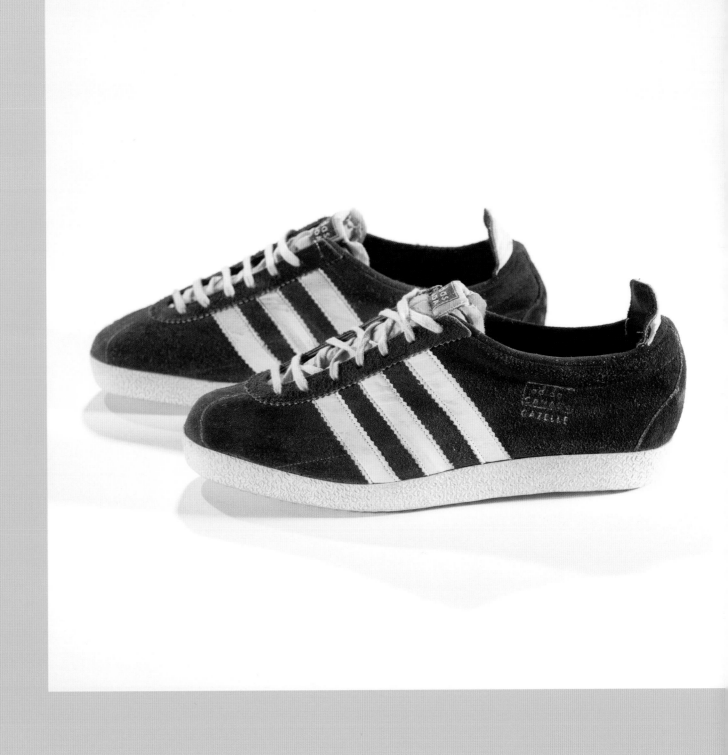

Right:
Gold medalist Tommie Smith
and bronze medalist John Carlos
removed their Puma shoes and
raised gloved fists in protest of
racial and economic inequality at
the Mexico Olympic Games on
October 20, 1968.

troduced the Superstar, the first low-cut leather basketball shoe with a stitched-shell sole construction, one of the most important shoes in sneaker history.

Puma also excelled during these years, making soccer and track shoes. Gold medalist Heinz Fütterer ran in Pumas at the 1954 Olympics, followed by other medalists in the 1960 and 1964 Olympics.[37] At the 1968 Mexico City Olympics, the new Puma Suede became a central feature in the protest made by American Olympic gold medalist Tommie Smith and his bronze medal–winning teammate John Carlos. At the medal ceremony, both athletes took off their black Suedes, embellished with the brand's signature panther, and mounted the podiums in stocking feet, heads lowered and black leather-gloved fists raised at the playing of the "Star-Spangled Banner." It was the height of the civil rights movement, and the athletes used their moment of fame to highlight the hypocrisy of an America that valorized their achievements yet maintained a racist society, as well as to symbolize the poverty endured by people around the world. They were immediately expelled from the games and faced harsh criticism at home. However, they were heroes in the eyes of many, their sneakers emblazoned in the memories of all who had watched.

As these German brands were claiming increasing market share internationally, the entrance of the high-end Japanese Onitsuka Tiger into the American market in 1964 cemented the arrival of a new era in sneaker history. Onitsuka Tiger had been started by Kihachiro Onitsuka in 1949 to meet the needs of elite runners and, like Adidas and Puma, was focused on innovation. All three brands created athletic shoes that looked strikingly different from the traditional canvas-and-rubber basketball high-top and low lace-up sneaker.

Onitsuka Tiger was introduced into the U.S. by Phil Knight, an ambitious Stanford MBA who would go on to be one of the cofounders of Nike. At Stanford, Knight had written a paper suggesting that Japanese brands could compete with German high-end sneakers for market share in the U.S. because of lower production costs. After graduation, he struck a deal with Onitsuka Tiger to sell its long-distance running and track-and-field shoes in the U.S. Knight, who had been a middle-distance runner in college, immediately reached out to his former coach, University of Oregon track coach Bill Bowerman, and sent him a few pairs of Onitsuka Tigers. Bowerman, who had himself been striving to create the lightest running shoe ever made, offered to be Knight's partner and provide critiques and design ideas to Onitsuka Tiger in the effort to make a better product. They named their company Blue Ribbon Sports, and Phil Knight famously sold the first shipment of Tigers out of his green Plymouth Valiant while Bowerman continued to tinker with sneaker designs.

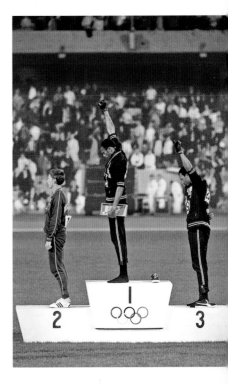

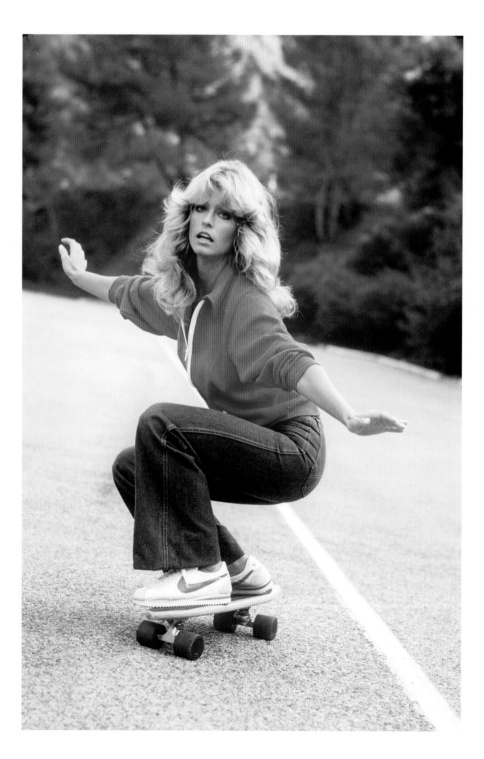

Left:
Farrah Fawcett-Majors mastered
skateboarding wearing Nike
Senoritas in her TV show *Char-
lie's Angels.* Senoritas were the
women's version of the popular
Nike Cortez.

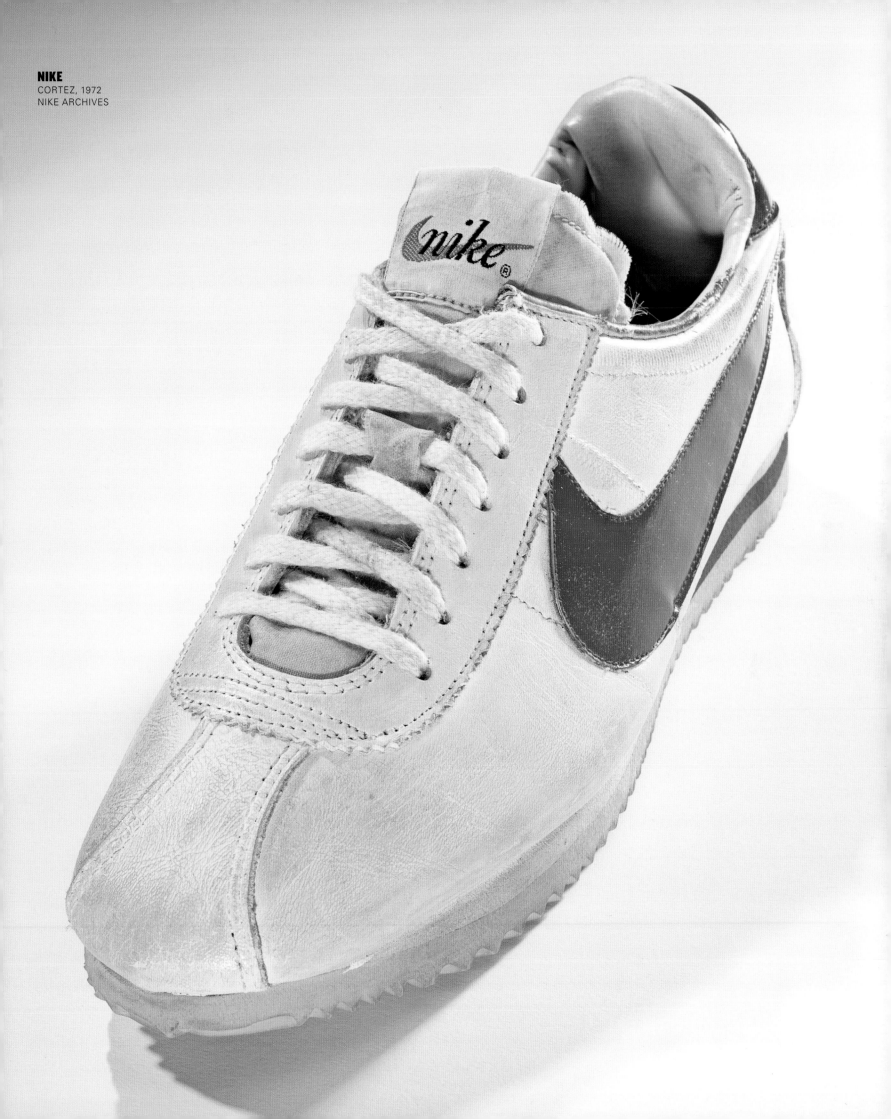

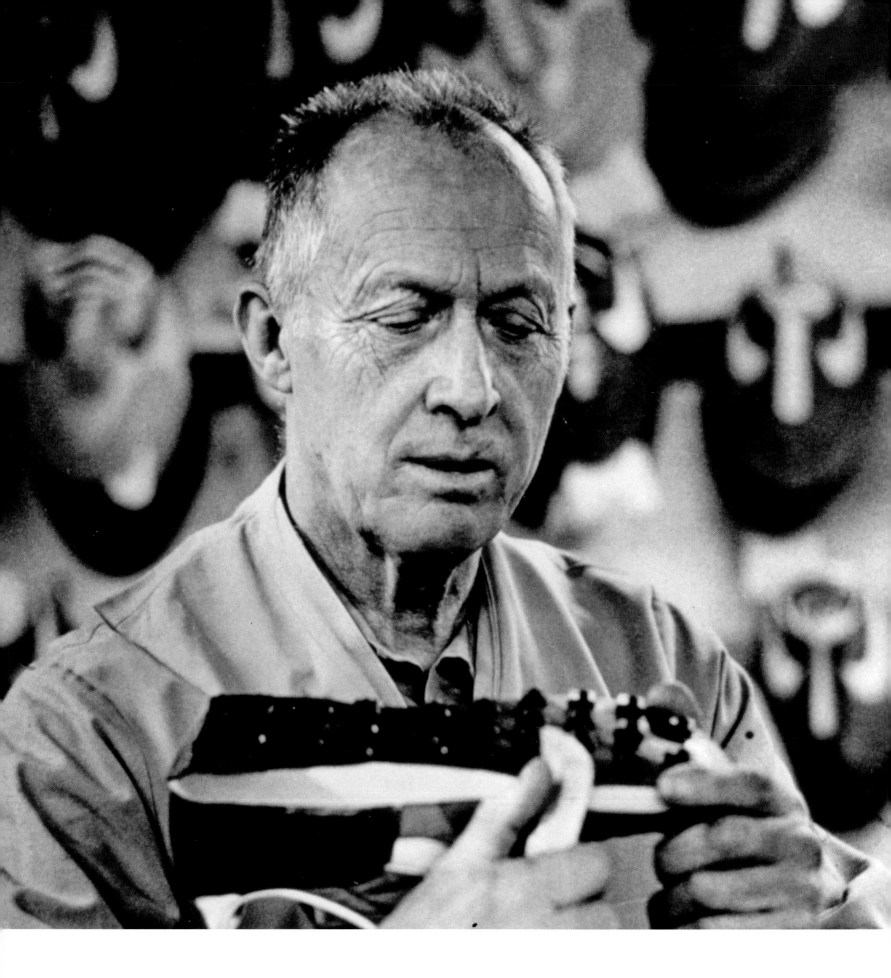

Bowerman was curious, inventive, and devoted to running. He was also a propo-
nent of jogging. In 1962, Bowerman had traveled to New Zealand to meet Arthur
Lydiard, who was popularizing jogging for fun and fitness. Bowerman, inspired by
the potential of this new form of exercise, became an enthusiastic proponent of
jogging in the U.S., and coauthored the book *Jogging* in 1966, which sold more
than a million copies.[38] Jogging quickly caught on, and by 1973, the President's
Council on Physical Fitness reported that six and a half million Americans were
jogging,[39] many in footwear designed by Bowerman.

The rapid embrace of jogging was part of the larger exercise craze that erupted
in the 1970s, coinciding with the self-focused interests of the Me Generation.
Obsessed with achieving personal bests, the Me Generation pushed aside earlier
ideas of perfecting the body as part of a moral duty or in service of the nation,
and instead used fitness to nurture media-driven ambitions related to health and
wore expensive athletic footwear as a means of flaunting conspicuous consump-
tion. As the desires of these weekend warriors increased, so did the number of
athletic shoe companies, each offering new and improved models.

Bowerman and Knight created Nike in 1972. They named their company after
the Greek goddess of victory, and their trademark "swoosh," which had been
designed by a young Portland State University graphic design student named
Carolyn Davidson for a fee of $35 the previous year, became a prominent design
feature on their footwear. Part of the allure of Nike sneakers for runners was
that they were very lightweight. Bowerman's experiments with rubber,
which included pouring it into his wife's waffle iron, resulted in soles that were
lightweight yet featured treads that remained high. This new Nike sole received
favorable reviews at the U.S. Track and Field Trials in 1972. The first commercial-
ly available Nike sneaker, the Cortez, also received high praise. By the time the
Waffle Trainer debuted in 1974, Nike had a devoted following and Nike sneakers
had become fashionable, their bright colors and high cost making them objects
of conspicuous consumption.

In 1977 *Vogue* proclaimed that "real runner's sneakers (the hottest status symbol
around)"[40] had reached new heights—sneakers had become items of fashion as
well as fitness. The *Globe and Mail* reported, "Farrah wears them. So do Bill
Cosby, Carol Burnett, Paul McCartney, and Pierre Trudeau. Mick Jagger has 35
pairs. You're as likely to see them on your neighborhood druggist as on the Wide
World of Sports. Purple nylon, orange suede, or yellow canvas, athletic shoes are
as essential to the 1970s as white bucks were to Pat Boone's generation."[41]
The article went on to say that the ten-billion-dollar sneaker industry was meet-
ing the needs of the "Me decade," and its "rampant narcissism resulting from
newfound wealth and the time in which to spend it [meant that] . . . ordinary folks
now have enough money to create new roles for themselves.

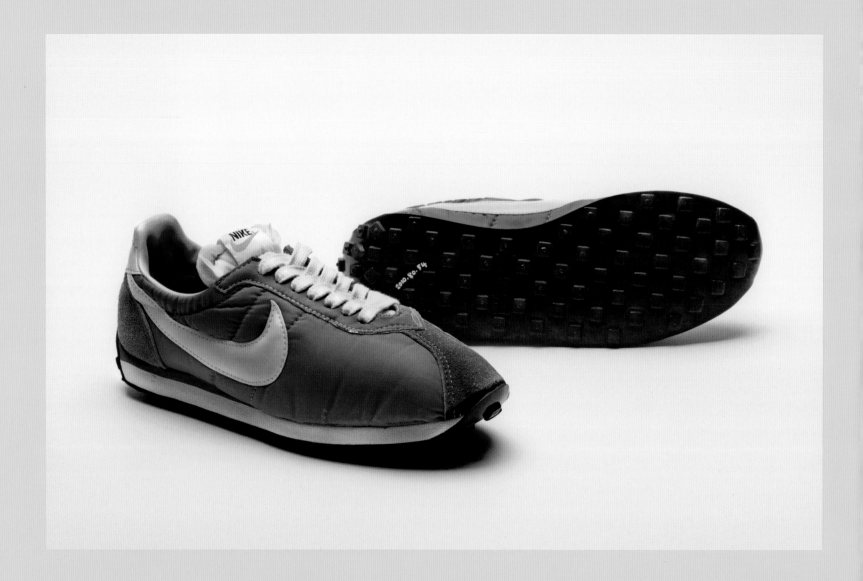

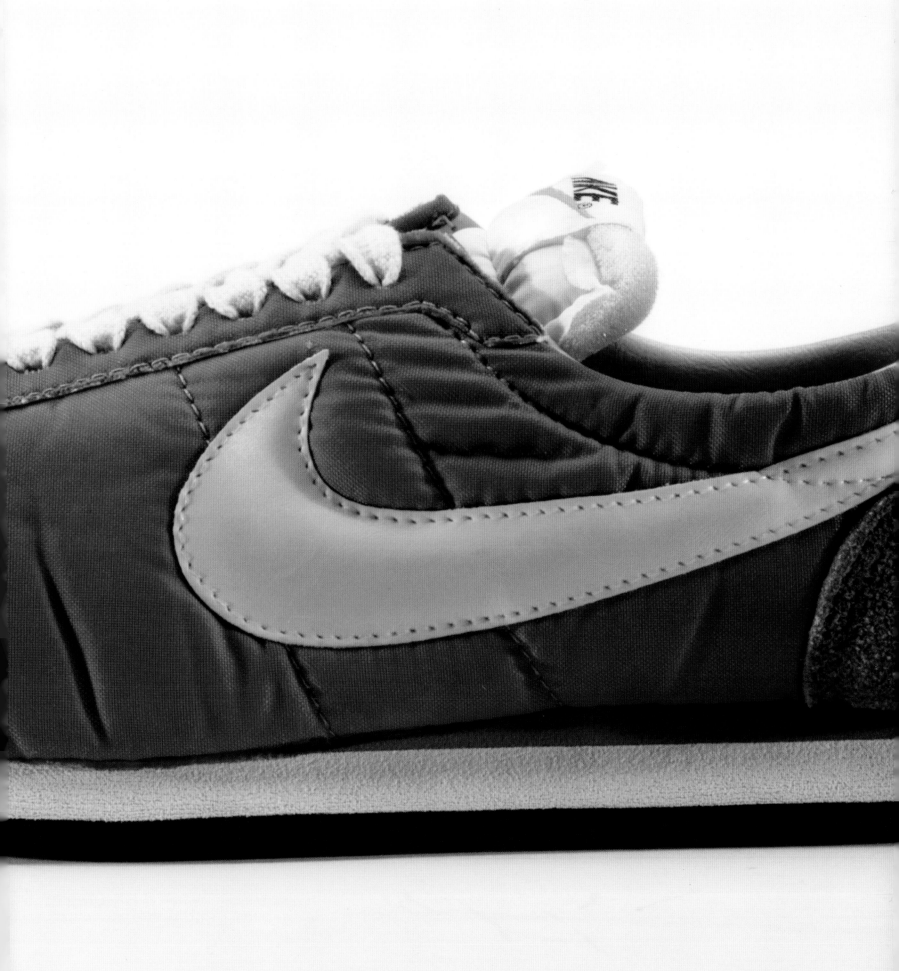

STAN SMITH

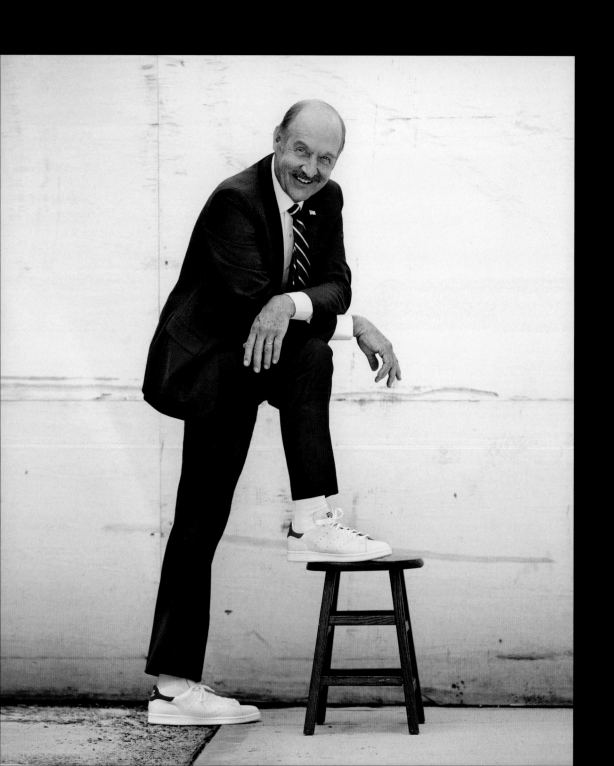

ONLY A HANDFUL OF PEOPLE'S NAMES ARE ASSOCIATED WITH SNEAKERS. HOW DID IT COME TO BE THAT YOU GOT TO HAVE YOUR NAME ON A SNEAKER?

A lot of people know my name and think I am a shoe. They are surprised that there is a guy named Stan Smith.

The shoe was created by Horst Dassler, Adi Dassler's son, with France's top tennis pro, Robert Haillet. Haillet wasn't well known around the world, especially in the U.S., so Adidas approached me when I became the number one tennis player in the world, to do a partnership. At that time, I was wearing a canvas shoe, and I liked that Adidas, which in my opinion was the foremost shoemaking company in the world, was making a leather tennis shoe. So we got together to talk about the arrangement, and for a few years, Adidas had both Haillet's and my name on the shoe. My picture and name were on the tongue, and Haillet's name was on the side of the shoe. Although eventually Haillet's name evolved off the shoe, U.S. distributors continued to refer to the shoe as the Haillet; it took five to ten years before it became known as the Stan Smith.

WERE YOU ABLE TO OFFER ANY SUGGESTIONS FOR THE DESIGN OF THE STAN SMITH?

The basic shoe had already been designed before I came on board at Adidas, but I did suggest that the tongue be given a loop that the laces could be threaded through to keep them in place. I didn't suggest it, but another difference between the Haillet and my shoe was the tab in the back. On mine, it was raised up to help protect the Achilles tendon. Of course, the shoe has gone through a number of evolutions over the years. The Millennium shoe is the one I still wear on the court; it has more support, more cushioning, and a thicker sole. Today, Stan Smiths are made using a lot of different materials, and they come in different colors.

WHAT DO YOU THINK OF THE INCREASED POPULARITY OF THE STAN SMITH IN THE U.S. AND ABROAD, ESPECIALLY FRANCE?

I always refer to the fact that the shoe was born in France. Robert Haillet was French, and Horst Dassler was really located in France, and the shoe has always been popular in France. When the shoe was taken off the market in 2012, I wasn't too pleased, but Adidas told me that they were going to relaunch it in January 2014. It was driven by social media. As part of the campaign, Adidas switched out my picture for portraits of various celebrities and gave them the shoes. One was Ellen DeGeneres, who got 30,000 likes. They even sent me a pair with my current picture on the tongue. It was awarded the shoe of the year for 2014, so it has been pretty successful.

SNEAKERS HAVE BEEN AROUND SINCE THE NINETEENTH CENTURY. DO YOU HAVE ANY INSIGHT INTO WHY SNEAKERS ARE SO IMPORTANT TODAY?

I think that because culture has become more casual, tennis shoes can be worn with almost anything. Certainly, my shoe has been worn with everything from cutoff jeans to tuxedos. One of my favorite moments was when we had the International Tennis Hall of Fame's Legends Ball, a black-tie affair, and around six young guys wore my shoes to the event. The new white shoes with the tuxes looked pretty sharp. One version of my shoe was in black shiny leather and had a pointy toe. If you didn't look too closely, it looked like a pair of dress shoes, but if you looked more closely you saw that they were tennis shoes. One of my favorites was a pair that Adidas made in calf hair to look like tiger fur with the stripes, but I really like the suede ones.

WHY HAS THE STAN SMITH HAD SUCH STAYING POWER?

People ask me that all the time, and I think that its simple design and clean white color make it versatile. It is fun to see people from all walks of life coming back to the shoe.

SINGLES AND DOUBLES TENNIS CHAMPION STAN SMITH WON THE 1971 U.S. OPEN AND IN 1972 WON WIMBLEDON, BECOMING THE NUMBER ONE MALE TENNIS PLAYER IN THE WORLD.

The new alchemical dream is remaking, remodeling, elevating, and polishing one's very self, and observing, studying, and doting on it. (Me!)"[42]

In the cultural climate of conspicuous consumption and dedication to personal bests, sneaker companies innovated new specialized and expensive niche sport sneakers. One reporter bemoaned that a single pair of sneakers was no longer reasonable for multiple activities. Now there were specialized sneakers for each sport, and even within a single sport, multiple sneakers were now needed: "training shoes for everyday use and competition shoes for races, shoes for grass and shoes for concrete, custom-made shoes for problem feet, and night joggers' shoes with flourescent orange strips."[43]

The gendering of sneakers also increased at this time, as sneaker companies began to capitalize on women's greater participation in fitness, which had been driven, in part, by women's liberation. Sneakers specifically for women were not novel. Keds, for example, had a long history of marketing to women, but innovation that purportedly met the needs of female physiognomy was new. The eager embrace of jogging by women incentivized sneaker companies and many began to offer jogging shoes designed specifically to fit the female foot. Nike created a women's version of its Cortez, called the Senorita, while Saucony found favor with women because of its narrower heel cup.

Tennis, with its suggestions of privilege, also experienced an upsurge in popularity. The 1968 rule change allowing amateurs to compete in major tournaments, coupled with the Me Generation's interest in competition, brought tennis into the spotlight. As with other sports, highly specialized footwear for tennis garnered increasing interest, and Adidas led the way, revamping the canvas and rubber-soled tennis sneaker with the introduction of the Haillet in 1964. Named for French tennis great Robert Haillet, the shoe featured a leather upper and an innovative dish sole. Some claim that the Haillet was the first leather tennis shoe, but Adidas had made them earlier. In 1950, the Modell Nüßlein was created in consultation with the German tennis champion Hans Nüßlein. Like all elite tennis shoes at that time, when it debuted, the Haillet was required to be completely white, which left little room for brand identification. Other than Adidas's iconic three stripes rendered in subtle perforated lines on the side of the sneaker, no other branding was visible on the shoe.[44] In 1971, Adidas signed the phenomenal American tennis player Stan Smith in an effort to gain a foothold in the American tennis-shoe market, and his name was added to the Haillet sneaker. Eventually, the sneaker was rebranded as the Stan Smith and featured a green heel tab, which displayed the new Adidas trefoil logo in addition to Stan Smith's name, likeness, and signature in green on the tongue. In 1975, Adidas released the Matchplay Tournament sneaker in association with Arthur Ashe, the first African American to win at Wimbledon. But it was the French brand Le Coq Sportif,

Left:
Interested in gaining a greater foothold in the American market, Adidas turned to tennis great Stan Smith for endorsement. The resulting Stan Smith sneaker replaced the Haillet and went on to become a classic.

ADIDAS
STAN SMITH, CA. 1980S
ADIDAS AG

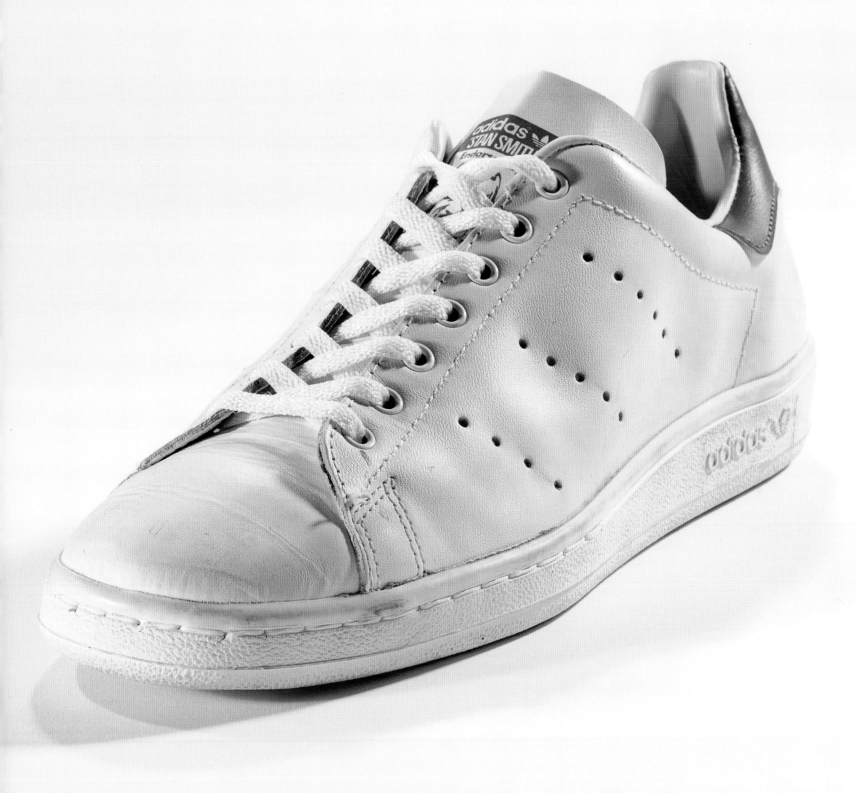

which had outfitted the American tennis star for his historic win against Jimmy Connors at Wimbledon, that released a more successful signature shoe. Like jogging and running shoes, high-end tennis shoes quickly became lifestyle footwear in their own right in the 1970s.

One of the greatest shifts, however, was the entrance of European brands into the American basketball-shoe market. The change began in 1965 with the Adidas leather high-top Pro Model. Although the Pro Model was not hugely successful and had limited availability, it was a harbinger of change; the traditional canvas high-top would soon be outmoded. For decades, Converse, B. F. Goodrich, Spalding, and Keds had been the uncontested suppliers of the ubiquitous canvas basketball shoe to both professional and amateur players. However, the push toward innovation in sneaker design and the creation of high-end status sneakers for niche sports caused these inexpensive and anti-innovation sneakers to lose favor. The arrival of the low-cut leather Adidas Superstar in 1969 and the suede low-cut Puma Clyde of 1972 further challenged the canvas high-top on the courts. By the end of the 1970s, the Keds division of Uniroyal posted a twenty-two-million dollar loss and it was sold to Stride Rite,[45] while Converse was turning away from its canvas All Star. A 1977 article in the *New York Times* titled "Pity the Sneaker: Its Era is Ended" was illustrated with an image of a rather sad canvas high-top that seemed to say it all: times were changing; the era of the canvas and rubber high-top seemed over.[46]

Canvas high-tops, however, did retain a position of importance in a number of subcultures. Sneakers had been associated with uniforms of discontent since the 1950s when beatniks incorporated them into their fashion statements. In the 1970s, Punks embraced old-school canvas high-tops. They were cheap, raw, and seemingly anticonsumerist. Their lack of bells and whistles set them apart from the highly commercialized status sneaker and gave them an air of authenticity. High-tops were also structurally similar to the other iconic forms of punk footwear, the lace-up combat boot and Dr. Martens. Joey Ramone sported low-top skippies while Sid Vicious often wore Chuck Taylors. In contrast to status shoes, these canvas-and-rubber sneakers worn until ragged for expressly nonathletic purpose helped to establish the alternative look that remains potent to this day.

Opposite Page:
Punk rockers the Ramones famously wore old-school sneakers like Keds and Converse, as seen in this photo from May 1977.

Pages 92–93:
Austin Peay State University's star player Fly Williams plays basketball at a playground in Foster Park, Brooklyn, New York, August 14, 1973.

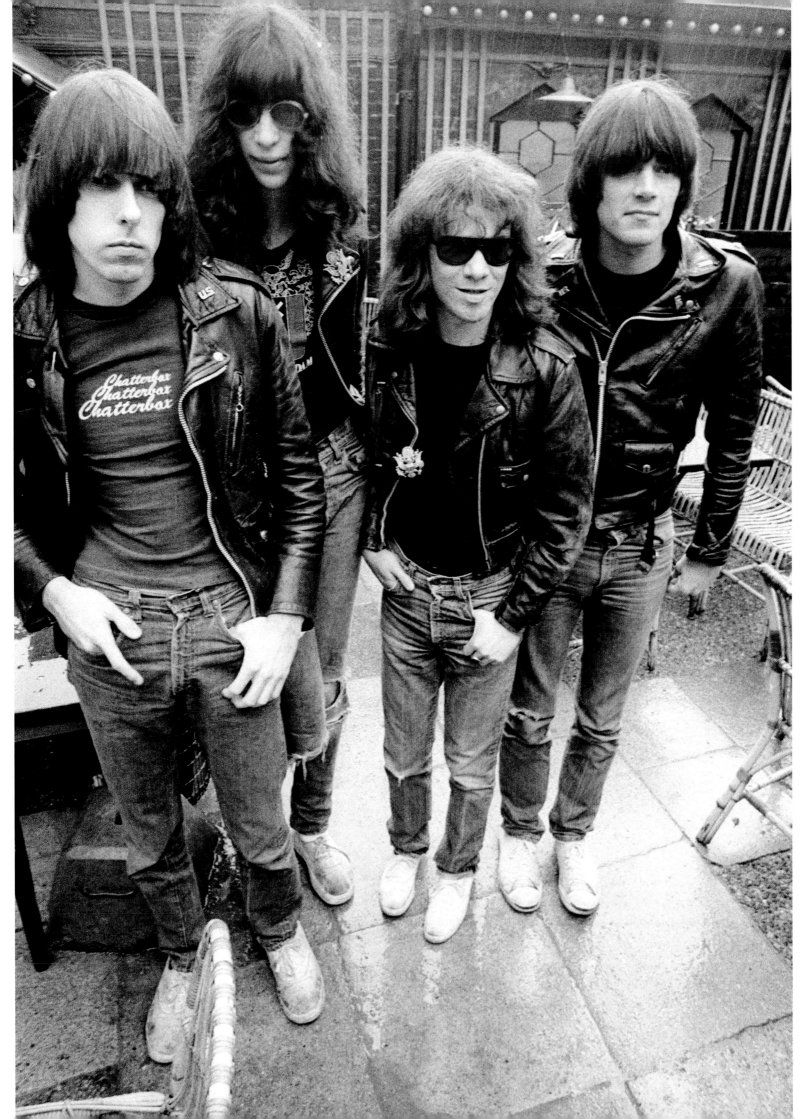

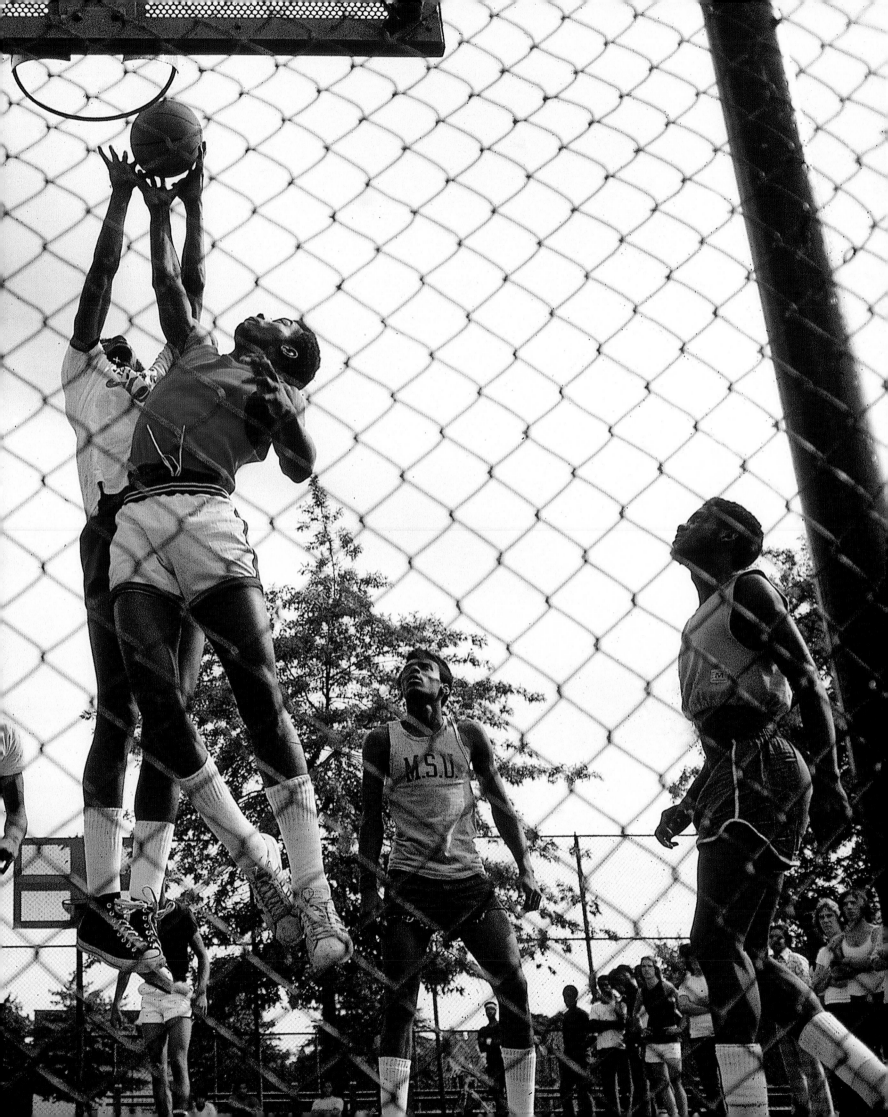

WALT "CLYDE" FRAZIER

WALT "CLYDE" FRAZIER WITH HIS ROLLS-ROYCE IN BROOKLYN, NEW YORK, JANUARY 9, 1973 (DETAIL)

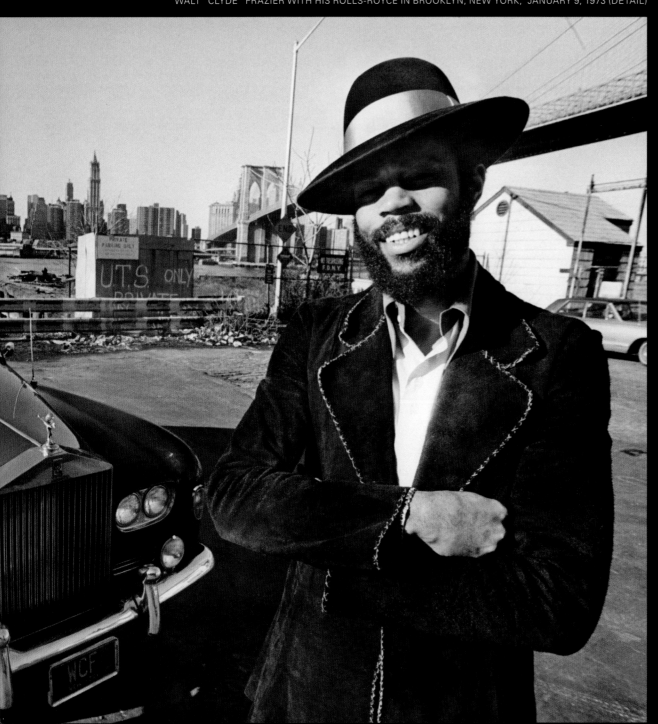

HOW WERE YOU INVOLVED IN THE INITIAL DEVEL-OPMENT AND DESIGN OF THE PUMA CLYDE?

Their initial design for the shoe was too heavy and wasn't flexible. I advised them to change the padding on the inside sole, which resulted in a shoe that is lighter and more flexible.

AS ONE OF THE NBA'S FIRST FASHION ICONS, HOW DO YOU THINK THE CLYDE REFLECTS YOUR PERSONAL STYLE?

The Clyde's style is a perfect match with mine. After forty years, it's still in vogue. It's not only an athletic shoe, it is a high-style shoe on and off the court.

WHAT ROLE DOES THE SNEAKER IN GENERAL PLAY IN MALE FASHION AND EXPRESSING ONE'S PERSONALITY?

It's huge. And because basketball players are so popular and basketball is an iconic sport, shoes are a way for players to show off their creativity and assert their personal style. Guys can trash-talk about their style when they are wearing their sneakers on the court playing.

ARE THERE CERTAIN FASHION RULES THAT YOU ADHERE TO WITH SNEAKERS, SUCH AS MATCH-ING COLORS, NOT WEARING SOMETHING WITH SNEAKERS, ETC.?

I always like the creative part to be expressed through being different and standing out, showing your own individuality and your own style. Back in the late '60s, I was wearing orange laces in one sneaker and blue in the other. That's why Puma approached me—because of my style.

FOR MORE THAN FORTY YEARS, THE LEGACY OF THE PUMA CLYDE HAS ENDURED, AND THE SHOE HAS BEEN REINCARNATED DOZENS OF TIMES THROUGH NEW COLLABORATIONS AND COLOR-WAYS. DO YOU HAVE A FAVORITE VERSION?

The original is my favorite. But I also like the rainbow of colors available now.

CAN YOU TALK ABOUT THE PLACE OF THE CLYDE IN THE HISTORY OF SNEAKER CULTURE AND THE INFLUENCE IT HAS HAD ON CURRENT SNEAKER CULTURE AND FASHION?

Puma and I were the first to work with suede and the first to make shoes in different colors. We also came out with the colored laces. We set the stage for all that came after us.

YOUR PERSONAL STYLE AND ENDORSEMENT OF THE CLYDE WERE PIVOTAL FOR MANY YOUNG PEOPLE, INCLUDING DJ CLARK KENT, AND INSPIRED A GENERATION TO WEAR SNEAKERS AS A FASHION STATEMENT. DO YOU SEE YOURSELF AS HAVING HELPED SHAPE THE APPEARANCE OF CONTEMPORARY BLACK MASCULINITY?

Yes, absolutely. I was the first guy to bring bling to the NBA with my Rolls-Royce, fur coats, and the Puma Clyde in suede.

THE 1970S WERE A TIME OF RACIAL UNREST, WHICH THE NBA WAS CERTAINLY NOT IMMUNE TO. YOUR PERSONAL STYLE WAS PROVOCATIVE, BUT YOU ALWAYS REMAINED TRUE TO YOUR INDIVIDUALITY. DID YOU IMAGINE YOURSELF AS A CULTURAL REBEL?

No. I was just having fun in the greatest city in the world. At 25 I never thought I would be talking about this forty years later. It's so different today, because people have stylists and someone to build their brand. I had to do it all by myself. I was criticized at first, but forty years later people are still talking about my style.

THE PUMA CLYDE SEEMS TO HAVE BEEN THE FAVORED SNEAKER OF CUTTING-EDGE CULT-URAL PHENOMENA IN THE EARLY 1980S. WHY DO YOU THINK THE CLYDE (AS OPPOSED TO OTHER CELEBRITY-ENDORSED SHOES) WAS THE SHOE EMBRACED BY CITY KIDS INTERESTED IN THE NEW HIP-HOP CULTURE AND BREAK DANCING?

Everyone just loved the style—you could jazz it up with the laces—and no one else had the suede. Break dancers loved the shoe. And the retro trend, where the old shoes came back into style, has helped Puma stay relevant throughout the years.

IN YOUR OPINION, IS THE CLYDE STILL A CLASSIC?

Yes, the Clyde is still a classic. It's a culmination of the shoe's style, color, and the fact that people are still wearing it.

CURRENTLY A COMMENTATOR FOR THE NEW YORK KNICKS, WALT "CLYDE" FRAZIER WON TWO NBA CHAMPIONSHIPS WITH THE KNICKS, IN 1970 AND 1973, AND IN 1987 HE WAS INDUCTED INTO THE NAISMITH MEMORIAL BASKETBALL HALL OF FAME.

FLY MOVES: SNEAKERS AND URBAN STYLE

It was also in the 1970s that one of the most profound shifts in basketball to affect sneaker culture occurred—the popularization of pickup games. In the boroughs of New York on the seemingly innumerable basketball courts, both official and jury-rigged, the cult of personality and fashion collided. Sneakers became a primary means of defining individuality and status, and New York became the epicenter of sneaker culture.

Basketball had been an urban sport almost from the moment of its inception. In 1910, seventy-five of New York City's ninety-two public schools had outdoor basketball hoops.[47] By the 1970s, the five boroughs had hundreds. The cultural significance of many of these courts should not be underestimated. Some, like the courts of the aristocratic past, were arenas where the local elite could hold audience, establish political alliances, orchestrate rivalries, and create stars through the staging of basketball games.

Urban basketball had become an aggressively athletic game. The new, highly individual style of play, often accompanied by the brazen bravado of star players, was part of the larger cultural trend toward pursuing personal bests through competition. It was thrilling to watch, and crowds gathered whenever a match was called. This shift toward spectacle was perfect for the age of televised sports, and a more street style of play began to seep into professional basketball. As Lars Anderson and Chad Millman have written, "Bob Cousy, Oscar Robertson, Julius Erving, Larry Bird, Magic Johnson, and Michael Jordan—all are direct descendants of the playground style that was forged on the asphalt in Brownsville, Williamsburg, the Lower East Side, Harlem, and the Bronx. Forget the peach baskets, the YMCA, and Springfield, Mass. Lose the image of burly young Christian men in matching outfits playing basketball as a wholesome winter alternative to summertime sports. The game of power and finesse we watch today was born in a time and place of quiet desperation. . . . Visit the playground, and you'll see that Naismith's original concept has as much to do with today's graceful, fluid game of hoops as Ford's Model T has to do with a Ferrari."[48]

As urban basketball began to transform the professional game, the face of the game also changed. In the 1970s, 90 percent of professional players hailed from urban centers, and by 1980, 75 percent of professional NBA players were African American.[49] Although becoming a highly paid basketball star was a long shot—especially for underprivileged players—those who rose in the ranks became superstars. Inspiring to many, the celebrity of these basketball heroes was quickly commodified. Adidas signed Harlem-born Kareem Abdul-Jabbar in 1971 and that year released the first basketball shoe to feature the signature of

NIKE
FRANCHISE, 1981
COLLECTION OF BOBBITO GARCIA

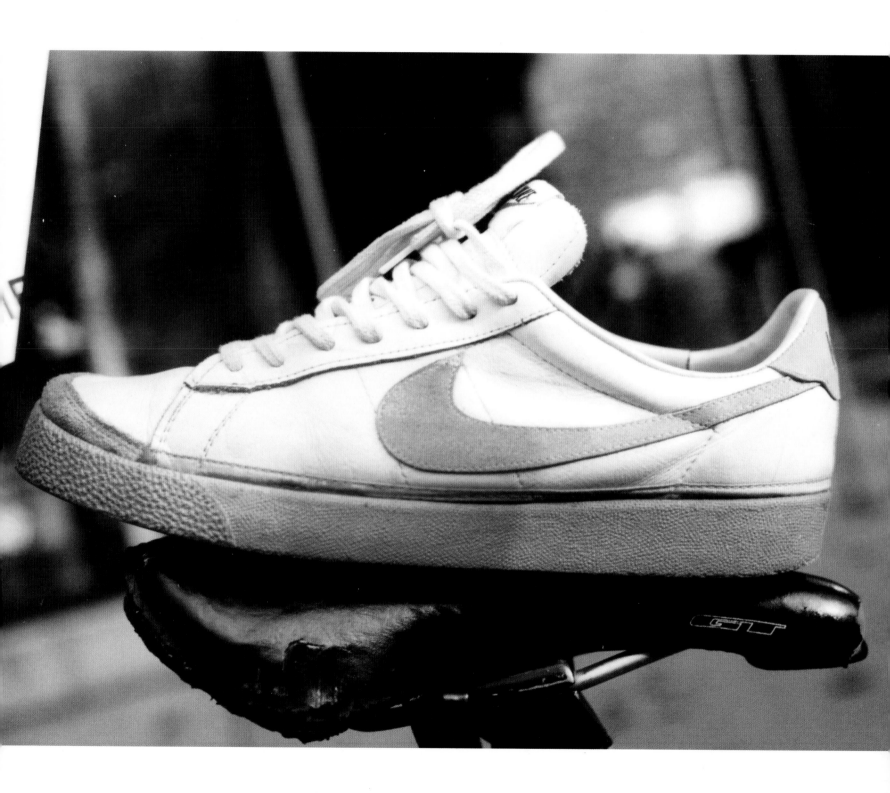

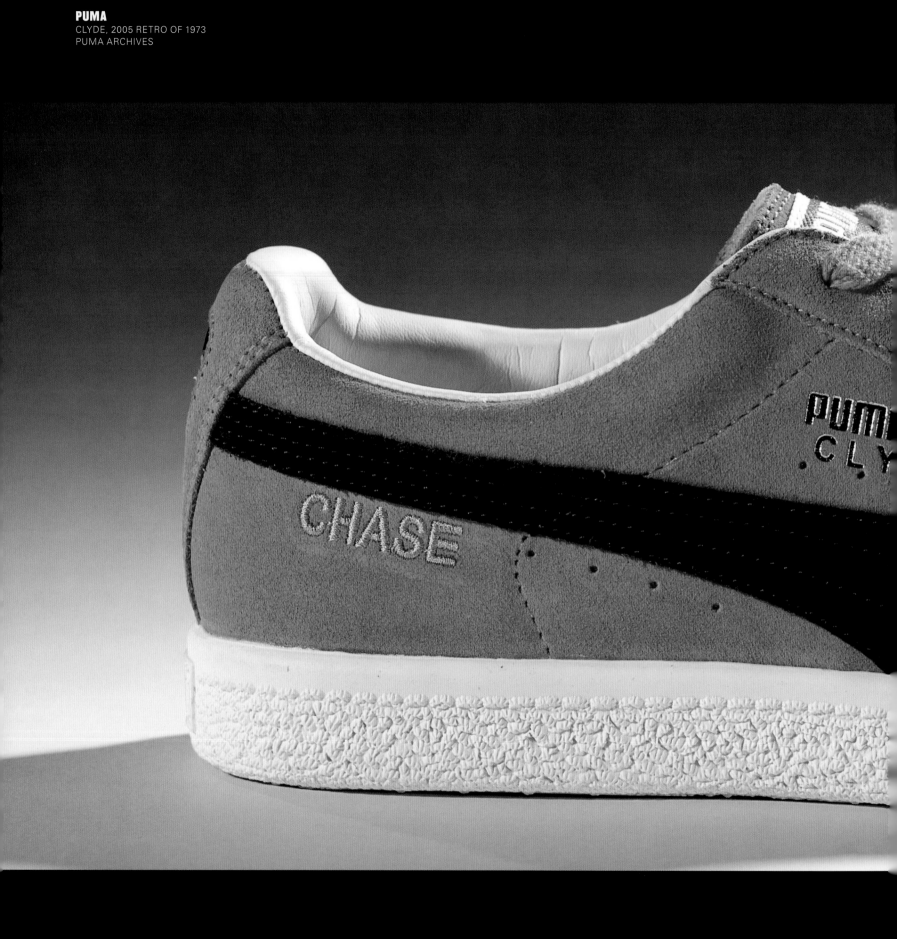

an endorsing celebrity. Puma signed New York Knicks great Walt "Clyde" Frazier in 1972, and Converse, in an effort to compete with the European brands, introduced the All Star Pro Model Leather, endorsed by Julius "Dr. J" Erving in 1976. Of these three sneakers, however, it was the Puma Clyde that, like Walt Frazier, easily traveled between the sports and fashion worlds. Frazier, the most flamboyant dresser in the NBA, even appeared in a Puma ad wearing his mink coat, suit, and sneakers, marking one of the first times sneakers were pictured with a suit.

Just as signature pickup moves demonstrated the unique styles of the best players, basketball sneakers became a means by which masculine individuality could be flaunted both on and off the court. By the end of the 1970s, the owning of multiple pairs of sneakers as a means of being "fresh" became increasingly common. In the *New York Times* article "For Joggers and Muggers, the Trendy Sneaker," the author described the nuanced meanings associated with the numerous types of sneakers available. As the title suggests, the article included prejudiced ideas about the place of status sneakers in the inner city, as well as an interview with an eighteen-year-old high school student whose six pairs of sneakers were remarked upon with some amazement. "I asked Rickey if it wasn't a little strange to have so many pairs of sneakers and he laughed, 'Hell, no'. . . . He thought for a moment and added, 'Besides, my brother Ray's got five pair of Pumas—five pair, just Pumas. Now that's crazy.'"[50] The racist overtones of the issues hinted at in this article, ranging from implied criminality to imprudent consumption, would haunt sneaker culture for decades.

If inner-city basketball was defined by braggadocio, brazen technique, and high-end sneakers, the debut of hip-hop in 1973 offered another competitive outlet based on equal parts skill and style—a point made clear by rapper Rakim at the celebration of the fortieth anniversary of hip-hop in New York, when he thanked DJ Kool Herc, widely credited with inventing the genre, by saying: "I'd probably be a football player or a basketball player if it wasn't for what Herc did to the game."[51] Herc's inventive use of two turntables so that he could play with the "break," or instrumental part of a song, led to the development of breaking, and his verbal exhortations to the break-boys, or b-boys, helped lead to the development of rap. B-boying was competitive by nature. The dances were inventive, extremely athletic, and, like urban basketball, required footwear that was both functional and fresh. Images documenting early competitions show many onlookers, as well as some b-boys, wearing canvas Converse All Stars and PRO-Keds 69ers, but many more sported Nike, Adidas, Puma, and Pony. Most striking are images of 1980s b-boying crews wearing matching outfits, with the exception of their shoes, when performing. Group cohesion may have been expressed through dress, but individuality was established through footwear. Indeed, as Bobbito Garcia writes, "From 1970 to 1987, the goal in New York was to assert your individuality within a collective frame. The collectives were playground ball-

Opposite Page:
In the 1980s, New York City urban style inspired fashion worldwide. This group portrait by famed photographer Jamel Shabazz, taken in 1985, captures the importance of sneakers to street style.

Pages 102–103:
Rock Steady Crew, 1982.

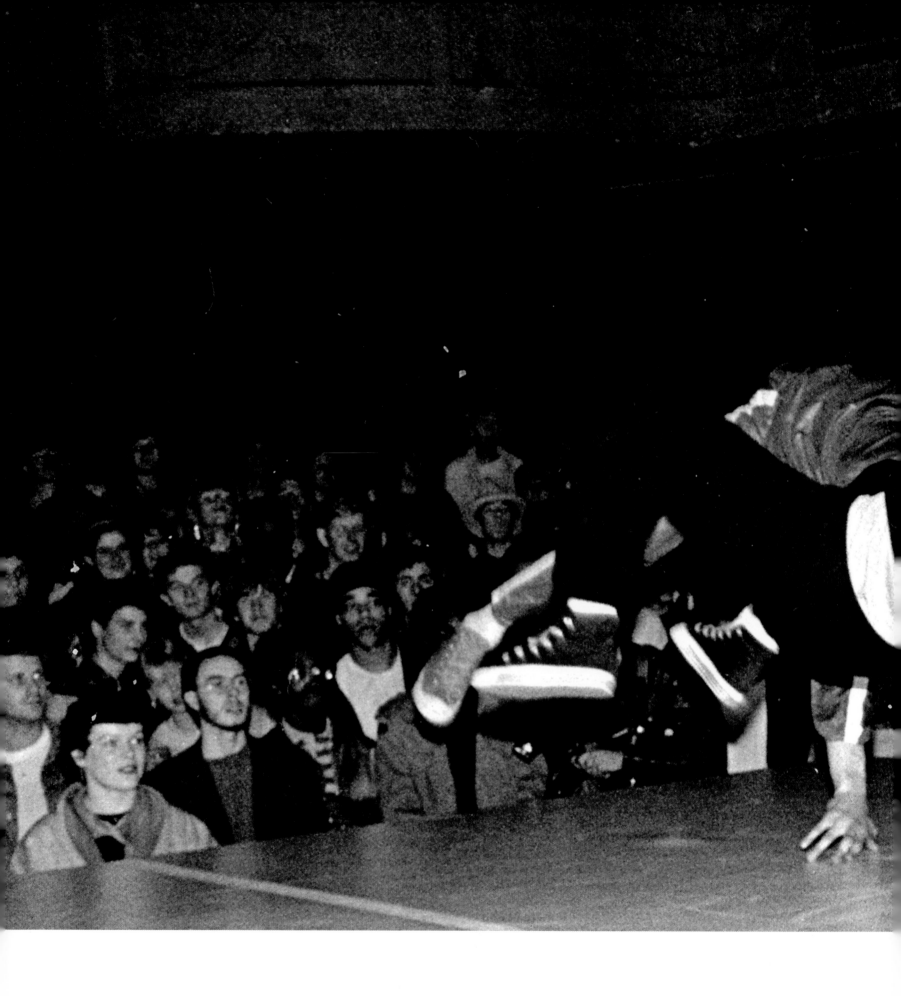

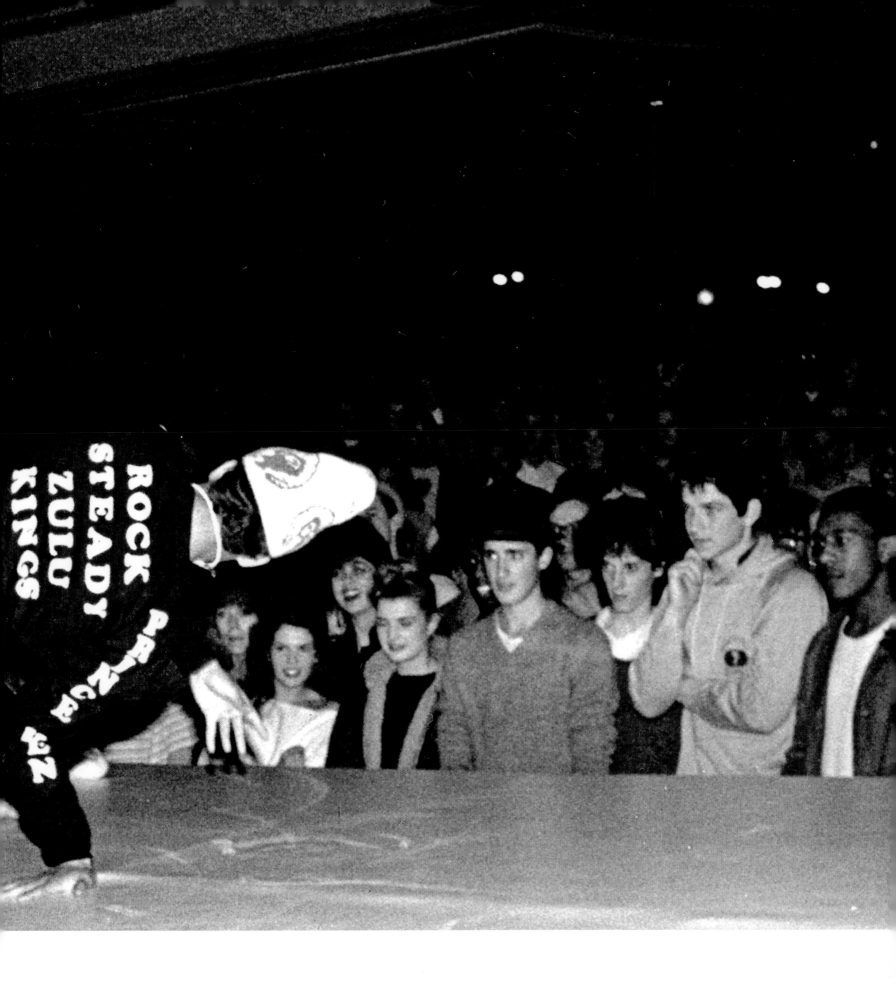

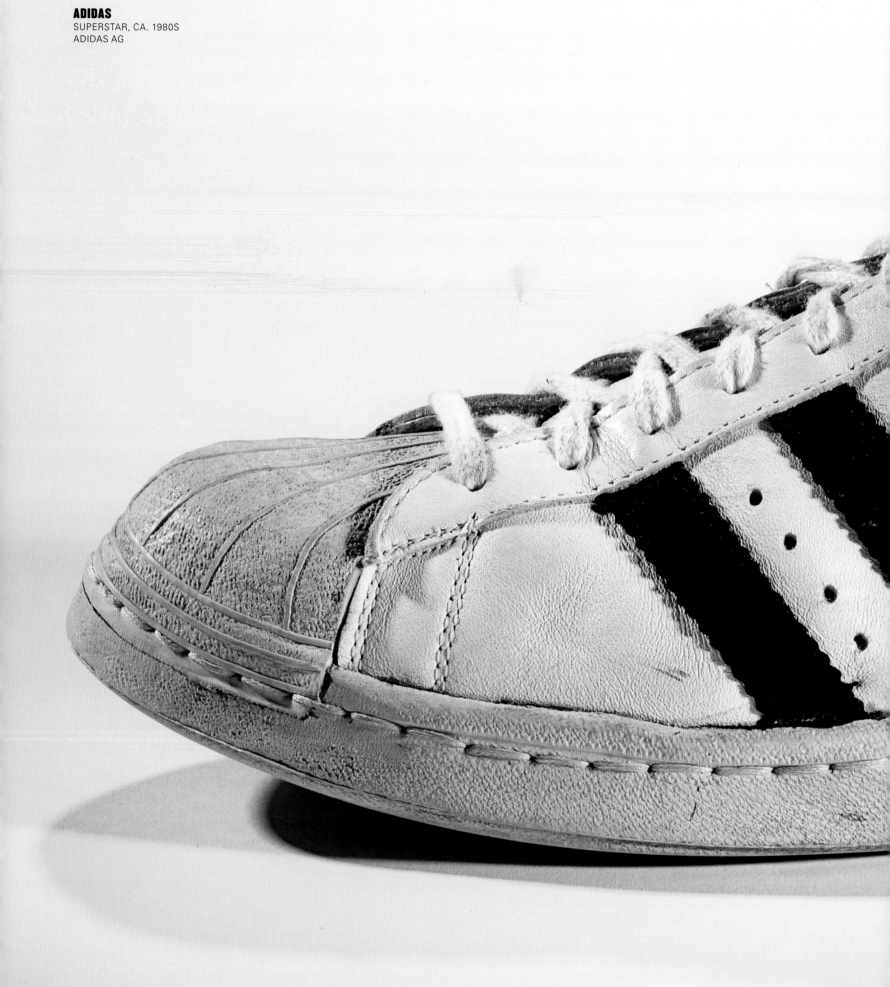

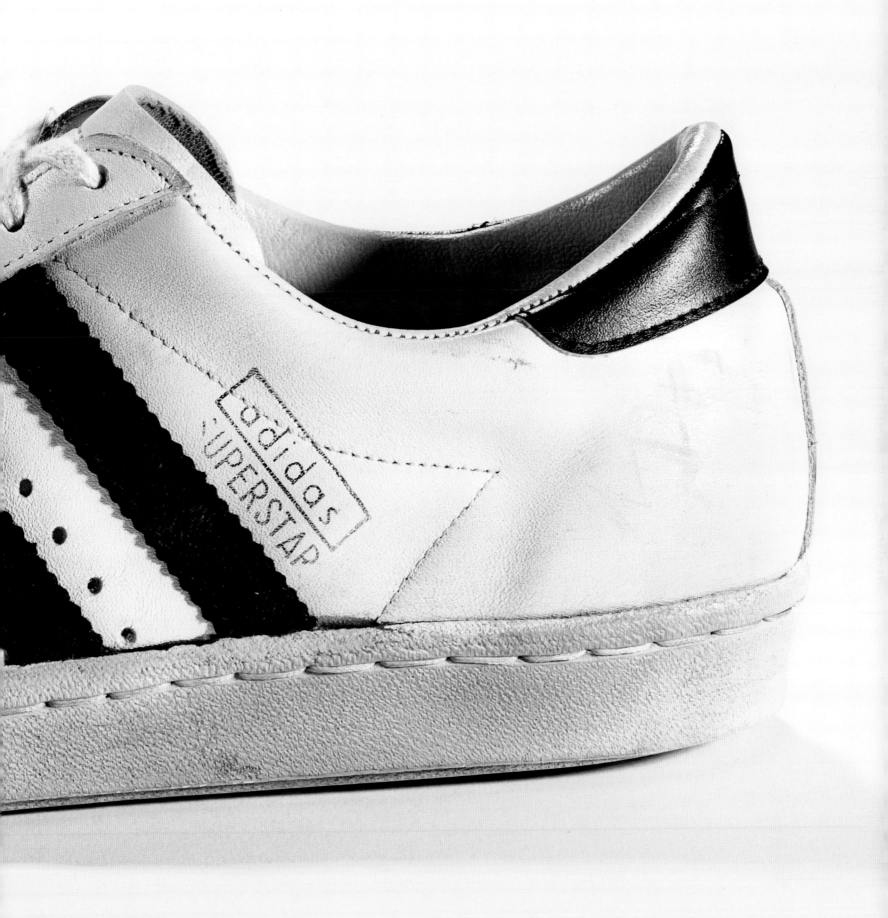

ADAM HOROVITZ

LEFT TO RIGHT: ADAM HOROVITZ, WITH ADAM YAUCH AND MIKE DIAMOND, 1985, THE YEAR
BEFORE THE BEASTIE BOYS'S DEBUT LP, *LICENSED TO ILL*, WAS RELEASED (DETAIL)

BEASTIE BOYS WAS ONE OF THE FIRST GROUPS TO BLEND SKATEBOARD CULTURE AND HIP-HOP CULTURE. HOW DID YOUR ICONIC PUMAS AND ADIDAS HELP ESTABLISH A RELATIONSHIP BETWEEN THESE TWO DISTINCT SUBCULTURES?

Musically and fashion-wise, we come partially out of skate culture—we used to skateboard, so that was something we were aware of. A mix—skaters, punk rockers, and people into rap—liked our band. It was through our music that we attracted different subcultures. I remember being at a deli in LA in the early '90s, and some kids made fun of my Puma Clydes, saying "You can't afford a pair of new sneakers?" I said, "Trust me, in a few years, you're gonna want these." When I was a kid, the Puma Clyde was a big deal—Walt Frazier was in New York. My brother had a pair of gold fake-suede Dr. Js, which were the Holy Grail of sneaks. When we got older and had money, we wanted those sneakers. As adults, it's normal to want to relive the good parts of childhood. For us, part of that was finding brand-new, fresh-in-the-box Puma Clydes, Converse All Stars, Dr. Js.

DO YOU STILL COLLECT SNEAKERS?

No . . . no, no.

Maybe collecting sneakers is a phase. When you get older, paying the mortgage or making rent might become more important. We were never collectors, but we would pick up pairs when we traveled, especially to Japan, which is the mecca of everything cool. They had sneakers we never saw in America, like Converse All Stars with this type of fake suede I had a green pair I bought in '92 that looked like I was wearing grass on my feet. They were awesome.

SO HOW DID YOU GET INVOLVED WITH THE ADIDAS SHELL TOE?

I first thought Clydes were cooler, but when Run–DMC came out, they really put Shell Toes on the map. Run–DMC were the coolest—if they wear Shell Toes, I wanna wear Shell Toes. We spent a lot of time with Run, DMC, and Jam Master Jay—this was when they did the deal with Adidas—and they were getting tons of free shit; we got their hand-me-downs. I would literally have two in-the-box pairs of Pat Ewing Adidas because Jay had fifteen pairs, and he didn't know what to do with them.

MOST PEOPLE WHO WEAR SNEAKERS, ESPECIALLY RAPPERS, ARE FIERCELY LOYAL TO A SPECIFIC BRAND. BUT YOU SEEM TO WEAR A LITTLE BIT OF EVERYTHING. DO YOU HAVE A FAVORITE?

I definitely align myself with comfiness as opposed to corporations. When I was younger a brand was important, or when we wanted to relive this "thing" through the Puma Clydes, because they reminded

us of a specific time. When you get dressed, do you dress for other people, or do you dress for yourself? I guess we were making some sort of statement by wearing Clydes.

SO WOULD YOU SAY, WHEN YOU WERE ONSTAGE OR DOING A PHOTO SHOOT, YOU WERE DRESSING FOR YOURSELF RATHER THAN OTHER PEOPLE?

Our clothes, music, or whatever was just for each other. Our lyrics were mainly meant to make the other two laugh, and Clydes were like that. I'd show up one day in a brand-new pair of sky blue Puma Clydes, and Mike would be angry and jealous. That was the whole point of our band, to make the other two guys angry and jealous.

THERE AREN'T MANY WAYS THAT STRAIGHT GUYS CAN EXPRESS THEMSELVES SARTORIALLY. MEN'S CLOTHES ARE PRETTY CONSERVATIVE; THERE'S A DRESS CODE FOR A LOT OF GUYS. NOW THAT SOME GUYS CAN WEAR SUITS AND SNEAKERS TO WORK, THIS HAS BECOME A WAY FOR A MAN TO EXPRESS HIS PERSONALITY.

Yeah, it's an interesting way to study maleness—we are taught that as straight men, wanting to be fashionable or to look "pretty" is female and therefore bad.

MAYBE WHAT MAKES IT OKAY IS THAT THE SHOES ARE TIED TO ATHLETES, MUSICIANS, OR SUCCESSFUL PEOPLE, OR SOMETIMES DANGEROUS PEOPLE.

Right! Like, I'm wearing sneakers, so I'm not soft. A lot of rappers have shoe collaborations too, which is interesting. Master P had a sneaker, Jay-Z had sneakers. Why doesn't the guy from Coldplay have a sneaker? I'm sure he wears them, but you know what I mean? Why doesn't Lenny Kravitz have a shoe? Joni Mitchell should come out with a sneaker!

IS THERE A HOLY GRAIL SNEAKER YOU WOULD LOVE TO SEE?

This goes back to childhood. Maybe that's the thing with Air Jordans—people wear them and hold on to them. They came out during a specific time in your life. You couldn't afford them back then, and now you can, so you wear them, and you wear them with pride. That's what we did. That's certainly what I did with Puma Clydes. I would want to see that pair my brother had as a kid: mustard-gold fake suede Dr. Js. For some reason, mustard-colored suede was so fucking cool.

MUSICIAN, RAPPER, AND PRODUCER ADAM "AD-ROCK" HOROVITZ IS A MEMBER OF BEASTIE BOYS, WHO WERE INDUCTED INTO THE ROCK AND ROLL HALL OF FAME IN 2012.

players, graffiti writers, b-boys and b-girls, DJs, MCs and beatboxers. The spirit was competitive and progressive . . . whether it was coming up with a new boogie move on the court or a new freeze on the linoleum, ballplayers and hip-hop heads alike were pushing the creative envelope at all times. This forward mentality affected what sneakers people wore, how they wore them, and where."[52]

The urban interest in status sneakers coincided with the increasingly larger cultural trend rampant throughout American society that suggested individual expression could be achieved through brand identification. Sneakers, in particular, offered a wide range of possibilities, as each brand, each model, each colorway allowed for nuanced expressions of individuality. The value of sneakers to the construction of male social identity appealed to many, and in short order this aspect of urban style was being commodified and was reaching a larger audience.

Professional basketball was one means by which urban culture began to seep into the imaginations of Americans across the country. The slam dunk contests, which showcased pickup acrobatics, first appeared in the ABA in 1976, with Julius Erving winning the same year that the ABA and NBA merged and allowed millions to see moves straight out of street ball. Music was another way in which urban style was popularized. Sylvia Robinson started the Sugar Hill label in 1979 and produced the first rap album with the Sugar Hill Gang, whose single "Rapper's Delight" made the Top 40 that year. In 1983, when the blockbuster movie *Flashdance* featured the b-boying Rock Steady Crew, a breaking craze swept the world and brought wide recognition of hip-hop fashion, including sneakers.

As urban style grew in popularity, sneaker fashion shifted from the brightly colored running shoes of the 1970s to the eye-catching basketball shoes of the 1980s. Nike, which had been at the forefront of the jogging craze, was now obliged to shift its focus in order to stay profitable. Nike had offered basketball shoes from the moment of the company's debut. Its first basketball shoe was the Nike Blazer, made for the NBA's Portland Trailblazers in 1972.[53] Yet unlike the Cortez, which became popular off the courts, the Blazer remained a player's shoe. The Nike low-top Bruin of the same year likewise didn't impact fashion until the 1980s. The Air Force 1 debuted in 1982, but it wouldn't be until its reissue in 1986 that it would gain cultural importance. Andrew Pollack of the *New York Times* wrote in 1985 that Nike had been "caught off guard about two years ago when fashions began changing. Running shoes gave way to more traditional leather shoes, as well as basketball, tennis, and aerobics shoes."[54] As Pollack was writing, however, Nike was debuting the Air Jordan line, which would change everything for both Nike and sneaker culture.

Left:
Cover of *Sports Illustrated* from December 3, 1973, showing the New York Nets' Julius "Dr. J" Erving (32) dunking versus the Denver Nuggets. Erving brought a thrilling street-ball style to professional basketball and was one of the first superstar basketball players whose signature sneakers would become objects of desire.

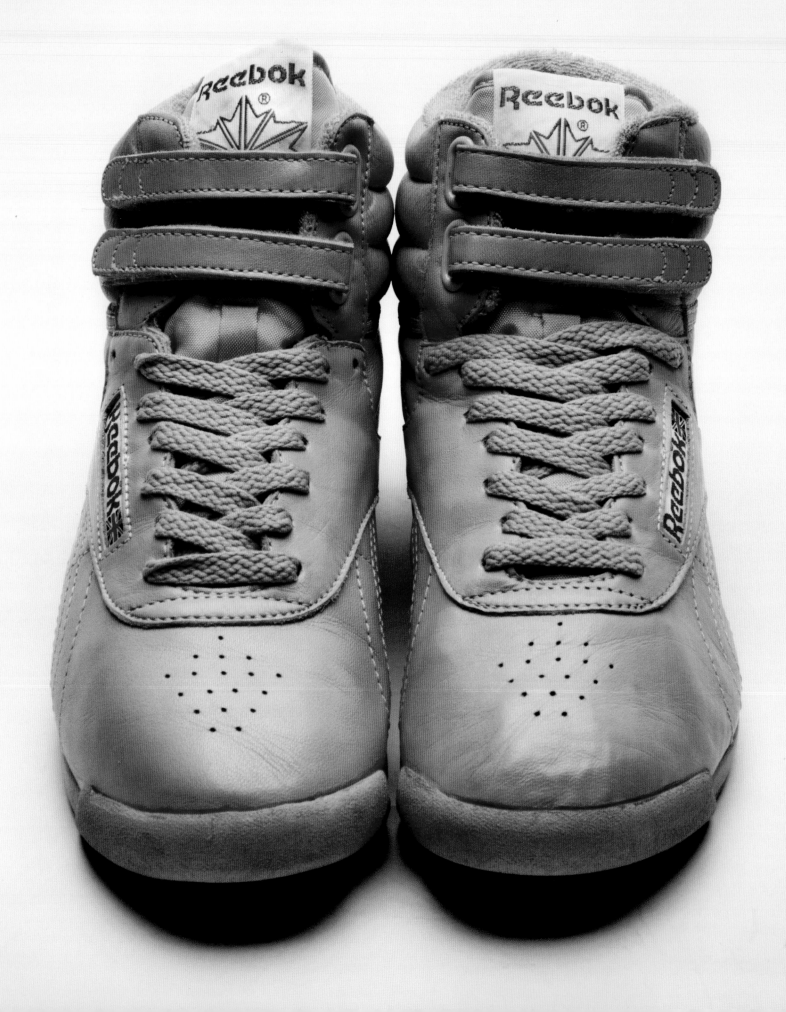

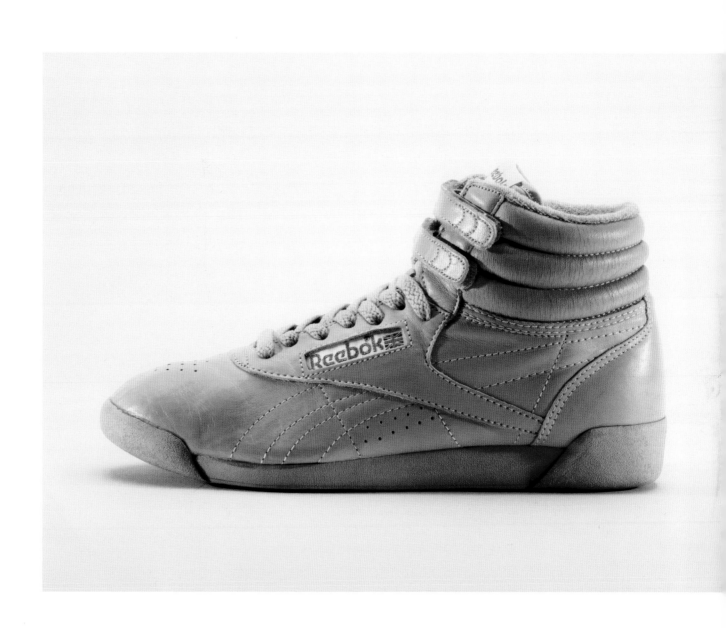

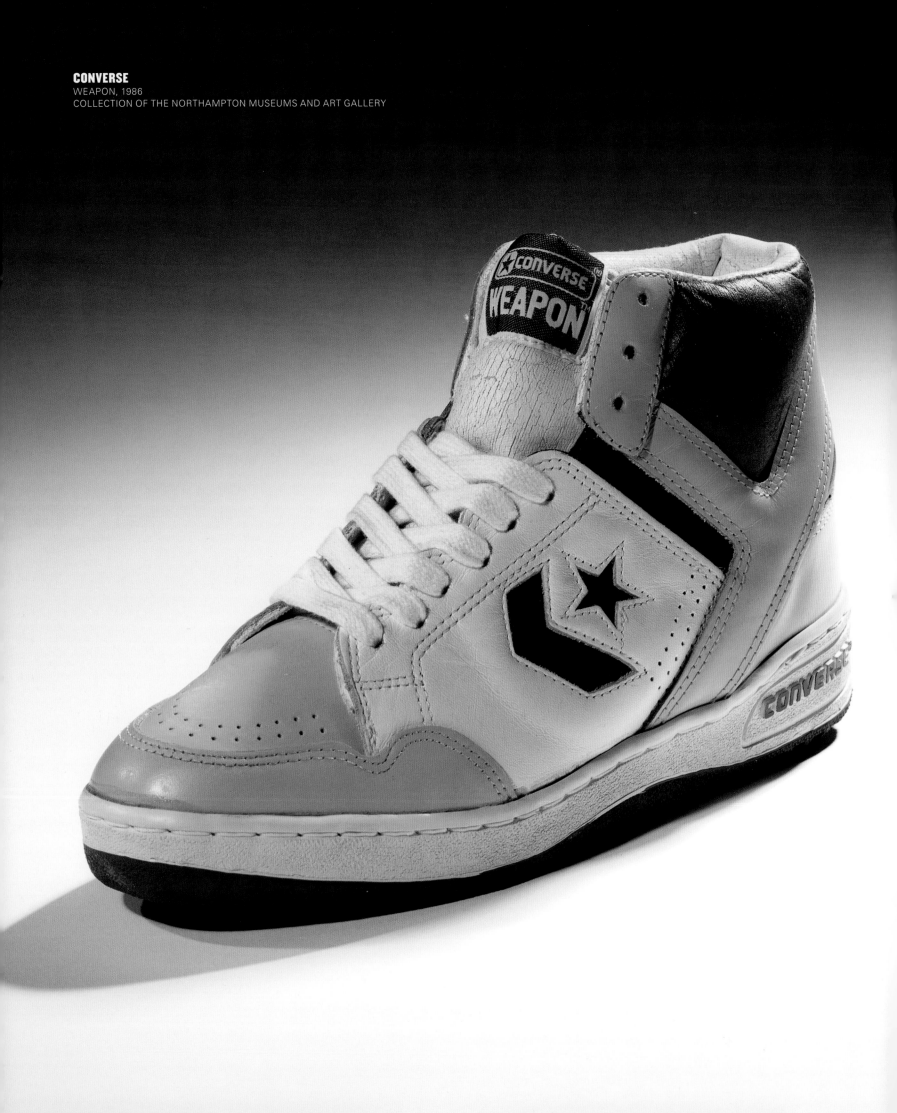

PONY
M-100, 1989 (DETAIL)
COLLECTION OF THE BATA SHOE MUSEUM, GIFT OF PONY

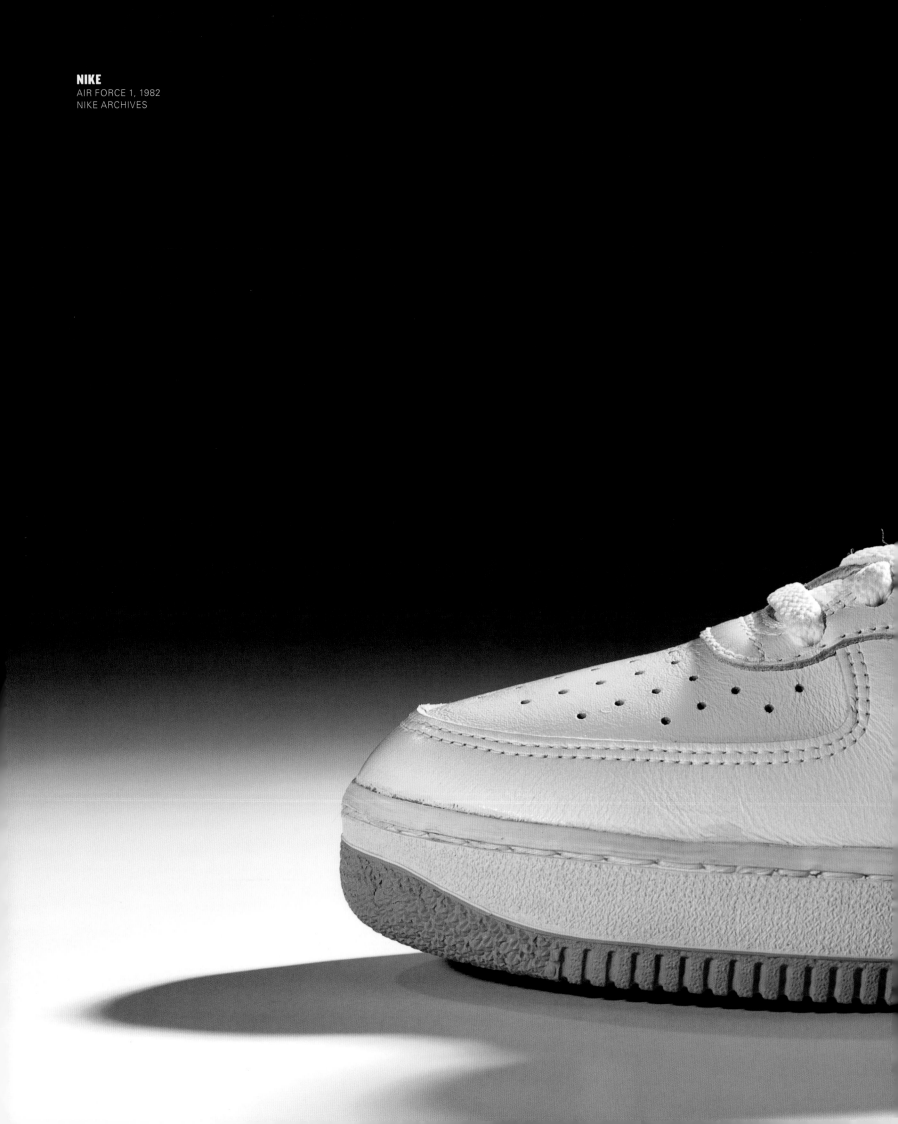

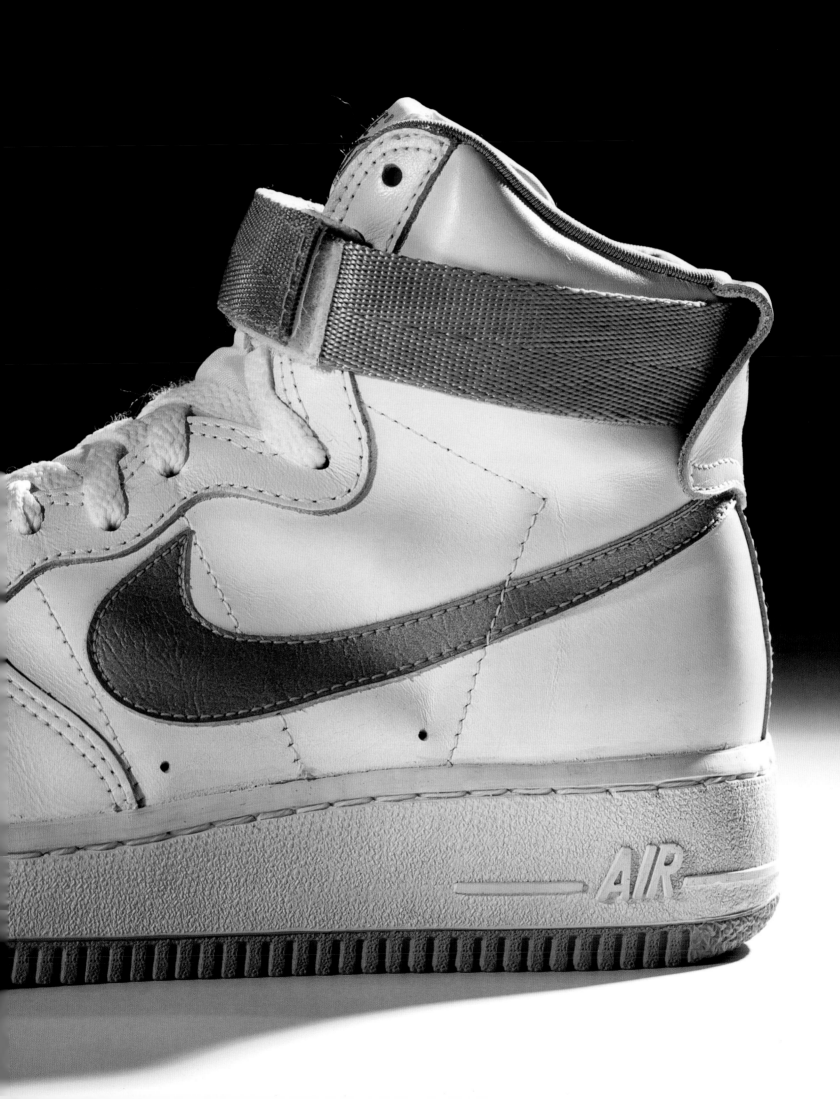

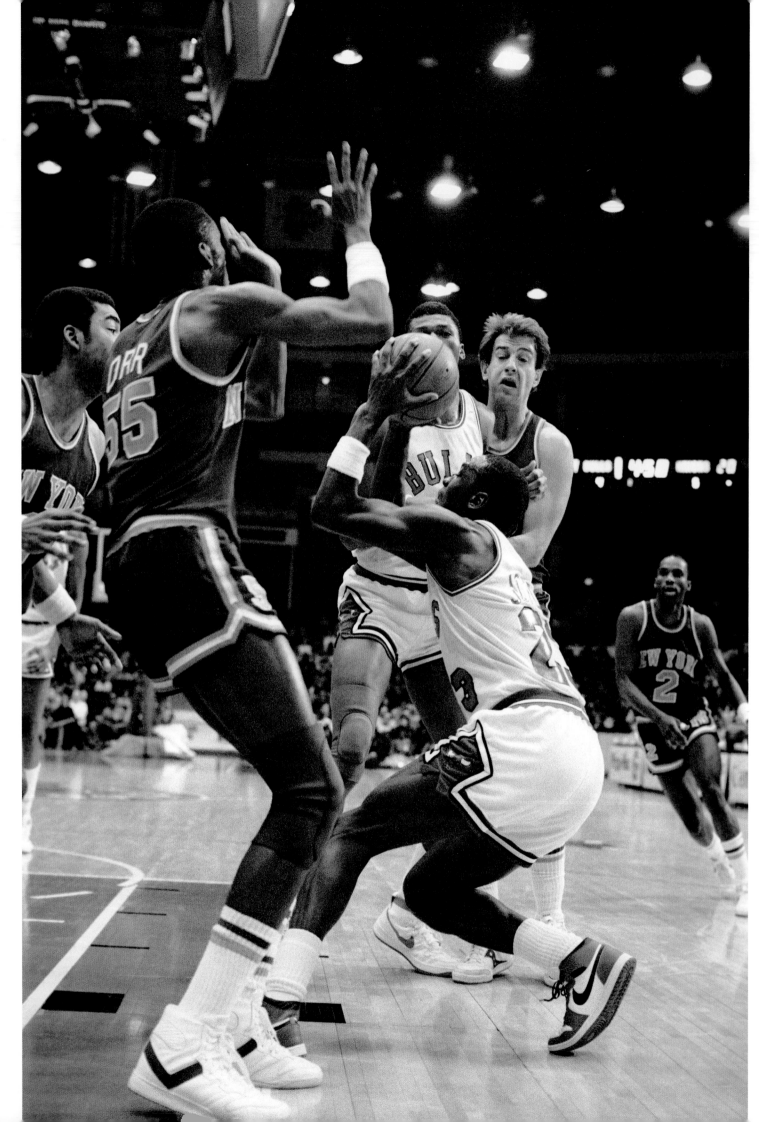

One of the most important markets that Nike missed was the emerging wo-
men's aerobic exercise market. Instead, it was Reebok that cornered it with the
introduction of the Freestyle in 1982, and by 1984 the shoe made up half of
Reeboks profits.[55] The widespread embrace of aerobics, in part driven by the
invention of the videocassette recorder, which encouraged women to exercise
at home, made the Freestyle a feature in many women's wardrobes. It also
became a commuter shoe—promoted in part by the 1980 New York City Transit
strike. In major U.S. cities, walking to work became a part of many women's daily
fitness routines, and the image of women in their "dress for success" business
suits paired with expensive white sneakers became seared in the minds of a
generation. The overwhelmingly negative appraisal of women wearing sneakers
outside of athletic pursuits belied the increased gendering of sneaker culture;
sneakers as fashion were set to become exclusively male.

"We are going back to what we know best, athletic wear with a little fashion
thrown in." declared Douglas S. Herkner, a Nike sales representative, in a *New
York Times* article pronouncing the new Air Jordan a hit.[56] Herkner had no idea
just how successful Nike's new shoe would be. In 1985, the year the first Air
Jordan dropped, Nike reported a third-quarter loss of $2.1 million, but it was
banking on the strength of a "new line of Michael Jordan signature shoes and
sporting apparel that is selling so well the company can't fill all the orders. 'They
are selling like Cabbage Patch dolls'; said Nike press spokesman Chris Van Dyek.
'We can't make enough of them, and we are only selling them to specialty sport-
ing goods stores in seven large cities.'"[57] The first Air Jordan made more than
$100 million in the first ten months, and effectively turned the company around.[58]

The first Air Jordan was designed by Peter Moore. It was a leather high-top in the
Chicago Bulls colorway of red and black and featured Nike air technology. When
Michael Jordan wore them at the start of the 1984 season and was immediately
reprimanded by the NBA, it was pure advertising gold, infusing both Jordan and
his sneakers with the aura of rebellion. As a Nike commercial put it, "On October
15, Nike created a revolutionary new basketball shoe. On October 18, the NBA
threw them out of the game. Fortunately, the NBA can't keep you from wearing
them."[59] The problem that the NBA had with the new Air Jordan was that it flew
in the face of its "uniformity of uniforms rule." Since the Jordans were red and
black but lacked white, the third color in the Bulls uniform, they didn't conform
to the rule that the entire team had to be similarly clad. The most common
way players were allowed to display their endorsement company's logo was to
wear white basketball shoes with the brands of their sneakers in a contrasting
team-uniform color; a formula that Jordan's highly individualized red-and-black
sneakers defied. Despite the uniformity of uniforms rule, Jordan continued to
wear his Air Jordans, and each time he played, he was fined. Nike couldn't get
cheaper advertising and happily paid for each infringement. Jordan was gifted,
hardworking, skilled, and daring, and his antiestablishment flouting of the rules
reverberated with the valorization of individualism in American culture and
broadened his appeal.

D'WAYNE EDWARDS

In 1975, at the age of six, in Inglewood, CA, I was introduced to rubber, metal, wood, and graphite, aka a No. 2 pencil. Little did I know at eleven years old, after I drew my first sneaker, that this instrument would design my life. Back then there was no Google, but I was in search of any *SneakerNews* so I could learn more about my new passion, or what people felt was an *Obsessive Sneaker Disorder*.

All through middle school, I was drawing sneakers on 3x5-inch index cards instead of doing of my schoolwork, and once I got into high school, I elevated my *Sneaker Game*:

- I would buy white/white AF1s and use duct tape and leather shoe dye to customize my sneakers. Other students were jock'n to the point they started paying me to customize their sneakers. I was Nike iD back in '86.

- Converse introduced the Weapons in '86 and I had to have them. My high school colors were green and white. The Bird version matched perfectly, BUT being a Laker fan I was rock'n Magic's Purple, Gold, and White's with my green-and-white uniform.

- The Lakers practiced at my high school back in the day, so I would always get certain players PEs (Player Editions). I would stuff them with two extra insoles and rock them at school even thought they were two or three sizes too big for me.

I was determined to have *NiceKicks* because, with no car, this was my mode of transportation.

Determined more than ever to go to college to study *Kicksology*, instead of biology, my dreams were crushed when I learned there were no schools that taught footwear design. Giving up on my dreams, I continued to work at McDonald's until I entered and won a design competition sponsored by Reebok. But my excitement was short-lived because I was only seventeen, and Reebok was looking for someone with a college degree. This experience made me even more determined, and I promised myself I would make Reebok regret passing on me.

After graduating from high school, I landed a temp job filing papers at a footwear company called LA Gear. To me, this was a dream come true, because finally someone would be able to see my talent. Within six months the president of the company, Robert Greenberg, hired me as an entry-level designer at the age of nineteen. I went on to have a successful twenty-six-year career designing shoes for more than thirty athletes, such as Derek Fisher, Dominique Wilkins, Derek Jeter, Roy Jones Jr., Carmelo Anthony, and Michael Jordan. I was able to work my way up from being a file clerk to the role of Footwear Design Director for JORDAN.

I had an amazing career, but I feel it was all a blessing so I could bless others. I knew there were more sneakerheads out there—like me when I was kid—who wanted to be footwear designers, and there was still no way for them to learn *Kicksology*. So I walked away from my JORDAN job to start my own school, called PENSOLE.

While designing, I was often inspired by Nelson Mandela's quote, "It always seems impossible until it's done." And I felt this way while designing PENSOLE itself, because a poor black kid from Inglewood who never attended design school had no business creating a school of his own. I defied the odds before and I was determined to do it again, simply because I wanted to leave the sneaker industry better than when I entered it.

PENSOLE has challenged the industry to look at education in a new way.

PENSOLE was created to give students a voice and a platform to feed their *Obsessive Sneaker Disorder*.

PENSOLE is a *KicksGuide* to help to discover, develop, and create a pipeline of talent that we have never had before.

PENSOLE has planted more than 100 alumni, aka *seeds*, throughout the industry at companies such as Adidas, Vans, Nike, Converse, Reebok, Puma, DC, Brooks, Asics, New Balance, Under Armour, and JORDAN, which will further elevate the culture and help the industry grow.

PENSOLE wants to provide sneaker lovers another way to contribute to sneaker culture besides just being consumers who think they have to run, jump, and dunk to have their own sneakers.

PENSOLE will create the new design legends; we want to establish new brands and create new legacies.

Rubber, metal, wood, graphite, cotton, and leather . . . THANK YOU!!!!

PENSOLE FOOTWEAR DESIGN ACADEMY FOUNDER D'WAYNE EDWARDS WAS FOOTWEAR DESIGN DIRECTOR AT JORDAN BRAND FOR NEARLY 10 YEARS AND IS ONE OF 8 PEOPLE TO EVER DESIGN AN AIR JORDAN (XX1 AND XX2).

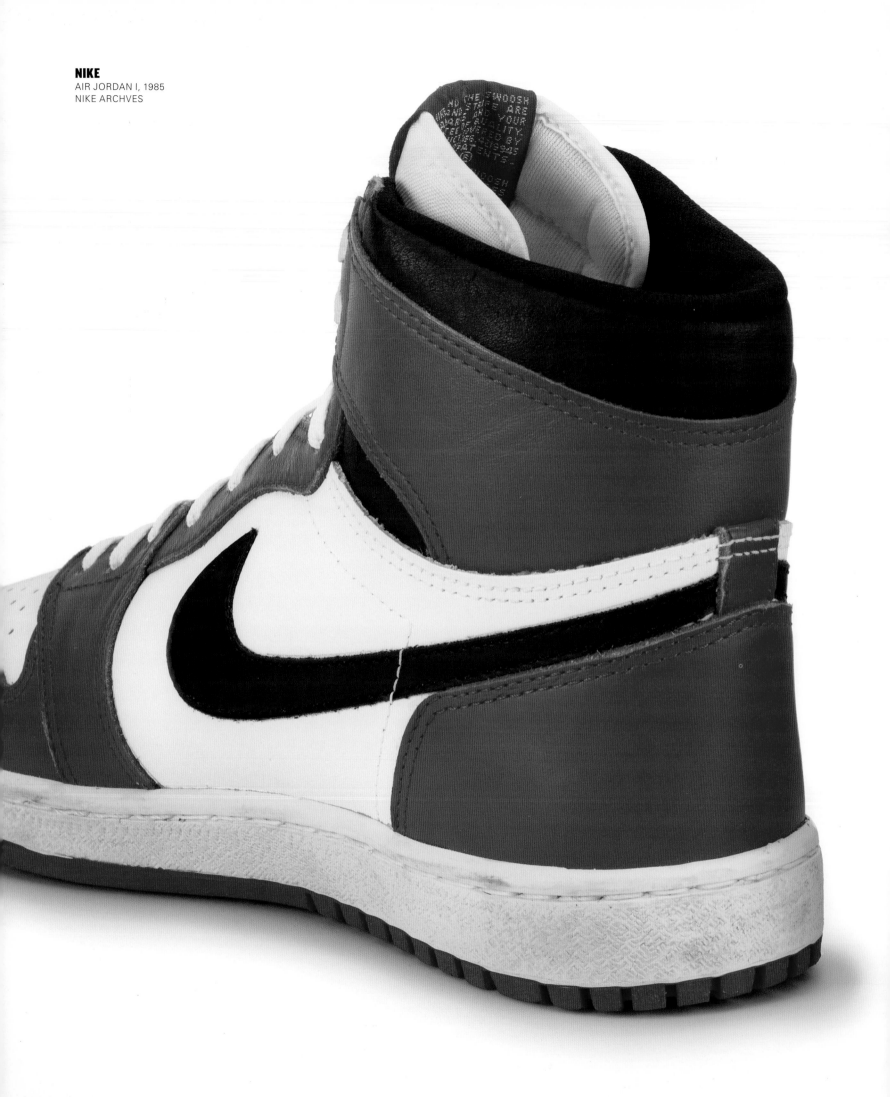

NIKE
AIR JORDAN II, 1987
KOSOW SNEAKER MUSEUM
(ELECTRIC PURPLE CHAMELEON, LLC)

NIKE
AIR JORDAN III, 1988
KOSOW SNEAKER MUSEUM
(ELECTRIC PURPLE CHAMELEON, LLC)

122

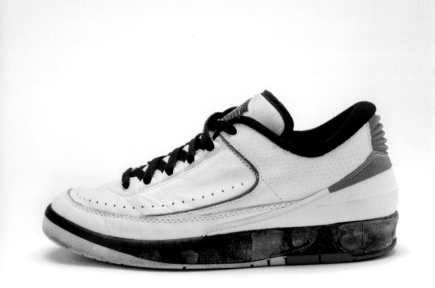

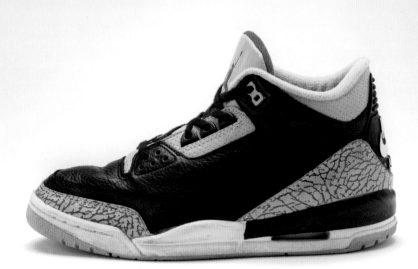

NIKE
AIR JORDAN II, 1987
KOSOW SNEAKER MUSEUM
(ELECTRIC PURPLE CHAMELEON, LLC)

NIKE
AIR JORDAN III, 1988
KOSOW SNEAKER MUSEUM
(ELECTRIC PURPLE CHAMELEON, LLC)

NIKE
AIR JORDAN IV, 1989
KOSOW SNEAKER MUSEUM
(ELECTRIC PURPLE CHAMELEON, LLC)

NIKE
AIR JORDAN V, 1990
KOSOW SNEAKER MUSEUM
(ELECTRIC PURPLE CHAMELEON, LLC)

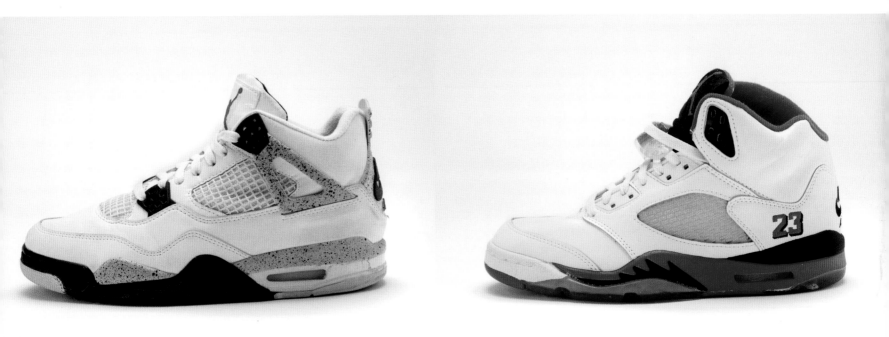

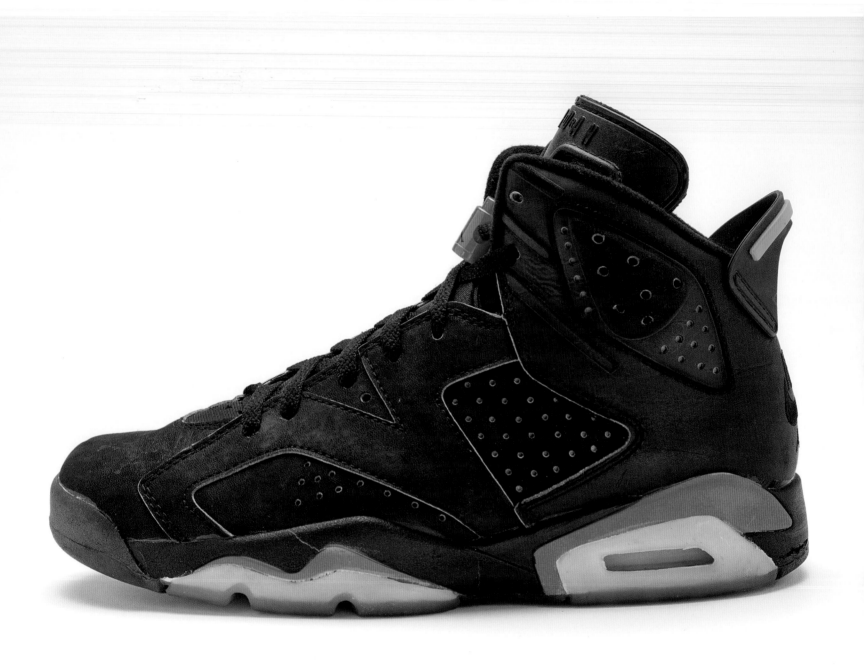

NIKE
AIR JORDAN VII, 1992
KOSOW SNEAKER MUSEUM
(ELECTRIC PURPLE CHAMELEON, LLC)

NIKE
AIR JORDAN VIII, 1993
KOSOW SNEAKER MUSEUM
(ELECTRIC PURPLE CHAMELEON, LLC)

NIKE
AIR JORDAN IX, 1994
KOSOW SNEAKER MUSEUM
(ELECTRIC PURPLE CHAMELEON, LLC)

NIKE
AIR JORDAN X, 1995
KOSOW SNEAKER MUSEUM
(ELECTRIC PURPLE CHAMELEON, LLC)

NIKE
AIR JORDAN XI, 1996
NIKE ARCHIVES

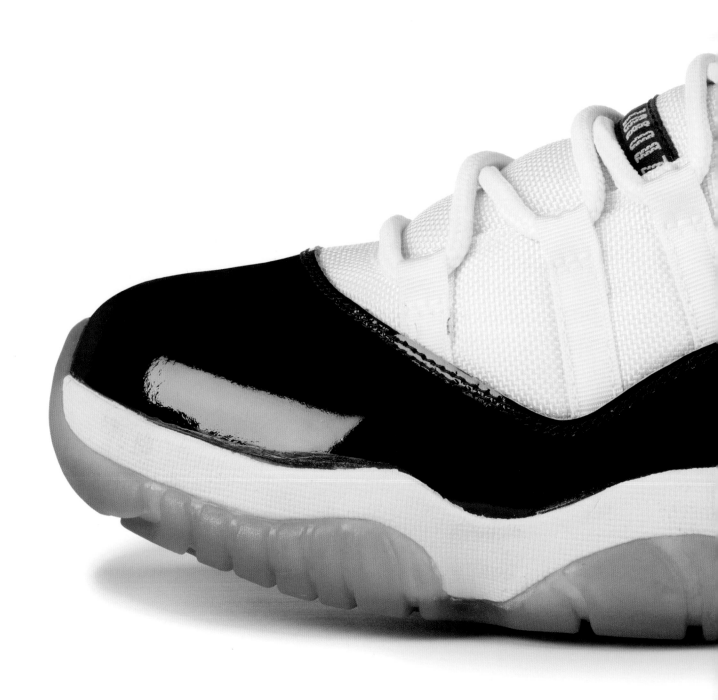

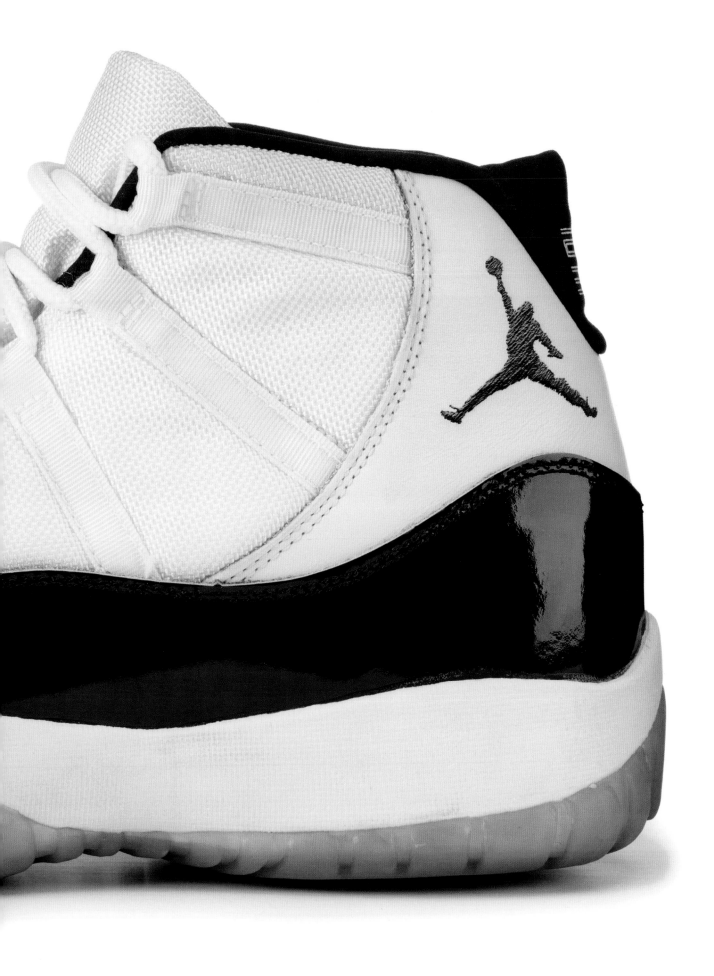

NIKE
AIR JORDAN XI, 2000 RETRO OF 1995 (DETAIL)
KOSOW SNEAKER MUSEUM
(ELECTRIC PURPLE CHAMELEON, LLC)

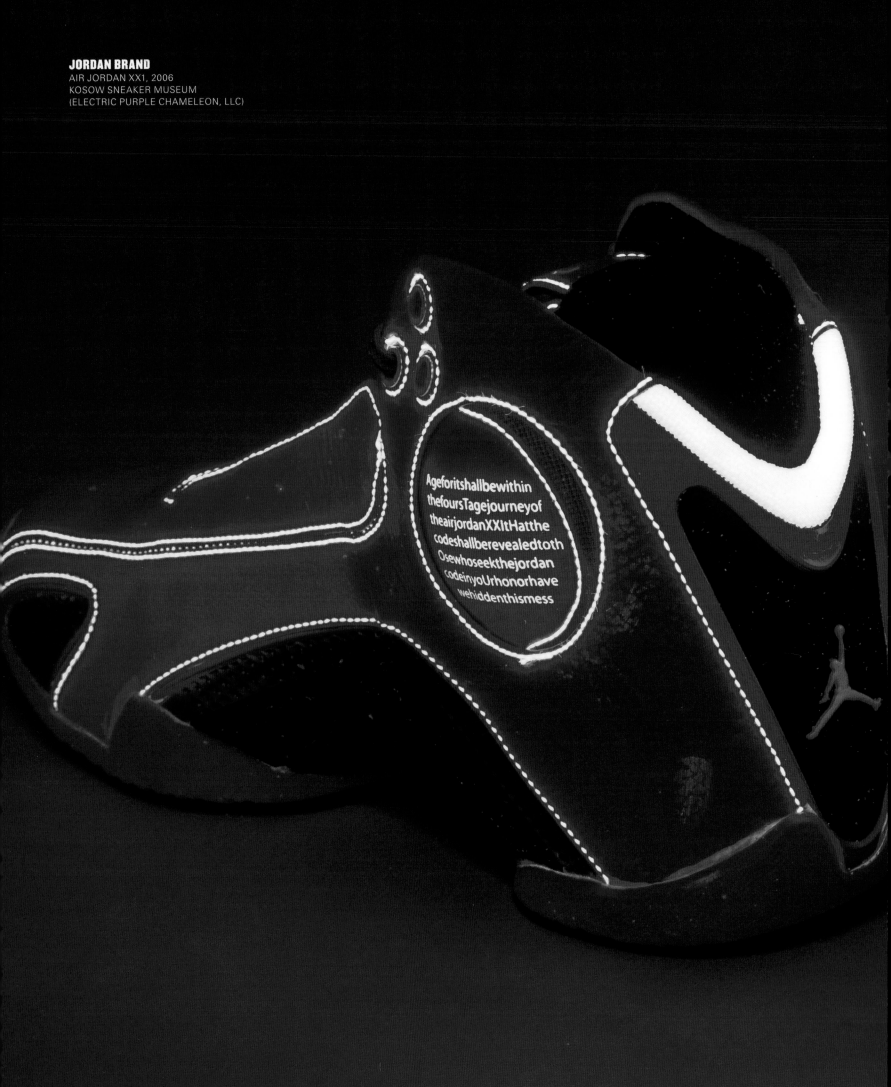

JORDAN BRAND
AIR JORDAN XX1, 2006
KOSOW SNEAKER MUSEUM
(ELECTRIC PURPLE CHAMELEON, LLC)

Ageforitshallbewithin
thefoursTagejourneyof
theairjordanXXItHatthe
codeshallberevealedtoth
Osewhoseekthejordan
codeinyoUrhonorhave
wehiddenthismess

Ageforitshallbewithin
thefoursTagejourneyof
theairjordanXXItHatthe
codeshallberevealedtoth
Osewhoseekthejordan
codeinyoUrhonorhave
wehiddenthismess

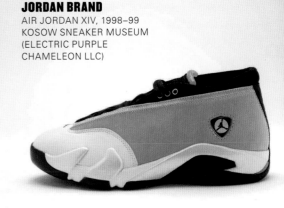

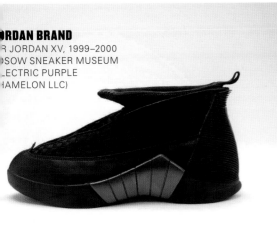

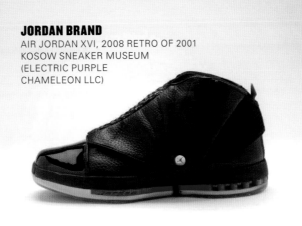

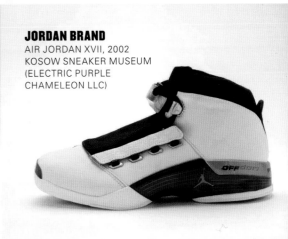

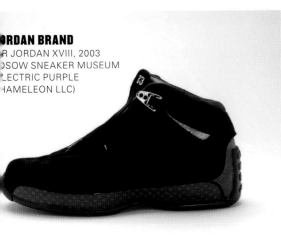

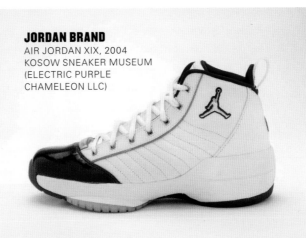

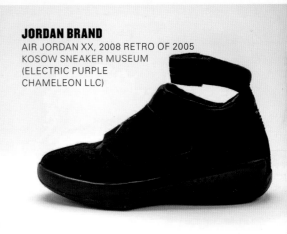

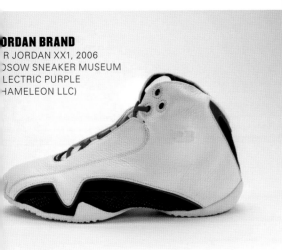

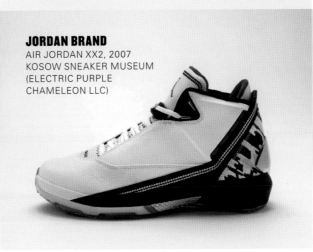

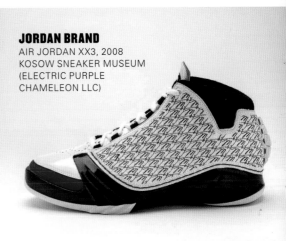

DARRYL "DMC" MCDANIELS

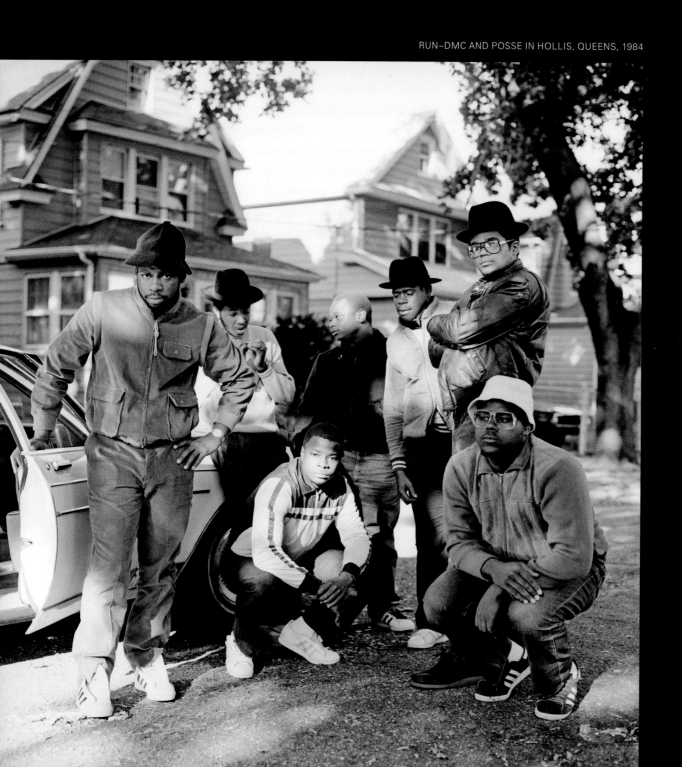

RUN–DMC AND POSSE IN HOLLIS, QUEENS, 1984

In 1986, when I sat down to write my verse for "My Adidas," I didn't want to do just another song bragging about how many pairs of sneakers I had or about how fly I was. Within our hip-hop culture, a fresh pair of sneakers made a powerful statement. It was a way of saying, "I am somebody! I am kool, I am all that and then some, and the world had better take notice!" Prior to this, sneakers were just associated with athletics, or, to many of our parents, they were the things we had to put on before we went outside to play so we wouldn't mess our Sunday school shoes up.

But hip-hop changed all that. With hip-hop, our sneakers became status symbols. In our minds, fresh sneakers were better than the finest jewelry and the finest cars! And getting a new fresh pair of sneakers was not easy, especially getting a brand-new pair of leather or suede sneakers. Most of us were getting the affordable canvas sneakers of the day, the Pro Keds or the canvas Converse, better known as Chucks. Growing up, my brother and I were pro–Pro-Keds kids, although twice in my life I did wear light-blue Chucks. Those light-blue sneakers were sooooo fly with my light-blue jacket! And I had a pair of standard black Converse sneakers. But when hip-hop became the dominant force in life within our communities, it totally raised the bar on style, and the Pumas and Adidas became the objects of our desires!

It was a little easier to save your allowance and get one or two pairs of canvas sneakers, but to stay freshly dipped in some leather or suede sneakers in every color to match your outfits was very difficult! To get a new pair of canvas sneakers when they wore out, all you had to do was plead with your mom or pop, or save your allowance for two to three weeks. But to get your hardworking parents to pay $40 to $50 for some leather or suede sneakers . . . that was kind of insane! Not to us, it was normal for us, but to our parents it was just plain stupid. Why would you pay all that money for some basketball shoes or, as some of our older folks called 'em, "trainers"?

They don't understand! It's a hip-hop thang!!!!

Anyway, my choice for the dopest pair of kicks is the shell-toe Superstar Adidas. One of the main reasons is that if you take care of 'em, don't wear 'em out on the ball court, and keep 'em toothbrushed clean . . . they can last forever and you won't have to sell your soul or make yourself look like a fool crying to your mom and dad for the sneakers you just have to have.

So when I was writing my verse, I felt I had to be responsible to my hip-hop culture and do it some honor by addressing the stereotypical image that had begun to be associated with "those kids with the fresh kicks."

The first thing someone would do when they got some loot was go purchase some brand-new sneakers.

Some of us saved our allowances, some of us just waited 'til birthdays or Christmas, some of us worked summer jobs, some of us worked two jobs to stay four and five pairs deep and . . . some of us robbed houses, did stickups, and sold drugs, which kept every color of new sneakers and new clothes on our bodies. All the social problems that affected our communities could not be fixed, even though politicians promised us if they were elected there would be change for the better. That didn't begin to happen 'til we created hip-hop, but that's another essay for another day. To make a long story short, many of our politicians, so-called community leaders, and influential people needed a scapegoat, so "the kids on the corners with the brand-new sneakers" became the ones blamed for causing all the problems with crime, gangs, and drugs in the neighborhoods.

I took that personally! Yes, we hung out on the corners, in front of the game room, the deli, and the candy store, but not all of us were doing sneaky things to get our new sneakers. So I wanted to make a new image to be associated with the statement that these fresh new kicks could be associated with. My sneakers walk the halls of an educational institution, I made it to St. Johns University, because hip-hop was taking me places I never thought I would go, and enabling me to do things I could never imagine. I had stepped onstage at Live Aid and played with the legendary, iconic rock-and-roll gods! So I thought this was something that should be known. In addition to the fact these sneakers represent something positive, these Adidas are the best out of ALL THE SNEAKERS FOR ETERNITY!

I don't play basketball, I don't do crimes, but it's not just about the flyness of the sneaker itself . . . it's about the flyness positivity power and potential of the person in the sneakers. The song I did about my Adidas is bigger than me, it's bigger than the sneaker business. It's about people who represent a culture that doesn't only look good but people who go out of our way every day to do good!

DARRYL "DMC" MCDANIELS IS 1/3 OF THE PIONEERING GROUP RUN-DMC, THE FIRST HIP-HOP ARTISTS TO BE NOMINATED FOR A GRAMMY, HAVE A MULTIPLATINUM ALBUM, AND APPEAR ON THE COVER OF *ROLLING STONE*.

Air Jordans may have attracted the attention of young men across America, but it was another Nike shoe, the Air Force 1, that would come to define urban street culture. Named after the presidential plane, the style first debuted in 1982 but was discontinued after only one year. When it was reintroduced in 1986 in the white-on-white colorway, the Air Force 1 quickly gained popularity and was touted as the sneaker of choice for drug dealers, whose ability to wear unscuffed sneakers signified both wealth and status. In Rick Telander's article for *Sports Illustrated* in 1990, which was part of a brewing controversy around sneakers and racism, he wrote that "certain young drug dealers feverishly load up on the latest models of sneakers, tossing out any old ones that are scuffed or even slightly worn and replacing them with new pairs. . . . [quoting Wally Grigo] 'There are stores doing $5,000 to $10,000 a week in drug money, all over. Drug money is part of the economic landscape these days. Even if the companies don't consciously go after the money, they're still getting it. Hey, all inner-city kids aren't drug dealers. Most of them are good, honest kids. Drug dealers are a very small percent. But the drug dealers, man, they set the fashion trends.'"[60]

The line—that drug dealers set fashion trends—spoke to a wide variety of people. Within the media, the drug dealer was positioned as both hero and villain, someone who pulled himself up by his sneaker laces, managed to live large in the face of crippling inequality in the urban wasteland, and was successfully living

Left:
Run–DMC's rap "My Adidas" reflected the importance of Adidas in street fashion and helped to reinvigorate the brand, bringing widespread focus on the company. This image was taken at a RUN–DMC concert showing the crowd holding up their Adidas in response to a request from the group during the performance.

Opposite Page:
Run–DMC members Run, DMC, and Jam Master Jay.

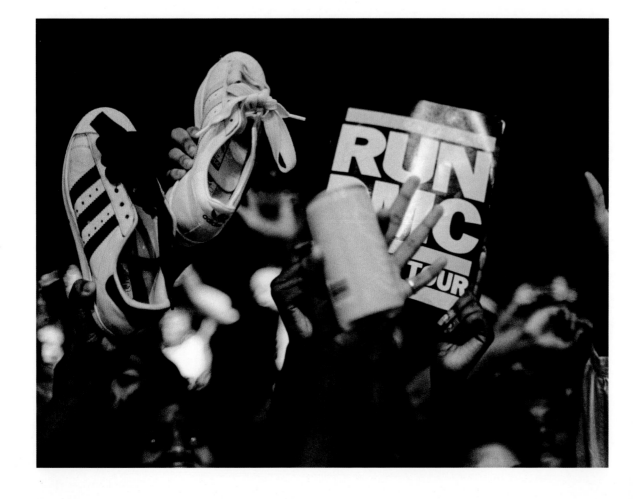

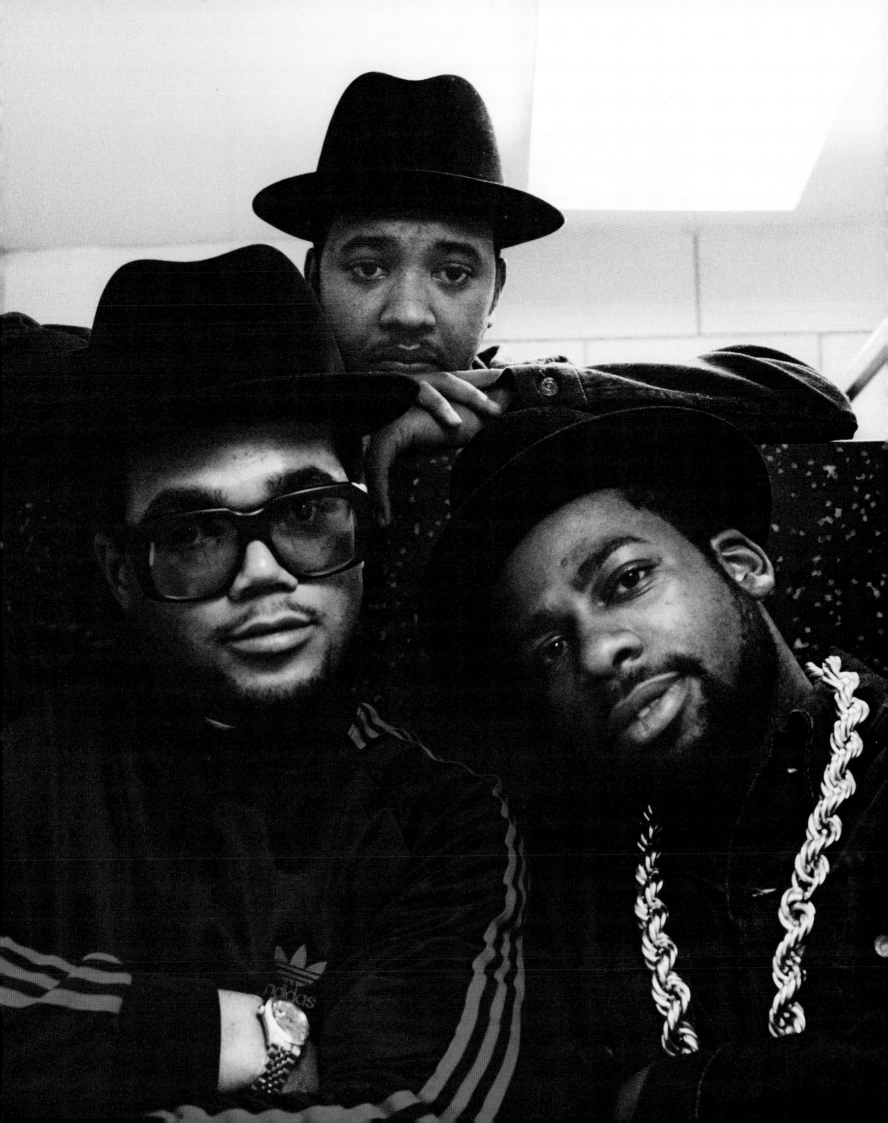

ADIDAS X RUN–DMC
25TH-ANNIVERSARY SUPERSTAR, 2011
COURTESY RUN–DMC, COLLECTION OF ERIK BLAM

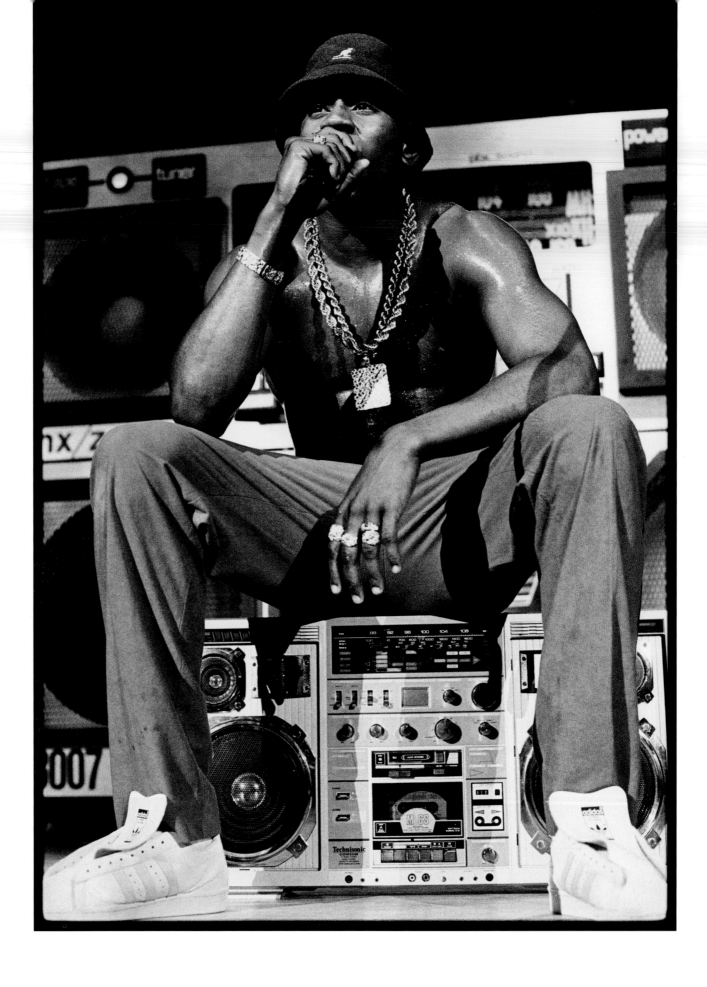

a version of the American dream complete with conspicuous consumption and unrestrained luxury. However, he was also the symbol of moral degeneracy who lacked the ability to control his desires and temper and who perpetrated violence that was both feared and glamorized. Like the complicated icon of the cowboy, the drug dealer was also a symbol of rugged individualism whose fashion was hypermasculine and easily marketed to many, in ways that capitalized on both its American-ness and its exoticism simultaneously.

As concerns about the inability of young black men to control their desires for sneakers and their increased criminality in relation to sneaker culture were escalating, the rap group Run–DMC came out with their song "My Adidas," about the ubiquitous Adidas Superstar that had become a staple of street fashion in the mid-1980s. The song offered a counterpoint to all the negative hype surrounding inner-city sneaker culture. Run–DMC all wore their Superstars without shoelaces, a fashion promoted as having started in prison, where prisoners were relieved of their laces so that they could not be used to harm others or themselves, but as their song declared, "My Adidas only bring good news and are not used as felon shoes." The rap also stated that although they wore their Adidas with "no shoestrings in 'em," they purchased their sneakers, had gone to university, and wore their Superstars to promote goodwill. It has been suggested that the song was written, in part, to counter the rap created by the social activist Dr. Gerald Deas called "Felon Shoes," in which the doctor linked lace-less sneakers with degeneracy and advises young black men to tighten up their laces and "put a goal in your mind, put your nose to that grindstone and success in life, you will find."

With their song already popular, the group decided to make a bold business move. Their astute manager, Russell Simmons, Run's brother, suggested that they send a tape to Adidas and ask for a million dollars. Adidas responded by sending executives to Run–DMC's Madison Square Garden performance in 1986. When the group started to perform "My Adidas," DMC stopped and asked everyone in the audience to take off their Adidas and wave them in the air. Enlightened by the market share represented by hip-hop, Adidas inked a deal with Run–DMC for the amount they had asked, and the band became the first in a long line of performers to have a sneaker endorsement. This arrangement, and the numerous deals with musicians that followed, helped to bring urban music, fashion, and most specifically sneaker culture to a much wider audience. The resulting popularization of urban fashion, however, put greater pressure on those seeking to proclaim their individuality through the consumption of unique shoes, which led some to hunt for rare, vintage footwear and encouraged the entrance of more sneaker companies into the fray.

BRITISH KNIGHTS
KING, 1985
COLLECTION OF THE NORTHAMPTON MUSEUMS AND ART GALLERY

KangaROOS came on the market at the start of the 1980s and featured a Velcro-covered zip pocket that was designed to hold a stash of cash or other small necessities. Caught between being a lifestyle brand and a performance athletic company, the original company lasted only until the late 1980s. British Knights first entered the sneaker market in 1983 with a conservative canvas shoe, but by the mid-1980s the company began to focus on the urban consumer with the ultimate aim of reaching the suburban crowd. This shift was made clear in a press release stating that "the only way to get a middle-class suburban high school kid to buy your product is to have an inner-city kid wear it," and as part of its attempt to reach a larger market, it launched the slogan "Your mother wears Nike."[61] The brand Troop's Street Force emerged in 1985. Numerous rappers, including LL Cool J, Chuck D, and Flava Flav, wore Troop, but the brand was plagued by baseless rumors and folded in 1989.

By the second half of the 1980s, rap was beginning to turn away from the polit-ical and positive to the more aggressive gangster rap. Urban fashion reflect-ed these shifts, and luxury brands that connoted the high life and signified ostentatious consumption became increasingly important. Schoolly D, considered by many to be the first gangster rapper, may have been referring to his watch when he rapped, "Looking at my Gucci, it's about that time," but he could have been rapping about a pair of Gucci sneakers. Gucci was one of the first luxury brands to enter the sneaker game on the wave of preppy fashion, and its visibly branded tennis sneakers insinuated country club exclusivity while simultaneously brashly promoting its pedigree. Another Italian company, Fila, also produced highly sought-after shoes that melded Italian luxury with performance.

Beyond the sneaker's connection to urban culture, the widespread integration of the sneaker into fashionable wardrobes was encouraged by social phenomena of the 1980s and 1990s. The stock-market crash on Black Monday, October 19, 1987, brought an end to confidence in the prosperity of the 1980s. Corporate downsizing and increased instability in the workplace marked the rest of the decade. The advent of the dot.com boom in the early 1990s ushered in new economic possibilities but also introduced a new model of masculine success: the "wonder boy" who challenged traditional signifiers of masculinity. The dress of childhood became the new mark of male success. Specifically, the sartorial style of Silicon Valley, informed by West Coast grunge and skater culture, set the trend. Rumpled jeans and striped tees à la the Muppets' Bert and Ernie paired with low-top Chucks became the uniform of tech millionaires and skate punks alike, and stood in stark contrast to the essentialized black athlete, or rap star simultaneously admired and feared for their physicality.

The West Coast skateboarder look had been evolving since the 1960s, and the low-cut skippy—a California icon of beach life—morphed into the skate-

Opposite Page:
Tony Hawk in action at Del Mar Skate Ranch, California, October 30, 1986.

VANS
CHECKERBOARD SLIP-ON, 2014 RETRO OF 1980S
COLLECTION OF THE BATA SHOE MUSEUM, GIFT OF VANS

MISTER CARTOON

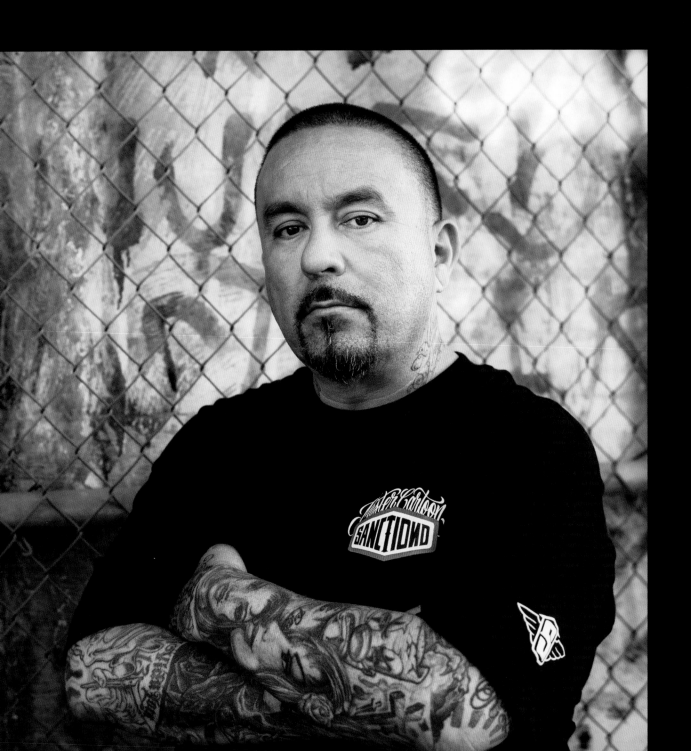

- On the West Coast we grew up wearing Nike Cortez, Chuck Taylors, slip-on Vans, and classic K-Swiss. Back in the year 2000, I started to notice West Coast kids collecting retro shoes like Air Force Ones and Jordans; now that the Internet is here it will never be the same.

- On the West Coast our ride is a '64 on Dayton's with switches; on the East Coast their ride is a retro 3.

- See, out on the West Coast, youngsters had "whips." I've got a '64 Impala on switches—that was my whip! Their whips on the East Coast are their shoes, because they're living in the Bronx and they ain't got no Impalas. Their shoe game would be so ridiculous, because that's where all their money went to. They were beyond us. They would know how to dress in the winter. Homies from LA don't know how to dress in the winter. So we learned as time went on. We borrowed from them like they borrowed from us—like them rocking white tees. We invented that. You go to the Bronx and there'll be a kid with a shaved head, tattoos, white tee, and Chucks. You go to LA and there'll be a kid with his hair ceaser'd, some fresh Js on, and a Polo.

- They have no idea how serious you shoe game is—your shoes reflect your personality, your cleanliness, and your net worth. If a female sees a pair of crispy Js on you, that lets her know you're focused.

- One of my passions in life is designing. When I think of designing a shoe, I think of something that's classic, something that doesn't play out, that has that hand-done edge to it, no funky colors—I stick to that industrial strength look.

THE ARTIST MISTER CARTOON IS SYNONYMOUS WITH THE STREET AND YOUTH CULTURE OF LOS ANGELES AND SPECIALIZES IN LINKING THE TWO WITH ICONIC BRANDS.

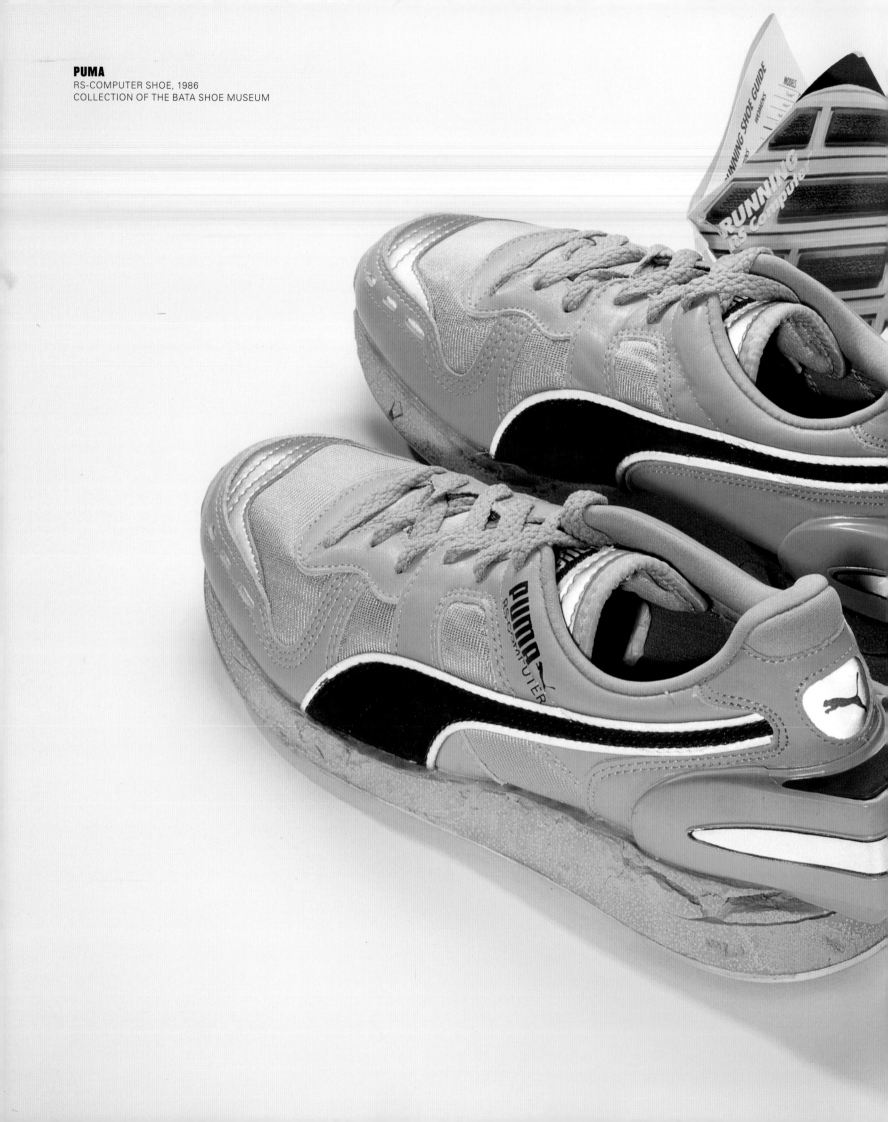

PUMA
RS-COMPUTER SHOE, 1986
COLLECTION OF THE BATA SHOE MUSEUM

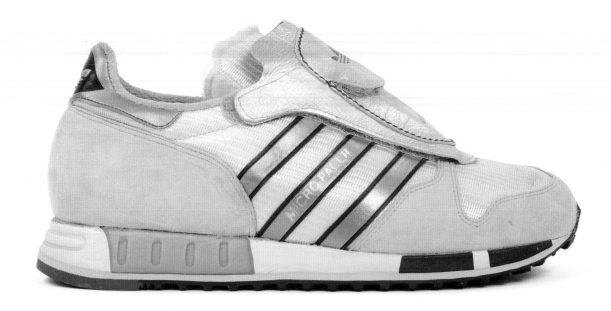

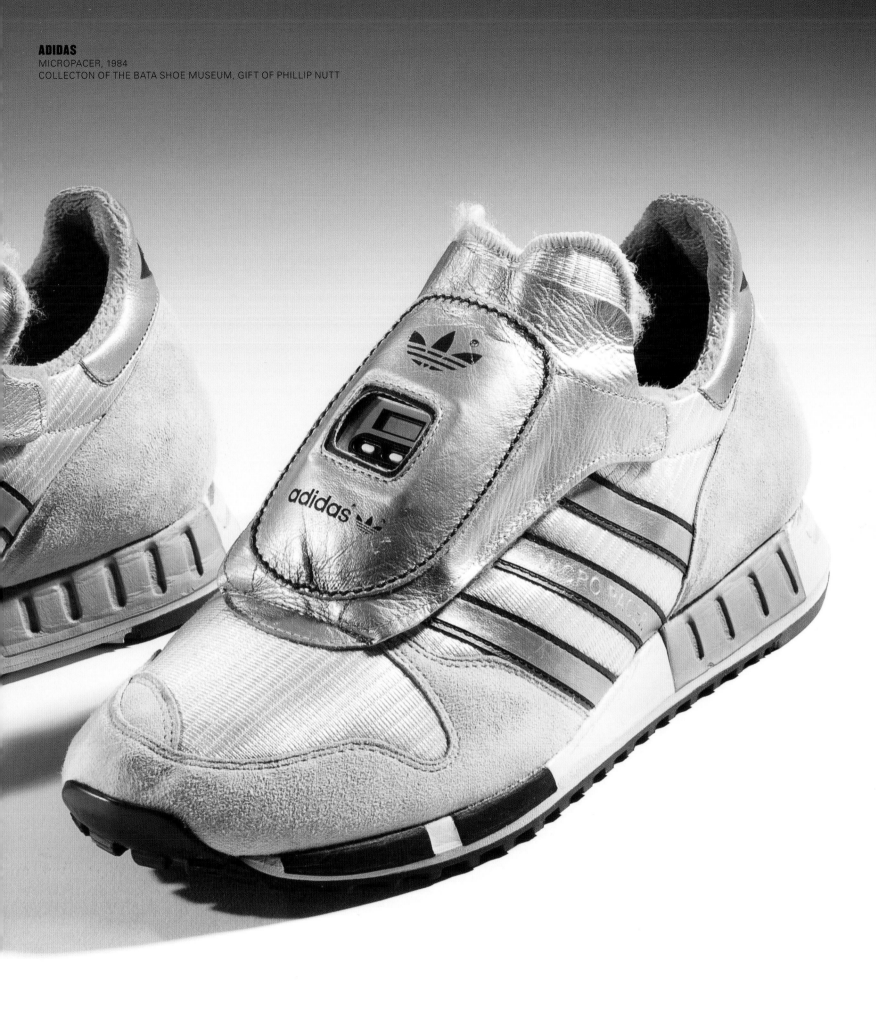

PAUL LITCHFIELD

In 1988, I was given the challenge by Reebok founder Paul Fireman to create a new standard in performance basketball shoes. We set out to create a shoe with the best fit and support possible. Through an intense effort, we were able to do just that. By our using inflation technology, the Reebok Pump established a benchmark in the industry for customization in fit and support that still exists today. However, it was through the coordinated efforts of Reebok marketing, advertising, and athlete endorsements that the product became larger than life.

The experience of developing the Pump also helped to establish a template for how we approach the entire product creation process. Only through the integration of resources, including teams of subject-matter experts in design and development, manufacturing, and material sciences, internal and external to Reebok, was this breakthrough product made possible. With a diverse team such as this, it is paramount to maintain a clear vision of the product objective, yet it is also imperative to allow each group to fully contribute its portion, eventually finding a balance that results in a product that lives up to the performance features needed for the athlete. The Reebok Pump delivered on that extraordinary challenge in customization in fit and support. This process continues to be the standard today. I have been very fortunate to have led this team in the creation of the Reebok Pump. It is flattering to be part of this product legacy that is still relevant today.

WITH A BACKGROUND IN MUSCLE BIOCHEMISTRY, PAUL LITCHFIELD IS THE VICE PRESIDENT OF ADVANCED CONCEPTS AT REEBOK AND THE PROGENITOR OF THE ICONIC REEBOK PUMP.

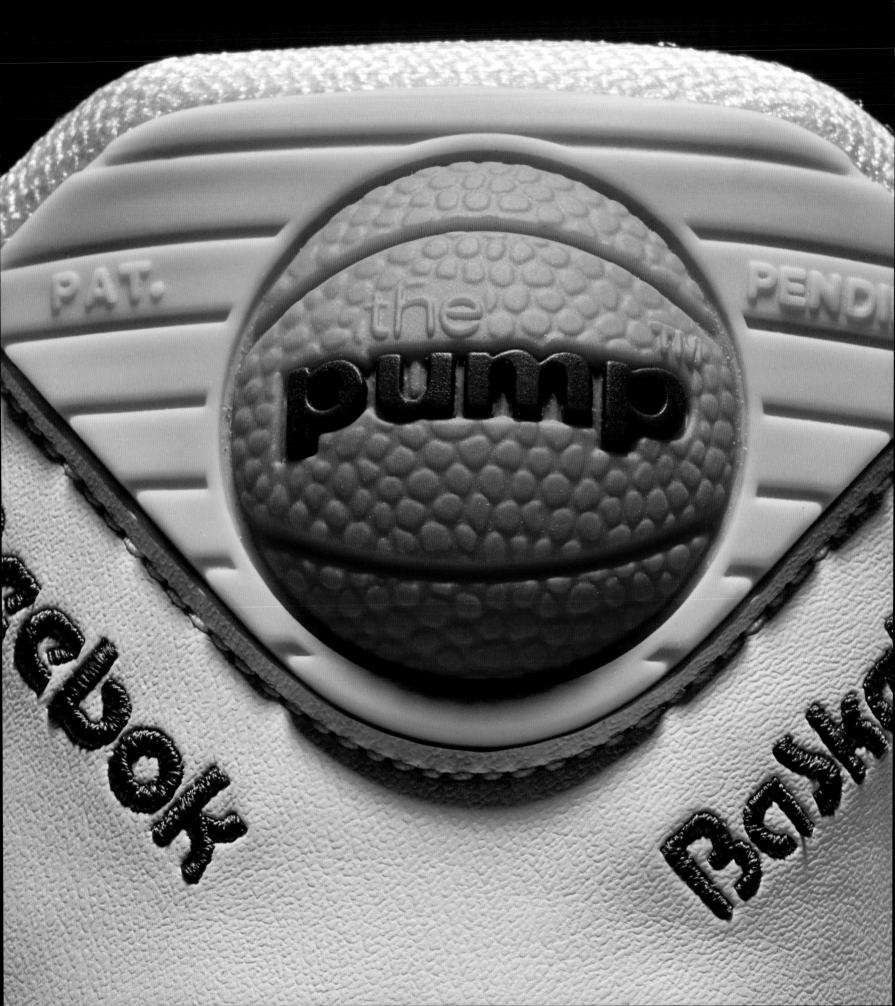

Right:
Boston Celtic Dee Brown
famously pumped his Reeboks
before doing his "no look" dunk
during the Slam Dunk Contest at
the NBA All–Star Week, February
9, 1991.

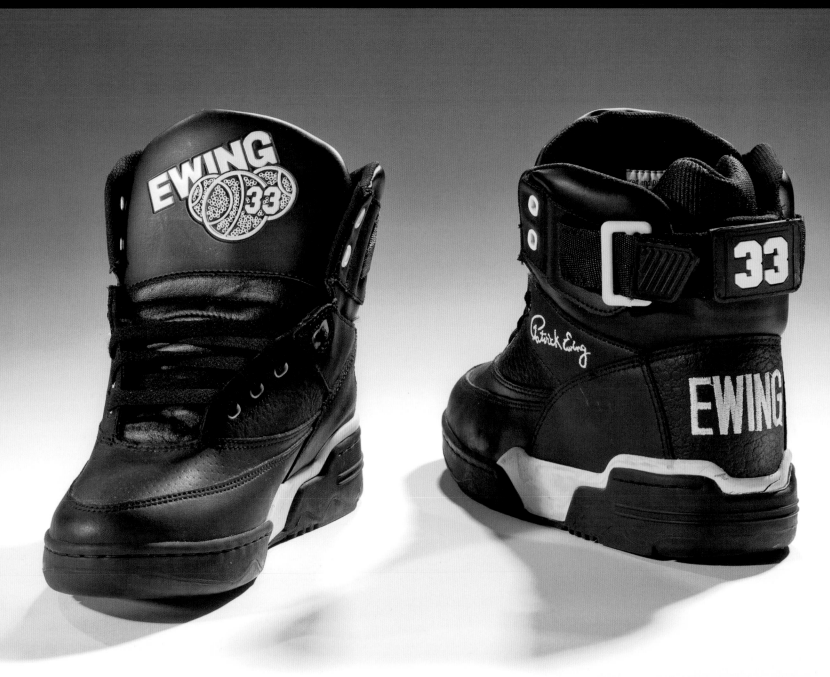

FILA
GRANT HILL II, 1996
COLLECTION OF FONDAZIONE FILA MUSEUM, BIELLA, ITALY

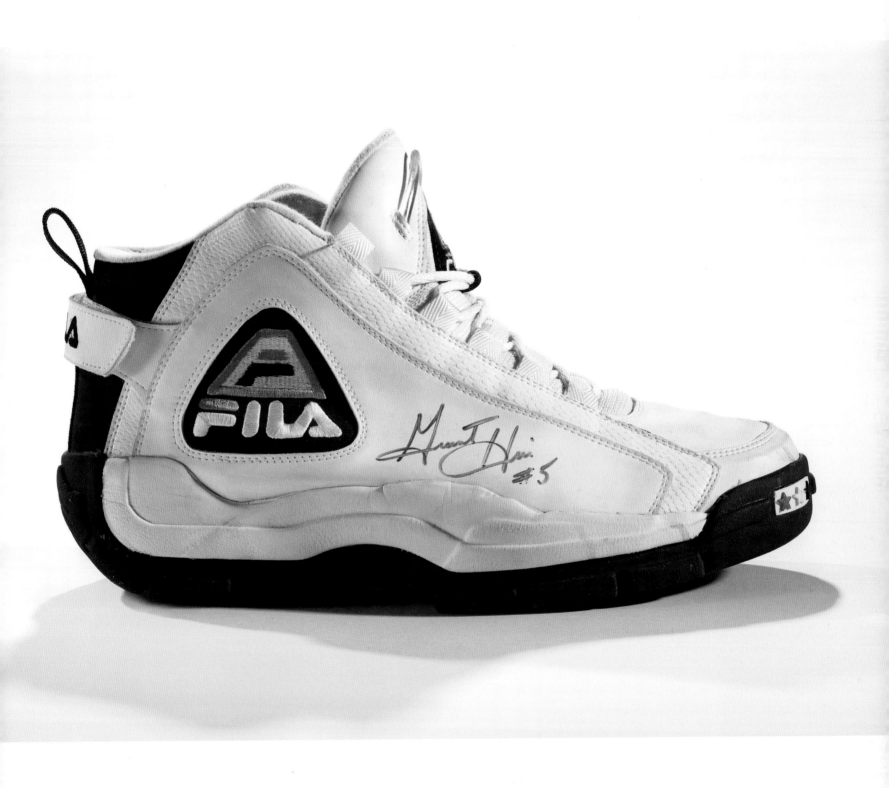

board shoe. Vans, which became the predominant skateboarding brand, started out as a small factory that sold shoes directly to the public with an unheard-of level of bespoke service. It was its strong grip soles and thick outsoles that attracted the skateboard crowd. When founder Paul Van Doren's son Steve noticed that kids were drawing checks on the sidewalls of their Vans, the company introduced the black-and-white checkered slip-ons that took off after Sean Penn wore a pair in his breakout movie *Fast Times at Ridgemont High* in 1982.[62] Skateboarding may have originated on the West Coast, but passion for the lifestyle quickly spread across the country. Its aficionados were mostly white, and it became a mostly suburban sport. The New York–based rap group Beastie Boys, however, offered a highly visible link between West Coast skater culture and East Coast urban hip-hop. Their enthusiasm for skateboarding, coupled with their incredible success as rappers, paved the way for skateboarding and skateboard sneakers to make forays into urban fashion.

In contrast to the disheveled dress of tech geniuses, the slick technology that they worked on was insinuating itself into daily life. Personal computers, cell phones, and the Internet were becoming a part of people's realities. The potential of technology to improve performance was eagerly embraced by sneaker companies; many sneaker designers were at the forefront of this technology wave. Adidas's revolutionary Micropacer, released in 1984, had a microsensor in the left toe that could record distance, running pace, and caloric output. This information was retrieved on the readout screen found on the lace cover of the left shoe. The prominence of the small readout screen was only one of the futuristic aspects of the sneaker. The choice of silver gilt leather and unusual lace covers also established that these sneakers were part of a new era. The Puma RS-Computer shoe, designed by inventor Peter Cavanaugh in 1987, had a computer chip in the heel that could record distance and time and came with a software package, program disc, and connector cable so that the shoes could be linked to a home computer for analysis. The instructions declared—rather amusingly when compared to today's computers—that the shoes were compatible with Apple IIe and Apple II/ plus (48K or more), Commodore 64, and most IBM PCs with DOS 2.0 or above, illustrating just how ubiquitous the personal computer had become.

New innovations using air were also introduced in the 1980s. Nike Air technology was first experimented with in the Tailwind of 1979, followed by the Air Force 1 in 1982 and the Nike Air Trainer and Air Max 1 in 1987. Reebok introduced a series of inflation technology shoes innovated by Paul Litchfield in the late 1980s, which hit the shelves in 1989 at the unheard-of price point of $170. The inflation device at the instep allowed the shoe to be secured to the foot without the need for laces, effectively customizing the fit. When Dee Brown of the Celtics stopped to pump his shoes before taking his turn at the NBA dunk

contest in 1991, then proceeded to do an unprecedented "no look" dunk, both he and his shoes were instant hits. Nike's innovation, the Air Pressure, designed by renowned Nike sneaker designer Bruce Kilgore, similarly relied on inflation but required a cumbersome air canister to recharge that proved too difficult, and the design was discontinued after only a year. Each of these technical innovations was accompanied by inventive design that was enthusiastically embraced by an eager sneaker-buying public who consumed them at ever-increasing prices—a point of concern for some.

IT'S GOTTA BE THE SHOES: COST AND CONTROVERSY

Among the many sneakers available in the late 1980s was the Air Jordan III. It was famed Nike designer Tinker Hatfield's first Air Jordan design, and it remains one of his most celebrated. The elephant-print leather "floater" was created to meet Michael Jordan's desire for a shoe that felt immediately worn in, because he typically wore a new pair of sneakers for every game. It was also the first Air Jordan to feature the "Jumpman" logo, also designed by Hatfield. If the sneakers were innovative, the marketing was even more so. Nike brought in Spike Lee to direct the commercials, with the idea that he would also appear as Mars Blackmon, his character from *She's Gotta Have It*. The pairing of Spike and Mike was an instant success, but it wasn't without controversy.

In 1990, after a number of highly publicized murders perpetrated in the course of stealing sneakers, Phil Mushnick wrote an article for the *New York Post* that put the blame for recent sneaker killings squarely at the feet of Nike, Michael Jordan, and Spike Lee. Lee responded with an article for the *National* in which he accused Mushnick of being racist and not focusing on issues of poverty. The debate about who and what was to blame raged. *Sports Illustrated* weighed in by putting the image of a pair of sneakers and a young black man's hand holding a gun to the back of an unidentified victim on the cover of its May 14 issue, accompanied by the title "Your Sneakers or Your Life." Inside, the article by Rick Telander focused on the role of drug dealers and the "fantasy-fueled market for luxury items in the economically blasted inner cities willingly tapping into the flow of drug and gang money. This has led to a frightening outbreak of crimes among poor black kids trying to make their mark by 'busting fresh,' or dressing at the height of fashion."[63] This in turn prompted Ira Berkow to write in the *New York Times* that Jordan and Lee were "quintessential role models for inner-city youths, or for anyone else. They work. They work hard. They have attained status by developing their talents to the highest degree they could, by sweat and by brains, and they have done so within the social system, and within the laws of the land. They have kept the faith. They are champions." Les Payne at *Newsday* added thst "blaming Jordan, even partially, for the street murders over sneakers is like blaming Dinah Shore, who endorsed Chevrolets, for the high

rate of stolen Corvettes. But it would never occur to the Mushnicks of the world to blame white celebrities for crimes they think nothing of laying at the feet of their black comparables. Were it so, Mushnik or some upscale colleague would perhaps at this hour be shoving the Donald McKinsey murder story under the nose of white celebrities who have endorsed the new target of a national rash of robberies and even murders: the Rolex watch."[64]

Opposite Page:
Tinker Hatfield, Design sketch
of Air Jordan XI, 1996, Courtesy
Nike Archives

Few social commentators were focusing on the fact that young African American men weren't so much being advertised to as they were being advertised through. Bill Brubaker in the *Washington Post* came close, writing that "once associated with games of youth, sneakers have become a cultural phenomenon, promoted by millionaire athletes and bought by fashion-conscious Americans who last year spent $11.7 billion on 393 million pairs of brand-name athletic shoes. The phenomenon is especially remarkable in that black inner-city youths . . . set the pace and styles for an industry managed mostly by white businessmen who sell the bulk of these products to white consumers."[65] Here was the real question. What was being gained by promoting the sneaker's association with inner-city street culture, including violence; what was being gained by this association with high-achieving black athletes? The answer was authenticity. Be they thugs who killed, drug dealers who acquired sneakers through crime, or heroic athletes who sweated to the top, each had achieved their goals. They were aspirational. They offered a new, edgy version of the American dream that appealed to a much broader demographic through its depictions of brute masculinity.

RELAXED STANDARDS: SNEAKERS AND SHIFTING MASCULINITIES

The importance of sneakers in the male wardrobe increased and became more widespread with the evolution of Casual Fridays in the late 1980s and into the 1990s. Purportedly meant to relax workplace hierarchies and increase conviviality among employees, Casual Fridays actually meant that men, in particular, had to be more considered about their attire. This was unsettling for many. As one reporter wrote in 1996, "I've never liked the idea of 'Casual Friday,' where companies allow workers to dress down on the last day of the work week. That's because I am a fashion dork."[66] For more than a century, men in the white-collar workplace had been expected to dress in confraternal uniformity by wearing the business suit. Status was expressed through fabric choice and fashionableness was conveyed through the cut of the garments, but in general a herd mentality of sameness reigned in men's dress. Casual Fridays, however, asked men to enter into the fashion system under which women had labored for years by demanding that greater individuality be expressed through their casual attire. In response, many men turned to sneakers as a means of establishing difference. The wide variety of sneakers available allowed for the construction of a nuanced projection of identity, but more important, the use of sneakers as items of fashion reaffirmed rather than threatened masculinity through their long-standing associations with hypermasculine models of success, be it rapper or athlete.

EXTLORE?

RUBBER MATERIAL?

EVA DENSITIES & THICKNESS IN FRONT?

WHERE ARE MOLD PROMISED? DID THEY FOLLOW OURS?

COLLAR HEIGHTS.

DO A. LESS ? SMALLER

General Comments
☐ NO AREA SUPRF..
☐ ACHILLES IRRITATION.
☐ DIFFICULTY LACING & CINCHING.
☐ SOURCING OF WHITE MATERIALS TO MA
SOCKLINER COLLAR IS TOO ARPO.

WRINKLES INSIDE.

REVERSE COLOR ON BASE TOO

HARD TOP EDGE.

SOFTEN HERE.

THICKEN EVA HERE BOTH SIDES.

POINT LOOK.

MEDIAL WRAP DOES NOT TRAVEL UNDER FAR ENOUGH

TAB IS NOT TACKED DOWN

CHECK THIC MIDSOLE TOO IS BAD

Tinker 12.8.0

MEDIAL.

JUMPMAN ON BOTTOM PLATE?..

ARCH IS TOO FAR FORWARD

AIR JORDAN
SHOE DEVELOPME

LIGHT WEIGHT IS GREAT

PLATE LOOKS GOOD

SHAPE OF PATENT LEATHER BAND IS GOLD.

LOCATION OF STRAPS IS GOLD.

EUGENE TONG

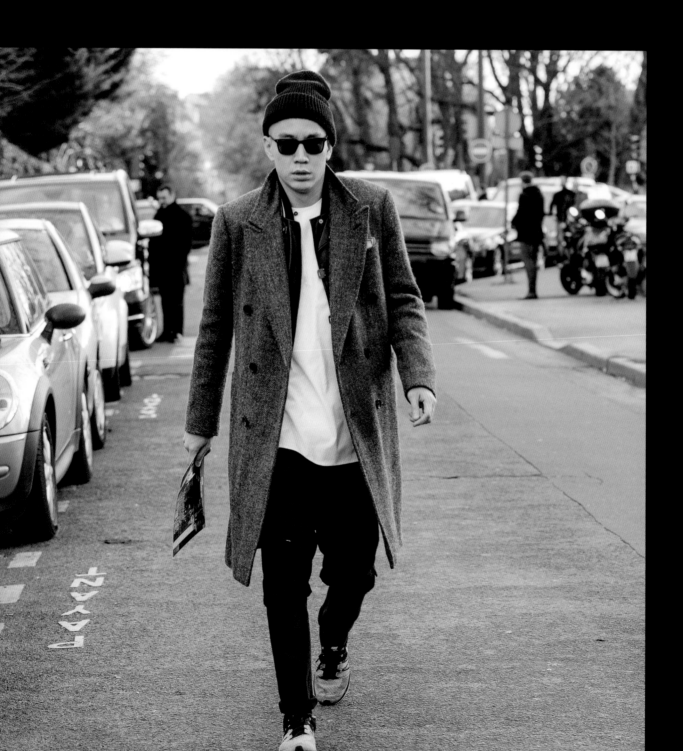

I don't know when it started, but for as long as I can remember, I have loved sneakers. I have distinct memories of being in middle school and wandering off into the local sneaker shop on a field trip; the first time I saw the original Air Max 95s at Herman's Sporting Goods at my local mall; and being jealous of my best friend's neighbor because he was the first kid I knew who had all of the Jordans.

I always wore sneakers when I was growing up, and had plenty, but it wasn't until I moved to NYC in 2002 that I started to collect in a serious way. That was when I really started hunting for Holy Grails. I literally spent all my money on sneakers, and I would do whatever it took to get the Grail I was hunting for at the time.

Most of my favorite sneakers have a story and take me back to a specific time in my life. I remember standing in line (the one and only time I stood in line for sneakers) at Supreme for the original Supreme Dunks release. And when I paid almost as much in shipping as I did for the shoes when I found a pair of Goldenrod Dunks in England. I remember begging my family in Taiwan to pick up Bapestas from Foot Patrol for me when they went to Japan.

Over the years, I have edited down my collection significantly, but I still have some of my most-cherished sneakers (all unworn): Air Jordan 4 Lasers, original Air Yeezys, Nike Goldenrod Dunks, Deadstock Nike Air Max 95s, original Supreme Dunks, various Supreme x Vans collaborations, and others.

I have always worn sneakers, and I've been lucky to be in professional positions where that was okay. But for a long time, my situation was the exception. Today, it's different: today, sneakers are a core part of a man's uniform.

I think the rise of sneakers into a true mainstay reflects an overall shift in the way men are approaching dressing combined with a confluence of changes in menswear in general.

Men have started taking more of an interest in fashion in the past few years, and at the same time, there has been a sort of casualization in the menswear category. A sharp ascent of luxury sportswear is happening, along with a general decline of more formal dressing. Men don't have to wear suits and ties to work anymore. The idea of "work wardrobes" and "weekend wardrobes" is a dated concept that no longer applies. Men today are focused on building foundational wardrobes, and sneakers are a huge part of that.

The market has responded. Everyone is in the sneaker game now. You still have cult styles for diehard sneaker fans who care about specific years, etc., but you also have luxury design–focused options from labels like Common Projects, which was really first to that space. Brands—from mass to high street to couture—are making sneakers in slimmer silhouettes, using luxury fabrics, etc. It's cool to see people applying the same level of care and technique to making sneakers that they have been to making shoes.

Designer sneakers are ubiquitous now, too. Before, there were moments when high fashion and sneaker culture collided—when Hedi Slimane did the German army trainer-inspired B01 sneaker for Dior Homme; when Kanye West did a Louis Vuitton sneaker collaboration; or, more recently, when Tom Ford introduced his high-tops—but now, it's no longer a novelty.

Plus, there is interesting cross-pollination in the category: Raf Simons and Rick Owens collaborating with Adidas, and Ricardo Tisci (Givenchy) collaborating with Nike. Partnerships like this really reinforce this new high-low mentality and how truly standard the fashion/sneaker relationship has become.

Everything in fashion is cyclical, but sneakers don't really fit into the trend conversation. They will always be a fundamental part of the way men dress and express their individuality. Without question, for me sneakers have always been—and I imagine always will be—a huge part of my own personal style.

EUGENE TONG IS STYLE DIRECTOR AT *DETAILS* MAGAZINE AND IS KNOWN FOR HIS STREET STYLE COMBINING LIFESTYLE BRANDS AND DESIGNER GARMENTS.

LANVIN
PATENT CAP TOE, 2013
COLLECTION OF THE BATA SHOE MUSEUM, GIFT OF HOLT RENFREW

PRADA
PS0906, 2013 (DETAIL)
COLLECTION OF THE BATA SHOE MUSEUM, GIFT OF PRADA

As early as the late 1980s, the sneaker had become the most baroque and arguably fashionable—if one defines fashion as quickly changing—accessory in the male wardrobe. A single pair could establish: age, sport affiliation, fashion sensibility, status, brand identity, and so on. Rare editions, new technologies, superstar endorsements, and celebrity sightings all tantalized the sneaker community, and increasingly sneakers were seen on the feet of trendsetters worn in places and at occasions where sneakers had been unthinkable only years earlier. When Michael Jordan first saw Tinker Hatfield's design for the Air Jordan XI, he supposedly declared it the first sneaker elegant enough to be worn with a suit.

As increasing numbers of sneakers produced by athletic companies were making their way to the feet of the highly fashionable, high fashion began to take notice. In 1996, the same year that the Air Jordan XI and the Question came out, Prada got into the luxury sneaker market with the PS0906, a similarly glossy and desirable model. That the sneaker was originally designed for the Luna Rossa team's participation in the first America's Cup only heightened its exclusivity. Sneaker companies also upped the ante by doing collaborations with important style gurus. Adidas, the earliest brand to do a collaboration with a cutting-edge fashion designer, first worked with Yohji Yamamoto and Jeremy Scott, two of the fashion industry's most avant-garde designers, in 2002.

In that same year, Nike collaborated with Supreme, the famous skateboard fashion brand, to create the Supreme x Nike Dunk Low Pro SB, which was followed a year later by the Supreme x Nike Dunk High Pro SB, one of sneaker culture's most sought-after shoes. The extremely limited edition of Staples x Nike Dunk Low Pro SB Pigeons, created by Jeff Ng of Staple Design in New York, caused pandemonium in 2005 when the available supply came nowhere near demand. Sneakerheads started camping outside the store days in advance of the launch. The morning of the release, the lineup was around the block. With only thirty pairs available, disappointment mounted, the police arrived, and so did the media. The "sneaker riot" made the cover of the *New York Post* and revived mainstream concerns about violence, sneaker culture, and racial inequality.

Just the year before, at the annual NAACP awards ceremony celebrating the fiftieth anniversary of the Supreme Court decision ending segregation in education, Bill Cosby gave his infamous "Pound Cake" speech in which he criticized some African Americans for not embracing hard-won opportunities, but instead squandering them through "frivolous" expenditures—and he used sneakers as an example:"The lower economic people are not holding up their end in this deal. These people are not parenting. They are buying things for kids. $500 sneakers for what? And they won't spend $200 for Hooked on Phonics."[67] His comments were immediately contested, from constesting the cost of sneakers to his blame-the-victim stance. Famed Georgetown University professor Michael Eric Dyson

NIKE
AIR FORCE XXV MACHE CUSTOMS, 2012
COLLECTION OF MACHE

JEFF STAPLE

NIKE X STAPLE DESIGN, DUNK LOW PRO SB PIGEON, COURTESY STAPLE DESIGN STUDIO

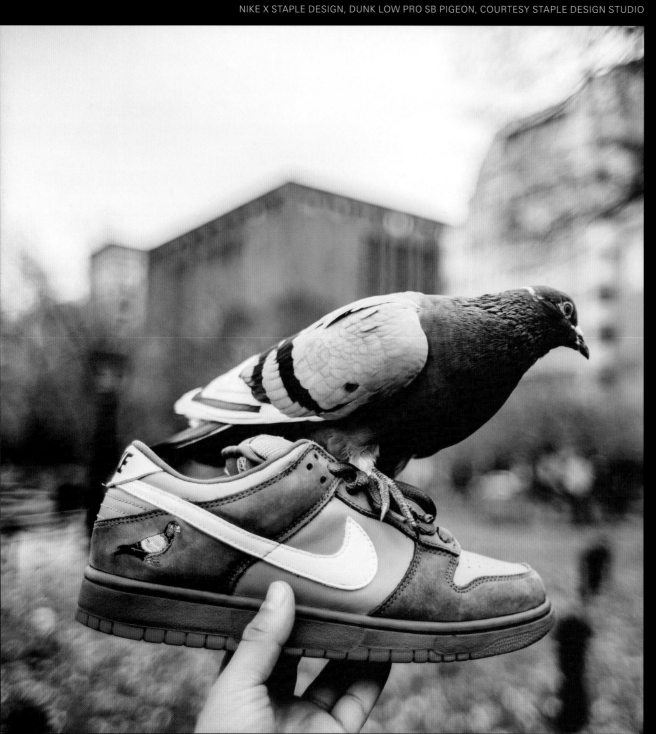

The project began with Nike approaching me to create a shoe that represented New York City. After sitting around and thinking for a while about what represented NY best, the Pigeon kept coming up. To me, it was the mentality of that bird—it's a warrior, it doesn't give up, and it doesn't take anything from anybody. It's the only bird that doesn't fly away. It walks over your feet and then it shits on your head. It represents something innate to New Yorkers. When Nike SB created a special Dunk Low Pro as part of their White Dunk exhibit for four influential cities of the world, Tokyo, London, Paris, and New York, I was asked to design the Nike Dunk Pigeon for the city that never sleeps. And the rest was history.

The Nike Dunk Pigeon was released on February 22, 2005. There were one hundred fifty made for the world—thirty pieces for five shops: Rival, Supreme, Recon, KCDC, and Reed Space. The thirty for Reed Space had engraved Staple Pigeon logos and each was individually numbered. It was also really important to expose our brand to a lot of different people, and I was able to do that with this collaboration. The Dunk represents our hometown New York in one project and was a dream come true to design.

There was a time before the Pigeon and after the Pigeon. Much like BC and AD, and for better or worse, there are positives and negatives that came after the Nike Dunk Pigeon. There was a sneaker culture before the Pigeon, and I was part of that culture. People would determine their outfits based around the kicks they wanted to wear for the day. But not too many people were out there camping out for shoes, trading, or reselling. Afterward, sneaker culture became a huge thing, a culture unto itself. Some people love that and others hate it.

There're a lot of people who fell in love with sneakers after this collaboration. It built so many different businesses: magazines, blogs, etc. It spawned worldwide attention. It elevated the appreciation for shoes and in return elevated the designs. Before, sneakerheads would look at a collection from a brand and pick out key pieces, or certain pieces would stand out on their own. They would be associated with an athlete or some development that was happening within the company. Now many companies are making collections just for sneakerheads. That's not what sneakers heads want deep down! Although it's successful in the short term, it becomes trendy very quickly. You've got to always keep it authentic.

DESIGNER AND CREATIVE ENTREPRENEUR JEFF STAPLE HAS COLLABORATED WITH BRANDS INCLUDING NIKE, NEW BALANCE, AND PUMA TO RELEASE A SERIES OF HIGHLY ANTICIPATED SNEAKERS THAT USE THE NEW YORK CITY PIGEON AS A RECURRING MOTIF.

wrote the book *Is Bill Cosby Right? Or Has the Black Middle Class Lost Its Mind*, in rebuttal to Cosby's stance. In this atmosphere of renewed debate and thoughtful argument, limited-edition collaborations and the creation of high-end sneakers continued unabated. New sneaker companies, such as the Bathing Ape, Supra, Visvim, and Android Homme, entered the game with a focus on fashion specifically accompanied by a high price tag.

Sneaker culture fractured as interests became increasingly varied and participation exponentially increased. Just as the first wave of sneaker culture in the early 1980s had sent sneaker connoisseurs in search of the rare and forgotten, the exploding interest in sneaker culture in the early 2000s sent another, larger generation of young men on the hunt for exclusive models. In 2005, the same year that the Pigeons debuted, vintagekicks.com opened a brick-and-mortar shop in New York called the Flight Club, where vintage sneakers could be consigned and purchased. Interest in acquiring OG (original issue) sneakers, preferably deadstock (sneakers forgotten in store warehouses, still in their original boxes with their original tissue paper), had been a feature of sneaker culture since the 1980s. The advent of eBay in 1995 brought more models out of the woodwork and fed the desire for the rarest sneakers, which by the 2000s had become the rage among sneaker connoisseurs. By the middle of the 2000s, sneaker events, from competitions to conventions, were drawing thousands.

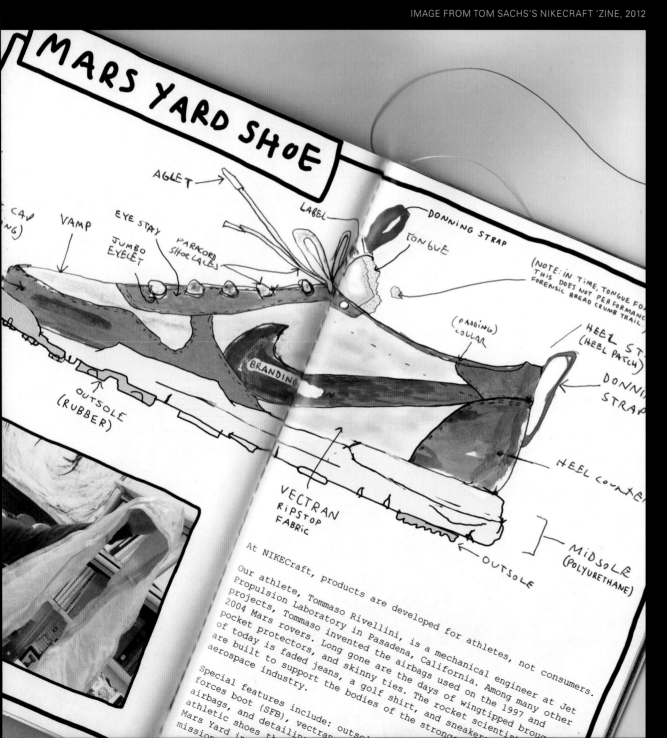

At NIKECraft, products are developed for athletes, not consumers.

Our athlete, Tommaso Rivellini, is a mechanical engineer at Jet Propulsion Laboratory in Pasadena, California. Among many other projects, Tommaso invented the airbags used on the 1997 and 2004 Mars rovers. Long gone are the days of wingtipped brog pocket protectors, and skinny ties. The rocket scientis of today is faded jeans, a golf shirt, and sneaker are built to support the bodies of the strong aerospace industry.

Special features include: outso forces boot (SFB), vectran airbags, and detailin athletic shoes th Mars Yard boot mission

This collaboration is a result of a 2009 conversation that I had with Mark Parker in Paris. We spoke for hours on the merits of individual handicraft versus the economy of scale in factory production. The design triangle: quality, speed, cost—choose two—is broken open by the innovative global production techniques and ethics developed and continually refined by NIKE.

The "die broke racing philosophy" (starting with 100% and ending with 0% to save weight and increase speed), is a useful strategy, but can also conflict with sustainability, and compromise long-term strength. Before recycling, there is reuse. Before reuse, there is durability.

John Ruskin's *Seven Lamps of Architecture*, from May 1849:

1. Sacrifice
2. Truth
3. Power
4. Beauty
5. Life
6. Memory
7. Obedience

153 years later, these ideas are the guiding principles of this collaborative capsule collection. Here we shun innovation for its own sake, but embrace the muse of innovation only as a necessity. Fashion is power and truth and beauty and life and obedience, and it's achieved at great sacrifice – just like athletics.

Parker said to me, "If you think you can do better, why don't you try?" I said "okay," and three years later, after we both learned a lot, this is result of that challenge.
Behold: NIKECraft.

Tom Sachs
April 11, 2012

BLENDING IRREVERENT HUMOR AND DIY SENSIBILITIES, TOM SACHS IS AN INTERNATIONALLY RECOGNIZED CONTEMPORARY ARTIST WHOSE WORK OFTEN REFIGURES ELEMENTS OF POPULAR AND CONSUMER CULTURES.

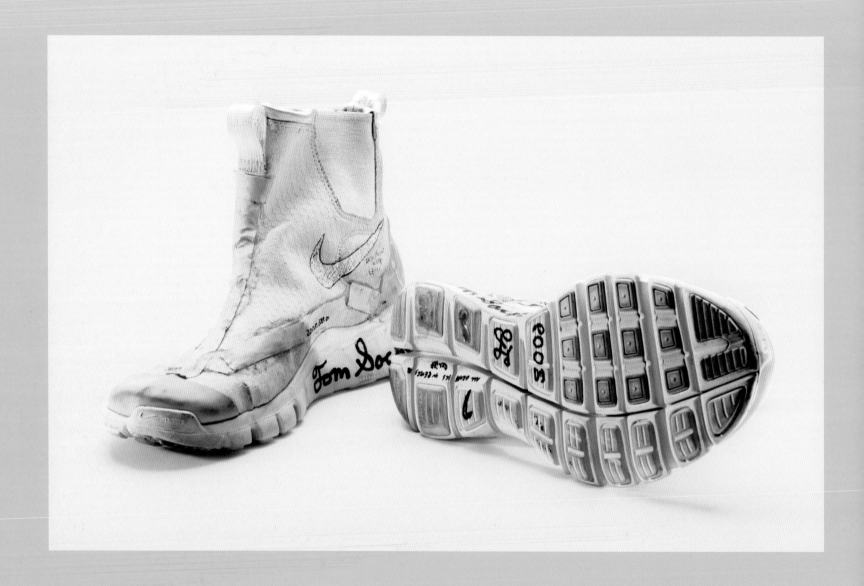

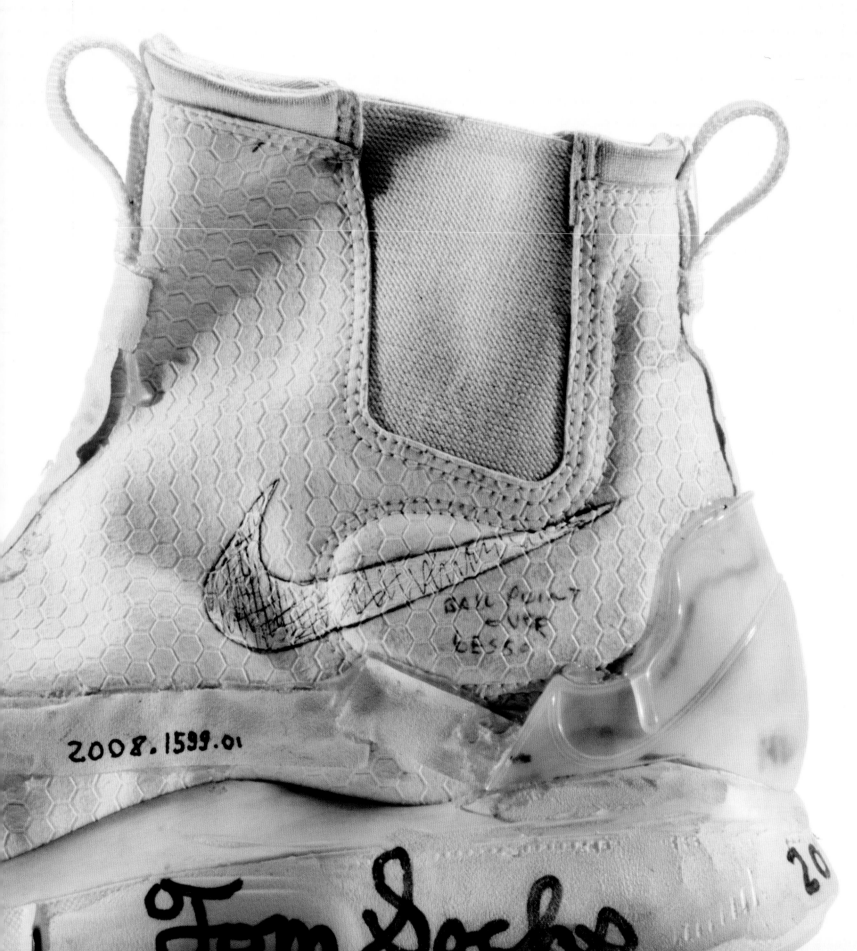

Sneaker magazines and sneaker websites devoted to all things sneaker proliferated, and sneaker release parties were thronged with attendees. To capitalize on the fever-pitch desire for the rare and vintage, companies increasingly released retro models. Nike had begun rereleasing Air Jordans starting with the Air Jordan I in 1994. This success was followed by many other retros, as rereleases were known, and soon other companies were reissuing their signature models as well. Large brands redesigned their stores to give customers unparalleled retail experiences, and these in turn became destination spots in their own right, while more intimate sneaker boutiques, from Kith in New York to Collette in Paris, disseminated the most exclusive sneakers, with price points to match.

Soon those who wanted unique footwear sought out customization. Nike debuted Nikeid in 1999, which allowed purchasers to individualize their sneakers, but for the truly exclusive, people turned to artists such as Eric Haze, Methamphibian, Sekure D, or Mache, who transformed sneakers into works that rivaled high art and garnered them international reputations and celebrity client lists. Celebrities themselves also collaborated with sneaker companies, creating hyped and limited-release models. Kanye West's collaboration with Nike resulted in the Yeezy I in 2009 and the Yeezy II in 2012. The Red October version was dropped in 2014 shortly after Kanye announced that he was moving over to Adidas. Although they had a recommended price point of just over $200, their real

Below:
Rapper Kanye West and fashion designer Marc Jacobs backstage at the Louis Vuitton fashion show during Paris Fashion Week, with the Louis Vuitton shoe designed by West, January 22, 2009.

l'Alfibulle

sneakers A
bulles de méta

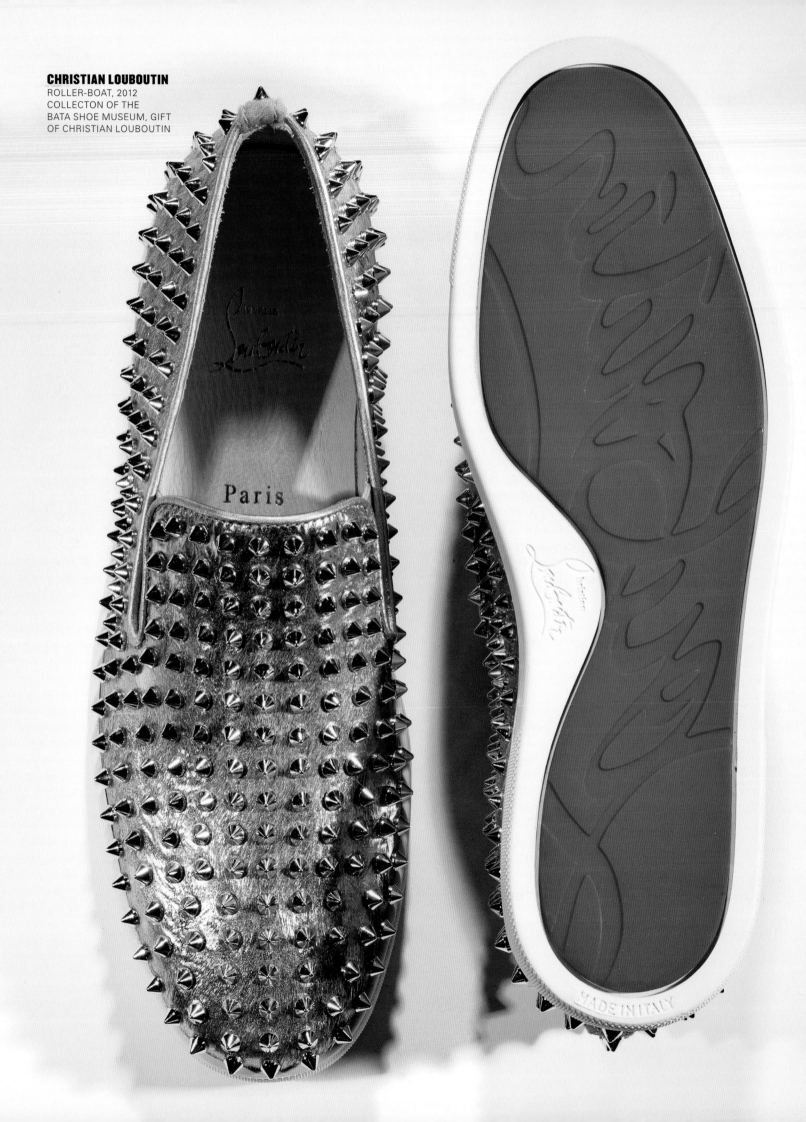

CHRISTIAN LOUBOUTIN
ROLLER-BOAT, 2012
COLLECTON OF THE
BATA SHOE MUSEUM, GIFT
OF CHRISTIAN LOUBOUTIN

value—to all involved—was the amounts they would fetch at resale. It was widely reported that a preorder pair of Yeezy IIs with the suggested retail price of $250 was sold on eBay for $90,300. There were those who questioned if the bid was real: "Some have wondered whether the outrageous eBay bid was a publicity ploy from West himself. One Yahoo! contributor speculated that the rapper intentionally bid up the price under a pseudonym in order to hype the shoes. . . . If he did, it's definitely working. The Air Yeezy II's debut has been called the most anticipated shoe release in history."[68] Whether or not it was true, the story made the news and heightened awareness of both Nike and Kanye West, underlining the desirability of both brands. Like Michael Jordan's fines for wearing the Air Jordan I, better publicity couldn't be purchased. Kanye also did a collaboration with Louis Vuitton in 2009 that similarly created a great deal of hype. Jay-Z created the short-lived Sean Carter line with Reebok in 2003, but more important, Jay-Z wore sneakers in combination with high fashion. In their haute couture suits and high-end sneakers, men such as Jay-Z and Kanye West legitimized to a popular audience the connection between high fashion and street style, between traditional signifiers and new models of masculine success.

The connections between fashion and sneakers also continued to be made in the world of basketball, especially after Nike brokered deals with Kobe Bryant and LeBron James. Both players were recognized for their style both on and off the court, but LeBron James, in particular, became a style icon in his own right. He was the first African American man to be on the cover of American *Vogue* and his sartorial choices, which frequently saw him not wearing sneakers, were often the focus of media attention. LeBron's ease with shifting from brogues to sneakers was illustrative of the larger-trend focus on interest in men's attire. Just as with Jay-Z and Kanye West, LeBron was central to changing the image of masculine success.

As celebrities such as Jay-Z began wearing haute couture, fabled fashion houses such as Lanvin, the oldest haute couture house in Paris, famous for making exquisite clothing for women for more than one hundred years, began to offer men's sneakers in 2005, and Yves Saint Laurent added men's sneakers in 2008. By the 2010s, high-fashion collaborations were becoming increasingly common. Hussein Chalayan, Alexander McQueen, and Mihara Yasuhiro created designs for Puma. Raf Simons was tapped by Adidas, while Riccardo Tisci designed for Nike, Marc Jacobs designed for Vans, and Missoni collaborated with Converse.

One of the most interesting developments in sneaker culture has been the entrance of extremely high-end women's shoe designers into the male sneaker market. In 2011, French shoe designer Christian Louboutin opened his first men's boutique and offered sneakers that were soon seen on the feet of the most fashionable men. The UK-based brand Jimmy Choo also began to make men's

CHRISTIAN LOUBOUTIN

- Weirdly enough, sneakers have introduced, for the first time, a simple concept unknown before to the men's shoe world: the idea of sexy. Before, shoes could be elegant, strong, powerful, well designed, funny, funky, curious, wild, even "perfect," sometimes, but they were never sexy. Sneakers forced that category. For this reason, I would say that the sneaker is to men what the high-heeled pump is to women.

- On a personal level, I always loved sneakers. I have always bought them, even if I've barely worn them. Sneakers for men are an addiction; you buy more than you need.

- Because, from the beginning, sneakers were dedicated to different sports, they contain a lot of elements essential to manpower: strength, efficacy, velocity, technical skill, and freedom. All these elements combined make a good sneaker. This is why, outside of the field of sports, sneakers have significantly reinforced casualwear over the last twenty or thirty years. When I design a sneaker, I may have in mind a possible athlete, but I don't see at that moment a team player—I just keep in mind the performer. And this makes my job as a designer very easy. To me, athletes are showmen; just like musicians onstage, they are here to deliver us great shows . . . and they do!

- When I design for men, I often think of "artists." Great athletes are great artists and, for that reason, very inspirational to me. They carry enough manpower and fun to translate these vibes into a vast category of shoes, which, once done, can go on many other men's feet. That is why sneakers are always fun to create.

CHRISTIAN LOUBOUTIN IS A RENOWNED LUXURY FOOTWEAR DESIGNER WHOSE MEN'S AND WOMEN'S SHOES ALWAYS EMPLOY ICONIC RED SOLES.

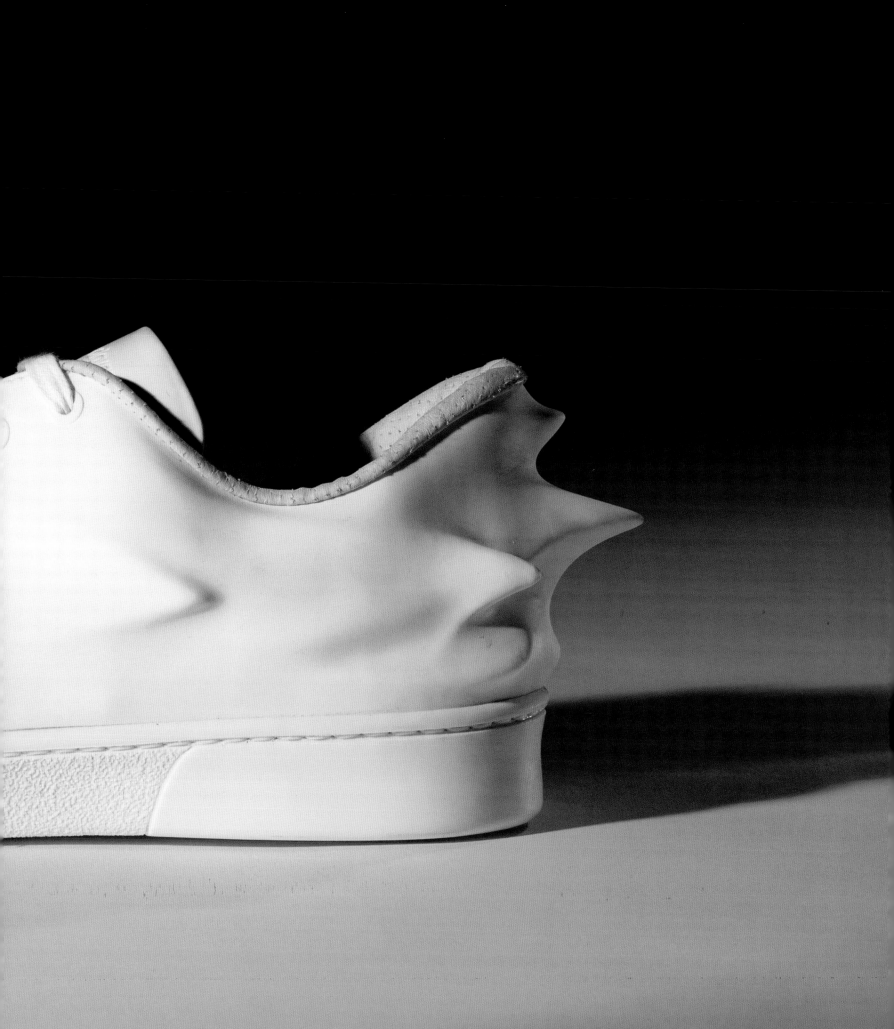

ADIDAS X JEREMY SCOTT
FORUM MONEY, 2002
ADIDAS AG

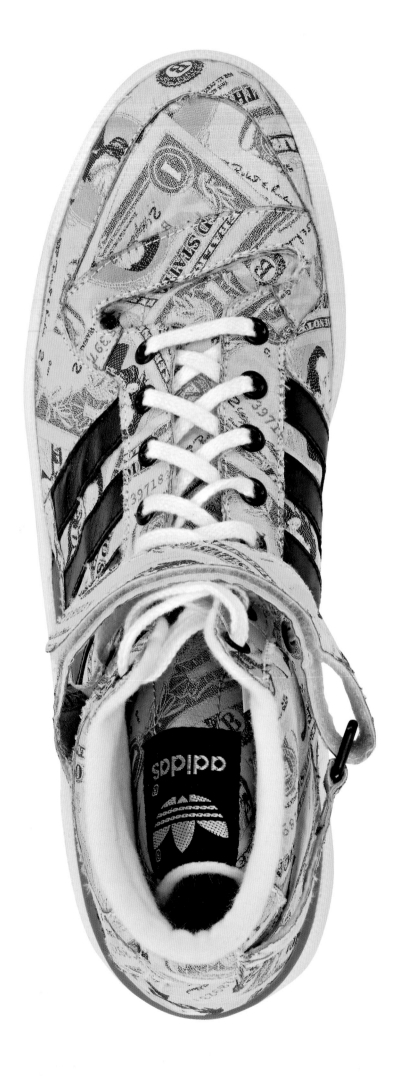

sneakers in 2011, while French shoe designer Pierre Hardy had launched his men's sneakers almost a decade earlier, in 2002.

The fact that many men have been willing to step into Louboutin's red-soled sneakers and wear high-tops sporting the name Jimmy Choo is a harbinger of a profound shift in idealized masculinities. In an interview with *Footwear News*, Louboutin stated, "There is a group of men that is thinking a little bit more like women. . . . They treat shoes very much as objects, as collectors' items."[69] In many ways, sneakers allow more men to function like traditional consumers of fashion who use brands and variety of dress to construct highly individual expressions of self. It also inculcates men into a system in which individuality demands constant consumption and hypervigilance to trends. It also demands difference in dress, just as women have historically been required never to attend a function in the same outfit, sneaker culture is now demanding the same level of diversity in men's fashion. The abandonment of the herd mentality in dress, while in part freeing in terms of individual expression, brings with it obligations that can be in many ways taxing.

Despite the similarities between men's participation in contemporary sneaker culture and more traditional forms of fashion consumption by women, there are also important differences. One of the most important is that sneaker consumers who have become collectors often bring a passion and dedication that reflects more traditional areas of men's consumption, such as baseball cards, cars, or fine wines. Many sneaker collectors approach collecting with clearly articulated objectives. Some might desire to have all the models in a set, such as the complete Air Jordan I–XX3, while others search out the rarest example. Still others buy pairs to wear and pairs to put "on ice," knowing that they will have access to their favorite shoes later on. Many of the most coveted shoes are related to moments in sports history or are connected to iconic players, with some collectors focusing on one player or another. A further difference between traditional women's fashion and male sneaker culture is the very strong promotion of the idea of collaboration, which is construed as active and engaged. For example, Kanye West was brought on to help design a Louis Vuitton collection, while in contrast, Madonna has functioned simply as the face of a company.

Another fact helping to establish sneakers as a fixture of men's fashion specifically and linking them to masculinity is the fact that the majority of the most coveted sneakers are not made in women's sizes, leaving female aficionados to search out the smallest men's sizes available. This lack of desirable sneakers that fit women prompted Londoners Emilie Riis and Emily Hodgson to start the campaign Purple Unicorn Planet in 2013, asking Nike to make some of its most iconic and desirable sneakers in smaller sizes.

SOPHIA CHANG

WHEN CREATING THE BROOKLYNITE COLLECTION, DID THE LANDSCAPE, BUILT ENVIRONMENT, OR ICONIC LANDMARKS OF THE BOROUGH INFORM YOUR DESIGN (FOR EXAMPLE, THE EAST RIVER, CONEY ISLAND, STREET ART, THE JMZ, ETC.)? IF SO, WHAT ELEMENTS DID YOU FOCUS ON AND HOW WERE THEY INCORPORATED INTO YOUR FINAL PRODUCT?

Working for a global brand like Puma, I wanted to tell the story of New York through a New Yorker's lens, but also be accessible to and inclusive of non–New Yorkers. Everyone is familiar with the iconic graphic references to New York—such as yellow cabs, the Empire State Building, the Brooklyn Bridge, and more—but there are also references that only native New Yorkers would get. Looking closely at the graphics, one can see the Midtown Tunnel sign, and the "Believe the Hype" sign, which you see entering Brooklyn from Queens; references to Kings County, Brooklyn's original name; and also quotes from rap songs, including "grand opening grand closing" from Jay-Z's "Encore." The collection was designed for a wide range of fashion tastes, from your trendy aunt and uncle who wear fresh kicks and shop at Fulton Street Mall, to the young hipster who dyes her hair ombre, to the Hypebeast teenager waiting in line for sneakers. There is an item for every subculture referenced here.

AFTER YOUR DESIGN WORK, YOU'RE WELL KNOWN FOR YOUR PERSONAL STYLE. WHAT TRACES OF YOUR PERSONALITY CAN WE SEE IN THE BROOKLYNITE COLLECTION?

My personal taste is referenced in the mixing of fitness and fashion materials, including reflective material, neoprene, and mesh. In terms of the color palette, ombre was a popular look for many young people the past few years, so I added that into the gum sole of the women's shoes. There are also references to native New York culture, which is a big source of inspiration for me.

YOU OFTEN TALK ABOUT YOUR SCRAPPY RISE FROM INTERN, TO FREELANCER, TO HAVING YOUR OWN LINE WITH PUMA. WHAT ADVICE WOULD YOU GIVE A YOUNG ASPIRING SNEAKER DESIGNER?

I wouldn't consider them scrappy, I would call mine more humble beginnings, which everyone should start from. As an aspiring creative, everyone should be prepared to pay their dues. I took my time and made the most out of my college days, dedicated myself to my work and education, so that I can be where I am today. I didn't have a specific plan in mind, but I knew I didn't want to stay static. Every morning is the start to a new day, to new opportunities, and it's up to me to build the platform for that.

CAN YOU EXPAND ON THE EXCERPT BELOW FROM YOUR INTERVIEW WITH *MTV VOICES*:

"THE BEST PART IS THAT THERE ARE SO MANY GIRLS TAKING PICTURES OF THEMSELVES WEARING THESE SNEAKERS AND THEY'RE CREATING SOCIAL CONTENT AROUND IT. IT'S SO COOL TO SEE WOMEN ACTIVE IN THE STREETWEAR COMMUNITY AND SNEAKER CULTURE."

—SOPHIA CHANG DISCUSSING THE PUMA COLLABORATION, *MTV VOICES*, 2014

HOW DO YOU ENVISION THE ROLE OF GIRLS AND WOMEN IN SNEAKER CULTURE?

When I was growing up, street and sneaker culture were very male dominated. The only time you see women featured is when they are half naked, posing next to sneakers. With the internet and the ability to voice your creativity, it's very inspiring to see that there are plenty of confident, creative, and stylish women who are just like me, sharing their stories online. It's exciting to see females expressing their own style and how they dress with Puma x Sophia Chang products.

CREATIVE DESIGNER SOPHIA CHANG HAS COLLABORATED WITH BRANDS INCLUDING NIKE, PUMA, AND UNDEFEATED TO CREATE FOOTWEAR AND APPAREL REFLECTIVE OF HER HOMETOWN, NEW YORK CITY.

Air Jordan is one of the few brands available in a range of sizes, and the brand collaborated with Vashtie Kola to create the Air Jordan II Lavender in 2010. Reebok has collaborated with Melody Ehsani to reimagine a number of classic Reebok shoes, including the Classic Pump Omni Lite and the Freestyle Hi Wedge. But these collaborations stand out as being directed at women rather than at sneakerheads, some of whom might be female. Sophia Chang's work with Puma, unlike either Kola or Ehsani collaborations, included sneakers for men and women, suggesting that women's participation in sneaker design may be increasing.

Female interest in sneaker culture has also been redirected to shoes that reference sneakers and yet aren't sneakers. The widely imitated wedge sneaker created by French designer Isabel Marant in 2013 is a part of a larger continuum of footwear dating back to the 1920s made for women that flirts with, but doesn't admit, women into the sneaker game. More surprising was Karl Lagerfeld's Spring/Summer 2015 Chanel show, in which all his models wore flat-soled sneakers. The sneakers, of his own design, seemed to signal a challenge to the prominence of the high heel, one of the most ubiquitous symbols of femininity, and suggested that something was changing in women's fashion.

The glamorization of sneakers within both men's and women's fashion, and the increased prominence and embrace of branding in hip-hop fashion, has given rise to the pejorative term *hypebeast*, used to belittle someone who is extremely label conscious. The term also carries with it racial overtones, as most people identified as hypebeasts are Asian. Hong Kong resident Kevin Ma used the term ironically when he started his blog *Hypebeast*, one of the most authoritative voices in relation to "hyped" sneakers and brands in 2005. A more recent trend, Normcore, which emerged in 2014 as a response to the insatiable interest in brands, reflects a move toward "anonymous" antifashion fashion that looks to the banal or understated for inspiration. Classic sneakers, such as the Converse Jack Purcell, the Adidas Stan Smith, and the Rod Laver, have become fashionable again because of Normcore, and new brands, such as Common Projects, which craft subtle yet luxurious sneakers for those in the know, have achieved cult status.

The expanding mix of people self-identifying or being identified as sneakerheads, in addition to the global expansion of hip-hop fashion, has also brought questions of exploitation and exclusion into the discussion. Issues have been raised concerning who has been designing and who has been making sneakers. Since the middle of the 1990s, concern has been voiced about sneaker production practices in Asia, particularly Indonesia and China. The significant sums paid to celebrity endorsers and the retail cost of sneakers were frequently contrasted to the pay of factory workers.[70] In response to concerns related to sustainability and waste

NIKE
FLYKNIT RACER NRG
LOOK-SEE SAMPLE, 2014
NIKE ARCHIVES

created during manufacturing as well as at the postconsumer point, the sneaker industry has innovated new manufacturing processes. Nike's Flyknit is fabricated using a continuous thread, allowing the shoe to be "knit" all in one piece rather than constructed out of discrete parts cut from larger pieces of material that create waste. Others, such as New Balance, have made a point of promoting their concern for the environment. New Balance has also attempted to keep jobs local by maintaining manufacturing facilities in North America.

In addition, the exportation of manufacturing jobs to offshore facilities has been criticized by many. The lack of diversity among those who were able to maintain employment in Western countries has also come under criticism. D'Wayne Edwards, who became only the second African American sneaker designer after William Smith III when he was hired by LA Gear in 1989, and went on to become lead designer for many of the Air Jordans, started his own sneaker design school, PENSOLE, to encourage a more diverse group of designers to find their way into the industry.

Increasingly, sneaker companies are encouraging customer input concerning the design or colorways of the sneakers they wish to buy. Adidas is able to print customer-supplied images directly onto the fabric used to make sneaker uppers. This level of customization may also become a part of sneaker manufacture—there has been some suggestion that Nike's knit technology could be used to knit sneakers to customers' exact specifications in a store. In addtion, 3-D printing technology points to this potential. These "bespoke" sneakers herald a new age for both sneaker production and sneaker culture. Prior to the Industrial Age, all footwear was made at the request of the customer to his or her specifications; it is interesting that one of the most mass-produced forms of footwear may be among the first to reintroduce bespoke-level, individualized production; everything old is new again.

When looking back across the long history of the sneaker, it is clear that the sneaker's extraordinary relevance today remains tied to the cultural impulses that have motivated and nurtured sneaker culture for the last two hundred years. The desire for the new and novel has inspired innovation since the moment rubber first gained of serious interest in the West and has remained a driving force in sneaker consumption today. Interest in proclaiming privilege likewise continues to inform sneaker culture as it did in the nineteenth century. The sneaker's intimate connection to athleticism also remains of importance, although its ever-increasing consumption as an item of fashion, especially in men's dress, reflects profound social shifts. This interest in sneaker-driven sartorial expression has encouraged men to participate in the fashion system in new ways. The widespread interest in urban men's fashion allows for greater expressions of individualism and challenges or reinterprets traditional notions of masculinity—in particular, what masculine success now looks like. As sneakers gain a greater presence in men's wardrobes, sneaker culture itself is growing exponentially. The new nexus between individuals and brands is expanding the vocabulary of style and allowing increasing voices to be heard. These wide-ranging interests in sneakers have also created new avenues for engagement, from gender politics to social change. How sneaker culture will continue to evolve remains to be seen, however, as the past two hundred years attest, it has earned its place in history and shows no sign of stopping.

COMMON PROJECTS
ACHILLES LOW, 2015
COMMON PROJECTS ARCHIVES

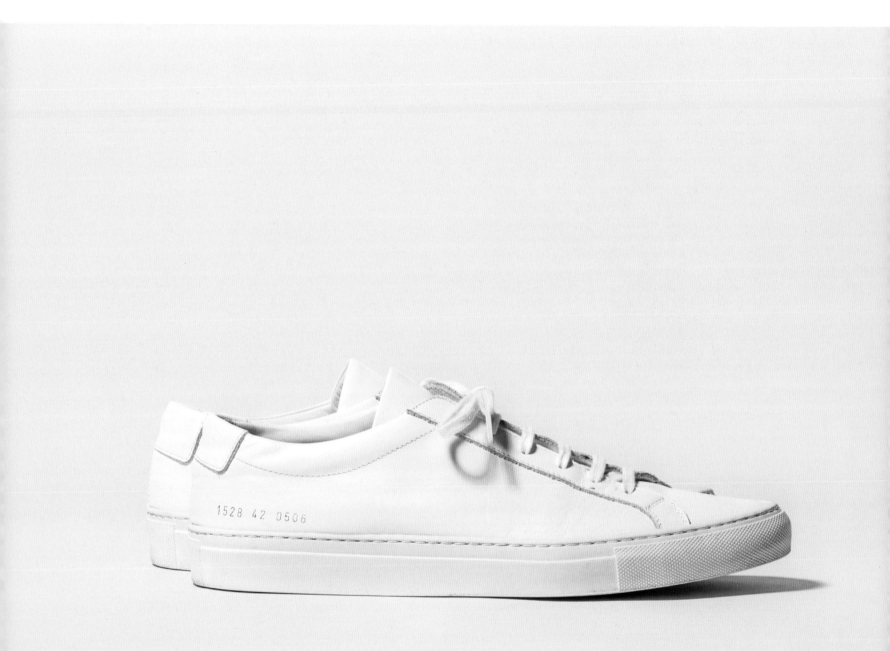

FOOTNOTES

1 There are a variety of plants in the Americas that yield latex sap. The tree *Heveabrasiliensis*, found in the Brazilian Amazon, gives the best-quality sap. Salo Vincour Coslovsky, "The Rise and Decline of the Amazonian Rubber Shoe Industry: A Tale of Technology, International Trade and Industrialization in the Early Nineteenth century" (PhD paper, unpublished, Massachusetts Institute of Technology, June 2006), 7.

2 Francois Fresneau, who La Condamine meet in Guiana, was fascinated by the rubber La Condamine showed him and was the first to understand its potential usefulness. John Loadman, *Tears of the Tree: The Story of Rubber–A Modern Marvel* (Oxford: Oxford University Press, 2005), 17–22.

3 Coslovsky, "The Rise and Decline of the Amazonian Rubber Shoe Industry," 11–12.

4 William H. Richardson, ed., *The Boot and Shoe Manufacturers' Assistant and Guide: Containing a Brief History of the Trade. History of India-rubber and Gutta-percha, and Their Application to the Manufacture of Boots and Shoes. Full Instructions in the Art, with Diagrams and Scales, Etc., Etc. Vulcanization and Sulphurization, English and American Patents. With an Elaborate Treatise on Tanning* (Boston: Higgins, Bradley & Dayton, 1858), 113.

5 M. P. Cheskin, *The Complete Handbook of Athletic Footwear* (New York: Fairchild, 1987), 5.

6 *Public Documents of Massachusetts* 4 (Massachusetts: 1835).

7 *The American Annual Cyclopedia and Register of Important Events of the Year* 5 (New York: D. Appleton & Co., 1869), 644.

8 As described by Paul W. Litchfield in 1939, quoted in John Tully, *The Devil's Milk: A Social History of Rubber* (New York: Monthly Review Press, 2011), 17.

9 "Confusingly, later in the century many ladies shoes of varying descriptions were called 'croquet shoes.'" John Nichols, *Gentleman's Magazine* 225 (London: Bradbury, Evans & Co., 1868), 235.

10 Tahir P. Hussein, *History, Foundation of Physical Education and Educational Psychology* (Pinnacle Technology, 2012).

11 Ibid.

12 In 1853, the land that would become the park was acquired and 1,600 poor city residents, including those who lived in the city's most established African American community, were displaced to carve out an expansive green space where people could find a respite from the throbbing metropolis and be returned to a bucolic setting where they could walk and boat in fine weather and skate in the wintertime. Roy Rozenweig and Elizabeth Blackmar, *The Park and the People: A History of Central Park* (Ithaca: Cornell University Press, 1992), 52–60.

13 "Park History," Prospect Park Alliance Online, accessed October 5, 2014, http://www.prospect-park.org/learn-more/park-history-slideshow/.

14 "Tennis Courts in Brooklyn Parks," *New York Times*, April 20, 1884, 3.

15 "'Sandbagging' in Chicago," *Barnstable Patriot*, February 8, 1887.

16 "Guyer's Shoe Store," *Sacred Heart Review* 2, no. 5, August 1895, 2.

17 Naismith details the origins of the game in his 1941 work, James Naismith, *Basketball: Its Origin and Development* (University of Nebraska Press, 1941).

18 "Planned for the East Side: A Concrete Structure to Cost $100,000 Is to Be Put Up in Rivington Street," *New York Times*, December 19, 1909, 11

19 "Active Woman's Game: Basket-ball the Rage for Society's Buds and Matrons," *Washington Post*, January 12, 1986.

20 There are a number of Colchester ads promoting "Bal shoes." This may be the source of some confusion. Bal stands for balmoral, a type of lace-up boot, not ball as in basketball.

21 Naismith, *Basketball*, 90.

22 "A Plea for Sports," *The Telegraph Herald*, June 24, 1917.

23 "National Disgrace says Senator Wadsworth," *Physical Culture Magazine* 38, no. 4, 1917.

24 Ibid.

25 Charlotte Macdonald, *Strong, Beautiful and Modern: National Fitness in Britain, New Zealand, Australia and Canada 1935–1960* (Wellington, New Zealand: Bridget Williams Books Ltd., 2011), 13.

26 "Protest Dumping of Japanese Shoes: Rubber Shoe Makers Include Czechoslovakia in Complaint to Customs Commissioner. Allege Sale Below Cost. Manufacturers Assert That Low-Priced Imports Will Close American Factories," *New York Times*, August 5, 1932, 29.

27 R. E. Andruss, "Time to Team up for Sport Shoe Week," *Boot and Shoe Recorder* 105, no. 6 (April 14, 1934): 24.

28 Discussion with Adidas Archive.

29 Owens stated in the press, "All we athletes get out of this Olympic business is a view out of a train or airplane window. . . . If a fellow considers offers, it's his own private business." However, any opportunities that might have emerged between Owens and the Dasslers were made impossible due to wartime politics; the Dasslers were swept up into the Nazi movement and the rampant racism faced by Owens when he returned home to the United States denied him opportunities offered to others. "Jesse Owens, Olympic Star is Suspended: Triple Winner for U.S. Believed Turning Professional," *Globe*, August 17, 1936.

30 Adolf Hitler, *Mein Kampf*, trans. James Murphy (London: Hurst & Blackett, 1939), 418.

31 Macdonald, *Strong, Beautiful and Modern*, 10.

32 Ibid.

33 Cheskin, *The Complete Handbook*, 14.

34 "Some Play Shoes off Rationing List: OPA Acts on Types Which Pile Up as Public Refuses to Use Stamps to Buy Them," *New York Times*, February 23, 1943.

35 Mary Beth Norton et al., *A People and Nation: A History of the United States*, vol. II, *Since 1865* (Belmont, California: Cengage Learning, 2014), 763.

36 Cheskin, *The Complete Handbook*, 16.

37 Ibid.

38 Jason Quick, "JOGGING GURU; Nike Founder Bowerman Popularized Running," *Cincinnati Post*, January 1, 2000, 8C.

39 Jack Anderson, "The Flabby American," *Free Lance Star*, April 12, 1973.

40 "Fashion Flashes," *Vogue*, April 1, 1977, 199.

41 "Something Afoot," *Globe and Mail*, May 13, 1978.

42 Ibid.

43 Ellen Roseman, "It's a Rat Race Keeping Up with the Jogging Joneses," *Globe and Mail*, June 12, 1978.

44 The Haillet did eventually have a green cloth added to the heel tab, which was later interpreted in leather on the Stan Smith.

45 Johnnie L. Roberts, "Stride Rite's Pro-Keds Takes a Run at Now-Fashionable Sneaker Market," *Wall Street Journal*, August 29, 1984.

46 Andrew D. Gilman, "Pity the Sneaker: Its Era Is Ended," *New York Times*, December 18, 1977.

47 Lars Anderson and Chad Millman, *Pickup Artists: Street Basketball in America* (London and New York: Verso, 1998), 10.

48 Ibid., 15–16.

49 Richard Lapchik, "The 2013 Racial and Gender Report Card: NBA," *UCF College of Business Administration: The Institute for Diversity and Ethics in Sport*, June 24, 2014, http://www.tidesport.org/The%202014%20Racial%20and%20Gender%20Report%20Card-%20NBA.pdf.

50 Greg Donaldson, "For Joggers and Muggers, the Trendy Sneaker," *New York Times*, July 7, 1979.

51 "Rap Legends Celebrate Hip-Hop's 40th Anniversary in New York's Central Park," *NME*, August 11, 2013.

52 Bobbito Garcia, *Where'd You Get Those? New York City's Sneaker Culture: 1960–1987* (New York: Testify Books, 2003), 12.

53 Ibid., 74.

54 Andrew Pollack, "Nike Struggles to Hit Its Stride Again," *New York Times*, May 19, 1985.

55 "Freestyle Forever! Reebok Celebrates the 25th Anniversary of One of the Most Successful Women's Footwear Collections of All Time—the Freestyle," Reebok Public Relations Release, March 1, 2007.

56 Pollack, *Nike Struggles*, 1985.

57 "Nike Rips Over a Loss of $2.1 Million," *Deseret News*, April 8, 1985.

58 Phil Patton, "The Selling of Michael Jordon: Uncanny Moves on the Court and 'A Charisma That Transcends his Sport' Have Created Basketball's Most Lucrative Property," *New York Times*, November 9, 1986.

59 Mary Flanner, "Sneakers: Putting on Airs," *Philadelphia Daily News*, April 3, 1985, 37.

60 Rick Telander, "SENSELESS in America's Cities, Kids are Killing Kids Over Sneakers and Other Sports Apparel Favored by Drug Dealers. Who's to Blame?," *Sports Illustrated*, May 14, 1990.

61 Ibid.

62 Jason Le, "History of Vans: Steve Van Doren Interview," *Sneaker Freaker*, accessed September 20, 2014, http://www.sneakerfreaker.com/features/the-history-of-vans.

63 Telander, "Senseless," 1990.

64 Les Payne, "Black Superstars Get Dunked for Nothing," *Newsday*, September 2, 1990.

65 Bill Brubaker, "Athletic Shoes: Beyond Big Business; Industry Has a Foothold on Defining Societal Values," *Washington Post*, March 10, 1991.

66 Joe Mullich, "Only Men are Challenged by Casual Friday Dress Code," *Business First*, April 22, 1996.

67 Bill Cosby, "Dr. Bill Cosby Speaks at the 50th Anniversary Commemoration of the Brown vs. Topeka Board of Education Supreme Court Decision," speech given at the NAACP Awards Ceremony, Washington, DC, March 2004, http://www.rci.rutgers.edu/~schochet/101/Cosby_Speech.htm.

68 Heba Hassan, "Kanye West's $245 Air Yeezy II Sneakers Sell Online for $90 000," *Time*, June 8, 2012.

69 Katie Abel, "Red State: Q&A with Christian Louboutin," *Footwear News*, November 19, 2012.

70 Ira, Berkow, "Jordan Owes It to Us All to Protest Those Sweatshops," *Chicago Tribune*, July 14, 1996, 16.

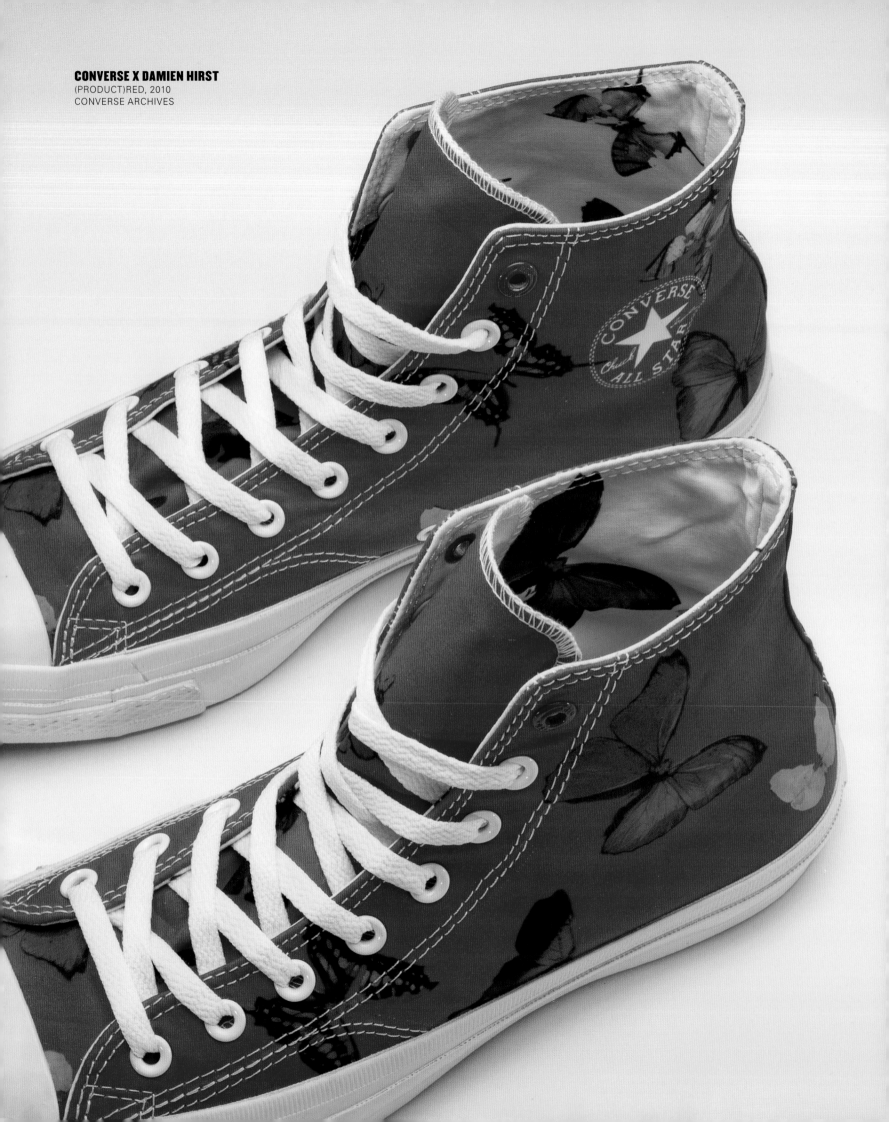

THE RISE OF SNEAKER CULTURE 1830-2015
A CHECKLIST OF THE EXHIBITION

In the early nineteenth century, Brazil supplied all of the world's rubber. Rubber had long been exploited by the indigenous peoples of Central and South America, but it wasn't until Westerners became interested in its potential that rubber goods, such as galoshes, entered the Western market. The earliest rubber overshoes were made in Brazil by dipping Western-style lasts, foot-shaped forms, into boiled latex. These stretchy waterproof overshoes captured the imagination of the Western world but proved to be unstable in both hot and cold temperatures. Brazilian rubber overshoes made for the American market were often embellished with incised floral decorations.

MANUFACTURER UNKNOWN
PRE-VULCANIZED RUBBER OVERSHOES
CA. 1830S
COLLECTION OF THE
BATA SHOE MUSEUM
P. 22

Despite the discovery of vulcanization in 1839, most serious running shoes were still made of leather in the middle of the nineteenth century. This pair is thought to be the oldest extant running shoes and features leather uppers and small heels similar to men's dress shoes of the period. The spikes on the soles, however, give them away as running shoes. The other unusual detail is the supporting broad band of leather across the instep.

THOMAS DUTTON AND
THOROWGOOD
RUNNING SHOE
1860–65
COLLECTION OF THE
NORTHAMPTON MUSEUMS
AND ART GALLERY
P. 24–25

This pair of women's athletic shoes was made in Italy around the turn of the century and features rubber soles that offered significant traction. The uppers are of tan kid and feature menswear details such as punch-work decoration. This nod to the male wardrobe reflects the fact that women were stepping into new roles and were embracing privileges that had previously been open to men only. This pair of shoes would have been worn to play tennis or to ride a bicycle.

MANUFACTURER UNKNOWN
ATHLETIC SHOE
CA. 1890S
COLLECTION OF THE
BATA SHOE MUSEUM
P. 30–31

These low-cut, lace-up sneakers would have been worn for a variety of athletic and leisurely pursuits at the end of the nineteenth century. They were made by the Goodyear Rubber Manufacturing Company, which was founded in the middle of the century. Although these are simple canvas shoes, they demonstrate a subtle elegance. The attention to detail seen in touches such as the addition of small decorative leather tabs below the lacing reflects the fact that the intended clientele was relatively privileged.

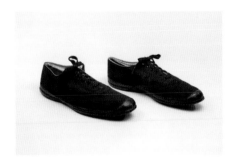

GOODYEAR RUBBER
MANUFACTURING CO.
LOW-TOP
CA. 1890S
COLLECTION OF THE
BATA SHOE MUSEUM
P. 27

This pair of children's high-top sneakers was made by the Beacon Falls Rubber Company in Connecticut and most likely dates to the early 1900s. The white, cotton canvas uppers and cream-colored rubber soles of these sneakers would have matched the summery fashions of the period. Although these are sneakers, one can imagine that the child who wore them was expected to keep them clean.

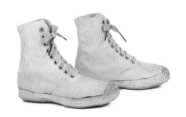

BEACON FALLS RUBBER CO.
HIGH-TOP
CA. 1900
COLLECTION OF THE
BATA SHOE MUSEUM
P. 32

PERFECTION RUBBER CO.
HIGH-TOP
EARLY 1900S
COLLECTION OF THE
BATA SHOE MUSEUM
P. 41

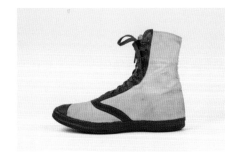

The khaki-colored uppers and brown rubber soles of this pair of Perfection high-tops were designed with the active child in mind. Dirt and stains would have been camouflaged by the color, and the waterproofing of the seams on the vamps would have helped to keep feet dry. Sneakers like this were clearly created for the rough-and-tumble reality of children's outdoor play.

UNITED RUBBER CO., KEDS
CHAMPION
1916
COLLECTION OF THE
BATA SHOE MUSEUM
P. 35

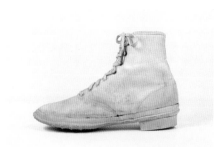

In 1916, the United Rubber Company debuted the Keds brand, and its first sneaker, the Champion, has been continuously available for almost one hundred years. The name of the brand was originally going to be Peds, inspired by the Latin word for feet, *pedes*, but it was changed to Keds after it was found that Peds was already in use. This pair of women's Champion sneakers is from the first year of the Keds brand.

CONVERSE RUBBER SHOE CO.
ALL STAR/NON SKID
1917
CONVERSE ARCHIVES
PP. 42–44

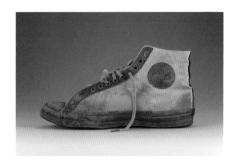

The famed All Star got its start in 1917, when the Converse Rubber Shoe Company debuted its new indoor gym shoe. Brown canvas models were marketed as All Stars, while the same shoes in white canvas and with a slightly different tread were called Non Skids. Both featured the brand's iconic toe cap, toe bumper, license plate on the heel, and an ankle patch over the inner ankle for protection. By 1921, famed basketball coach Chuck Taylor had joined the company to promote the sneaker as well as to advise on its design and development.

UNITED RUBBER CO., KEDS
CONQUEST
1924–29
COLLECTION OF THE
NORTHAMPTON MUSEUMS
AND ART GALLERY
P. 48

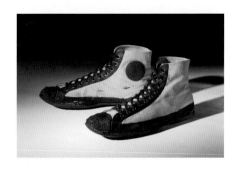

Basketball was invented by the Canadian-born James Naismith in Springfield, Massachusetts, in 1891, and went on to become one of the most popular sports in North America. A newspaper reported in 1915 that basketball was "ideally suited for winter conditions, when the body demands violent exercise," and could provide games that "thrilled the blood as much as any football contest." The popularity of basketball was not lost on sneaker manufacturers, and by the 1920s specially made basketball shoes were offered by most major brands.

DOMINION RUBBER CO.
FLEET FOOT
CA. 1925
COLLECTION OF THE
BATA SHOE MUSEUM
P. 47

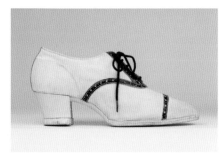

Although women had been encouraged to participate in physical culture since the second half of the nineteenth century, it wasn't until the 1920s that women were able to embrace a wide range of sports and female athletes were celebrated. Despite these advances, there were still abiding concerns that women's participation in athletics would detract from their femininity. This pair of rubber-soled footwear betrays these concerns. The menswear influence seen in the broguing suggests that women were stepping into the masculine realm, but the high heels confirm that the wearer was, without question, female.

GEBRÜDDER DASSLER
SCHUHFABRIK
MODELL WAITZER
1936
ADIDAS AG
P. 60–61

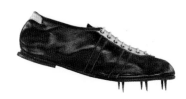

In 1936 at the Olympic Games in Berlin, shoemaker Adi Dassler offered his athletic shoes to an African American athlete from a rival country, despite being a German at the height of Nazism. That athlete was Jesse Owens, who went on to win four gold medals. Owens tested Dassler's shoes while at the Olympics, but it has yet to be proven that he wore them during his Olympic wins. The type of shoe Owens wore was a bespoke pair of Modell Waitzers, named after the German national coach Josef Waitzer, similar to this shoe.

Bata mass-produced canvas sneakers in the 1930s and was the largest shoe exporter in the world, responsible for shodding people across Europe, Southeast Asia, and Africa. In addition to prosaic sneakers, the company made performance running shoes. Like the pair of running spikes made by Adidas for Jesse Owens, this pair features leather uppers and leather soles with spikes for traction. The instep strap was designed to ensure that the shoes stayed on the sprinter's feet. Lightweight running shoes of man-made materials were not produced until after World War II.

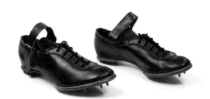

BATA
SPRINTING SHOE
PRE-1939
COLLECTION OF THE
BATA SHOE MUSEUM,
GIFT OF BATA TILBURY

Not all high-tops were intended for leisure or sporting pursuits. These aptly named Garrison high-tops date to 1940 and were part of the U.S. Army uniform. Unfortunately, the construction of the shoe was so poor that it proved to be a liability. The rubber shortage that emerged after the U.S. entered the war the following year led to the creation of even less satisfactory footwear, which eventually contributed to the development of the military combat boot.

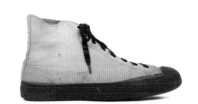

GARRISON
HIGH-TOP
1940
COLLECTION OF THE
BATA SHOE MUSEUM,
GIFT OF JONATHAN WALFORD

Converse sold a wide variety of high-tops in the 1940s and 1950s. Big Fives featured black canvas uppers with black rubber soles and were marketed as offering value at a reasonable price. The Big Five was one of the last models to feature grommets in the rubber sidewall; on later sneakers, the grommets would be placed in the canvas upper just above the rubber sidewall. The ankle patches, designed to offer protection for the ankle bones, prominently display the Converse logo.

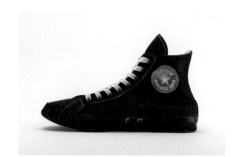

CONVERSE
BIG FIVE
LATE 1940S
COLLECTION OF THE
NORTHAMPTON MUSEUMS
AND ART GALLERY

In 1933, Hyman L. Whitman patented a type of arch support insole that he called Posture Foundation. A few years later, this insole was found in sneakers by B. F. Goodrich and Hood, a subsidiary of B. F. Goodrich. In 1944, this type of arch support was added to children's sneakers and the P. F. Flyer was born. P. F. Flyers enjoyed great popularity in the postwar years, when sneakers emerged as the essential footwear of the baby boomers. This pair of P. F. Flyers was probably worn by a high school or university athlete.

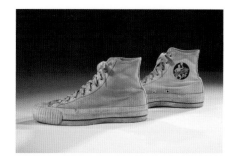

B. F. GOODRICH
P. F. FLYER
LATE 1940S–50S
COLLECTION OF THE
BATA SHOE MUSEUM
P. 64

These high-tops may look like Converse All Stars, but they are Converse Grippers, a style popular in the late 1940s and early 1950s. These postwar sneakers were advertised as being made from sturdy Army duck cloth, and their heavy ribbed white toe guards, ventilating perforations, and duck-covered insoles with "comfort cushioned arches" were designed for wear to play basketball as well as general sports.

CONVERSE
GRIPPER
LATE 1940S–EARLY 1950S
COLECTION OF THE
BATA SHOE MUSEUM
P. 66–67

In Zlin, Bata had been producing its famous Trampki high-top since the 1930s, but in North America it was the Bata Bullet that became popular in the 1950s, 1960s, and into the 1970s. They were one of the few types of shoes made by Bata in the U.S. and were manufactured in Maryland. Bata Bullets were the official footwear of the Baltimore Bullets basketball team from 1944 to 1954. This pair dates to the 1950s.

BATA
BULLET
CA. 1950S
COLLECTION OF THE
BATA SHOE MUSEUM

CONVERSE
TRACK STAR
1957–68
COLLECTION OF THE
NORTHAMPTON MUSEUMS
AND ART GALLERY

Although Converse had become famous for making basketball shoes in the first half of the twentieth century, its running shoe, the Converse Track Star, became very popular after it was introduced in 1959. The Track Star was promoted as a lightweight and well-priced running shoe that provided "confident footing," and many high school and university athletes embraced it. The prominent stripes found on the uppers were used by Converse for only a short time.

CONVERSE
ALL STAR
1958
CONVERSE ARCHIVES

The All Star may be presumed to be an unchanging icon, yet over the decades alterations have been made. The most dramatic was the addition of Chuck Taylor's name to the All Star in 1934, but over the years subtle tweaks to the graphics on the ankle patch and license plate have occurred. The graphics of the ankle patch on this pair, for example, would change on All Stars made the next year.

ADIDAS
REKORD
1960
ADIDAS AG

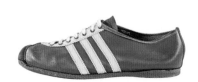

This rare Adidas sneaker dates to 1960. The blue color and smooth leather established the look of athletic footwear that would last for decades. The popularity of these sleek sports shoes also signaled the emerging European dominance of the sneaker market that was to mark the 1960s.

ADIDAS
ALLROUND
1960
ADIDAS AG

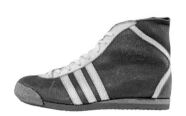

In response to the request by many athletes for a leather high-top, Adidas debuted the Allround in the 1950s. Although designed to be worn while playing a number of indoor sports, it was primarily worn for basketball. The bright blue color and yellow midsole foreshadowed the riotous colors that would define sneaker fashion a decade later.

DUNLOP
GREEN FLASH
CA. 1960
COLLECTION OF THE
NORTHAMPTON MUSEUMS
AND ART GALLERY
P. 55

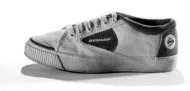

Today, Dunlop is famous for making tires, but for most of the twentieth century it was famous for making sneakers too. The Dunlop company made sneakers as early as the 1870s, but by the 1930s it was shifting its focus to making tennis shoes. The British tennis champion Fred Perry wore Green Flash sneakers in the 1930s, and it remained an important tennis shoe well into the middle of the century. This pair dates to the early 1960s. The padded throat line is a nod to the wearer's comfort.

ADIDAS
SAMBA
1965
ADIDAS AG
P. 75

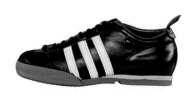

The original Adidas Samba was launched in 1950 and was designed for wear in icy conditions. By the 1960s the shoe was gaining in popularity, and in the 1970s it was remodeled for indoor soccer practice; it soon became one of the best-selling sneakers in the history of Adidas. This example dates to the mid-1960s and features a hallmark of Adidas footwear: the name of the shoe stamped in gold on the side.

World champion badminton player Jack Purcell was one of Canada's most famous athletes in the 1930s. In 1935, he signed on with B. F. Goodrich to create the Jack Purcell sneaker, designed to improve performance on the badminton court. It went on to become a style icon. One of the hallmarks of Jack Purcell sneakers is the "smile" line at the toe; this detail was retained by Converse when it acquired the trademark rights in 1972. This pair predates that acquisition, and was made by B. F. Goodrich.

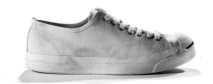

B.F. GOODRICH
JACK PURCELL
1965–69
COLLECTION OF THE
NORTHAMPTON MUSEUMS
AND ART GALLERY
P. 52–53

The first Adidas Gazelle was introduced in 1965 as a soccer shoe but was quickly embraced by soccer fans for streetwear, especially in the United Kingdom. By the early 1970s, the Gazelle was available in North America through specialty sporting goods stores. These brightly hued sneakers were soon adopted by those whose interest was in the pursuit of fashion rather than just fitness in North America.

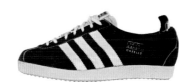

ADIDAS
GAZELLE
1971
ADIDAS AG
P. 76–77

The shoe that would go on to become one of Adidas's most popular models, the Stan Smith, was first created for French tennis great Robert Haillet in 1964. The Haillet featured a leather upper and thick outsole. In keeping with the all-white rule for tennis clothes, embellishment on these sneakers was limited to Haillet's signature and a small green felt tab at the heel. Adidas's iconic three stripes were rendered in perforated holes to increase circulation.

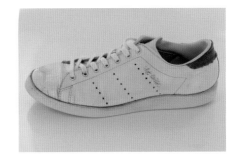

ADIDAS
ROBERT HAILLET
1968–72
COLLECTION OF THE
NORTHAMPTON MUSEUMS
AND ART GALLERY

Before the Puma Clyde came the Puma Suede. Basketball great Walt "Clyde" Frazier was searching for a custom-made pair of Puma Suedes when Puma decided to redesign the shoe for him by making it a bit lighter and wider. The company also stamped the redesigned shoe with the name "Clyde" on the side in gold. It quickly became a street-wear staple.

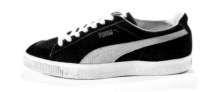

PUMA
SUEDE
CA. 1970S
COLLECTION OF THE
NORTHAMPTON MUSEUMS
AND ART GALLERY
P. 78

In 1971, Adidas approached tennis great Stan Smith with the idea of having him endorse one of its tennis shoes. The Haillet was chosen as the model, and for a brief history in the evolution of the Haillet to the Stan Smith, the sneaker featured two endorsements. Haillet's signature remained on the upper, while Stan's Smith portrait and signature were added to the tongue. By 1978, however, Haillet had retired from tennis, and his name was dropped from the shoe, allowing it to become known simply as the Stan Smith.

ADIDAS
HAILLET/STAN SMITH
CA. 1970S
COLLECTION OF THE
NORTHAMPTON MUSEUMS
AND ART GALLERY

In 1949, Keds introduced the PRO-Ked brand of basketball shoes, and by the 1970s the PRO-Keds Royal had established firm footing in the New York hip-hop scene. Like the ubiquitous Converse All Star, the PRO-Ked Royal Hi featured a breathable canvas upper and ankle patches bearing the brand name, but it also featured distinctive red and blue stripes on the foxing that made it easily identifiable even when worn with long pants.

KEDS
PRO-KEDS ROYAL HI
CA. 1970S
COLLECTION OF THE
NORTHAMPTON MUSEUMS
AND ART GALLERY

NIKE
CORTEZ
1972
NIKE ARCHIVES
P. 81

In the early 1970s, Bill Bowerman and Phil Knight already had a company, Blue Ribbon Sports, which sold Onitsuka Tiger sneakers imported from Japan. In 1972, however, they debuted a lightweight running shoe of Bowerman's design under a new independent brand name—Nike—and sneaker history was made. The name Nike comes from the ancient Greek winged goddess of victory.

NIKE
WAFFLE TRAINER
1974
COLLECTION OF THE
NORTHAMPTON MUSEUMS
AND ART GALLERY
P. 84–85

In his quest to make lightweight running shoes, Bill Bowerman was constantly seeking improvements. In 1965, in collaboration with Jeff Johnson, he introduced nylon uppers and cushioned insoles for running shoes, but it wasn't until he destroyed his wife's waffle maker that he managed to revolutionize the running shoe. Bowerman discovered that by pressing rubber into a waffle maker, he could create soles that used less material yet featured durable treads. His famously lightweight Nike Waffle Trainer debuted in 1974.

LE COQ SPORTIF
ARTHUR ASHE
CA. 1975
COLLECTION OF THE
NORTHAMPTON MUSEUMS
AND ART GALLERY

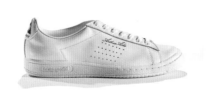

In 1975, the French brand Le Coq Sportif outfitted American tennis star Arthur Ashe for his match against Jimmy Connors at Wimbledon. Ashe won and became the first African American to win a Wimbledon Championship. The 1975 Arthur Ashe sneaker features clean lines and a monochromatic palette, as well as a perforated leather upper designed to keep the feet cool, which have made it an enduring tennis classic.

BATA X WILSON
JOHN WOODEN
1977
COLLECTION OF THE
BATA SHOE MUSEUM,
GIFT OF BOBBITO GARCIA

This rare pair of 1977 Bata x Wilson x John Woodens was donated to the museum by famed sneaker historian Bobbito Garcia. John Wooden was one of America's winningest college basketball coaches and is the only person to be inducted into the Basketball Hall of Fame as both a player and a coach. His signature shoe featured a revolutionary polyurethane sole that was exceptionally lightweight to reduce fatigue and improve endurance. Despite the sneaker's design excellence, it was available for only one year; today, it is one of the most sought-after sneakers by sneaker collectors.

ASICS
TIGER CORSAIR
1977–79
COLLECTION OF THE
NORTHAMPTON MUSEUMS
AND ART GALLERY

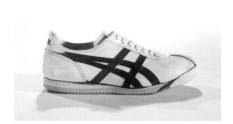

The ASICS Tiger Corsair was a relative of the Nike Cortez, the sneaker developed by Bill Bowerman. The Corsair was first embraced as a jogging shoe but quickly became an exceptionally popular leisure shoe as well. This pair dates to the late 1970s, after Onitsuka Tiger was renamed in 1977. The new name, ASICS, is an acronym derived from the Latin phrase *anima sana in corpore sano*, which means "a sound soul in a sound body."

ADIDAS
JABBAR
EARLY 2000S RETRO OF 1978
ADIDAS AG

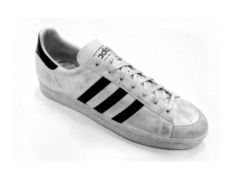

Kareem Abdul-Jabbar was one of the best basketball players of all time, and in 1971, Adidas debuted his signature shoe. The Jabbar was available in both high- and low-top versions, and it was extremely popular until the early 1980s. According to Bobbito Garcia, it was the popularity of the Jabbar both on and off the court that secured the Adidas brand in hip-hop fashion. This pair from the early 2000s is an exact copy of the 1978 low-top Jabbar pictured on page 109.

As its name implies, the Adidas Marathon 80 was designed for running, particularly for long-distance marathons. It excelled at shock absorption. Over the course of the 1970s, running and jogging became increasingly popular sports with both men and women; unisex sneakers like the Marathon 80 were embraced by both genders.

ADIDAS
MARATHON 80
1979
COLLECTION OF THE
NORTHAMPTON MUSEUMS
AND ART GALLERY

One of Adidas's most popular sneakers has been the Stan Smith. The Stan Smith was the same model as the sneaker designed for Robert Haillet in 1964, but was updated in 1971 to include tennis star Stan Smith's name and image. By 1978 the Haillet's name was dropped and the shoe officially became known as the Stan Smith. Later models, such as this 1980s version, featured Stan Smith's image and signature as well as the higher heel tab embellished with the Adidas trefoil.

ADIDAS
STAN SMITH
CA. 1980S
ADIDAS AG
P. 89

The Adidas Superstar debuted in 1969 and was the first low-cut leather basketball sneaker. Its distinctive toe earned it the nickname of Shell Toe, and in short order both professional and amateur basketball players were sporting pairs. The entrance of Adidas into the North American basketball market signaled a shift in the sneaker game; no longer would basketball shoes be predominantly North American in design and manufacture. Superstars are always white, but over the years the stripes and heel tabs have come in different colors.

ADIDAS
SUPERSTAR
CA. 1980S
ADIDAS AG

The Superstar II debuted as an improvement on the Superstar and featured Cangoran synthetic leather with white suede accents as well as a hard gum rubber sole. The missing shell toe, however, diminished its popularity, and it remained overshadowed by the original version.

ADIDAS
SUPERSTAR II
CA. 1978
(PICTURED) ADIDAS AG
(EXHIBITED) COLLECTION OF THE
NORTHAMPTON MUSEUMS AND
ART GALLERY

Half Gazelle and half Jabbar, the Adidas Campus debuted in the late 1970s as a low-top basketball shoe but went on to be embraced as a lifestyle shoe. Its popularity only increased when the Campus became the signature shoe of Beastie Boys and skateboarders began wearing it. The development of the Campus Vulc transformed the Campus into a dedicated skate shoe.

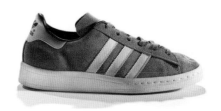

ADIDAS
CAMPUS
CA. 1980S
COLLECTION OF THE
NORTHAMPTON MUSEUMS
AND ART GALLERY

The Saucony Jazz running shoe debuted in 1981 and quickly became a cult favorite among runners. The Saucony last features the narrow heel shape of figure skating footwear and the wide forefoot of the football cleat. This heel-to-forefoot ratio is particularly suited to women's feet, and the sneaker soon became popular with female runners. The triangular tread blocks on the sole provide superior traction as well as midsole comfort when running on pavement. It remains the most popular model sold by Saucony.

SAUCONY
JAZZ
1981–84
COLLECTION OF THE
NORTHAMPTON MUSEUMS
AND ART GALLERY

GUCCI
TENNIS SHOES
CA. 1980S
COLLECTION OF THE
NORTHAMPTON MUSEUMS
AND ART GALLERY
P. 144

Schoolly D may have been referring to his watch when he rapped "Looking at my Gucci it's about that time," but he could have been looking at a pair of Gucci sneakers. Living large in the 1980s included sporting luxury brands, and Gucci was one of the first to enter the sneaker game on the wave of preppy fashion. This pair of canvas Gucci sneakers insinuated country club exclusivity but brashly promoted its pedigree through its highly visible Gucci stripes.

VANS
CHECKERBOARD SLIP-ON
2014 RETRO OF 1980S
COLLECTION OF THE
BATA SHOE MUSEUM,
GIFT OF VANS
P. 147

Inspired by surfing, skateboarding emerged in California in the 1950s. Vans was the first company devoted to making skate shoes and in 1976 debuted the first Off the Wall Vans. Of all the shoes Vans has made, the Checkerboard slip-ons are the most iconic. Memorialized in the film *Fast Times at Ridgemont High*, the checkerboard pattern inspired by designs kids drew on their sneakers has become an icon of skateboard culture. This example dates to 2014.

VANS
LOW-TOP
CA. 1980S
COLLECTION OF THE
BATA SHOE MUSEUM

The goal of Vans cofounder Paul Van Doran was to build shoes like Sherman tanks. Skateboarding requires hardwearing footwear with soles thick enough to withstand high-speed contact with pavement, yet responsive enough to let the rider feel the board. Vans fit the bill and skateboarders swarmed to the brand. In addition to using sturdy canvas and thick vulcanized soles, in the late 1970s the company started using leather to make skate shoes.

NIKE
AIR FORCE 1
1982
NIKE ARCHIVES
P. 114–15

Bruce Kilgore designed the Nike Air Force 1, one of the most important sneakers within sneaker culture, in 1982. This first version came in white with a light-gray Swoosh design, but in 1986 an all-white version was released. Although the AF1 went on to come out in multiple colorways, the white-on-white version became a staple of streetwear. Worn in pristine condition, the all-white AF1 became a means of signifying status and secured its enduring position in sneaker history.

REEBOK
FREESTYLE
1982
COLLECTION OF THE
NORTHAMPTON MUSEUMS
AND ART GALLERY
P. 110–11

The fitness craze and, in particular, the arrival of aerobics in the late 1970s opened up a whole new market for specialized athletic footwear designed for women. Although Reebok was not the first company to seek to meet the needs of this emerging market, its innovative Freestyle sneaker went on to be the most popular aerobics shoe ever made and helped to define the age. These Freestyles are in bubblegum pink, leaving no room for confusion as to the gender of the intended wearer.

NIKE
FRANCHISE
1981
COLLECTION OF
BOBBITO GARCIA
P. 97

The Nike Franchise became important both on the court and on the street. Bobbito Garcia, DJ, author, filmmaker, and important sneaker historian, has proclaimed the Franchise his all-time favorite shoe in part because they came in almost innumerable colorways. This pair of white-on-white Franchises from 1981 comes from his personal collection.

By the early 1980s, computer technology was embraced in athletic footwear as a means of enhancing athletic performance. The revolutionary Adidas Micropacer was released in 1984 and had a microsensor in the left toe that could record distance, running pace, and caloric consumption. This information was retrieved on the readout screen found on the tongue of the left shoe. The prominence of the small readout screen was only one of the futuristic aspects of the sneaker; the choice of silver gilt leather and unusual lace covers also established that these sneakers were part of a new era.

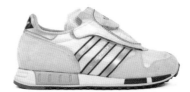

ADIDAS
MICROPACER
1984
COLLECTION OF THE
BATA SHOE MUSEUM,
GIFT OF PHILLIP NUTT
PP. 152–153

The Adidas Kegler Super used the same peg-system concept first designed for the 1984 LA Trainer to offer athletes customizable comfort. The colored pegs of the "Vario Shock Absorption System" had different densities, and one's choice of pegs customized the firmness of the sole. The blue key was the means by which the pegs were inserted into and removed from the sole. The Kegler Super was introduced in 1984 and was kept in production well into the 1990s.

ADIDAS
KEGLER SUPER
MID 1980S
COLLECTION OF THE
BATA SHOE MUSEUM,
GIFT OF PHILLIP NUTT

In the late 1980s, the brand Troop emerged, but it managed to last only four years. The brand was closely aligned with hip-hop and numerous rappers, including LL Cool J, Chuck D, and Flava Flav, all wore Troop. The brand was plagued, however, by baseless rumors and folded in 1989.

TROOP
STREET FORCE
1985–1989
COLLECTION OF THE
NORTHAMPTON MUSEUMS
AND ART GALLERY

Chicago Bear Walter Payton was one of football's greatest running backs, and in the 1980s he wore KangaROOS. This pair of Walter Paytons was endorsed by the Sweetness himself and was designed as a serious athletic shoe. The feature that made KangaROOS unique, however, was the Velcro-covered zip pocket that was designed to hold a stash of cash or other small necessities. Caught between being a lifestyle brand and a performance athletic company, the original company lasted only until the late 1980s.

KANGAROOS
WALTER PAYTON #34 ROOS
1985
COLLECTION OF THE
BATA SHOE MUSEUM

In 1991, the upstart American sneaker brand British Knights proclaimed that it was part of a new generation with the slogan "Your mother wears Nike." The brand had debuted in 1983 with a conservative canvas shoe, but by the mid-1980s had shifted focus to the urban consumer. This change was made clear in a press release stating that "the only way to get a middle-class suburban high school kid to buy your product is to have an inner-city kid wear it." The appeal of the BK sneaker did not survive, however, and British Knights fell out of fashion.

BRITISH KNIGHTS
KING
1985
COLLECTION OF THE
NORTHAMPTON MUSEUMS
AND ART GALLERY
P. 145

In 1984, Nike began making sneakers for the phenomenal Chicago Bulls rookie Michael Jordan. However, the NBA did not allow colorful sneakers to be worn, so each time Jordan wore a pair of red-and-black Air Jordans during a game he was fined $5,000. Jordan's defiant flouting of the rules combined with his athletic prowess transformed his footwear into icons. The controversy fueled fans' desire for the shoes, and in 1985 the first Air Jordans were released.

NOTE: Air Jordans I, III, XI, XVII, and XX appear in two sections in the exhibition, but are represented by one photograph.

NIKE
AIR JORDAN I
1985
(PICTURED) KOSOW SNEAKER
MUSEUM (ELECTRIC PURPLE
CHAMELEON, LLC)
(ALSO EXHIBITED)
NIKE ARCHIVES
COVER, P. 2, 120, 121

CONVERSE
WEAPON
1986
COLLECTION OF THE
NORTHAMPTON MUSEUMS
AND ART GALLERY
P. 112

The Converse Weapon was a far cry from the classic canvas Chuck Taylor All Star. Indeed, it was one of the most advanced basketball shoes of the era, boasting the Converse Y-bar system designed to offer players' feet greater stability. NBA greats Larry Bird of the Boston Celtics and Magic Johnson of the L.A. Lakers both wore Converse Weapons during the dramatic 1986 NBA finals, making the Weapon the shoe of choice for many fans. This pair sports the L.A. Lakers colorway.

NIKE
AIR JORDAN II
1986
KOSOW SNEAKER MUSEUM
(ELECTRIC PURPLE
CHAMELEON, LLC)
P. 122

The second Air Jordan was designed by Bruce Kilgore and Peter Moore for the 1986–1987 basketball season. It was a slick design and was manufactured in Italy. It was the first Nike shoe not to feature the iconic swoosh and, like the Air Jordan I, signaled that basketball shoes were changing. The IIs came in both high- and low-top versions. Michael Jordan wore the lows when he was recuperating from a broken foot.

NIKE
AIR TRAINER 1
1987
NIKE ARCHIVES
P. 228

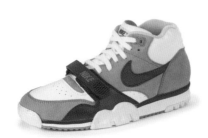

The Nike Air Trainer 1, Nike's first cross-trainer, was designed by Tinker Hatfield, after he observed athletes changing into different footwear for running and weightlifting. These sneakers were phenomenally popular and opened up new possibilities for the world of sneakers.

REEBOK
COMMITMENT
1988
REEBOK ARCHIVES

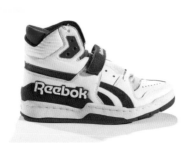

Worn by L.A. Clipper rookie and NCAA champion Danny Manning, the Reebok Commitment was a highly visible shoe with bold branding and strong graphic lines. The Velcro instep strap allowed the shoe to be secured to the foot, but it also made it a stylish streetwear choice. The Commitment, along with the Pump, declared Reebok's arrival in the world of basketball.

NIKE
AIR JORDAN III
1988
(PICTURED) KOSOW SNEAKER
MUSEUM (ELECTRIC PURPLE
CHAMELEON, LLC)
P. 122
(ALSO EXHIBITED) 2001 RETRO;
NIKE ARCHIVES

The Air Jordan III was Tinker Hatfield's first Air Jordan design, and it remains one of the most celebrated. The elephant-print leather "floater" was created to meet Michael Jordan's desire for a shoe that felt immediately worn in, as he typically wore a new pair of sneakers for every game. It was also the first Air Jordan to feature the Jumpman logo. The III was part of the first wave of Jordan III retros, rereleases of iconic sneakers, starting in 1994, after Jordan first retired from basketball.

NOTE: Air Jordans I, III, XI, XVII, and XX appear in two sections in the exhibition, but are represented by one photograph.

REEBOK
PUMP PROTOTYPE
1989
REEBOK ARCHIVES

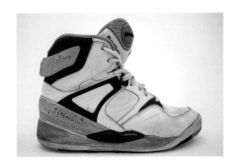

In the quest to make the lightest and most custom-fitting basketball shoe, Reebok's Paul Litchfield built upon the idea of a pumping mechanism first conceived of for a ski boot. He innovated an inflatable bladder that was activated by means of a button on the tongue, which expanded to customize the fit of the shoe. The Pump's cutting-edge technology and individualized fit made it one of the most sought-after sneakers, and its unprecedented price tag of $170 made it infamous.

The Air Jordan IV was designed by Tinker Hatfield in 1989. It was worn by Michael Jordan when he made "the Shot," his series-winning basket in Game 5 of the 1989 Eastern Conference First Round against the Cleveland Cavaliers.

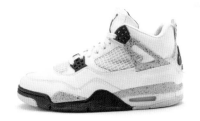

NIKE
AIR JORDAN IV
1989
KOSOW SNEAKER MUSEUM
(ELECTRIC PURPLE
CHAMELEON, LLC)
P. 123

The ZX 5000 was designed as a running shoe and was part of the first generation of Adidas shoes using Torsion technology, which used an instep stability bar that allowed the forepart of the foot and the heel to move independently while supporting the midsole. This system allowed the forepart of the runner's foot to respond to multiple surfaces while supporting the rest of the foot.

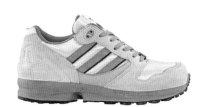

ADIDAS
ZX 5000
1989
ADIDAS AG

PONY, which stands for Product of New York, was founded in New York in 1972. It quickly gained prominence within the sneaker market, especially with its running and basketball shoes. This M-100 came out in 1989 and features colors that could be construed as feminine, but there is no mistaking the fact that it was intended for the male customer.

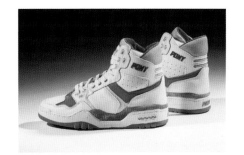

PONY
M-100
1989
COLLECTION OF THE
BATA SHOE MUSEUM,
GIFT OF PONY
P. 113

The Air Jordan V was designed by Tinker Hatfield, and it is said that he was inspired when creating the shoe by the shark-tooth motif that would frequently embellish World War II fighter jets. Hallmarks of the design are the reflective tongue, translucent sole, and, most noticeably, the shark-tooth motif on the sneakers' side wall.

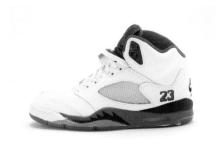

NIKE
AIR JORDAN V
1990
KOSOW SNEAKER MUSEUM
(ELECTRIC PURPLE
CHAMELEON, LLC)
P. 123

Michael Jordan was wearing Air Jordan VIs when he won his first NBA championship. The VI featured a rubber tongue with two cutouts and "spoiler" in place of a loop at the heel, designed by Tinker Hatfield to allow the shoe to be quickly slipped on. At Michael Jordan's request, the VI also featured a reinforced toe. The VIs were released in five different colorways, including Black and Infrared. The VI was also the last Air Jordan to feature a visible air chamber in the sidewall of the midsole.

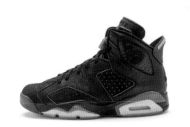

NIKE
AIR JORDAN VI
1991
KOSOW SNEAKER MUSEUM
(ELECTRIC PURPLE
CHAMELEON, LLC)
P. 124, 125

In 1989, the famous basketball player Patrick Ewing eschewed getting a signature shoe from an existing manufacturer and instead started his own company. The most popular sneaker Ewing Athletics produced was the 33 HI. It featured ski boot–like styling and became a cult favorite. This model was the first style to be retroed when the brand relaunched in 2012.

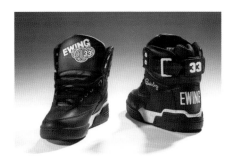

EWING ATHLETICS
EWING 33 HI
1991
COLLECTION OF THE
BATA SHOE MUSEUM, GIFT OF
EWING ATHLETICS
P. 158

NIKE
AIR MOWABB
1991
NIKE ARCHIVES

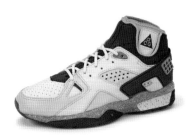

Tinker Hatfield designed the Nike Air Mowabb as an outdoor training shoe that was part running shoe and part hiking boot. The Air Mowabb was one of Nike's first ACG (All Conditions Gear) offerings and incorporated aspects of the Nike Air Huarache and the Wildwood. Its original colors reinforced its hiking boot associations; it looked rugged and able to handle the dirt of the real world beyond the gym.

NIKE
AIR JORDAN VII
1992
KOSOW SNEAKER MUSEUM
(ELECTRIC PURPLE
CHAMELEON, LLC)
P. 126

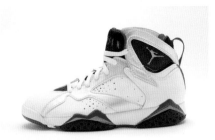

The VIIs came out in 1992, the same year that Jordan won his second NBA championship and went to the Olympics as part of the Dream Team. The design of the VII, while similar to the VI, incorporated Huarache technology, including a neoprene inner sock. It also did not feature the Nike Air logo or the sidewall air pocket window. The Olympic version of the shoe used Jordan's Olympic number 9 rather than number 23, his Chicago Bulls number.

REEBOK
INSTA PUMP FURY
1993
COLLECTION OF THE
BATA SHOE MUSEUM,
GIFT OF REEBOK

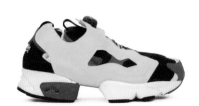

The Insta Pump Fury, aimed at runners, was part of the series of inflation technology shoes created by Reebok in the 1990s, but its futuristic styling caught the attention of the fashion forward. The Insta Pump Fury was designed to be exceptionally lightweight and dispensed with both laces and a manually inflatable bladder. Instead it came with independent CO_2 cartridges that inflated the bladder at the instep, insuring a snug and individualized fit without the need for laces. The Insta Pump Fury was tested in the 1992 Summer Olympic Games and was debuted to the public in 1993.

NIKE
AIR JORDAN VIII
1993
KOSOW SNEAKER MUSEUM
(ELECTRIC PURPLE
CHAMELEON, LLC)
P. 126

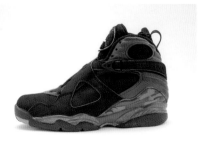

The VIIIs featured another rendition of the innovative strapping system that Tinker Hatfield had introduced with the Air Raid. Like the Air Raid, the straps crisscrossed the shoe, allowing the shoe to be tightly fitted to the foot. It also featured a chenille rendition of the Jumpman logo on the tongue. The shoe was released in three colorways, including Black and Bright Concord–Aqua Tone, that Michael Jordan wore during the NBA All Star game in 1993.

NIKE
AIR JORDAN IX
1993–94
KOSOW SNEAKER MUSEUM
(ELECTRIC PURPLE
CHAMELEON, LLC)
P. 127

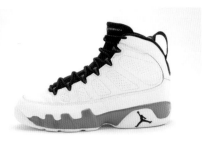

The IX came out the year Michael Jordan retired from basketball to pursue a childhood dream of playing baseball. Although he never wore a pair in the NBA, other players did, and he received redesigned IX baseball cleats, which he wore to play minor league ball. The design of the IX is strikingly minimalist in form, featuring a one-pull lacing system, but is embellished on the outsole with inspirational words in different languages from German to Swahili that Tinker Hatfield chose to represent Michael Jordan's international superstar status.

NIKE
AIR JORDAN X
1995
KOSOW SNEAKER MUSEUM
(ELECTRIC PURPLE
CHAMELEON, LLC)
P. 127

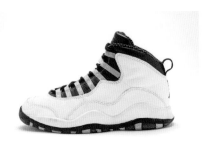

The X, also called the comeback shoe, was the model worn by Michael Jordan when he returned to the NBA in 1995. Tinker Hatfield's original design of the X had not been done in consultation with Jordan, resulting in the removal of the shallow toe cap at Jordan's request when the X was released later in the year. The outsole of the X features all of Jordan's accomplishments up until 1994.

The biomorphic features of the Air Max 95 were intended to be analogous to the structure of the human body. The lacing mirrors the spine, the straps are the ribs, and the panels that create the uppers are meant to suggest the muscular system and the skin. These shoes were designed as running shoes but have become staples of casual style as well.

NIKE
AIR MAX 95
1995
COLLECTION OF DEE WELLS

Reebok designer Jonathan Morris created the Shaqnosis for legendary basketball player Shaquille O'Neal in 1995. The hypnotic design of concentric circles in black and white ripple out across the uppers and continue under the sole, functioning like zebra stripes, confusing the opposition so that it is unclear where one shoe begins and the other finishes. The striking design made the Shaqnosis one of the most memorable shoes of the 1990s.

REEBOK
SHAQNOSIS
2013 RETRO OF 1995
REEBOK ARCHIVES

The futuristic Nike Air Zoom Flight 95 not only had space-age styling but was also the first Nike in the Zoom line and featured full-length Zoom Air. The large bulging ovals in the midsoles were the source of the shoe's nickname, Bug Eyes. NBA All Star Jason Kidd wore them the year he played for Dallas; many felt that the unusual shoes suited his maverick playing style.

NIKE
AIR ZOOM FLIGHT 95 HI
PLAYER'S SAMPLE
1995
COLLECTION OF THE
BATA SHOE MUSEUM,
GIFT OF KEN SO

The Air Jordan XI is one of the most popular models of all the Air Jordans; it is also one of Tinker Hatfield's favorite shoes. When Michael Jordan saw its elegant design, he foretold that the XIs would be worn not only for athletics but also with suits. His prophecy proved to be true. The fervor over the XIs began even before the sneakers were officially released. Michael Jordan wore a sample pair at the end of his first season back at the NBA, letting the cat out of the bag and creating a stir among sneakerheads. The White/Columbia Blue colorway debuted in 2000 when the XI was first retroed.

NOTE: Air Jordans I, III, XI, XVII, and XX appear in two sections in the exhibition, but are represented by one photograph.

JORDAN BRAND
AIR JORDAN XI
2000 RETRO OF 1996
(PICTURED) KOSOW SNEAKER
MUSEUM (ELECTRIC PURPLE
CHAMELEON, LLC)
P. 128–129
(ALSO EXHIBITED) NIKE, AIR
JORDAN XI, 1995, NIKE ARCHIVES
P. 130–131

Over the years, Reebok has made basketball shoes with strong aesthetic as well as athletic appeal. Like its predecessor the Shaqnosis, the Blast offered graphic punch along with performance; Nick van Excel wore them while playing for the Lakers. This prototype from the Reebok Archives is dated January 6, 1996, and is solid white with a black blast rather than having a half-white/half-black upper with contrasting blasts as seen in the 2014 rerelease.

REEBOK
BLAST
1996
REEBOK ARCHIVES

One of Tobie Hatfield's most famous designs was the Gold Shoe made for sprinter Michael Johnson and worn by him in the 1996 Olympic Games in Atlanta. They were the lightest-weight track spikes at the time, and Johnson wore them when he gained two gold medals in his historic 200- and 400- meter wins. At the following Olympic Games, in Sydney, Johnson wore shoes designed by Tobie again, but this time they were made with a new 24 karat gold–covered material. This pair donated in 1997 to the Bata Shoe Museum has shoes of different sizes; Johnson's left foot is 10.5, while his right is size 11.

NIKE
MICHAEL JOHNSON
GOLD SHOE
1996
COLLECTION OF THE
BATA SHOE MUSEUM

FILA
GRANT HILL II
1996
COLLECTION OF
FONDAZIONE FILA MUSEUM,
BIELLA, ITALY
P. 159

Fila was established in Italy in 1911 and became a staple brand in North American sneaker culture in the 1980s. Fila was the first sportswear company to sign basketball great Grant Hill when he was a rookie with the Detroit Pistons. This shoe was worn by Hill when he and his team won the gold medal in basketball for the United States at the 1996 Olympics and bears his signature.

NIKE
AIR JORDAN XII
1996–97
KOSOW SNEAKER MUSEUM
(ELECTRIC PURPLE
CHAMELEON, LLC)
P. 135

Inspired by the Japanese flag, the XII features quilted rays radiating across the entire upper, lending an Art Deco elegance to the design. In addition, the XIIs were the first Air Jordans to feature Nike Zoom Air Technology, and the one-pull lace system was replaced by a return to standard lacing with the exception of metallic speed-lacing hooks at the top of the shoes, adding a bit of glam to the design. The XII was the first Air Jordan to be released under the brand's own label.

NIKE
FOAMPOSITE
1997
NIKE ARCHIVES
P. 238

Eric Avar's striking sneaker, the Nike Foamposite, marked the first time that an entire upper had been made of one piece of synthetic material. The sculptural quality of the shoe and its ability to mold to the wearer's foot established the Foamposite as a classic. It was the signature shoe of famous basketball point guard Penny Hardaway and came in only one color, Dark Neon Royal Blue. Eric Avar is currently Nike's Vice President of Design and Innovation.

REEBOK X CHANEL
INSTA PUMP FURY
CA. 1997
REEBOK ARCHIVES

Although the specific date of the Reebok x Chanel Insta Pump Fury release remains uncertain, it clearly was one of the earliest and most coveted high-fashion and athletic footwear collaborations. The iconic Chanel logo of interlaced CCs was wrought large on the heel, while the upper and sole were done in an elegant, sophisticated dove gray. The monochrome palette was a dramatic departure from the shoes' original yellow, red, and black colorway, and it allowed the striking architecture to be more fully appreciated.

JORDAN BRAND
AIR JORDAN XIII
1997–98
KOSOW SNEAKER MUSEUM
(ELECTRIC PURPLE
CHAMELEON, LLC)
P. 135

Tinker Hatfield incorporated aspects of a black panther when designing the XIII. The shoe featured a paw-like outsole and a hologram on the back quarter that used the Jumpman logo, the number 23, and a basketball to simulate the eye of a cat. The upper material was stitched to give the effect of ostrich skin, adding to the exotic qualities of the shoe.

JORDAN BRAND
AIR JORDAN XIV
1998–99
KOSOW SNEAKER MUSEUM
(ELECTRIC PURPLE
CHAMELEON, LLC)
P. 135

Inspired by Michael Jordan's sleek Ferrari 550 Maranello, Tinker Hatfield, working with Mark Smith, designed the XIV as a sophisticated and technologically advanced shoe with Zoom Air cushioning as well as a Ferrari-inspired metal Jumpman on the outside quarters. Seven Jumpman logos appear on each shoe, the most of any Air Jordan. The XIV was the last shoe Jordan would wear as a Chicago Bull, and he wore it only once on the NBA court for his final game with the franchise, helping them to win their second "three-peat" and sixth NBA championship. The XIV was released in five mid- and three low-top versions and in a number of colorways, including Ginger.

With Michael Jordan retired, Tinker Hatfield designed the XV to be both commemorative and forward-looking. The inspiration for the shoe came from the 1950s record-breaking fighter jet the X-15. It featured a woven Kevlar upper and a tongue that seemed to jut forward in imitation of Jordan's habit of thrusting his tongue out during game play.

JORDAN BRAND
AIR JORDAN XV
1999–2000
KOSOW SNEAKER MUSEUM
(ELECTRIC PURPLE
CHAMELEON, LLC)
P. 135

Building on the advances created by the design of the Foamposite, Nike designer Eric Avar introduced Nike Shox technology into basketball with the Nike Shox BB4 in 2000. The idea for the shoe centered on the space-age concept of a rocket and its boosters. The uppers were designed to be reminiscent of a spacesuit. Vince Carter wore this style when he was a Toronto Raptor, and he had them on his feet when he accomplished his historic "dunk of death" in 2000.

NIKE
SHOX BB4
2000
COLLECTION OF DEE WELLS

In 1996, Reebok took a chance and signed controversial rookie Allen Iverson to a ten-year sneaker deal; Iverson launched his professional career as a Philadelphia 76er wearing his own signature shoe, the Question, which was followed by a number of Answers. For many, the Answer IV was the highlight of the series. Worn by Iverson in the 2000–2001 season, it had sleek styling, including a zippered closure, and featured a portrait of Allen Iverson on the sole.

REEBOK
THE ANSWER IV
2000
REEBOK ARCHIVES

In keeping with Tobie Hatfield's devotion to creating the lightest and most comfortable running shoes available, he designed the Nike Air Presto, considered by many to be one of Nike's most comfortable shoes. Tobie designed the sneaker in 2000, and it was touted as "a T-shirt for your feet"; it was even made available in T-shirt sizing, XS–XXL, rather than traditional shoe sizing.

NIKE
AIR PRESTO
2000
NIKE ARCHIVES

The XVI marked the first time in more than a decade that an Air Jordan was not designed by Tinker Hatfield. Senior Nike designer Wilson Smith III designed the shoe, and he gave it a nod to the Jordan past by including a patent-leather toe cap and a nod to the historic past by creating a removable gaiter that, like spats of the early twentieth century, provided protection out-of-doors but could be removed from a shoe during indoor play. This pair is from the retro Countdown pack released in 2008.

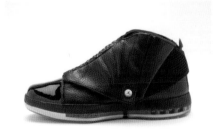

JORDAN BRAND
AIR JORDAN XVI
2008 RETRO OF 2001
KOSOW SNEAKER MUSEUM
(ELECTRIC PURPLE
CHAMELEON, LLC)
P. 135

Japanese fashion designer Yohji Yamamoto is one of the industry's most avant-garde designers, and his forward thinking led him to be one of the first couturiers to collaborate with a sportswear company. This pair of high-tops dates to the inaugural year of the partnership, and in typical Yamamoto style he took a traditional form, the high-top, and put his inimitable stamp on it.

ADIDAS X YOHJI YAMAMOTO
YY PROMODEL 2G
2002
ADIDAS AG

JORDAN BRAND
AIR JORDAN XVII
2002
(PICTURED) COLLECTION OF
THAD JAYASEELAN
(ALSO EXHIBITED) KOSOW
SNEAKER MUSEUM
(ELECTRIC PURPLE
CHAMELEON, LLC)
P. 135

The XVII was designed by Wilson Smith III and is said to have been inspired by jazz music and the sleek design of Aston Martin cars. The sneakers were outfitted with removable lace covers and came in their own Jumpman logo-embossed case. A CD of the Air Jordan XVII song was also included. Jordan wore XVIIs when he returned to basketball for a second time to play for the Washington Wizards. The XVII mid came in three colorways, including Red and White, Sport Royal Blue and White, and Black and Black.

NOTE: Air Jordans I, III, XI, XVII, and XX appear in two sections in the exhibition, but are represented by one photograph.

ADIDAS X JEREMY SCOTT
FORUM MONEY
2002
ADIDAS AG
P. 188

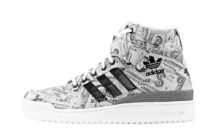

In 2002, cutting-edge fashion designer Jeremy Scott collaborated with Adidas to make one hundred pairs of Forums embellished with dollar bills featuring portraits of Scott in place of George Washington, all of which were handmade in Germany. The shoes created quite a stir and inaugurated Scott's incredibly successful relationship with Adidas. The money motif was appropriate for the Forum; in 1983, the Forum was the first sneaker with a one-hundred-dollar price tag, an event referenced in this 2002 collaboration.

JORDAN BRAND
AIR JORDAN XVIII
2003
KOSOW SNEAKER MUSEUM
(ELECTRIC PURPLE
CHAMELEON, LLC)
P. 135

Once again, elite race cars provided the inspiration for the XVIII. The designer for the XVIII was Senior Jordan Brand designer Tate Kuerbis, and he sought to design a shoe that combined the sleekness of F1 racing cars, with the elegance of racing shoes with a touch of Italian shoemaking craftsmanship in the stitching along the outsole.

NIKE X SUPREME
DUNK HIGH PRO SB
2003
COLLECTION OF SHERAZ AMIN
P. 172

Nike ventured wholeheartedly into the world of skateboarding in 2002. The Nike Dunk Supremes were highly anticipated and released only in New York and Tokyo. Hallmarks of the design are the gold stars and mock-croc leather of the uppers and the gold debray on the laces. Only one thousand Supremes were released in the White and University Blue colorway, making this one of the most sought-after sneakers of all time.

JORDAN BRAND
AIR JORDAN XIX
2004
KOSOW SNEAKER MUSEUM
(ELECTRIC PURPLE
CHAMELEON, LLC)
P. 135

Tate Kuerbis, supported by Wilson Smith III, Jason Mayden, Josh Heard, and Suzette Henri, created the XIX to reflect the deadly power of a Black Mamba, using innovative new Flex Tech fabric to mimic the snake's scale pattern. In addition to the five colorways that were released, four Special Edition XIXs were also released, but they lacked the Flex Tech fabric lace cover, including the white/metallic gold/purple West release that suggested Lakers colors.

NIKE
AIR ZOOM HUARACHE 2K4
2004
NIKE ARCHIVES
P. 234–235

According to Eric Avar, the idea behind the Nike Air Zoom Huarache 2K4 was to "bring back classic basketball design principles in a very modern way." In direct contrast to the space-age aesthetic explored in his Nike Foamposite design, the Nike Air Zoom Huarache 2K4 suggested traditional, old-school styling in line with the emerging interest in retros.

The concept behind Tobie Hatfield and Eric Avar's Nike Free series of shoes was to translate the barefoot running experience into a sneaker. Legendary running coach Vin Lananna had been training his athletes using barefoot running. His motto "Less Shoe More You" became a rallying cry for the design team, especially Tobie, Senior Innovator in Nike's Innovation Kitchen, who has a great personal interest in running without footwear. The Nike Free 5.0 has an articulated midsole, to increase the movement of the foot, and a very lightweight woven upper. The 5.0 references the level of support offered by the sneaker, 0 being barefoot and 10 being fully supported.

NIKE
FREE 5.0
2004
NIKE ARCHIVES
P. 240

For the twentieth anniversary of the Air Jordan, Tinker Hatfield was once again called upon to design a shoe worthy of this milestone. The design was inspired in part by Michael Jordan's love of motorcycles and featured innovations such as the use of an ankle strap. The lace cover featured two hundred symbols celebrating Jordan's career and marked one of the first applications of Mark Smith's innovative laser etching. The retro pair in black is from the 2008 Countdown pack.

NOTE: Air Jordans I, III, XI, XVII, and XX appear in two sections in the exhibition, but are represented by one photograph.

JORDAN BRAND
AIR JORDAN XX
2008 RETRO OF 2005
(PICTURED) KOSOW SNEAKER
MUSEUM (ELECTRIC PURPLE
CHAMELEON, LLC)
P. 135
(ALSO EXHIBITED) 2005; NIKE
ARCHIVES

Hip-hop group De La Soul collaborated with Nike to design this high-top. The holographic heel cover was from the cover of their 1989 album *3 Feet and Rising*, and the "altitude green" leather was embossed with an elephant hide print. This pair is one of the all-time most popular Nike SB releases.

NIKE X DE LA SOUL
DUNK HIGH PRO SB
2005
COLLECTION OF SHERAZ AMIN

The pattern on the uppers of these sneakers is the artwork of Boston artist Josh "Wisdumb" Spivack. His graffiti-like lines add a street vibe to the classic 574 New Balance sneaker. These sneakers are also known by their nickname, Wisdumb Icicles, because of the artwork's crystalline pattern.

NEW BALANCE X JOSH WISDUMB
574
2005
COLLECTION OF DEE WELLS

Conceptual artist Judi Werthein chose the word *brinco*, Spanish for jump, for these cross-trainers, as it is the term used to describe the illegal crossing of immigrants from Mexico into San Diego. Werthein designed Brincos to assist with the crossing; each pair is equipped with a compass, a light, and painkillers in case of injury. The shoes protect the wearer's ankles from snake and tarantula bites, and they have removable insoles printed with maps of the most popular routes from Tijuana to San Diego. The shoes also feature the Aztec and American eagles and small images of Saint Toribio Romo Gonzalez, the patron saint of immigrants. Werthein handed out Brincos at the US-Mexico border in 2005.

JUDY WERTHEIN
BRINCO CROSSTRAINER
2005
COLLECTION OF THE
BATA SHOE MUSEUM,
GIFT OF DALE HENDERSON
AND MARIE POON

In 2005, Jeff Ng, aka Jeff Staple of Staple Design, released his now infamous Pigeons at his store, Reed Space, in New York City on February 22, 2005. Nike had approached Staples to design a limited-edition sneaker in honor of the city, and he decided to use the ubiquitous pigeon as his inspiration. The buzz around the sneaker was huge; before the launch day, people started lining up outside the store. The day of the release, pandemonium reigned as Reed Space had only thirty sneakers to sell. The ensuing riot made the news. Today, the original Pigeon remains one of the most sought-after sneakers.

NIKE X STAPLE DESIGN
DUNK LOW PRO SB PIGEON
2005
COLLECTION OF JEFF STAPLE

PUMA
CLYDE
2005 RETRO OF 1973
PUMA ARCHIVES
P. 98–99

When the Puma Clyde debuted in 1973, it became an instant classic, central to urban culture and important on the basketball court. New York Knicks player Walt "Clyde" Frazier, for whom the shoe was named, had a habit of dressing flashily, and on the court he would sometimes wear one blue and one orange Clyde. This orange example, part of the 2005 retro pack, was signed by Walt Frazier across the toe.

JORDAN BRAND
AIR JORDAN XX1
2006
KOSOW SNEAKER MUSEUM
(ELECTRIC PURPLE
CHAMELEON, LLC)
P. 132–133, 134, 135

The XX1 was the first Air Jordan designed by D'Wayne Edwards. Like other Jordan designers, Edwards was inspired by a vehicle, but rather than turning to a race car, he looked to a refined Bentley, the Continental GT coupe. The elegance of the XX1 is matched by its sophisticated technology, which includes the Independent Podular System that allows the wearer to choose between Zoom and Encapsulated air to customize the shoe's cushioning.

ADIDAS
SAIGON
2006
COLLECTION OF
THAD JAYASEELAN

Designed to celebrate the diversity of the world's cultures, Adidas's Materials of the World collection produced limited-edition shoes using materials that recall traditional fabrics from around the world, including Peru, Japan, Turkey, and Greenland. Vietnam is represented by the Saigon; its ornate fabric is reminiscent of the luxurious material used to make traditional Áo Dài outfits.

ADIDAS X CEY ADAMS
ALI CLASSIC
2007
COLLECTION OF THE
BATA SHOE MUSEUM, GIFT
OF CEY ADAMS

Legendary artist Cey Adams, famous for his work with Def Jam records and its many hip-hop artists, including Run–DMC and Beastie Boys, was commissioned by Adidas in 2006 to create a limited-edition sneaker, T-shirt, and jacket as part of the Adidas Ali Values Project, which sought to honor Mohammad Ali's core values. Adams worked on the value of confidence and used historic images of Ali in his prime to create a strikingly graphic shoe.

JORDAN BRAND
AIR JORDAN XX2
2007
KOSOW SNEAKER MUSEUM
(ELECTRIC PURPLE
CHAMELEON, LLC)
P. 135

D'Wayne Edwards was again called upon to design an Air Jordan in 2007. For the XX2, the F-22 fighter jet, the most advanced jet in the world at the time, provided inspiration as seen throughout, from the shoe's sleek upper to its zigzag stitching. The back quarters were decorated in camouflage pattern, and the use of titanium was a further nod to its fighter-jet inspiration.

JORDAN BRAND
AIR JORDAN XX2
2007
COLLECTION OF
D'WAYNE EDWARDS

D'Wayne Edwards also created the XX2s in basketball leather in response to a direct request from Michael Jordan himself. Rather than using the typical orange basketball leather, Edwards looked to the past and chose a leather closer to that used on early basketballs. Jordan loved it, and it became the first Air Jordan to feature Michael Jordan's signature. A basketball in the same leather was also released.

Alife's reimagining of Reebok's famous tennis shoe the Court Victory Pump went on to become one of the most sought-after sneakers. True to its name, Ball Out, the upper was cleverly made using tennis ball-like material. The original release of the Ball Out was yellow, followed by a number of other bold colorways including this bright, fuzzy pink version.

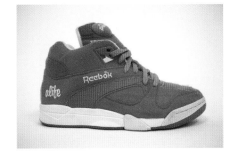

ALIFE X REEBOK
COURT VICTORY PUMP "BALL OUT"
2007
REEBOK ARCHIVES

Tinker Hatfield's vision was instrumental in the design the XX3. As 23 remained the most famous number associated with Jordan, the XX3 was designed to celebrate him in a very personal way: Jordan's fingerprint was the inspiration for the sole of the shoe, and his signature graced each toe cap. The design was also forward looking and was the first Air Jordan to incorporate the tenets of Nike's Considered Design, a new directive that sought to be thoughtful toward the environment through the use of less-toxic materials and an intent to minimize waste.

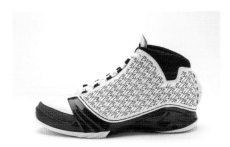

JORDAN BRAND
AIR JORDAN XX3
2008
KOSOW SNEAKER MUSEUM
(ELECTRIC PURPLE
CHAMELEON, LLC)
P. 135

Reflecting on his generation—Generation X—artist Jimm Lasser wondered about its legacy. Choosing the election of President Obama as his generation's most significant moment, Lasser transformed a pair of iconic Air Force 1s into a commemorative totem. Lasser engraved soles and added them to the AF1. The left sole depicts a profile of President Obama along with the text "A Black Man Runs and a Nation Is Behind Him," and on the right is a portrait of the president.

JIMM LASSER
OBAMA FORCE ONE
2008
COLLECTION OF THE ARTIST

American artist Tom Sachs rose to fame creating works that engaged issues of the fetishization of branding. He is a proponent of the concept of bricolage, and his work emphasizes the retention of the maker's mark in response to the perfected anonymity of mass-produced consumer goods. Sachs began working on NikeCraft, his collaboration with Nike, with these principles at the forefront of his work. It resulted in a limited-edition capsule collection in 2012.

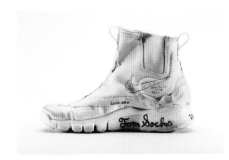

NIKE X TOM SACHS
NIKECRAFT LUNAR UNDERBOOT
AEROPLY EXPERIMENTATION
RESEARCH BOOT PROTOTYPE
2008–12
COLLECTION OF THE ARTIST
P. 176–177

Kanye West, internationally renowned rapper, fashion designer, and sneaker aficionado, released a line of shoes with the storied fashion house Louis Vuitton in 2009. The resulting sneakers created by the "Louis Vuitton Don" were the epitome of luxury and featured premium materials and 24K gold shoe lace rings. This pair of Louis Vuitton x Kanye West Don's was given by West to Matte Babel, the Los Angeles correspondent for *ET Canada*.

LOUIS VUITTON X KANYE WEST
DON
2009
COLLECTION OF MATTE BABEL
P. 179

This pair of exceptionally rare Nike LeBron James sneakers was inspired by Stewie, LeBron James's favorite cartoon character from the television show *Family Guy*. The color palette is linked to the character, and the cartoon-like quality of the shoes is reinforced by the bold black outlines. It is rumored that only twenty-four pairs were made and were never put into production, but they were available only through a "friends and family" promotion.

NIKE
STEWIE GRIFFIN LEBRON VI
2009
COLLECTION OF CHAD JONES
P. 18

NIKE
SPECIAL FORCES BOOT
2009
NIKE ARCHIVES

In 2009, Tobie Hatfield turned his attention to making footwear that could be used by the military. Building upon the advances that had been made with the design of the Nike Free 5.0 sole, Tobie was able to create a boot that was rugged, quick drying, and most important, exceptionally lightweight. Although originally designed with the military in mind, the boots have proven to be popular with the public as well.

NIKE
AIR MAX LEBRON 7
ALL BLACK EVERYTHING
2010
COLLECTION OF CHAD JONES

This extremely rare sneaker was designed by DJ Clark Kent to pay tribute to LeBron James and Jay-Z. Taking the phrase "all black everything" from Jay-Z's "Run This Town," Kent created a monochromatic shoe that is a play of textures, from the ostrich-skin toe cap to the perforated suede and flywire upper. Jay-Z's "Diamond Cutter" hand gesture is reproduced on the tongue, and the insoles list the achievements of the two superstars. This shoe never made it to retail, but instead was given away to friends and family members.

PUMA X KEHINDE WILEY
TEKKIES MAME
2010
COLLECTION OF THE ARTIST

For the 2010 World Cup, Puma commissioned New York artist Kehinde Wiley, renowned for his compellingly heroic paintings, to create portraits of three African soccer stars sponsored by Puma. That summer, Puma released a series of shoes made using fabric that featured patterns inspired by the African textiles in Wiley's work. The fabric used to create this very limited-release pair of Kehinde Wiley sneakers features embroidered rather than printed designs.

CONVERSE X DAMIEN HIRST
(PRODUCT)RED
2010
CONVERSE ARCHIVES
P. 200

Controversial British artist Damien Hirst teamed up with Converse to have his artwork *All You Need Is Love* translated into street fashion in an effort to raise money for the charity (Product)RED. Crafted out of finely woven textile and printed using a high-definition laser printer, these sneakers feature a faithful reproduction of Hirst's butterfly print and were produced in limited numbers. Butterflies also embellish the lining of the sneakers.

ONITSUKA
TIGER TAI CHI LE
2010 RETRO OF 1978
COLLECTION OF THE
BATA SHOE MUSEUM
P. 7

The original Onitsuka Tiger Tai Chi were made famous by Bruce Lee in 1978, when he wore a pair with a yellow track suit in the movie *Game of Death*. In reference to Bruce Lee, the look was revised by Uma Thurman's character in the 2003 Quentin Tarantino film *Kill Bill* and this led to the relaunch of the sneaker.

SUPRA
SOCIETY
2011
COLLECTION OF THE
BATA SHOE MUSEUM,
GIFT OF K'NAAN

Supra came onto the sneaker scene in 2006 as a maker of fashion-forward skateboard shoes. This West Coast brand quickly became a fashion staple, and numerous skateboarders and musicians took to wearing them. This Supra Society pair was worn by K'naan, the Toronto-based rapper and musician who rose to international acclaim with his song "Wavin' Flag."

Hiroki Nakamura, founder of the Japanese brand Visvim, combines his interest in traditional footwear from around the world with the traditional Japanese aesthetic of *wabi-sabi*, which privileges authenticity and the embrace of imperfection. Visvim's most popular model, the FBT, was inspired by the moccasins worn by the lead singer Terry Hall of the British New Wave band Fun Boy Three and modeled on traditional footwear and craftsmanship.

VISVIM
FBT ELSTON
2010
COLLECTION OF MAYAN RAJENDRAN

In 1986, Run–DMC invited Adidas executives to Madison Square Garden to hear "My Adidas." Adidas responded by giving the rappers a million-dollar contract, making them the first nonathletes to get a sneaker deal. Run–DMC wore Superstars without laces, a controversial choice as the fashion originated in prisons, where laces were removed upon incarceration. This pair of Adidas Superstars was released on 11/11/11 in honor of the twenty-fifth anniversary of the rap and was autographed by Run and DMC for this exhibition.

ADIDAS X RUN DMC
25TH ANNIVERSARY SUPERSTAR
2011
COURTESY OF RUN–DMC,
COLLECTION OF ERIK BLAM
P. 140–141

Pierre Hardy launched his eponymous line of footwear for women in 1999 and for men in 2002. Among his many designs are sneakers that play with primary colors and geometric shapes. The design of this pair of limited-edition Poworamas was inspired by the artwork of Roy Lichtenstein and translates the artist's graphic appeal into wearable art.

PIERRE HARDY
POWORAMA
2011
COLLECTION OF THE
BATA SHOE MUSEUM,
GIFT OF PIERRE HARDY
P. 195

As its name implies, the Urban Swift connotes the speed of life. Its shape was inspired by fashion designer Hussein Chalayan's 2009 Spring/Summer Inertia collection, which incorporated molded latex garments that suggested speed. The Urban Swift achieved a similar effect through the use of injection-molded thermoplastic polyurethane to achieve the spikes on the quarters of the shoe.

PUMA X HUSSEIN CHALAYAN
URBAN SWIFT
2011
PUMA ARCHIVES
P. 186–187

In 2010, Future Sole, a competition spearheaded by D'Wayne Edwards, gave high school and college students the opportunity to submit sneaker design ideas to Nike designers. Out of 22,000 participants, sixteen-year-old Allen Largin's design was chosen, and it became the Melo 7 Future Sole. The shoe was launched at a game at Syracuse, Carmelo "Melo" Anthony's alma mater, and was worn by him when the Knicks played the Pistons in Largin's hometown of Detroit.

JORDAN BRAND
AIR JORDAN,
MELO 7 FUTURE SOLE
2011
COLLECTION OF D'WAYNE
EDWARDS

Not all exclusives are put out by major brands; some of the rarest sneakers are the ones customized by artists such as Mache. This pair of hand-painted Nike Air Force XXVs was made by Mache and features a portrait of Heath Ledger as the Joker from the Batman movie *The Dark Knight*. Mache's work has garnered him an international reputation and a celebrity client list including Jay-Z, Kanye West, and LeBron James.

NIKE
AIR FORCE XXV MACHE CUSTOMS
2012
COLLECTION OF MACHE
P. 169

JORDAN BRAND
AIR JORDAN VII
OLYMPIC GOLD MEDAL
2012
COLLECTION OF
CHAD JONES

When NBA basketball star Chris Paul won Olympic gold in 2012, the Jordan Brand presented him with a pair of special player's edition VIIs embellished with gold leather detailing, gold embroidery, and gold aglets on the laces. Only two or three examples of this shoe were made, making it an exceptionally rare and highly sought-after sneaker.

JIMMY CHOO
BELGRAVIA
2012
COLLECTION OF THE
BATA SHOE MUSEUM,
GIFT OF HOLT RENFREW

Jimmy Choo, famed manufacturer of high-end women's footwear, has recently begun to make sneakers for men. These Belgravia high-tops are made with an ornate paisley fabric on the uppers that features the silhouettes of naked women scattered throughout the design, providing ample proof that the wearer is unquestionably masculine.

NIKE X TOM SACHS
NIKECRAFT MARS YARD
2012
COLLECTION OF THE ARTIST

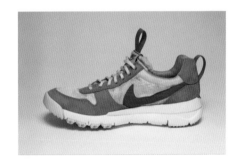

After a conversation with Nike CEO Mark Park on the "merits of individual handicraft versus the economy of scale in factory production," artist Tom Sachs began working on NikeCraft. Knowing that Nike designs shoes for athletes, he chose to make sneakers for great minds. His booklet for the project states, "These shoes are built to support the bodies of the strongest minds in the aerospace industry," and the materials used to make the shoes include Nike Special Forces outsoles and Vectran fabric from the airbags on the Mars Excursion Rover. Mars Yard shoes were limited edition and retain a feeling of hand manufacture.

CHRISTIAN LOUBOUTIN
ROLLER-BOAT
2012
COLLECTION OF THE
BATA SHOE MUSEUM, GIFT
OF CHRISTIAN LOUBOUTIN
P. 182

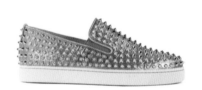

Christian Louboutin made his name as a designer of exclusive women's footwear, and in 2011 he opened his first men's boutique. In an interview with *Women's Wear Daily*, he stated, "There is a group of men that is thinking a little bit more like women. . . . They treat shoes very much as objects, as collectors' items." These Roller-Boats feature Louboutin's iconic red soles and gold pony-skin uppers embellished with aggressive studs.

NIKE
FLYKNIT RACER
2012
COLLECTION OF THE
BATA SHOE MUSEUM

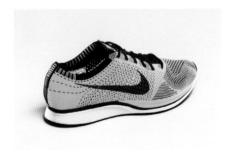

The Flyknit Racer was the first shoe with a knit upper, and it presented the answer for runners who sought a sock-like fit. The revolutionary fabrication technique allows structure and support to be knit into the shoe, enabling it to be both formfitting and exceptionally lightweight. Knitting also dramatically reduced the wastage associated with pattern cutting.

PUMA X RONNIE FIEG
DISC BLAZE OG COVE
2012
PUMA ARCHIVES

Puma first released its innovative disc closure system in 1993. The design removed the need for laces with the simple turn of the disc. In 2012, famed sneaker connoisseur Ronnie Fieg partnered with Puma to reimagine one of his all-time favorite sneakers. Fieg introduced a newly designed toe box, a black leather "mud guard," and Fieg's signature Cove colorway.

The thought-provoking drawings of British-born, Brooklyn-based artist Shantell Martin have been exhibited around the world, from New York to Tokyo, and have inspired collaborations with major brands. Using black marker on stark white surfaces, Martin makes her dreamlike and semiautobiographical drawings on every surface available to her, including her sneakers. Martin stripped these sneakers of their branding to transform them into a blank canvas. This extremely personal customization provides insight into her work.

SHANTELL MARTIN
CUSTOMIZED DE-BRANDED HIGH-TOPS
2012
COLLECTION OF SHANTELL MARTIN
P. 192–193

Puma first collaborated with Undefeated in 2009 and again in 2011 and 2012. This pair of Puma Clyde x Undefeated Gametime Gold was created in homage to the U.S. gold-medal-winning Olympic basketball team. It is a classic Clyde, with perforation on the uppers and red, white, and blue heel tabs.

PUMA X UNDEFEATED
CLYDE GAMETIME GOLD
2012
PUMA ARCHIVES

The "sneakerfication" of men's fashion is seen in DSquared2's reinterpretation of a traditional derby, which dispenses with somber-hued leather and offers an upper that mixes new and traditional materials with a sneaker-inspired sole while maintaining details such as broguing, pinking, and a winged toe cap. Although fashion design twins Dean and Dan left Canada years ago to work in Italy, their work frequently incorporates Canadian motifs, such as the maple leaf in red on the heel tab of their Spectator Abrazivato.

DSQUARED2
SPECTATOR ABRAZIVATO
2013
COLLECTION OF THE
BATA SHOE MUSEUM,
GIFT OF HOLT RENFREW

American designer Jeremy Scott is known for pushing the limits of design and for finding inspiration in many things, from stuffed animals to computer keyboards. For his Totem collection, Scott turned to the traditional art of the West Coast First Nations peoples. Based on traditional totem-pole designs, the sneakers have not been without criticism concerning cultural appropriation.

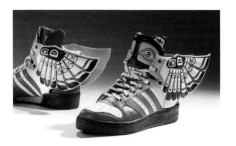

ADIDAS X JEREMY SCOTT
TOTEM
2013
COLLECTION OF THE
BATA SHOE MUSEUM
P. 10–11

Unchanged since making its debut in 1997, the PS0906 sneaker marked Prada's entrance into the sneaker market. This pair was originally designed by Prada for the Luna Rossa sailing team's participation in the first America's Cup, but it quickly became a style icon. This version from 2013 features bright red patent leather detailing.

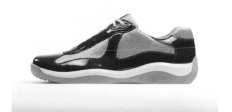

PRADA
PS0906
2013
COLLECTION OF THE
BATA SHOE MUSEUM,
GIFT OF PRADA
P. 167

Lanvin, the oldest couture house in Paris, has been making exquisite haute couture clothing for women for more than one hundred years. In 2005, the house branched out into menswear and began offering sneakers. This sleek, understated Lanvin patent toe-cap sneaker is now a legend among fashion-forward men.

LANVIN
PATENT CAP TOE
2013
COLLECTION OF THE
BATA SHOE MUSEUM,
GIFT OF HOLT RENFREW
P. 166

SULLY WONG X KARIM RASHID
IKON DESERT BOOT
2013
COLLECTION OF THE
BATA SHOE MUSEUM,
GIFT OF SULLY WONG

In 2013, famed Canadian industrial designer Karim Rashid collaborated with Toronto-based designers Sully Wong. Each pair of sneakers in the series features one of Karim's iconic patterns. He was also responsible for designing the original Toronto presentation of *Out of the Box* in 2013–14 at the Bata Shoe Museum.

PUMA X SOPHIA CHANG
BASKET
2014
COLLECTION OF THE
BATA SHOE MUSEUM,
GIFT OF PUMA

Approached by Puma to do a limited-edition capsule honoring New York, Chang created the Brooklynite collection. The iconic Puma Baskets are made using leather decorated with Chang's drawings and her signature, which is a feminine flourish in gold on the tongue. Sophia Chang is one of only a few women designing men's sneakers.

GE X ANDROID HOMME
MISSIONS
2014
COLLECTION OF THE
BATA SHOE MUSEUM,
GIFT OF GE

In honor of the forty-fifth anniversary of the first moon landing, GE, Android Homme, and JackThreads collaborated to make one hundred pairs of moon boot–inspired sneakers using innovative GE materials. GE's silicone rubber had been an integral part of the original boots that first walked on the moon, and to celebrate this anniversary Android Homme was given access to stabilized carbon fiber, hydrophopic coating, 3M Scotchlite reflective material, and thermoplastic rubber in designing this shoe. The shoe dropped on the JackThreads website on July 20 at 4:18 p.m., the exact time of the landing of the lunar module, and sold for $196.90 to honor the date.

NEW BALANCE X CONCEPTS
CM496 POOL BLUE
2014
COLLECTION OF THE
BATA SHOE MUSEUM,
GIFT OF NEW BALANCE

Boston-based Concepts and New Balance collaborated to create the limited-release CM496 Pool Blue. Inspired by the Charles River and its many boating events, the shoe features bright red and blue uppers, rope laces, and insoles printed with a unique water graphic.

UNDER ARMOUR
SPEEDFORM APOLLO
2014
COLLECTION OF THE
BATA SHOE MUSEUM,
GIFT OF UNDER ARMOUR

Under Armour began offering shoes in 2006. Building upon its reputation as a company that develops performance apparel using technologically innovative textiles, the Speed-form Apollo turned to a high-end lingerie manufacturer to apply cutting-edge textile technology to create an exceptionally lightweight, formfitting, and breathable upper with a seamless heel cup.

COMMON PROJECTS
ACHILLES LOW
2015
COMMON PROJECTS
ARCHIVES
P. 198

Common Projects's clean, minimalist aesthetic and low-batch, high-quality manufacture, coupled with its cryptic numbering system stamped in gold on the quarters of their shoes, has propelled the brand to cult status. The Achilles, a stripped-down yet luxurious version of an iconic low-top, was the first model designed by company cofounders Peter Poopat and Flavio Girolami when they launched Common Projects in the mid-2000s.

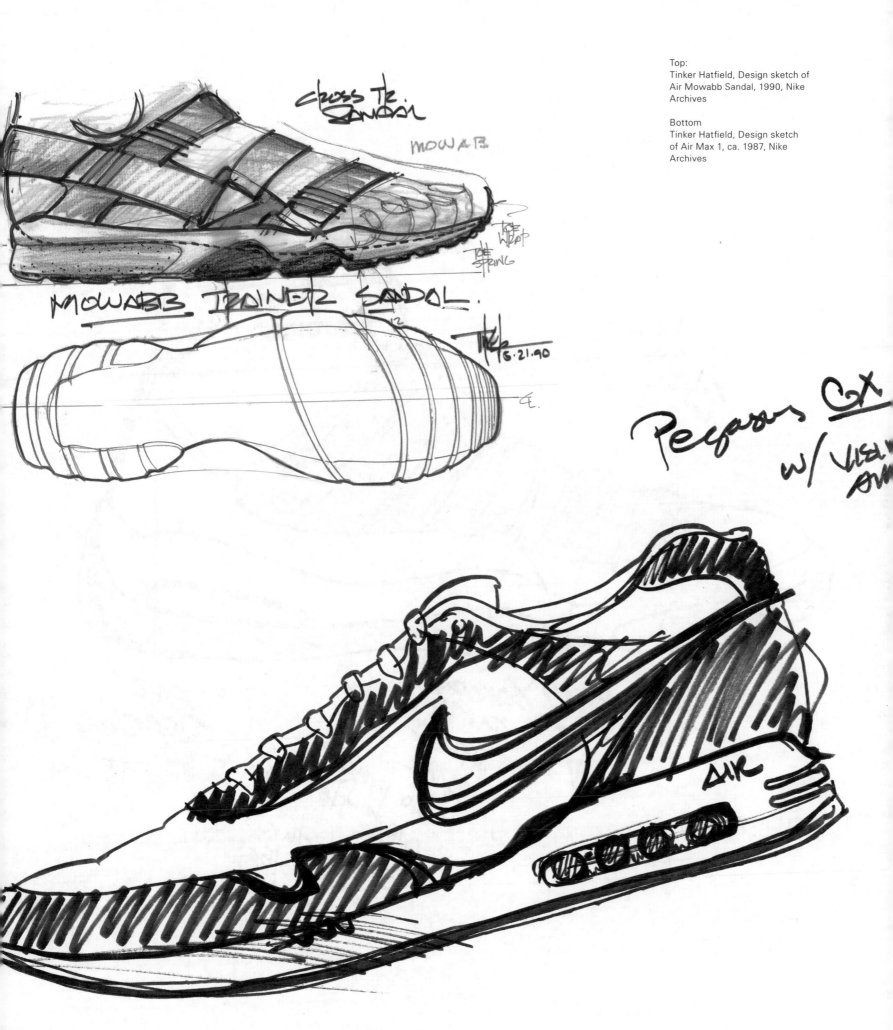

Top:
Tinker Hatfield, Design sketch of
Air Mowabb Sandal, 1990, Nike
Archives

Bottom
Tinker Hatfield, Design sketch
of Air Max 1, ca. 1987, Nike
Archives

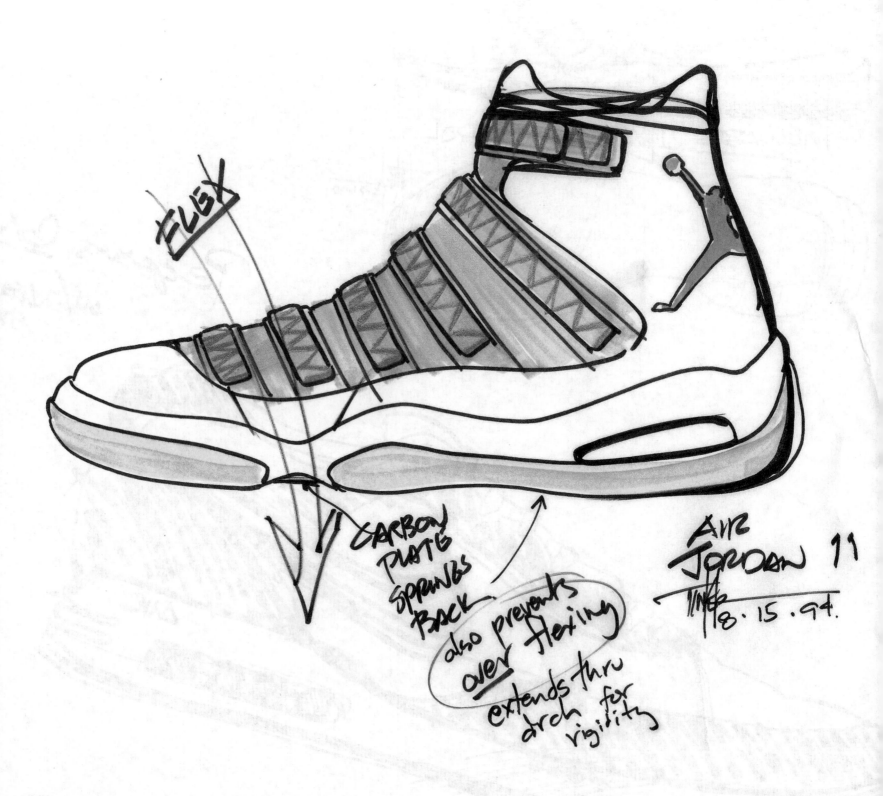

INTERVIEW
DEE WELLS & TINKER HATFIELD

There are some footwear designers that you want to meet. Not just because they're the most famous or the easiest to deal with, or even the most relevant person in footwear going on three decades. You want to meet them because when you're faced with having an in-depth conversation about some of the freshest basketball, running, and cross-training sneakers to have ever been worn by some of the best athletes from professional to weekend warriors, one simply has to say "Tinker" and it's immediately game over!

There are very few footwear designers, and I can count them on one hand with two fingers removed, who've had as large an impact on sneakers and fashion as Tinker Hatfield.

I had an opportunity to speak with Tinker about his background in architecture and how those skills have transferred to footwear design and, maybe, how they've aided him as he's come full circle taking on more architectural projects.

DEE WELLS: Knowing what you know now about footwear and footwear design, if you were to return to architecture, what gems would you take back and apply to architecture that you learned from footwear design?

TINKER HATFIELD: That's a fantastic question. Before I answer that, I'd like to point out that I do more architecture now than I ever have in my entire life. And that's a little bit of a segue into answering your question, because there is no doubt in my mind that after having designed shoes and worked with athletes—and also I don't want to short the whole notion of what it means to be in marketing and merchandising, and we work as such good teams here in Nike—all this stuff contributes to how you think about consumers and design and innovation. When I think about the experience of being at Nike, and being exposed to these aspects in the world of design and business, now when I sit down to design architecture, I guess you can say my palette to draw from, or menu of experiences, is so large that the architecture starts to look more and more like something that should move through space rather than sit stationary. And the architecture tends to be more avant-garde: more innovative and more risk-taking. It's something that comes from having worked for a company that has supported that kind of thinking, and with the team that helped support those kinds of actions.

Then we begin to discuss how he keeps his eyes sharp and continuously looking for ways to innovate.

DW: How are you seeing things? I know you do a lot of what I call "exploratory missions." How do you keep your eyes open to see those?

TH: Well, there is a certain amount of pressure when you work on any particular line of sneaker to be refreshed, or to rethink and innovate, to try to beat what you did before, year after year after year. In order to do that, you really have to learn how to not just sit down with a blank piece of paper and try to conjure up something fabulous. The process was to go out in the world and become inspired and injected with modern culture and crazy new experiences. There is always something really exciting that can instigate a new idea, new designs.

Bruce Lee, the famous actor, director, and martial artist, has been quoted numerous times, but one particular quote stands out: "Simplicity is the key to brilliance." Tinker epitomizes this belief, and a number of his sneaker designs adhere to this mantra. Tinker is certainly very smart, and many people would argue that he's downright brilliant, but instead of tooting his own horn, Tinker is known for his humility and ability to see things from various perspectives.

TH: I'm a visual person. For me, vision is the most important thing. I'm impacted by what I see. Whether or not I'm a great artist is subject to scrutiny, but the reality is, I draw because I see it in my head.

DW: You've said in the past that you are a problem solver.

TH: Well, historically speaking, Nike wouldn't be here if a group of athletes and coaches weren't trying to solve problems to improve performance. I still believe in that. I think that helped me do the work I've done because I always start from that foundation of trying to think if this product will help this particular person. And that someone could be a person who is hoping to win a gold medal in the Olympics, or someone who just wants to run and be fit, or work out and rehabilitate an injury, or anything.

So solving a problem to enable an athlete to perform even better is one of the many goals that Tinker and other Nike designers face. How Tinker and his fellow designers address those challenges head-on is interesting, but what I really wanted to know was how Tinker came up with a design or how inspiration for a design presented itself to him in the first place.

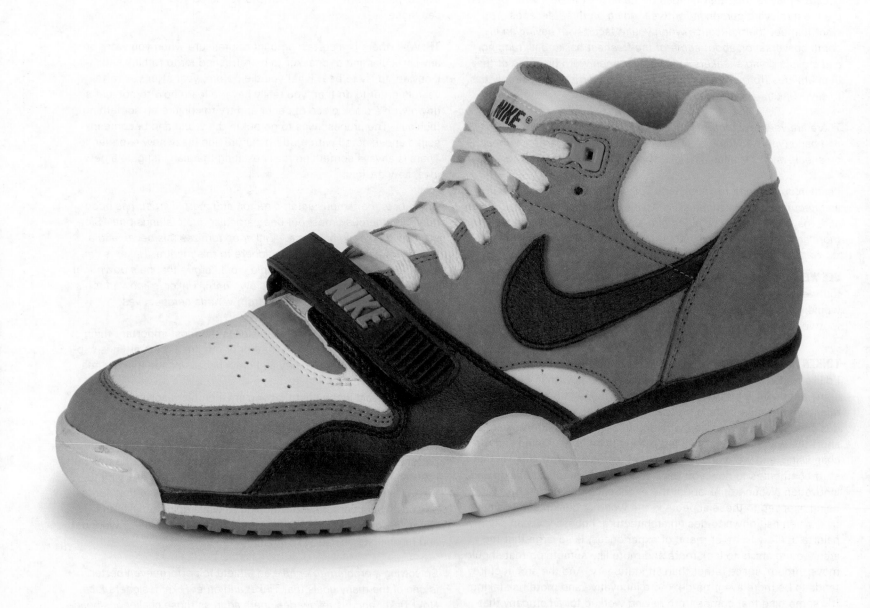

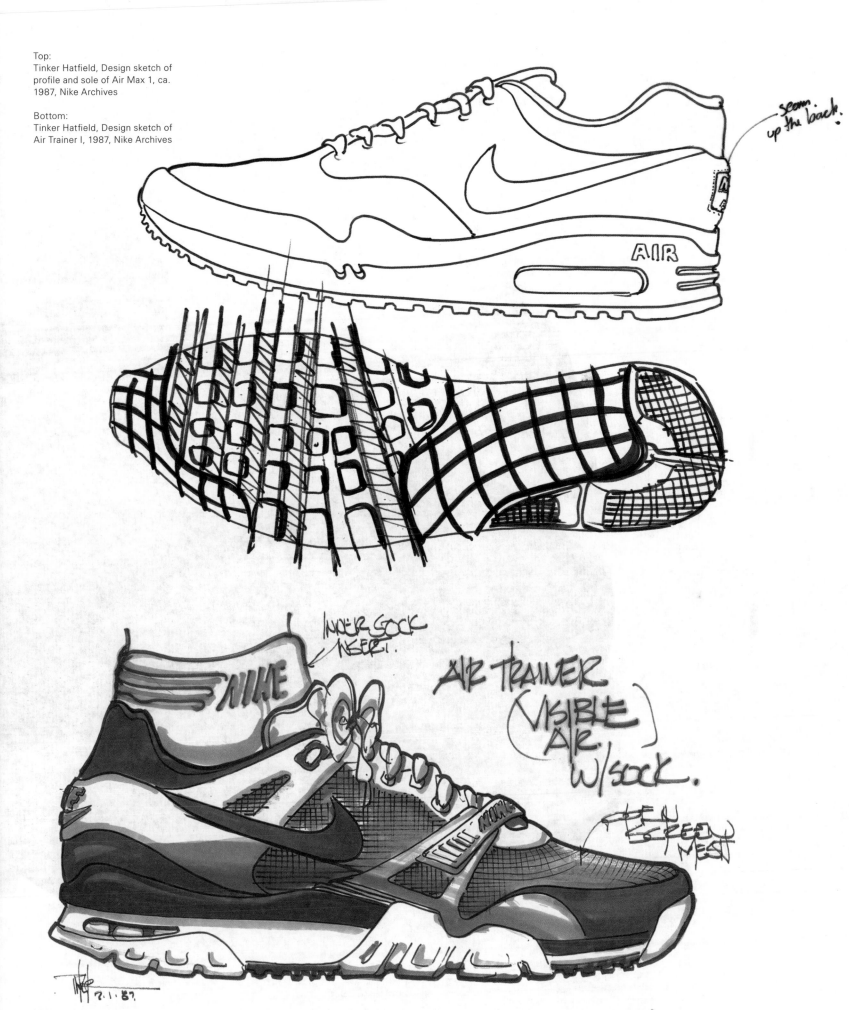

Top:
Tinker Hatfield, Design sketch of profile and sole of Air Max 1, ca. 1987, Nike Archives

Bottom:
Tinker Hatfield, Design sketch of Air Trainer I, 1987, Nike Archives

Tinker shared a great story about being at a lake, in the water, no less.

TH: I had a little bit of an epiphany once when I was waiting to be yanked out of the water behind a water-ski boat. I was sitting in the water and I was not a great water-skier, in fact I had only done it five or six times before, but there I was inside a neoprene bootie with my feet lined up in front of one another on the water ski, and just before I got yanked out of the water by the boat, I thought, wait a minute, this neoprene stuff is really comfortable and supportive and fits my foot and ankle perfectly and yet it wasn't even my ski, right? I had no business in the water, I was about to do a face plant anyway, but nonetheless, there I was skiing, and I was like, Wow! this is pretty cool. To me, it was one of those moments where I probably should have been thinking about not dying, but I was thinking about shoe design and how shoes fit, how they adapt, or how they don't fit and don't adapt, and how old notions of shoe design, which we still do today, could change. So, not long after that experience in the water, I went to my studio at home, which, by the way, is where I design almost everything on the weekends or at night, and I sketched up a shoe with no heel counter, a shoe that was highly sculpted where the midsole wasn't shaped like a normal shoe. Looking at the design I thought, well, this shoe still needs a little bit of support here and there. So I put a rubberized exoskeleton over the heel of the shoe and I added a couple of traditional pieces to the shoe, which were a normal tip and a vamp.

Sketching what would become known as the Nike Air Huarache, Tinker had to remain mindful that his design wasn't too far out there.

TH: I learned long before that you have to be careful about designing a spaceship no one's ever seen before and not expect them to like it. Oftentimes, when you have new ideas, it's not a bad strategy to add back something familiar. Huarache, to me, was probably one of the more interesting new ideas that we had done. We were really trying to make a shoe that would fit better, feel better, adapt to different feet, and also have a lighter-weight approach to the midsole and outsole design.

Fast-forward to present day.

TH: If you look at the Huarache today, it may not look as crazy as

it did when it came out, but I remember the shoe was printed with some kind of speed mark behind it, and the tagline was: "What was that?" My point of view was that the shoe was so unique and based on problem solving that it didn't even need a swoosh. There are more stories, but you get the point—this is an example of being inspired by experience and thinking about performance.

By now, I've noticed a common thread with Tinker: he finds inspiration in many places.

DW: What comes to mind immediately for me, other than the Huarache, were the cross-training sneakers.

TH: Yeah, I used to go to Metro YMCA in Portland, and it was anything but an old-school YMCA. It was a beautiful new building. We were probably one of the first clubs in the entire country that was really high tech and you could run indoors, play basketball, take an aerobics classes, lift weights, play racquetball and tennis. I used to go there because at Nike we didn't have our own workout facility. People would jump around from one activity to another, and their shoes were often ill-suited for what they were actually doing. Someone would show up in a pair of running shoes and end up playing racquetball or doing aerobics in them. Or, conversely, someone would show up in basketball shoes, because basketball was their main thing, but they might also run for three miles on the indoor track or something else that basketball shoes weren't really well suited for. That was the genesis for thinking about a product that didn't necessarily need to be the best in any particular area, but needed to be competent and good enough in multiple activities—that was the birth of cross-training.

Tinker sees himself as a problem solver, and while that may be a given, what doesn't come across is an air of superiority. He has figured out how to keep his senses sharp and continuously look for opportunities to be inspired and to innovate.

DW: It seems a consistent theme with your sneakers is that you want to disrupt the norm. Not only do you have to be a designer, but also a salesman and marketer because you have to explain to them, teach them how to relate, how to connect with the product.

TH: In the end, you have two or three different clients. One is yourself. I always believed I was the first client. The second is the internal team. The third is the buyer who is actually going to spend the money to purchase

(Pictured)
Eric Avar, Design sketches of
Zoom Huarache 2K4 "Olympic,"
ca. 2004, Nike Archives

REMOVE
LOGO + CIRCLE

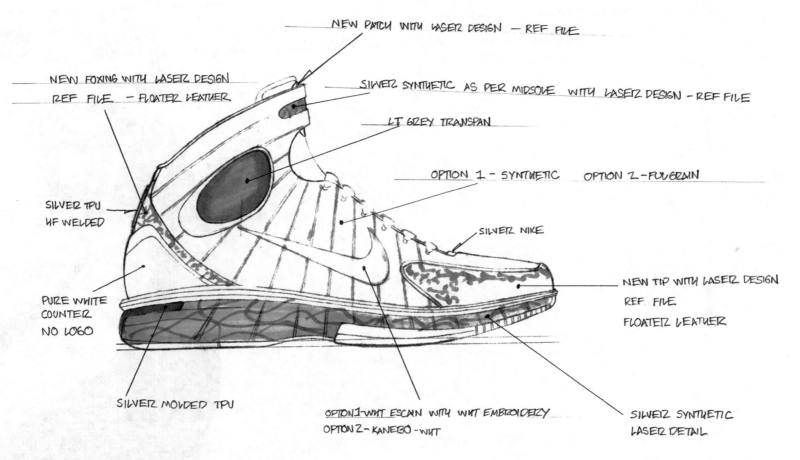

NEW PATCH WITH LASER DESIGN — REF. FILE

NEW FOXING WITH LASER DESIGN
REF FILE — FLOATER LEATHER

SILVER SYNTHETIC AS PER MIDSOLE WITH LASER DESIGN - REF FILE

LT GREY TRANSPAN

OPTION 1 - SYNTHETIC OPTION 2 - FULLGRAIN

SILVER TPU
HF WELDED

SILVER NIKE

NEW TIP WITH LASER DESIGN
REF. FILE
FLOATER LEATHER

PURE WHITE
COUNTER
NO LOGO

SILVER MOLDED TPU

OPTION1-WHT ESCAIN WITH WHT EMBROIDERY
OPTION 2 - KANEBO - WHT

SILVER SYNTHETIC
LASER DETAIL

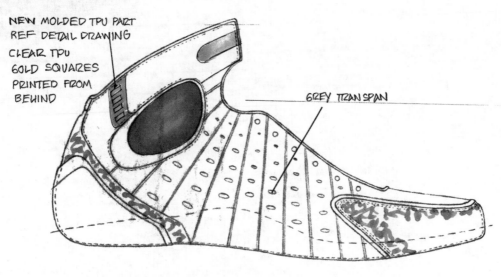

NEW MOLDED TPU PART
REF DETAIL DRAWING
CLEAR TPU
GOLD SQUARES
PRINTED FROM
BEHIND

GREY TRAN SPAN

* MEDIAL VIEW

the product. And I think when you are trying to do something new and different, you need to tell stories to help people understand why it might be a good idea. I would even go so far as to say there is a difference between art and design. I think art figures into design, but design means you are trying to do something that somebody else might want or need, therefore it's more than just your own personal expression as an artist. In my world of design, it has to be purposeful.

You see, everything that we are and everything that we do is purposeful, and Tinker maintains a determined attitude that both inspires others and breathes life into art, design, and innovation.

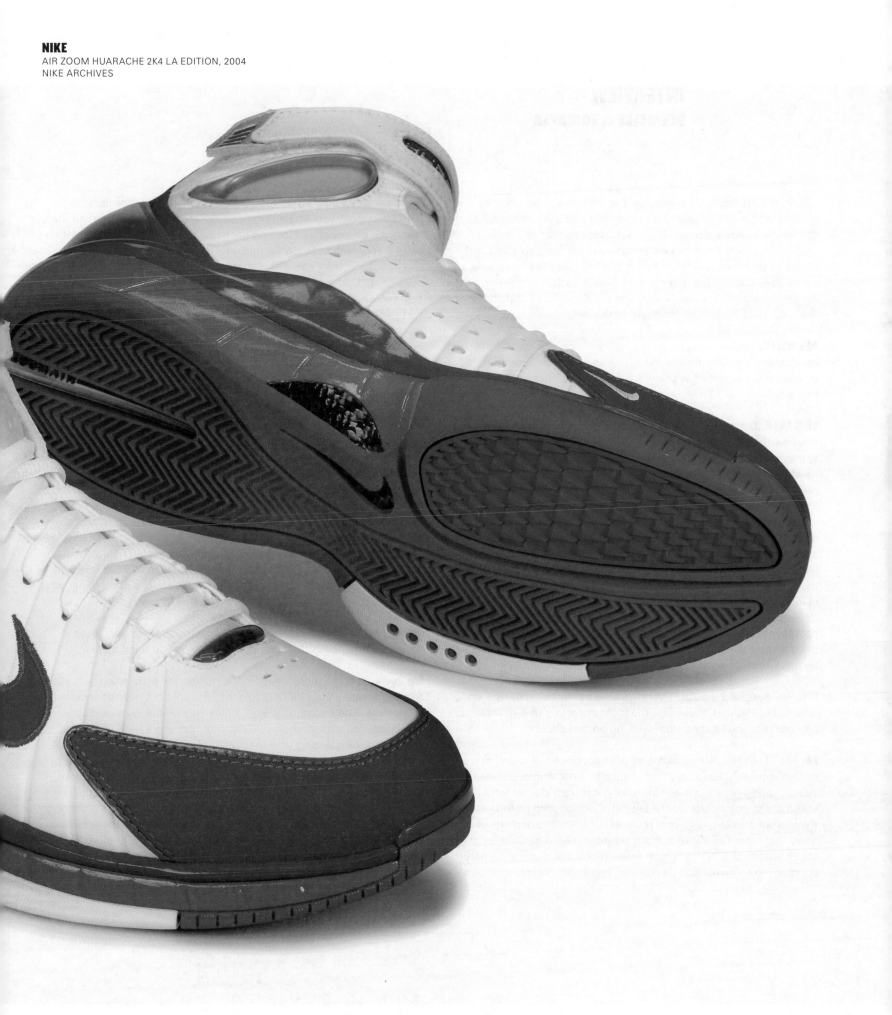

INTERVIEW
DEE WELLS & ERIC AVAR

Like Tinker Hatfield, Nike designer Eric Avar has changed the sneaker game. His passion for storytelling and drive to always push the envelope have resulted in sneaker designs that amaze. But more than these innovations it is his enthusiasm for the next thing that keeps us all wondering what that might be. Dee Wells was able to speak to Eric about how he came to design such iconic shoes as the Air Zoom Huarache, Foamposite, and the Kobe 9 and to discuss what the future of sneaker design might hold.

DEE WELLS: You've always said that good design is a marriage of science and art. Out of all of the sneakers you've designed for athletes you've worked with, which collaboration best embodies this idea?

ERIC AVAR: There are four dimensions to designing sneakers: art, science, the athlete's perspective, and storytelling. Everything starts with talking to the athlete and gaining an understanding of their needs, wants, and aspirations. This is the springboard for the design process. Next is the science, the performance, the function, what an athlete needs to perform better. I have to identify the problem I'm trying to solve. From there I consider the art—I believe the highest form of science is art, and the highest form of art is science. The two are so interrelated that the lines blur. You want to solve a functional problem in a way that is simple, beautiful, and expressive. Finally, there's the art of storytelling, bringing a character to life with a personality, spirit, soul, and backstory. It's more than just rubber and cotton. I've developed this philosophy while working with Kobe [Bryant] over the past few years. Kobe is very involved in storytelling and wants to bring a story to each of his products. That's forced me to dig deeper, be more expressionistic, and tell a narrative.

DW: You designed the Air Flight Huarache basketball sneakers alongside Tinker Hatfield. What was the most important design lesson or process that you learned from working on that shoe?

EA: The Flight Huarache holds a lot of importance to me and to my design approach. It was my first chance to work with and learn from Tinker. I had interacted with him before, but from afar, so when he asked me to collaborate on the project, I was beyond elated. It was the start of a twenty-five-year mentorship and friendship. There isn't a day that I don't continue to learn something from him. Tinker started the Huarache philosophy, which was a functional, minimalist, natural approach to footwear and design. He referenced Native American

moccasins at a time when footwear was in a phase of protectionism. Everything was about durability and protecting your foot, so the Huarache philosophy of looking back to a more functional, minimalist, natural approach to footwear design was very progressive. Applying this philosophy to a basketball shoe made a lot of people anxious, me included. At the time, the University of Michigan and the Fab Five were a big story in the basketball world, so we at Nike decided that might be a good place to showcase the product. The team tried the shoes and wanted to wear them. I remember I was at the Final Four at the semifinal game, and I saw them running out to the court to warm up. Everything that you work toward and believe in, all the testing and revisions, and then it's real life on the biggest stage. As the game progressed, it worked out pretty good.

DW: What were you the most nervous about with the Huarache? Did you think people weren't ready for it?

EA: It was nothing in particular, but Tinker says the true mark of good design will elicit a love-or-hate relationship. If you're not taking risks and being provocative, you're not pushing the needle of what the future of design could be. Every so often you need to zig when other people are zagging, and I think that holds true from functional and aesthetic perspectives. We had proved the science and performance of the Huarache, but it was a progressive approach to what footwear design could be at the time. To be a little nervous is a good thing; you know you're pushing the limits when you feel that way.

DW: You've designed a number of iconic sneakers, but one that's having resurgence is the Foamposite. Why do you think that is?

EA: Every so often there's a moment, maybe the stars or planets align, and you create a little bit of magic that you couldn't have anticipated at the time. The Foamposite was a new way of making a product. The basic idea was, If you could dip your foot into a bath of liquid that would form around your foot seamlessly to give you a perfect fit, and then it would harden just enough to give you the right amount of structure or support, it could be like a natural extension of your foot. We wanted to do away with rubber, synthetic overlays, and stitching and create something that was really simple and almost like a second skin. From there we talked about how to make this idea expressionistic, so we used a new armor material that was iridescent blue. It was that blue that became iconic to the Foamposite. At the time it was very different, radical and risky. We almost killed the product internally

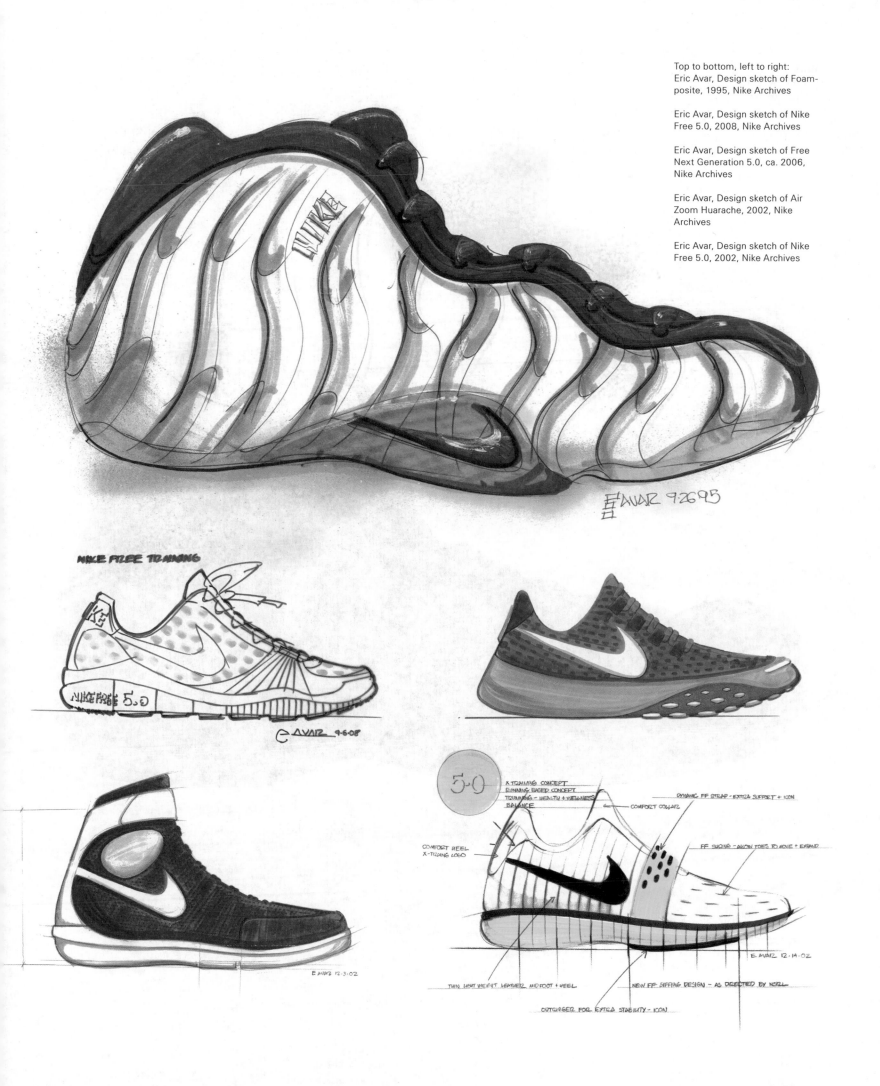

Top to bottom, left to right:
Eric Avar, Design sketch of Foam-posite, 1995, Nike Archives

Eric Avar, Design sketch of Nike Free 5.0, 2008, Nike Archives

Eric Avar, Design sketch of Free Next Generation 5.0, ca. 2006, Nike Archives

Eric Avar, Design sketch of Air Zoom Huarache, 2002, Nike Archives

Eric Avar, Design sketch of Nike Free 5.0, 2002, Nike Archives

238

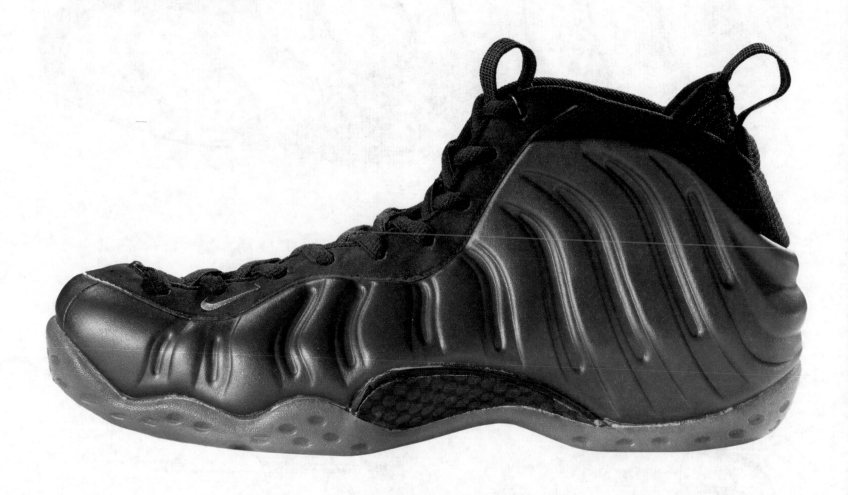

five times before we actually introduced it. Finally the University of Arizona players wore it. We were meeting with Penny Hardaway and presenting a number of prototypes. I had the Foamposite in my bag, and I didn't take it out because I thought it was too crazy. He leaned over and looked into my bag and said, "What is that? That's my next shoe." There was a visceral visual connection. The voice of the athlete is what gives us the confidence to take greater risks.

DW: I'm aware that you are a cancer survivor. How has that impacted your work or creativity? Has it changed how you tell a story through sneakers?

EA: Coming out of the experience, I was grateful for every day. It was reinforcement to be positive and thankful and to try to look at the big picture. All those experiences distill down to how you live your life and, in my case, my design approach. I felt more empowered, and I continue to feel empowered to do the right thing, do good work, and make a difference. I want to live every moment like that and make every product like that.

DW: How did that challenge you to be more innovative?

EA: When you're faced with a challenge you can go one of two ways. I went into fight mode. All I knew is that I would do anything possible because I had so much to live for. It fueled my design approach because when you take risks and try to be progressive, it's a fight to get through the system. You have to have resolve and you have to fight yourself to continue to do the right thing. If you start to waver or question yourself, it becomes easy to find a reason not to do something.

DW: Is there a pair of sneakers that tell that story?

EA: If I had to pick one, it would be the Kobe 9s or the original Free. The Free was happening at the same time I was coming back to work, so even from a timing perspective that shoe has an emotional correlation for me. With the Kobe 9, he decided he wanted to switch from a low-top basketball sneaker to a high-top. Actually, he said, "I want to reinvent the high-top." It was a new design and performance challenge that came from insight from one of the greatest athletes in the world. We had to create a high-top that plays like a low-top, so the challenge was to buck the trend and reinvent high-top design.

DW: *Back to the Future Part II*, which opened in theaters twenty-six years ago, featured self-lacing Nike Air Mag shoes. If another movie were made today envisioning the future of lifestyle and design in twenty-six years, what sneaker technology do you think would be included?

EA: I have a short-term answer and a long-term one. I think there will be new materials and material sciences that allow a more seamless integration of product to the body so you don't even know you're wearing it, but it gives you a wide range of performance abilities. A more kid-like approach, to reference the movie and the hoverboard, would be to create true flight shoes, building off the past of what flight has meant to Nike and taking that even further.

240

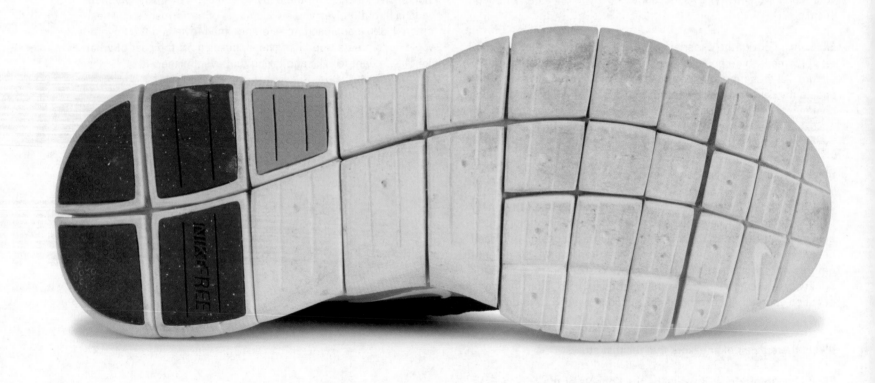

You stand in line for hours to get the latest limited-edition design, anticipating the moment when you open the box for the first whiff of your brand-new kicks. Or you spend ages poking around on eBay seeking out that vintage pair of your dreams. The dilemma you face once you've scored that crucial pair: Do you want to wear them? Or do you want to add them to your personal sneaker museum?

NEW SNEAKERS

If you want to wear your new sneakers, here are a few simple steps to increase their longevity:

Don't wear your new shoes every day; rotate them with another pair. Let them air out overnight, allowing any moisture or sweat to evaporate, particularly from the insole. Insert the manufacturer's stuffing for internal support (or if you're a purist, replace it with acid-free tissue paper) and place them back in the original box.

If you're out and about and the weather changes and your sneakers get wet, gently dry them with a soft microfiber cloth using a light blotting motion, which will eliminate the possibility of surface scratches if there is grit on your shoe. Microfiber cloths are available at some grocery stores and most hardware stores.

Try not to stack your boxed running shoes too high, as the weight from above will crush those below. If you have the great fortune of being the owner of multiple pairs, place the boxes side by side on a shelf. If space constraints demand that you pile more boxes on top, interleave each subsequent layer with a sheet of Coroplast, a corrugated plastic sold in most art supply shops. Cut the leaves so that the channels run perpendicular to the shoeboxes. A sharp box cutter and a steel ruler are the best tools for this job. The heaviest shoes should be in the bottommost layer.

1

DON'T WEAR YOUR SHOES EVERY DAY; ROTATE THEM WITH ANOTHER PAIR. LET THEM AIR OUT OVERNIGHT, ALLOWING ANY MOISTURE OR SWEAT TO EVAPORATE.

2

TRY NOT TO STACK YOUR BOXED RUNNING SHOES TOO HIGH, AS THE WEIGHT FROM ABOVE WILL CRUSH THOSE BELOW.

VINTAGE SNEAKERS

There are a few basic rules of thumb that can be applied to handling and storing most historical objects, including vintage sneakers:

Wear clean nitrile gloves (which can be purchased at a drugstore, medical supply store, or anywhere else that sells surgical gloves) to handle plastic materials, as traditional cotton gloves can leave lint or the imprint of the weave on degraded or softened surfaces.

Try to handle your shoes by their most stable elements. For instance, don't pick them up by the tongue, as the stitching may not be as robust as it looks. Sometimes the decorative materials on the toe cap, vamp, or heel counter can become sticky as the surface starts to deteriorate. When handled by these structural components, the tacky substance will be transferred to the next item you handle. If this is an issue, slip your gloved hand inside the sneaker for repositioning. Otherwise, picking them up with your hand over the vamp is usually safe.

Avoid storing your collection in damp basements and uninsulated attics. High humidity can lead to mold growth and the breakdown of chemical bonds within the plastic components. An even room temperature is important: keep your collection away from air vents, external doorways, and windows to eliminate dramatic temperature fluctuations. Properly maintained temperature and humidity levels—68°F and 30–40% humidity—will help prolong the life of any object.

Protect your collection from ultraviolet light, which can be found in sunlight, fluorescent tubes, and, to a lesser degree, halogen bulbs and even some LEDs. UV breaks the chemical bonds that form the structural foundations for plastics, resulting in yellowing surfaces and crumbling, as witnessed in polyurethane foams.

If you plan to add your shoes to your personal sneaker museum, you will need to think about their multiple component materials and how they will inform the optimal method for long-term storage. Whether your kicks are vintage or the latest design fresh out of the box, they require the same careful consideration.

COMPOSITION OF YOUR KICKS

Your sneakers are a marriage of diverse materials, such as rubber out-soles, polyurethane midsoles, and nylon aglets, all selected for their individual physical properties. These materials reflect the rapid developments in chemical engineering by plastics manufacturers. Plastics have been part of shoemaking since the late 1800s. One such instance is nitrocellulose, which was developed as a replacement for expensive ivory once used to make billiard balls. Nitrocellulose was used as faux mother-of-pearl for buttons, formed into a high-gloss film used to cover wooden heels, and also applied as a top coat on leather to imitate the polished wax finish we think of as "patent leather." Another game changer was the development of vulcanized rubber in the 1840s. This process made latex easier to work with and more resilient to long-term wear.

Manufacturers have always sought to find economical solutions to increase the performance and reduce the cost of footwear manufacturing. Sometimes they are looking for materials that will perform specific functions, such as increasing shock absorption and flexibility. Other times they are the result of blue-sky thinking, leading to the development of a new material, its practical application being secondary. Many of these innovations have found their way into the production of your sneakers.

3
THE RUBBER FOXING CAN HARDEN AND CRACK. SIGNIFICANT CRACKS CAUSE LOSS, EXPOSING THE CANVAS UPPER AND THE FOXING SUBSTRATE.

THE MATERIAL: RUBBER

Rubber was used for the soles of sneakers because of its malleability and durability plus the added bonus of being waterproof. Fun fact: In 1775 a British clergyman discovered that a small piece of gutta-percha brought back from Brazil could be used to rub out marks from pencil lead—hence the name rubber.

Problems: Sulfur, one of the primary chemical components used to make rubber flexible, affects its life span, as this additive reacts to oxygen and light. The degradation process is exacerbated by high humidity and fluctuating temperatures. The rubber becomes rigid and cracks appear, creating fissures, which can result in physical losses (small chips falling off), and white surfaces will turn varying shades of yellow. High temperatures can soften the rubber, which will retain any dimensional changes upon cooling. This deterioration process also results in the release, or off-gassing, of hydrogen sulfide, which has a strong odor just like bicycle tires. This off-gassing can cross-contaminate materials in its immediate vicinity, such as silver, which will tarnish.

Solutions: Reduce exposure to oxygen by sealing your shoes in an impermeable food-grade inert plastic bag. One sneaker collector recommends partially sealing the bag, gently pressing out air, then using a drinking straw to suck out the remaining trapped air before completing the seal.

4 AVOID STORING YOUR COLLECTION IN DAMP BASEMENTS AND UNINSULATED ATTICS. HIGH HUMIDITY CAN LEAD TO MOLD GROWTH AND THE BREAKDOWN OF CHEMICAL BONDS WITHIN THE PLASTIC COMPONENTS

5

THE PLASTIC FILM CAN FRACTURE INTO PIECES, WHICH DELAMINATE AND BECOME STUCK TO ANY SURFACE.

6

POLYURETHANE (PU) FOAMS WERE COMMONLY USED, PREDOMINANTLY IN THE 1980S, FOR THE MIDSOLE OF ATHLETIC SHOES.

REDUCE EXPOSURE TO OXYGEN BY SEALING YOUR SHOES IN AN IMPERMEABLE FOOD-GRADE INERT PLASTIC BAG.

7

8

SEPARATE EACH SNEAKER FROM ITS MATE BY INSERTING A SHEET OF NONSTICK SILICON OR TEFLON-COATED PAPER BETWEEN THEM.

9

GENERALLY YOUR SNEAKERS SHOULD BE STORED IN A COOL, DUST-FREE, DARK ENVIRONMENT.

THE MATERIAL: POLYURETHANE
Polyurethane (PU) foams were commonly used, predominantly in the 1980s, for the midsole of athletic shoes, as they have great cushioning and shock absorption qualities.

Problems: polyurethane foam midsoles can yellow, become sticky, or crumble as a result of light damage and high humidity. Sometimes they lose their structural resilience.

Solutions: If the foam is sticky, separate each sneaker from its mate by inserting a sheet of nonstick silicon or Teflon-coated paper between them. This will prevent the two shoes from becoming stuck to each other. You can use this paper as a liner should you wish to store your sneaker in its original box.

THE MATERIAL: POLYVINYL CHLORIDE
Polyvinyl chloride (PVC) was patented by a German scientist, Friedrich Klatte, in 1913, but its use wasn't fully realized until the 1920s. Demand increased during World War II, when it was used for insulation on wiring for the U.S. Navy's ships. In the 1950s, it was used to make molded "jelly" sandals; in the 1960s, futuristic fashions produced clear PVC shoes and PVC film, which was applied to textiles to create the "Wet Look." Problems: Plasticized polyvinyl chloride (PVC-P) films can be found lami-

nated to a synthetic fabric or foam substrate, like a tongue, the collar line, or an Achilles tendon protector. PVC-P is also used for decorative elements, such as eye stays. A plasticizer is a chemical additive that makes the end material malleable and easy to work with. It is this component that makes PVC unstable in the long run. The plasticizer leaches out onto the surface, rendering it a sticky dust trap. This greasy product will transfer on contact. Sometimes a white bloom will appear; other times the surface develops cracks along the edges, which expand over time if the storage environment is not stable.

Solutions: Use the same storage techniques as for polyurethane foam.

KICKING IT INTO THE FUTURE

Generally your sneakers should be stored in a cool, dust-free, dark environment. Be sure to provide an internal support to alleviate stress caused by sagging. For kicks in good condition, you can use acid-free tissue paper, which can be purchased from a store that stocks archival supplies. For sneakers with deteriorating plastic components, it is best to use a thin polyethylene (PE) foam sheet for support (also available from archival suppliers), as paper can become permanently attached to sticky surfaces. You can also use a PE film, which can be sourced at a hardware store. Gently insert your material of choice into the forepart to support the vamp; next use a rolled-up piece of the sheet and place it inside the ankle/leg area.

You can literally put modern "kicks on ice" by placing them in a sealed bag, with the air removed, inside a frost-free domestic chest freezer. Vintage sneakers with rigid or cracking rubber soles should not be frozen, as this will lead to further embrittlement. Freezing will stop immediate deterioration, but upon removal, the process will start again. Boxes should be stored separately away from the light to prevent the printing inks from fading. When the bag is removed from the freezer, be sure to allow its contents to acclimatize to room temperature for a minimum of twenty-four to forty-eight hours before opening.

The ephemeral nature of synthetic materials is a well-established fact, as museums, art galleries, and private collectors strive to respond to their deterioration. Bench conservators, those who stabilize artifacts, work with conservation scientists to determine the best methods for long-term preservation. The inherent vice associated with these composite objects, whether it be contemporary art or vintage fashion, will be the main challenge for future collectors.

Most of the suggested storage materials are readily available and reasonably priced, which means you can direct your hard-earned cash toward your sneaker shopping list. By employing the basic storage ideas listed above, your cherished collection will last for many years.

BIBLIOGRAPHY

Cavanagh, Ph. D, Peter R. *The Running Shoe Book*. Mountain View, California: Anderson World, Inc., 1980.

Cheskin, Melvyn P., with Kel J. Sherkin and Barry T. Bates. *The Complete Handbook of Athletic Footwear*. New York: Fairchild Publications, 1987.

Christensson, Pia, Pelle Johansson, Ulrika Brynnel, Katrin Hinrichs Degerblad, and Thea Winther. "Reshaping and Rehousing of Rubber Galoshes." *Conserving Modernity: The Articulation of Innovation*, preprint of ninth NATCC Conference (CD). San Francisco (2013): 161–73.

Cohn, Walter E. *Modern Footwear Materials & Processes: A Topical Guide to Footwear Technology*. New York: Fairchild Publications, 1969.

Fenn, Julia and R. Scott Williams. "Care of Plastics and Rubbers." *CAC Workshop Identification and Care of Plastics in Museums*. Ottawa: Canadian Conservation Institute, 2010.

Hackett, Joanne. "Man-Made Uppers, Man-Made Soles: The Technology of Modern Shoes." *Conserving Modernity: The Articulation of Innovation*, preprint of ninth NATCC Conference (CD). San Francisco (2013): 145–60.

Lavédrine, Bertrand, Alban Fournier, and Graham Martin, eds. *Preservation of Plastic Artefacts in Museum Collections*. Brussels: Bietlot Imprimerie, 2012.

Vanderbilt, Tom. *The Sneaker Book: Anatomy of an Industry and an Icon*. New York: New Press, 1998.

Waentig, Friederike. *Plastics in Art: A Study from the Conservation Point of View*. Petersberg: Michael Imhof Verlag, 2008.

LENDERS

adidas AG
Sheraz Amin
Matte Babel
Bata Shoe Museum
Erik Blam
Common Projects Archives
Converse Archives
D'Wayne Edwards
Fondazione Fila Museum
Bobbito Garcia
Thad Jayaseelan
Chad Jones
Kosow Sneaker Museum (Electric Purple Chameleon, LLC)
Jimm Lasser
Mache
Shantell Martin
Nike Archives
Northampton Museums and Art Gallery
PUMA Archives
Mayan Rajendran
Reebok Archives
Tom Sachs
Jeff Staple
Dee Wells
Kehinde Wiley

This catalogue is published on the occasion of the traveling version of the exhibition *Out of the Box: The Rise of Sneaker Culture*, co-organized by the American Federation of Arts and the Bata Shoe Museum. The exhibition was first shown at the Bata Shoe Museum in 2013.

 AMERICAN FEDERATION OF ARTS BATA SHOE MUSEUM

First published in the United States of America in 2015 by

Skira Rizzoli Publication Inc.
300 Park Avenue South, New York, NY 10010
www.rizzoliusa.com

and

American Federation of Arts
305 East 47th Street, 10th Floor, New York, NY 10017
www.afaweb.org

The American Federation of Arts is the leader in traveling exhibitions internationally. A nonprofit institution founded in 1909, the AFA is dedicated to enriching the public's experience and understanding of the visual arts through organizing and touring art exhibitions for presentation in museums around the world, publishing exhibition catalogues featuring important scholarly research, and developing educational programs. For more information, visit www.afaweb.org.

The Bata Shoe Museum in Toronto, Canada, is an internationally acclaimed museum that boasts a collection of more than 13,000 artifacts spanning 4,500 years of history and actively supports a mandate to collect, research, exhibit and publish on the cultural, historical, and sociological value of footwear. For more information, visit www.batashoemuseum.com.

Guest Curator: Elizabeth Semmelhack, Senior Curator of the Bata Shoe Museum

For the American Federation of Arts:
Managing Curator: Michelle Hargrave
Manager of Publications and Communications: Audrey Walen

For Skira Rizzoli Publications, Inc.:
Publisher: Charles Miers
Associate Publisher: Margaret Rennolds Chace
Editor: Jessica Fuller
Production: Alyn Evans

Book Design: Stella Giovanni

2015 2016 2017 2018 2019 / 10 9 8 7 6 5 4 3 2 1
Library of Congress Control Number: 2015933359
ISBN: 978-0-8478-4660-3

Printed in China

Front cover: Nike, Air Jordan I, 1985, Nike Archives

Out of the Box: The Rise of Sneaker Culture will travel to:

Brooklyn Museum (July 10–October 4, 2015)
Toledo Museum of Art (December 3, 2015–February 28, 2016)
High Museum of Art (June 12–August 14, 2016)
Speed Art Museum (September 9–November 27, 2016)

ACKNOWLEDGMENTS

This project could not have happened without the passion and expertise of all those who participated. We are exceedingly grateful to our lenders, contributors, photographers, and colleagues. There are too many to list all those who have generously assisted with this project; among them we would like to acknowledge:

adidas AG and adidas archives: Andrea Bader; Susen Friedrich; Martin Gebhardt; Martin Herde; Gabriele Herzog

Sheraz Amin

Matte Babel and Jaimey Robertson

Erik Blam

Christian Louboutin: Megan Kay; Christian Louboutin; Anne Muhlethaler; Alvina Patel; Cat Staffel

Common Projects: Andrew Enness

Converse and Converse Archives: Peter Dericks; Elizabeth Fox; Greg Galbraith; Rodney Rambo; Sam Smallidge; Ian Stewart

D'Wayne Edwards

Ewing Athletics: David Goldberg

Fila USA: Jennifer Estabrook

Bobbito Garcia

GE: Linda Boff; Sydney Lestrud; Sam Olstein

Thad Jayaseelan

Chad Jones

Kehinde Wiley Studio: Amy Gadola; Brian Pinkley; Kehinde Wiley

Kosow Sneaker Museum: Rick Kosow

Jimm Lasser

Mache Custom Kicks

Shantell Martin

New Balance: Kate Tetirick

Nike and Nike Archives: Eric Avar; Reggie Borges; Tinker Hatfield; Steven Hofmeister; Kristi Keiffer; Aaron Last; Todd Olbrantz; Julie Papen; Keith Parker; Rick Shannon; Nate Tobecksen

Northampton Museums and Art Gallery: Rebecca Shawcross

PONY: William Chan

Puma: Michelle Perrault

Mayan Rajendran

Reebok and Reebok Archives: Claire Afford; Matt Costa; Scott Daley; Richard Dilando; Paul Litchfield; Bethany O'Dell; Jessica Ruscito; Patricia Ryan; Sarah St. George

Staple Design: Kim Caban; Jeff Staple

Tom Sachs Studio: Daniel Caputo; Tom Sachs

Under Armour: Tai Foster; Jasmine Maietta; Ernie Talbert

Vans: Chris Duran

Dee Wells

Cey Adams
Bill Adler
Sugar Ansari
Luke Baker
Nishi Bassi
Linda Bein
James Bond
Mister Cartoon
Sophia Chang
Xue Chen
Linda Clous
Alexandra DiLorenzo
Marc Eckō
D'Wayne Edwards
Anna Hayes Evenhouse
Colin Fanning
Michael Faso
Clarence Ford
Amy Foster
Jim Fox
Walt "Clyde" Frazier
Pierre Hardy
Adam Horovitz
Kazuya Hisanaga
Hunter
Patricia James
Danny Jestakom
Lee Joseph
Liz Keen
Maud Junca
Brian Keliher
Sophie Kerr-Dineen
Matthew Kneller
Michael Krueger
Christian Langbein
Darryl "DMC" McDaniels
Chris McDonnell
Hiroki Nakamura
Phillip Nutt
Lindsey O'Connor
Pablo Olea
Loren Olsen
Matthew D. Ray
Dan Rookwood
Lois Sakany
Jeremy Scott
Joseph Setton
Rev. Run (Joseph Ward Simmons)
Rachel Shapiro
Stan Smith
Jasmine Teer
Eugene Tong
Toronto Loves Kicks
Dion Walcott
Dan Wasserman
Sperone Westwater Gallery
Sean Williams
Sully Wong